This book is dedicated to those who are living in war while imagining peace, and those who are brave enough to build it.

Concept and Editorial Direction
Gary Knight

Project Director
Fiona Turner

Edited by
Constance Hale and
Fiona Turner

Consulting Editor
Ron Haviv

The VII
Foundation

VIIF

blue chip
Foundation

HEMERIA

SPARKPRESS

Imagine: Reflections on Peace

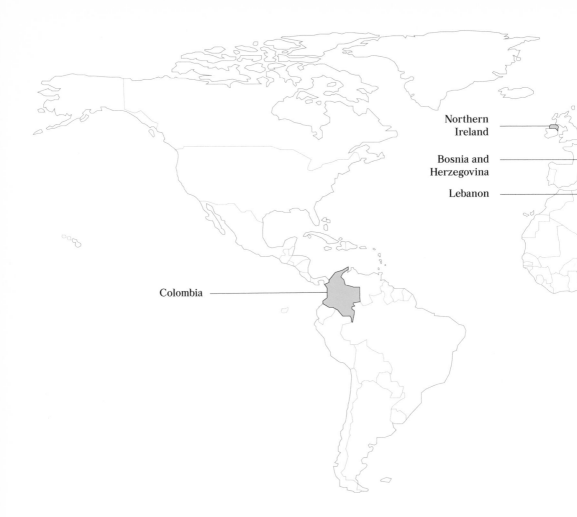

Northern
Ireland

Bosnia and
Herzegovina

Lebanon

Colombia

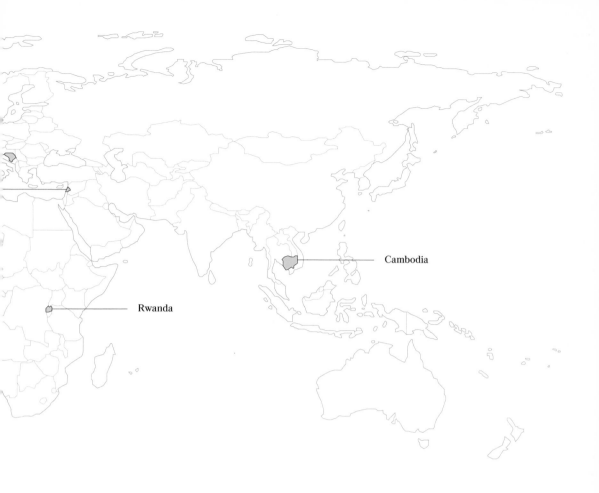

Cambodia

Rwanda

— **Preface**
Out of War

7

by Gary Knight

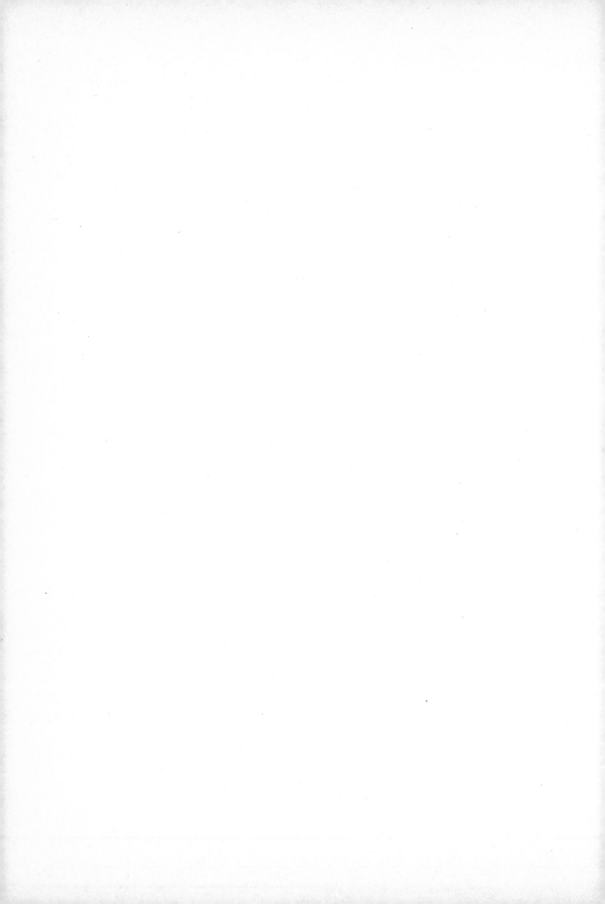

I n 1988, I flew to Bangkok on a cheap KLM flight and sat at the back of the plane with the smokers. My rucksack was in the hold and my precious Billingham camera bag on my knees. The flight was the third I had taken in my life. When the plane landed, I went to the Bangkok Youth Hostel on Phitsanulok Road, beginning my career as a photographer from a bunk bed in a dormitory.

In the 20 years that followed, I lived with an omnipresent inner conflict between my wonder at just being present and my distress about the violence and injustice I was witnessing. I lived through incidents that made me feel grateful but profoundly uncomfortable, like the moment when a Khmer Rouge officer—a man who had, 10 years earlier, been involved in the slaughter in Cambodia—tenderly held my hand and guided me safely through a minefield.

As my career progressed, the intensity of the wars also ramped up. In 1993, I moved to the former Yugoslavia to document war crimes and crimes against humanity during the Balkan country's civil war. I covered conflicts in Africa and the Middle East, the occupation of Afghanistan and the civil war in Kashmir. I also worked in Latin America, South Asia, and North Korea.

For nearly two decades, war was my life. It was also central to the lives of many of my friends and indeed led to the formation of many friendships. War consumed us— literally, in the case of some who never made it home. And in the case of others who survived, war remains buried deep inside us decades later.

War invaded any peace I tried to find, like a parasite burrowed into my skin, eating away, invisible but present. One day, in April 2003, shortly after returning home from Iraq, I visited a close friend and pored over the photographs I had taken there. The invasion of Iraq was a personal turning point in my journalism career and my final act of photographing violence. I was exhausted by it. I wondered what it would take to make peace in Iraq, as well as in the neighboring countries, which were fast falling prey to violence. Reflecting on all the countries I had covered during wartime, I couldn't say that peace had proved to be an unmitigated success. In some cases, the best that could be said was that the peace was preferable *only* to war—a notion that struck me as a very low benchmark.

That conversation about war and the inconclusiveness of peace was the first of many. Collectively, these conversations led to the making of this book, and it continued in the essays themselves. One synonym for peace might be *tranquility*, yet we are hard-pressed to find such calm in the wake of war. Peace is universally lauded as one of humankind's highest achievements, yet every city is filled with statues of soldiers cast in bronze, and we continue to define *valor* as bravery in war. Violence is palpable, horrific, yet it doesn't necessarily fade when conflict yields to concord, or when concord relies upon cobbled-together agreements. Violence is graphic and describable, peace more of an elusive ideal, an ephemeral space between wars, a pause, both an aftermath to war and prelude to yet another war. As long as we celebrate warriors more than peacemakers, as long as we insist fiercely on our differences, rather than humbly seeking our commonalities, peace will be framed in the context of war, as an absence of something rather than as a presence.

Once a war starts and its violence hems people in, they summon the elusive ideal and try to imagine peace. As the war consumes more and more lives, the desire for peace becomes more and more acute. When battlefield prowess and political manipulation are not enough to achieve peace through victory, we summon our best and brightest to negotiate an end; we celebrate peace settlements; and we give prizes, if not to victors, then to visionaries. We exalt peace as a human achievement, and justly so.

But the reality of peace is flawed. The rewards of peace are elusive for the men and women who live in the post-conflict societies of our time. Why is it so difficult to make a good peace when it is so easy to imagine?

That is the question at the heart of this creative endeavor. We asked more than a dozen journalists, six writers and seven photographers, to revisit countries with which they had become achingly familiar during the months and often years of seemingly intractable conflict. We wanted to see peace on the ground through the prism of their journalistic experience; to revisit the towns and villages; to talk to the women, men, soldiers, civilians, statesmen, and students who had survived the conflict or who had been born or grown up in the postwar society, and discover what their experience of peace felt like. We sought input from academics and peacemakers. And because every story has many facets, we invited citizens of those countries to give us their very personal narratives, in their own voices.

While we have hewed to journalistic methods and the art of fact, the pursuit of authentic voice has been central to this project. We gave all the writers and photographers the freedom to tell the story in the way they deemed fit, and we encouraged them to bring their full subjectivity to bear. We did not soften hard edges or delete unpalatable impressions, but rather trusted that these distinctive parts would add up to an edifying whole.

Peace in every country has a distinct shape and hue, but these reports, analyses, and first-person accounts revealed some common elements that can hinder reconciliation and growth, as well as others that can help build the road to an empowered and stable society. We want to understand those elements.

In Cambodia, a generation after the United Nations supervised elections and the long war ended, rural citizens have the quiet they craved but have scant access to adequate health care, education, or basic freedoms, and they are ruled by a dictator who was a former Khmer Rouge commander. In Bosnia, the Dayton Accords, imposed by outside powers, stopped the killing but created a dysfunctional political system, which failed to deliver dividends: 50 percent of the country's youth is unemployed, and almost half of its population now lives elsewhere. Northern Ireland reached the much-heralded Good Friday or Belfast Agreement in 1998, yet the arrangement of power-sharing in Stormont, the seat of the Northern Ireland Assembly, collapsed in 2017. The haggling over Brexit and Northern Ireland's borders with the Irish Republic, an issue that was at the heart of the negotiated agreement, has exposed the fragility of the two-decade-old peace. In the 1990s, when I covered the Tutsis' revenge murder of thousands of Rwandan Hutus in Congo, I could not anticipate that Rwanda would become the poster child for peace—and yet Rwanda has demonstrated a commitment

to justice and reconciliation, boasts the highest number of female parliamentarians in the world, and has seen its "miracle economy" grow at 7 percent annually. Its populace, though, has never elected a replacement for its autocratic leader. Lebanon continues to suffer from the destabilizing influence of its squabbling neighbors, with more than a quarter of its population refugees. Colombia today, flush with the success of a peace treaty ending 50 years of civil war, is getting down to the difficult business of binding together a society riven for a very long time by violence, with both sides threatening to undermine—or abandon altogether—the terms of the accord.

Not everything is bleak. Humans are resilient. Concentration camp survivor Elvis Garibovic and genocide witness Dydine Umunyana have emerged from their experiences without succumbing to bitterness. Palestinian filmmaker Mira Sidawi and Cambodian bomb disposal technician Sophary Sophin use the legacies of war as inspiration for art and activism. John "Jackie" McDonald is building cross-community relations from the ground up in Northern Ireland. Kamal Mouzawak welcomes all comers at his restaurant, Tawlet, in Beirut.

These are not the wars of our grandparents, wars that we've heard about but that are so distant they are abstract and easy to disown. The countries we chose for this project share recent histories of violence that are part of our collective consciousness. The peace in these countries, and the treaties that world leaders and diplomats are brokering outside their borders, may not hold, but the success or failure of these efforts will affect us all. Even if we feel no personal responsibility, the consequences of failed outcomes will lead to further conflict, epic migration, the destabilization of societies, the rise of populism, and the politics of fear.

A century ago, the Treaty of Versailles—an accord that created the conditions for an even more terrible war than the one it tried to resolve—offered a cautionary tale about the pitfalls of peacemaking. A hundred years later, we should ask anew: How can we raise the benchmark? How can we make a better peace?

In the last days of assembling this book, just before heading to the printing plant, we find ourselves staring into the breach of unseen but universal horrors, a worldwide pandemic of unknown consequences. Emerging out of Wuhan, COVID-19 soon cloaked Beijing, Moscow, Berlin, Paris, London, and Washington in an invisible shroud, and along the way, it infected Beirut, Phnom Penh, Kigali, Sarajevo, Belfast, and Bogota.

As the major world powers look inward, fighting political battles at home and struggling to rebuild broken economies, the appetite for solving problems far from home may diminish. As Samantha Power notes, in this time of rising populism and nationalism, the commitment to diplomacy is already impoverished; it may be further lessened as attempts to grapple with the pandemic and its aftermath take precedence over efforts to prevent destabilizing conflict.

Still, we must learn from the questions posed in this book; this is no time to turn our eyes away from tribalism, dogma, and extremism.

Gary Knight
Massachusetts
March 2020

— Introduction
Building the Tunnel

by Jonathan Powell

Jonathan Powell was Prime Minister Tony Blair's chief of staff
and the principal UK government negotiator on Northern Ireland.
His experience in Northern Ireland led him to understand that
to make peace, you first have to build trust—and to build trust,
you have to take risks. Realizing peace, he believes, takes more
than seeing an opening at the end of a dark tunnel, declaring a
ceasefire, and walking towards the light. Often, peacemakers
must build the tunnel itself. And then civilians must find a way
to live together—and perhaps to forgive.

I was closely involved in two of the peace processes recounted in this book—Northern Ireland and Colombia—and the first changed my life. I was no friend of the Irish Republican Army (IRA) when I started working on peace. In 1940, the group had shot my father through the ear and injured him; in the 1980s, it put my brother, who worked for Prime Minister Margaret Thatcher, on a death list for eight years. The first time I met the IRA leaders in 1997, I refused to shake hands, something I now regret. My boss, Prime Minister Tony Blair, was much more sensible and greeted them as he would any other human being.

A few weeks later, I was surprised to receive a phone call from Martin McGuinness. He asked if I would come incognito to Derry in Northern Ireland and insisted that I not tell the "securocrats," as republicans called the police and security services. I asked Tony if I should go, and he said that I should. I flew to Belfast and took a taxi to Derry. As I stood on a street corner, per my instructions, feeling mildly foolish, two men with shaved heads appeared and pushed me into the back of a cab, saying, "Martin sent us." They drove me round and round the city for an hour till I was completely lost and then pushed me out next to a little modern house on the edge of an estate. I knocked on the door and Martin answered on crutches, making a not very funny joke about kneecapping—the IRA's favoured method of punishment, where they would shoot holes in their victim's kneecaps and ankles.

The lady of the house had gone out, asking no questions, and had left sandwiches and cups of tea by an open fire. We sat and talked for three hours. We made no breakthroughs, but it came home to me as I travelled back to London that to make progress towards peace, you have to build trust by going onto the other side's turf rather than demanding that they come to meet you in grand government buildings. Shared risks can foster a bond. I spent the next 10 years in Downing Street regularly crossing the Irish Sea to meet Gerry Adams and Martin McGuiness in various safe houses in Belfast and Dublin until we eventually arrived at a lasting peace.

This book brings together very personal stories of peace and reconciliation and a remarkable collection of photographs. What becomes clear is that the signing of an agreement is not the culmination of a peace process. Indeed, it is only the beginning, for lasting peace is built by the people left in a ravaged country long after the peacemakers are gone. The essays here present a series of lessons on peacemaking and peace building around the world.

One is the importance of identity in so many conflicts, which Martin Fletcher's essay

about peace in Northern Ireland captures. The conflict there was not about religion, as some external observers mistakenly think, or about self-determination, but rather about the identity of the two communities who lived side by side in the province. We couldn't resolve that conflict, and the Good Friday or Belfast Agreement was in the end an agreement to disagree. Unionists continued to want to be part of the United Kingdom, and nationalists and republicans continued to want to be part of a united Ireland. But what we managed to do, in part because of the open border we created between Northern Ireland and the rest of the island, was build a place where both identities could live happily alongside each other without violence. People could feel they were Irish, British, or both. That solution is now under threat from Brexit, which threatens to reintroduce a hard border between Ireland north and south and throw the issue of identity back into political relief, with the potential return of violence.

A further lesson is the unwillingness of governments to be seen talking to their enemies, whom they characterise as terrorists. Doing so in public exacts a political price. It is for that reason that negotiations often start by way of secret and deniable back channels. The British government opened a back channel to the IRA in 1972 and maintained it for more than 20 years. The channel was crucial in allowing British Prime Minister John Major to get to an IRA ceasefire and the early stages of inclusive peace talks, but he wouldn't admit to its existence. He stood up in Parliament and said that he would never speak to Gerry Adams—that it would turn his stomach to do so. But at exactly the same time, he was corresponding with Martin McGuinness, the leader of the IRA, and thank goodness Major was doing so or peace would never have come. In Colombia, when I went to work with President Juan Manuel Santos in 2011, he revealed to me that the government had a secret channel to the FARC. This channel, too, was fundamental in exploring whether talks were possible.

Governments are always anxious to hide such contacts. Every Spanish prime minister after Francisco Franco, up until Mariano Rajoy, engaged in talks with the Basque terrorist movement Euskadi Ta Askatasuna (ETA, Basque Homeland and Liberty), but they all denied it. Adolfo Suárez, the first democratically elected prime minister after Franco, stood up in the Cortes Generales and denied that he had met with the ETA. The leader of the opposition, Felipe González, got to his feet and said, "That's funny—you told me over dinner last night that you had."

Such exploratory conversations can last a long time, but the time must be right to enter into negotiations. Experience suggests that two factors need to be in place if peace negotiations are to be successful. The first is what academics call *a mutually hurting stalemate*—that is, not just a stalemate, but one in which both sides perceive that they are paying a price and want the conflict to stop. The British Army's leaders realised in the late 1970s that while they could contain IRA violence at "an acceptable level" indefinitely, they were not going to defeat the insurgents with military force alone. Adams and McGuinness, who had joined the Republican movement very young, were past fighting age by the mid-1980s, when they too realised that while they could not be defeated, nor were they going to drive the Brits out of Northern Ireland with physical force. It was then that they started reaching out in search of peace—first to the moderate Catholic leader John Hume, and then to the Government of Ireland, and finally to the British government.

The second determining factor is having the right leadership. In Northern Ireland, we were lucky to have Adams and McGuinness, who were prepared to risk not just their careers but their lives in pursuit of peace. We were also fortunate to have unionist leaders such as David Trimble and Ian Paisley, who made bold decisions in order to get to an agreement. And in particular we were lucky that British Prime Minister Tony Blair and his Irish counterpart, Taoiseach (Prime Minister) Bertie Ahern, came to office at the same time. They served alongside each other in a remarkable partnership for 10 years, which gave them time to conclude the eventual agreement and put it into practice. In Colombia, only a president like Juan Manuel Santos could have made peace with the FARC, because he was prepared to be bold and risk even his reelection in the interest of completing the peace negotiations, despite the views of his close advisers that he should run on a safe platform such as the economy.

Aside from these two factors, these essays bring home the truth that peace is not an event, the signing of an agreement, but a process which takes time. If there is a process in place, people have hope that there will be a settlement. But if the agreement collapses and there is no process, violence soon fills the vacuum. Former Israeli Prime Minister, the late Shimon Peres, used to like to say that the solution to the Middle East conflict was fairly clear in terms of land, of refugees, and even of Jerusalem, but the problem was that there was no process to get there. The good news, he said, was that there was light at the end of the tunnel. The bad news was that there was no tunnel. The job of peacemakers is to build that tunnel.

Keeping a peace process going is not always easy, but it is crucial to do so. It is like riding a bicycle—you have to keep moving or you will fall off. Even if you face political and personal challenges along the path to peace, you have to keep going.

In 2004, the Northern Ireland peace process was in danger of collapse. The Leeds Castle agreement had disintegrated and everyone had given up. I travelled over to Belfast for talks with Adams and McGuinness in a monastery in West Belfast, and no one wanted to come with me. A Northern Ireland Office official met me as I got off the airplane. He stopped the car after a mile and told me to get out so the driver wouldn't overhear our conversation. He said that the biggest bank robbery in world history had happened the night before, and "the dogs on the street knew the IRA had done it."

I was furious. I was out on a limb, and the IRA had cut it off behind me. I kicked a stone, stubbed my toe, and thought about getting back on the plane and returning to London. But then I thought of my bicycle theory and decided I should instead go ahead with the meeting. It was a particularly painful encounter because I couldn't mention the robbery to Adams and McGuinness, as the police wouldn't be announcing it till the afternoon. So I sat through the meeting fuming.

As Philip Gourevitch's essay on Rwanda and Anthony Loyd's essay on Bosnia make clear, finding a way to put the past in the past and achieve reconciliation and forgiveness is perhaps the central challenge in all peace negotiations. It's not an easy thing to do. In Northern Ireland we still have not succeeded, and the past keeps intruding into the present with prosecutions of soldiers or former IRA members. Yet in Rwanda, despite a civil war that involved murder and mayhem on an almost

unimaginable scale, community genocide courts, known as *gacaca*, required Rwandans to not just confront their past but pursue the seemingly incompatible ends of accountability and reconciliation.

"*Génocidaires* who confessed and repented their crimes were rewarded with substantially reduced sentences," Gourevitch writes, "while survivors were called upon, in turn, to forgive them." The community forums, he continues, "constituted the most ambitious and comprehensive exercise in accountability for crimes against humanity that any country has ever undertaken."

The problem is even more challenging in the age of the International Criminal Court (ICC). In the old days, peace agreements used to end with amnesties for both sides, but that is no longer possible. Unless there is a system of transitional justice in place, the ICC will prosecute. Richard Goldstone's essay demonstrates the need for and success of this new body. But as Margarita Martinez shows in her essay on Colombia, justice comes at a cost. If crimes against humanity go unpunished, then they will be repeated again and again, so it is of course right that victims of conflicts should receive justice.

However, we also have a duty to protect future potential victims by bringing conflicts to an end. If you approach a guerrilla leader saying that you want to make peace but he will have to go to jail for 30 years, he will be unwilling to engage. Colombia's leadership managed these conflicting objectives by agreeing on a system of transitional justice which had to be outsourced to three lawyers from each side. Naturally it was unpopular. The public wanted the FARC terrorists to go to jail and the soldiers who had fought them to be pardoned. But this system still survives and is the best and only answer likely to be found in seeking a balance between peace and justice in that country.

Perhaps the most crucial lesson of all is the central role of implementation. Building peace is in many ways harder than making peace and certainly takes longer. Too often, when people reach a breakthrough agreement, they collapse in exhaustion and fail to follow through. Both Palestinians and Israelis met the Oslo Accords with celebrations, but neither side made the necessary efforts to enact them, and the region collapsed into even worse violence in the second intifada. If we thought we had made peace in Northern Ireland when we took off in our helicopters from Stormont Castle on the morning of Good Friday 1998, we were sadly mistaken. It took another nine years to implement the agreement and get the institutions up and running. In fact, it is after signing the agreement that the hard work really starts.

There is a reason for this. An agreement does not make enemies trust each other. They have a written agreement exactly because they don't trust each other, and a piece of paper doesn't make them trust each other either. It is only when both sides begin to do what they have promised to do in that agreement that trust begins to grow.

I hope this book persuades people to dedicate even more effort to the peace process. I am firmly of the view that there is no such thing as a conflict that cannot be solved— there is only one that has not been solved *yet*. The first attempt at making peace is

not always successful, but if you persist, you will succeed. The Cartagena Agreement in Colombia built on four previous failed attempts at making peace with the FARC. And in Northern Ireland, the Sunningdale Agreement in 1973 failed, the Anglo–Irish Agreement in 1985 failed, and the Downing Street Declaration in 1993 failed. But the Good Friday Agreement of 1998 did not appear from nowhere. Those earlier efforts created its foundation. Seamus Mallon, the Catholic Social Democrat and Labour Party leader at the time, described this agreement as "Sunningdale for slow learners" because it contained many of the same provisions on power–sharing as the earlier attempt at peace but took another 25 years of bloodshed to arrive at.

A funny thing happens as you approach the end of negotiations and arrive at a peace agreement. Beforehand, many consider the conflict insoluble. Winston Churchill and Margaret Thatcher considered Northern Ireland impossible to resolve. Afterwards, many suggest that the agreement was inevitable. Following the signing of the Good Friday Agreement, some commentators argued that peace was the outcome of a host of external factors, including 9/11, which made terrorism more difficult for the IRA to carry out, and economic progress in the Republic of Ireland, which made the threat from the south less palpable. Neither of these viewpoints is the reality. It is important that people understand that while no conflict is beyond solving, nor is that solution inevitable. Addressing conflict requires strong leadership prepared to take risks, patience, and above all a willingness to learn from past mistakes.

Perhaps the most important thing is to learn from the experience of others, as Padraig O'Malley demonstrates in his essay on the 1997 visit of Northern Ireland's political leaders to South Africa. This visit offered a chance for those leaders to learn from the experience of the African National Congress and National Party government in making peace, but it was also a chance for them to talk informally to each other about the peace process they were themselves about to embark on. Now the opposing sides from other conflict areas, such as Myanmar and the Philippines, have travelled to Northern Ireland and Colombia to learn from these countries' experiences and to talk to each other. That learning opportunity, like the lessons set out in this book, can help people engaged in long-lasting and bloody wars finally realise that they, too, can make peace.

Don McCullin
**Lebanon Then
(1976, 1982)**

Robin Wright
The Fire under the Ashes

Nichole Sobecki
Lebanon Now

Mira Sidawi
**I Am a Refugee,
Just Like Superman**

Lebanon Then (1976, 1982)

by Don McCullin

I went running with the first wave. It was evening and raining hard. They all wore hoods. We stopped behind a low wall and watched people being shepherded out of a hospital for the insane. People came to the windows of one wing. One of the Falange fighters shouted and when he didn't get a proper answer he shot a burst of automatic fire into the window.

There was the same snip-snap of sniper bullets in the morning. Everyone seemed to have shrunk in the center of Karantina. An old American truck, like a Dodge pick–up, was brought up with a huge 50mm machine gun mounted on it. The Falangist on top was pouring out fire indiscriminately.

It was more than frightening, it was catastrophically fearful, like the dawn of a new dark age. I photographed, and went on photographing.

I had pictures that would tell the world something of the enormity of the crime that had taken place in Karantina.

Don McCullin, *Unreasonable Behaviour* : The Updated Autobiography, London: Jonathan Cape, 2015

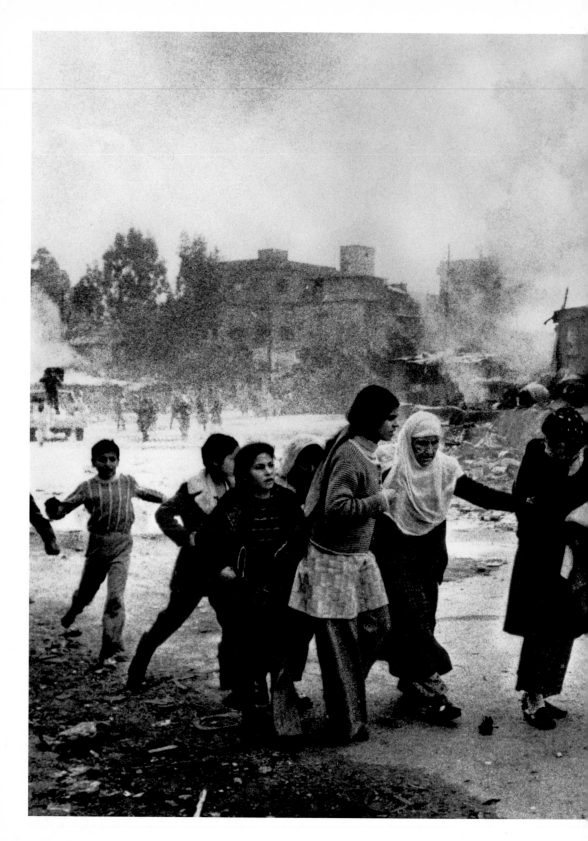

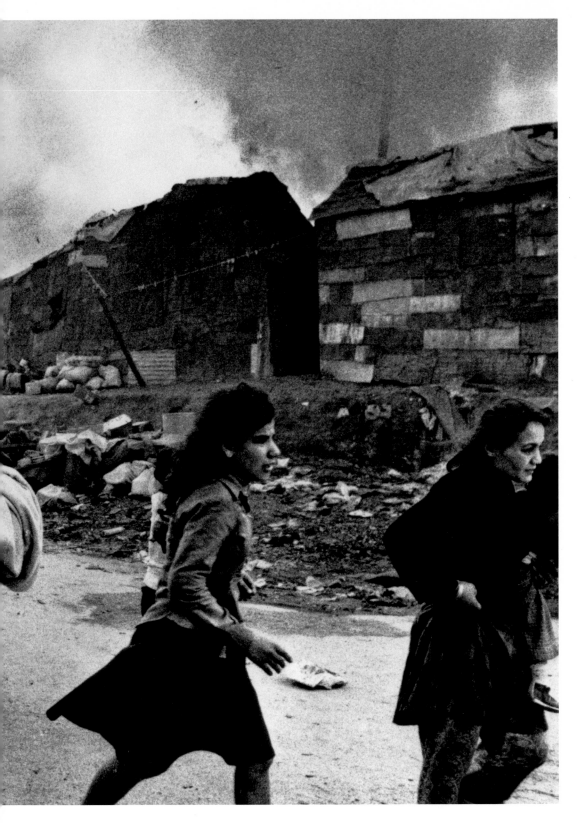

Lebanon Reportage

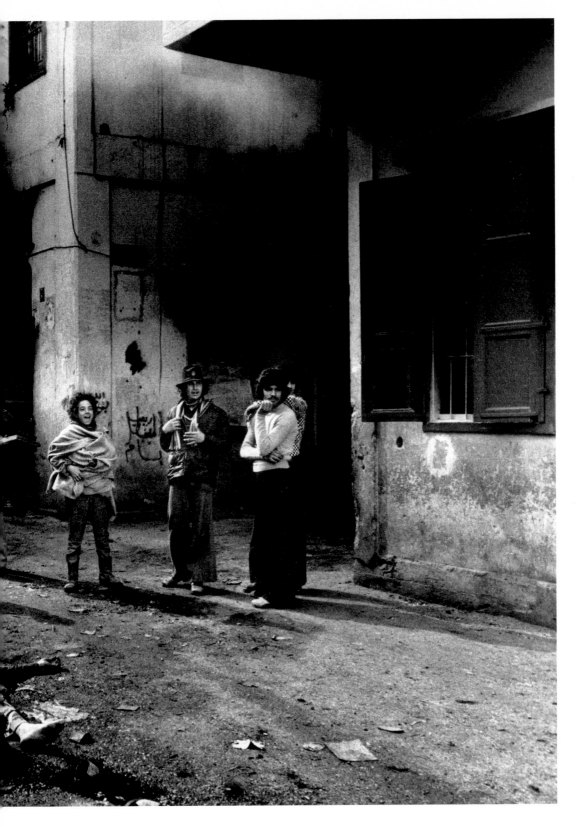

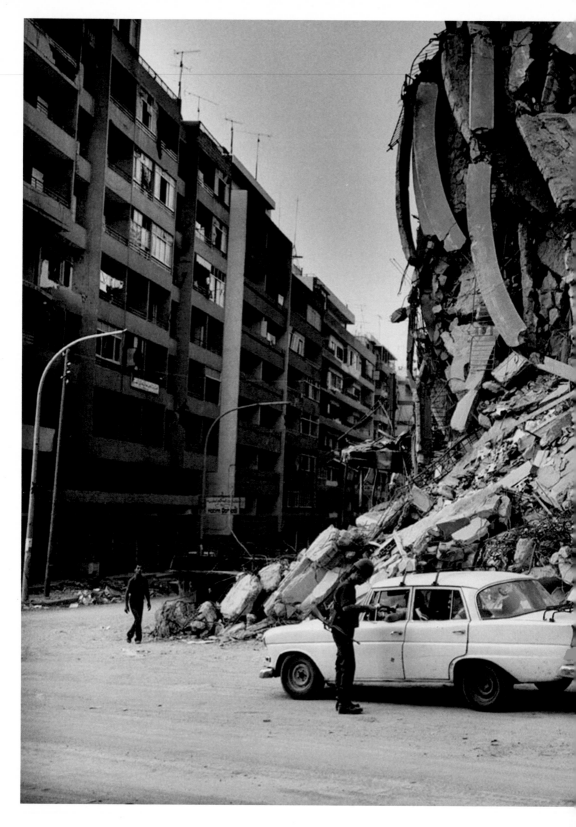

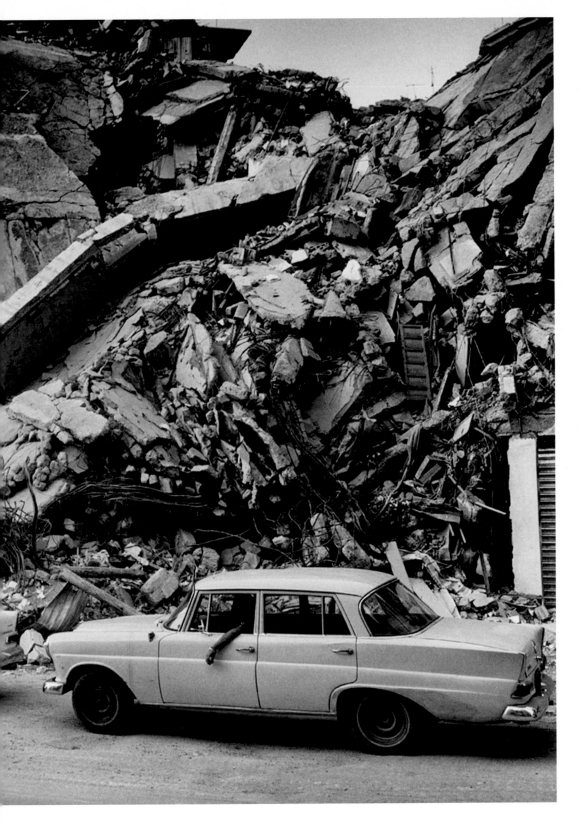

Lebanon

Reportage

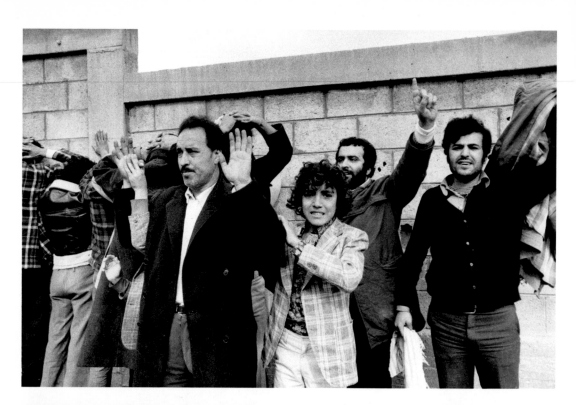

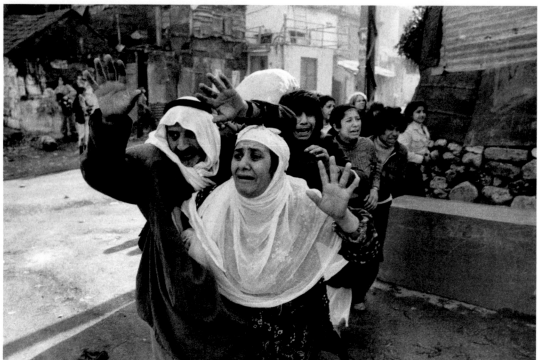

Pages 24–25. Palestinians flee attack. Up to 1,500 Palestinians died in the Karantina massacre by Christian Falangist gunmen. Beirut, Lebanon, 1976

Pages 26–27. Young Christians with the body of a Palestinian girl. Beirut, Lebanon, 1976

"Further down the same road we heard strumming. A young boy was playing a lute ransacked from a half-burnt house. The boy was strumming it among his mates, as if they were at a picnic among almond groves in the sun. In front of them lay the body of a dead girl in puddles of winter rain.

"My mind was seized by this picture of carnival rejoicing in the midst of carnage. It seemed to say so much about what Beirut had become. Yet to raise the camera could be one risk too many.

"Then the boy called over to me. 'Hey, Mistah! Mistah! Come take photo.'

"I was still frightened but I shot off two frames quickly. This, when it's published, will crucify this lot, I thought."

Don McCullin, in *Unreasonable Behaviour: The Updated Autobiography*. London: Jonathan Cape, 2015

Pages 28–29. West Beirut under Israeli bombing, Lebanon 1982

"Cities never die. You can bomb cities flat and they will come back and live because of the tenacity of the people and the basic will to survive. I saw some horrendous crimes against humanity in Beirut-bombing and shelling and killing. It just makes people more resilient."

Don McCullin, in *Don McCullin*, by Simon Baker and Shoair Mavlian. London: Tate Publishing, 2019

Page 30 top left. Palestinian men over the age of 14 rounded up by Christian gunmen. Within hours the men in this photograph were all murdered and their bodies burned. Karantina, Beirut, 1976

Bottom left. Palestinians beg for mercy from Christian gunmen. Karantina, Beirut, 1976

The Fire under the Ashes

32

by Robin Wright

T he 15-year conflict in Lebanon actually featured many wars. It erupted, on April 13, 1975, in a hail of bullets fired by a Christian militia and Palestinian gunmen in tit-for-tat ambushes. Most of the first victims were civilians shot while standing in front of a church or riding on a public bus. The war in the little Levantine country, which is about the size of Connecticut, eventually spilled across borders, then continents. More than a dozen local militias and the armies or interests of foreign governments on four continents were sucked into the strife. Like most conflicts, it proved easier to start than to stop.

The war had many messy layers. Among them, Christians were pitted against Muslims, Palestinians against Israelis, America's Marines against Iran's proxies, the West against the East, fascists against socialists, devout believers against stoic atheists. Over time, alliances fluctuated, enemies flipped. The war was full of contradictions. At some point, every major sect also fought its own brethren—just as bloodily—for turf or power. Lebanon's graveyards (and some backyards) were filled with more than a 100,000 war dead. A million people, roughly a quarter of the population, were displaced. As the economy deteriorated, Lebanon became the pirating capital of the world. The nation's infrastructure—the electricity grid, water supply, and sewage system—collapsed in disrepair; it still hadn't recovered three decades later.

The internal conflict formally ended in 1989 after the Saudi-brokered Taif Accord. The deal only slightly changed the balance of power between Christians and Muslims. The warlords who commanded the conflict became the politicos running government, with many of the original flashpoints still defining their agendas. "The conflict simply moved from the street to the state's institutions. They treated Lebanon's institutions as war booty," reflected Maha Yahya, director of the Carnegie Middle East Center.

"We're not like other countries that have one dictator," quipped Mustafa Baalbaki, a young techie. "We have eight or nine." The state remained so dysfunctional that Baalbaki developed an algorithm for a popular app to alert Beirutis when the power was going to go out—something the state failed to do.

Regional intervention—especially by Lebanon's two neighbors—took longer to end. The Israeli Army took another decade to withdraw, the Syrians 15 years. And still their meddling didn't cease.

The conflict resonated deep into the 21st century. Lebanon's war changed the tactics of warfare worldwide. It introduced the first suicide bombs against Western targets by jihadi

Robin Wright has covered conflicts and political intrigue across the Middle East since the 1973 war. She lived in Beirut during Lebanon's 15-year civil war that played out over local sectarian strife, regional rivalries, and Cold War tensions. When peace was finally brokered through the Taif Accord in 1989, the guns were silenced but the political friction persisted. Wright returns to Lebanon to find the familiar faces who made headlines in the 1980s and 1990s: a six-time hijacker, a repentant militiaman, a defiant war lord. She also finds a new generation struggling to create a post-war society: a student politician, a music therapist, and an organic restaurateur who runs cross-sectarian cooking classes in the hopes that food will act as a recipe for tolerance. Yet Lebanon underscores the challenge of reconstructing a riven society. By 2020, thirty years after the war's end, Lebanon was once again on the political precipice after months of popular protests. A spent population took to the streets—crossing sectarian lines—to demand the ouster of the entire political class and the end, finally, of endemic warlordism. Peace still seemed a long way off.

extremists. It popularized hostage taking for political ransom. It changed sectarian consciousness—and the religious balance of power regionally. It also paved the way for other wars in the world's most volatile arena.

Lebanon's war ended, but decades later, a full peace has yet to take hold. Dergham Dergham, a former fighter, mused, "There's still a fire under the ashes."

Assaad Chaftari twitched uncomfortably as he talked about his role in the war. "I was responsible for the deaths of a lot of people," he told me. "Some were killed by proxy or indirectly—but I was still responsible." He fought for the Lebanese Forces, a Christian militia. During the war's early days, he was an artillery officer directing fire on the Muslim quarters of Beirut. He rose to become the second-highest-ranking intelligence officer. He acknowledged his role in a letter to his countrymen after the war. "My task was to decide the fate of all those rounded up at checkpoints—whether someone should be spared, exchanged, or killed," he wrote. "A human being was little more than a product to me."

I met Chaftari at a Starbucks on the old Green Line that once divided the warring halves of Beirut. "The worst thing is that my conscience was very clear at the time," he told me. He had attended Christian schools and lived in a Christian neighborhood where many believed that France had created Lebanon to sustain its Christian population. His friends, teachers, neighbors, and ministers considered Muslims "invaders and traitors," he said. They also resented Palestinian refugees who had fled to Lebanon as a base to fight Israel.

"I started off disliking Muslims and Palestinians, then I hated them," Chaftari said. "Eventually I was afraid of them and wanted only to destroy them."

The Lebanese Forces was the largest militia. Politically, it was right wing. It was aligned with the Falange Party, modeled on Spain's fascists of the same name. Both were dominated by Maronite Christians, members of a branch of the Catholic Church.

"There was no pleasure in killing," Chaftari told me. "I was fighting for two holy things—my religion and my country, which was as holy as my faith. I could go to church and have communion and not even worry that I had sinned during the week. I would confess some small thing, petty thing. I never confessed to killing because I didn't see it as a sin. I was a crusader."

Chaftari is a man of modest height with a slight paunch and, above a fringe of white hair, a balding pate. We sat in an outdoor café across from the historic L'Orient–Le Jour building, classic architecture from the French mandate. It had housed a popular newspaper and magazine. It still had gaping pockmarks from bullets, grenades,

rockets, and artillery. It'd been empty for decades. The area symbolizes Lebanon—war damage on one side of the street, a Starbucks in a glitzy new mall on the other. Easily the most beautiful country in the Middle East, with its sunny Mediterranean coast, skiable mountains, and ancient Roman temples, Lebanon is still trying to recover from its bloody past.

Chaftari began to rethink killing toward the end of the war. His wife joined Moral Rearmament, a social movement launched in the 1930s by an American Protestant. He was invited to attend. "The idea was that the ladies could convince their men," he explained. "I asked,'Who was the boss? Which embassy was sponsoring it?'" At the first meeting, he had a gun tucked into his belt and two bodyguards outside. "They asked me if I was first ready to change myself. I thought there was nothing to change. I thought I was the best person alive."

Over time, he engaged with members of other faiths. "They had faces and names and I learned to listen—and how to discover the truth. It was not my truth, or their truth, but a common truth," he said. "I discovered that maybe most of what I had heard about 'the other' was wrong. And vice versa. I understood why we were killing each other—because we didn't know each other."

The process proved painful. "It was as if someone took me by the hand and put me in front of the mirror. It was the shock of my life," he said. "I saw a monster with blood on his hands." Chaftari fidgeted.

"So what was I to do then?" he said. "Stay in my room and not move and cry? Say, like others, that war has its own logic? Say 'I was following orders?' Or, to the contrary, be responsible? I went through all these phases.

"I even contemplated committing suicide. In the end, I decided to be responsible for what I did and to try to help my society."

Chaftari wrote candidly about a life of early hate and late-in-life discovery in his memoir *The Truth Even If My Voice Trembles*. He also co-founded Fighters for Peace, a movement of 50 former Christian, Muslim, and Druze gunmen. The numbers are minuscule, given the tens of thousands who fought in the war. But they provided what Lebanon as a state has not: education about a conflict that almost unraveled the country. The school system doesn't teach about the war; different communities have disparate versions of it. The peace accord gave amnesty to the warlords, but Lebanon has never had a formal reconciliation process.

The former fighters have targeted students between 15 and 25, civil society start-ups, Boy Scouts, and Girl Scouts. In 2008 and in 2012, when new wars appeared possible, the former gunmen held press conferences to appeal to a new generation not to repeat their mistakes. The group held readings about the war and discussion groups for the young at public libraries. In collaboration with Playback Theatre, former fighters recounted their war stories as specially trained actors reenacted them.

I went to hear Chaftari and two former rivals—a Druze and a Shiite—talk to teenage girls at the Besançon School, which had been bombed during the war. For an hour,

the three fighters talked about hate. It wasn't a speech; it was an anguished recounting of trying to kill each other.

"I'm sure I gave orders to shoot at his barracks," Chaftari said, referring to the Druze fighter. He gesticulated as he spoke; he sprinkled words of French and English into his Arabic, the way multilingual Lebanese often do. "We were the same age as you are when we started being afraid of the others, socially, then politically," he told the packed audience of girls in prim white shirts and dark skirts. Their questions were poignant, naive, sometimes pointed. One girl, wearing a ponytail, asked Chaftari if he had been free to act as he pleased during the war.

"I listened to the politicians and the clerics," he told them. "But, ultimately, I was the one who decided whether or not to carry a weapon." He paused. "It's hard to wake up. Many who fought in the war still haven't awakened."

———

Akel Hamieh held the record for hijackings—six passenger planes commandeered from airlines all over the world. One hijacking still ranks among the longest in aviation history. In December 1981, he commandeered a Libyan plane after it took off from Zurich. It went on a 6,000-mile odyssey to Beirut, then Athens, Rome, Beirut again, and Tehran, and finally ended on its third stop in Beirut.

I met Hamieh shortly after his final hijacking in the early '80s. He was the military commander of Amal, then Lebanon's largest Shiite militia. It was founded by Musa Sadr, a charismatic local cleric. Amal was an acronym for Movement of the Dispossessed; it's also the Arabic word for "hope." Shiites were the most disadvantaged of Lebanon's major sects.

"Until Amal, Shiites were the shoeshine boys and farmworkers," Dergham Dergham, an Amal member, told me.

Amal evolved into a political party and a militia. Touring the Arab world to rally regional support in 1978, Sadr disappeared in Libya. Hamieh hijacked planes to draw world attention to Sadr's kidnapping. The hijackings all ended peacefully, without deaths or destruction. Sadr was never seen again.

It took more than two years to track down Hamieh in the mid-1980s. I found him on an intravenous drip, recovering from an injury, in the maze of Beirut's poor southern suburbs. With his good arm, he was rocking a small hammock holding his six-month-old son, Chamran. Amal commandos ringed the small room. Hamieh had a following across the Middle East. He had accompanied Ayatollah Khomeini when the revolutionary leader flew from exile in Paris back to Tehran in 1979. He'd fought against Saddam Hussein's army during the Iran-Iraq war. His fighters nicknamed him "Hamza," after the Prophet Muhammad's uncle, a famed warrior in the Islamic empire's early days. We talked for hours about why men fight. He was a prototype.

"I see the future of my people determined by blood," he told me. He compared Lebanon's Shiites to South Africa's blacks under apartheid. "For myself, I don't have any future except to stay a fighter." He gestured toward his son. "I hate to see him live as a slave. My child has the right to live well, to go to university. He has a right to be equal."

I saw Hamieh again in 2016. His hair was silvering; he was paunchy. He'd shed his fatigues in favor of a loose-fitting sweat suit. We pored over his grainy old pictures from Middle East war fronts. He had quit Amal in 1993 when its

political chief, Nabih Berri, ordered him to fight Hezbollah, another Shiite militia. Hamieh refused to kill members of his own sect.

"I slapped Berri hard and walked out," Hamieh told me. He took up arms again, in 2006, during the 34-day war with Israel. A decade later, he advised Iraqi Kurds how to fight ISIS (Islamic State of Iraq and Syria). But he stayed away from Lebanon's internecine rivalries. The only trace of the war was a huge picture of Musa Sadr in his living room.

A year later, I saw Hamieh again as he was dying of brain cancer. He had lost his balance and needed help walking. His son, Chamran, then in his 30s, joined us. Chamran and his wife were both officers in Lebanon's military police. They'd just had a son, whom they named Akel, after Hamieh. One of his daughters worked for the Ministry of Justice. Another was a doctor. The next generation had carved out a different future.

I asked if he'd ever thought about the people he'd killed. "I feel the guilt and a huge burden. I think about it all the time. But I didn't start the war," he said. "We were the weakest group, and our opponents were supported by foreign countries. We got dragged into the war. We didn't want it. They made us do it. We defended ourselves. Unfortunately, people died."

Hamieh had left college to fight. Newly married, he had sent his wife to the United States. "Most of our marriage was by letters," he told me. As the war dragged on, she opted to stay in Toledo, Ohio. They eventually divorced. "I sacrificed my education and my personal life to fight," he said. "I didn't enjoy killing people."

———

In Lebanon, everyone blames everyone else for the war. Everyone was a victim; everyone was wronged. Facts were ignored. Truth was an illusion. So the war defined politics long after it ended. In 2020, it still does.

Samir Geagea was among the most notorious warlords. He is a Maronite, from Lebanon's dominant Christian sect. He picked up a gun in the early 1970s when he was in high school. He was recruited as Palestinians—from poor refugee camps around Christian strongholds—clashed with Lebanese security forces. Both sides were trying to protect themselves. "There was another army in the country," Geagea told me, at his heavily fortified compound, in 2017.

After the war started in 1975, he left medical school to fight full-time. In 1986, he took command of the Lebanese Forces' 15,000 fighters. He had a reputation as a military mastermind—and a killer. I asked how many people had died in operations he led over 15 years. "I didn't kill anyone," he said. "Nobody! I don't have guilt about the war. Even in the harshest days of war, I slept in peace.

"Given what the population of Lebanon was subjected to, and endured, those who didn't fight were the criminals. And those who did fight," he added, "were fighting for the right cause."

I asked why the Christian militia had agreed to a truce. "The scope of the future was not brilliant. An unacceptable peace agreement was offered. Why not? We could have continued as fighters. But after 15 years, where do you go from here?" he told me. "All of us are human beings, and we get tired sometimes."

The Taif Accord altered the balance of power. Since the French mandate in Lebanon had ended in 1943, all government positions—from members of Parliament to civil servants who taught school or collected garbage—had been divided in a ratio based on a 1932 census: six Christians for every five Muslims. To end the war, the division was changed to 50-50.

With other warlords, Geagea was amnestied. But a loophole voided protection for murder of political or religious leaders. In 1994, he was charged with killing a former Sunni prime minister in a helicopter bombing; attempted murder of a Christian defense minister; murder of the leader of a rival Christian party and his family; and bombing a Christian church, which killed nine. Geagea was acquitted of the church bombing but convicted of the murders. He received multiple life sentences. He was the only warlord to face trial.

In court, Geagea blamed the murders on Syria, which had thousands of troops in Lebanon and wielded a veto in its politics. He was held in solitary confinement at a special Ministry of Defense prison. He was not allowed access to news; he was banned from talking politics during visits from his family or lawyer.

"Sometimes I thought I'd spend the rest of my life in prison. At least I'd die with my conscience clear," he told me. "But the case was based on politics—and politics in Lebanon change day-to-day."

In early 2005, 15 years after the war ended, Lebanon became the first Arab country to witness a popular uprising. The Cedar Revolution—the cedar decorates Lebanon's flag—was sparked by the assassination of former Prime Minister Rafiq Hariri, a wealthy business-man who had returned from exile in Saudi Arabia to help reconstruct his country after the war. He was killed on Valentine's Day in a car bombing as his convoy drove past the Saint George Hotel on the Mediterranean coast. The murder triggered mass protests for 10 weeks. At their height, more than a million people—roughly a quarter of the Lebanese population—rallied in downtown Beirut. They demanded the government's ouster, an end to the 30-year presence of Syrian troops, and an international tribunal to investigate the Hariri bombing.

They prevailed. The Lebanese government fell; new elections were held. Syria was forced to withdraw troops that had been deployed—initially as suppposed "peacekeepers"—since shortly after the civil war began. And the United Nations established a special tribunal.

As a by-product, Geagea was pardoned by Lebanon's Parliament. "Once Syria left, I was let out of jail," he told me. The Lebanese Forces reconstituted as a political party under Geagea's leadership. It won seats in Parliament and positions in the cabinet. Geagea's wife won one of them; she led the party's parliamentary bloc.

In 2008, Geagea admitted guilt—kind of. "I fully apologize for all the mistakes that we committed when we were carrying out our national duties during past civil war years," he said. "I ask God to forgive, and so I ask the people whom we hurt in the past." By 2014, he had orchestrated a full comeback. He declared for the

presidency, although he later deferred to another Christian candidate. (In the prescribed division of power, Lebanon's presidency is reserved for a Maronite. The prime minister's job goes to a Sunni. The speaker of Parliament is a Shiite.)

In 2017, I asked Geagea if he would make a more serious run for the presidency down the road. His mustache by then was more salt than pepper. He was seriously balding. But he was still lanky and lean, still at his fighting weight.

Geagea smiled. "I'm not ruling it out."

———

Lebanon's main struggle has been to rebuild one state from all the little statelets created during the war. It has drifted for decades in political purgatory. It was the Arab world's first democracy, yet its power-sharing pact—among 18 sects—also made it one of the most dysfunctional Arab states. It remains the only Middle East country based on sectarian coexistence, yet it has not allowed interfaith marriage. Weddings can be conducted only by clergy; civil ceremonies are illegal. Unless one converts, an interfaith couple has to leave the country to get hitched. Many have gone to Cyprus.

A quarter century after the war ended, the underlying tensions had not changed. Lebanon was without a president for more than two years, between 2014 and 2016. It had no new budget for a dozen years. Garbage wasn't collected for months in 2015 and 2016 as rival politicos vied for contracts—for friends, relatives, or supporters—and rejected garbage being dumped on their turf. Sectarianism survived partly because of its patronage system. Bulging plastic bags of debris just piled up, consuming streets, fields, and public property. Pilots protested as birds scavenging near the airport endangered flight paths. Doctors warned of surging disease.

The garbage crisis galvanized the postwar generation. In 2015, the aptly named You Stink movement mobilized more than 100,000 people—from all faiths—in protests that lasted for weeks during the stench-filled summer. It took more than eight months to broker a compromise to end the rubbish rebellion.

Jean Kassir was part of the You Stink movement. He headed a student group headquartered at the American University of Beirut. "When you're in the street demanding change, you realize it's like asking a drunk person to fix the problem of alcoholism," he told me. "He's not going to help because he's the issue."

So Kassir, a tall youth with curly dark hair and glasses, helped launch the grassroots movement Beirut, My City, or Beirut Madinati. "We wanted to take the streets into the political mainstream and go to elections," he said. "It meant a mutation of our work. We had to present ourselves as an alternative, an equal, to the political class." In 2016, it

put up a slate of independent candidates for Beirut's municipal election. Its 10-point platform was based on principles, not a party or sect, and transparency. It included waste management.

The new political energy stunned the old warlords and politicos, who joined forces in a united ticket. "We were the main opposition list against a coalition of all the major parties," Kassir told me. Beirut, My City amassed 40 percent of the vote. But the system was not proportionate; it was winner-take-all.

"We got no seats, but it still meant a lot," Kassir said. "We were there to confront them as equals, not just to be cute civil society. People were amazed at what we accomplished in just six months. We opened the window."

———

Attempts at recovery have taken imaginative forms. Naji Gebran was kidnapped during the civil war. He was 15. "It was the first big shock of my life," he recalled. "Muslims used to kidnap Christians. Christians kidnapped Muslims. Both killed those they kidnapped. It was a dirty war." Gebran was badly beaten but released when one of the gunmen recognized him from his father's restaurant.

In his 20s, Gebran started hosting "music therapy" for friends in his apartment. He played blues, jazz, soul, and funk. "Music of the '80s," he said. "People came, danced, listened."

The Lebanese have long lived with a self-indulgent this-may-be-it intensity. With hedonistic abandon—legal convention, physical danger, morality, or even marriage be damned—they sought any semblance of normalcy during the war's

erratic ceasefires. The Middle East's most famous racetrack, smack in the middle of the Green Line, would trot out its horses to take a few laps—and to take a few bets. Boutiques on Hamra Street would hold "bomb sales" of fashions that had survived the latest fighting.

The legendary Saint George Hotel—once the hangout of politicians and princes, international movie stars and foreign spies—was gutted during the War of the Hotels in 1976. But its pool was salvaged. It opened spontaneously whenever guns fell silent. Women in bikinis lounged around the pool while men in little Speedos smoked hookahs and played backgammon. The poolside bar was famous for its Bloody Marys, the best in the Middle East. At the sound of the first cannon, swimmers grabbed their towels, games, hookahs, and drinks to race for home, to hide until the next ceasefire.

After the war ended, Gebran opened a real club—B 018, named after the number of his original apartment. He built it on the site of an infamous 1976 massacre, in Karantina, which had been a slum of Palestinian refugees in a Christian part of Beirut. It was overrun by the Lebanese Forces. Some 20,000 people, mainly Muslims, lived in the slum; at least 1,500 were killed. A memorable photograph captured a Christian gunman popping a champagne cork after the Karantina killings. The militia bulldozed the shanties.

"We deliberately rented that piece of land," Gebran told me. "There had been nothing there for two decades, since the massacre. It was all dust and rock." B 018 is literally underground; it's been compared to a bomb shelter or communal grave. The night I went, in late 2017, the place began to pulsate around midnight. Booze flowed. Music blared. Bodies, often skimpily clad, swayed and seduced in dance areas around clusters of tables. One

corner was all cigar smokers, females too. In good weather, a retractable roof opens to let revelers dance under the stars.

In memory of the war years, every Thursday is '80s Night. I heard Tina Turner belt out "Simply the Best," ABBA sing "Dancing Queen," and Stevie Wonder croon "I Just Called to Say I Love You."

"It's to remember that time, that history," Gebran told me.

During the war, 30 people showed up at his apartment to hear music. Three decades later, 700 showed up at B 018 on a good night. In 2014, it was voted "one of the 25 nightclubs to visit before you die." Lebanese loved the irony.

In a country where communities had self-segregated during the war, B 018 was one of the few social places they came back together in peacetime. "All religions, all people come to my club," Gebran, a Christian, told me. "Most clients are Muslim, mainly because there are more of them than Christians in Lebanon now. But we don't ask identity at the door. There's no racism. We never close for religious holidays."

———

Souk el Tayeb (the Good Market) was launched on the Green Line, under the shadow of the bullet-pocked L'Orient-Le Jour building, in 2004. Once a week, more than a hundred small producers from across the country—including Sunni, Shiite, Maronite, Druze, Greek Orthodox, and Armenian vendors, as well as Palestinian and Syrian refugees—show up to sell their food and crafts at the open-air bazaar. On my last visit, long rows of tables, covered with green-and-white-checkered tablecloths and protected by tented umbrellas, were laden with bulbous tomatoes, leafy organic greens, fresh bread, almondy marzipan, chunks of cheese, pomegranate molasses, piles of flaky herbs, batches of blooming flowers, jars of honey and pickled olives, homemade candles in homespun glass, even fragrant oils for a man's beard. A weaver from the Institute for the Blind was guiding thin rope into the frame of a sisal footstool. A winery was offering tastings across the aisle from Muslim women in traditional hijabs making crepes.

The market's motto is "Make food, not war." It was bustling.

"It's not a market to buy or sell food," Kamal Mouzawak, who founded it, told me. "I don't give a shit about food itself. It's a means to do something else. It's a means of finding common ground between people who used to kill each other." Mouzawak is a tall man with dark hair gelled in waves. He is open about being gay in a country where homosexuality is illegal.

In 2009, Mouzawak, who grew up during the civil war, opened Tawlet (Arabic for "Table"). The trendy restaurant serves organic foods and abuts a garden where locals claim skulls were buried during the war years. Tawlet has on its staff rotating chefs from all sects. They train and cook together. "It's a kitchen without religion," Mouzawak said. The restaurant is set up the same way: long tables where everyone sits together.

"For me, there's no nation called Lebanon. It's a patchwork of different things. We all live on the same land. We've transformed it into the same cuisine. The population of Lebanon is five million. There are 15 million Lebanese abroad. The only things they took with them were kibbeh and tabbouleh. Food is the simplest expression of roots, of identity, of history."

He's adapted the cross-sectarian model in cooking classes and food festivals across Lebanon. "At the beginning, they cluster in their religious groups," he said. "Slowly they learn that they have the same fears and that religion doesn't define one as a human. We're not here to teach how to cook, but to teach self-confidence about living with each other."

————

Before the war, the Barakat Building was an avant-garde apartment block housing Muslim and Christian families. It was an architectural marvel. Families could commune with each other across facing balconies that overlooked a courtyard. When the war started, residents were forced to flee. The building marked one of five crossings on the Green Line between the predominantly Muslim west and the largely Christian east. The Lebanese Forces turned it into a command center for snipers.

"This beautiful building was designed to unite. Then it became a place, a tool, to kill each other," the architect Mona El Hallak told me. The ocher limestone façade—with its dramatic arches and elegant columns—looked as if it had chicken pox from all the retaliatory fire.

Like a lot of the French architecture shot up during the war, it was marked by the city to be razed rather than reconstructed.

High-rise behemoths of glass and steel have gone up across the Lebanese capital, erasing its quaint history. In 1983, the U.S. Embassy, which overlooked the palm-fringed Mediterranean, was the first American site hit by a suicide bomber in the Middle East. It's been replaced by high-rent apartment towers. Hallak rallied activists and artists and even the French government to save the Barakat Building as a museum—and a reminder of Lebanon's violent past. She remembered running across the Green Line during the fighting. "The first time I stood here, where someone had killed someone, all the war came rushing back to me," she told me, caressing the bullet holes in the walls. "Suddenly, I was there, standing where it was coming from."

The Barakat Building opened as Beit Beirut—the House of Beirut—in 2017. Visitors can stand at the snipers' posts, wander through sandbagged positions, and read the graffiti spray-painted by gunmen, now preserved behind glass. Before the war, a photo shop had commercial space on the ground floor. From the ruins, Hallak retrieved old negatives of people who had lived nearby. She had them enlarged. The faces of a peaceful bygone era decorate a hall on the ground floor.

"So now the building is still there, and it will tell its story, both before the war and during it," Hallak said. "Its preservation is important to prevent the city from being swept by amnesia about the war— and to prevent it from happening again. If I remember, then other people will remember, too."

————

The many phases of Lebanon's war are reflected in its graveyards. One of the loneliest is the Palestinian Martyrs' Cemetery near the Green Line. It is full,

largely from the war. It seems forgotten. A huge mural of Palestinian Liberation Organization (PLO) chief Yasser Arafat—a broad grin on his face and a black-and-white kaffiyeh covering his bald pate—overlooks long rows of white marble headstones. Arafat was forced out of Beirut in 1982, along with thousands of his fighters. The dead were left behind, some of their graves now overtaken by weeds.

Wars often perpetuate themselves, albeit in new forms, with new types of fighters, new tactics, and new flashpoints. The original cause can be superseded, even dwarfed, by a conflict's unintended consequences. Such was the case with Hezbollah. The Shiite Party of God did not emerge until seven years into Lebanon's civil war, as the PLO was leaving.

Israel's interventions, first in 1978 and then, in fuller force, in 1982, were by-products of the civil war. As the Lebanese state grew weaker, the PLO grew stronger. It launched border raids and lobbed shells into Israel. Israel's first invasion forced the PLO farther back and created a buffer zone inside Lebanon—manned by a local Christian militia armed, trained, and subsidized by Israel—in 1978. The PLO persisted. In 1982, Israel returned, cannons blazing. It marched all the way to Beirut. It ended up staying in Lebanon for the next 18 years.

Lebanon's Shiites, who populated the south, initially welcomed the Israelis. The Palestinians had usurped local power and endangered their homes by targeting Israel. Shiites were getting killed and their property destroyed for a cause not their own. When the Israelis rolled in, the local community greeted them with rosewater and rice. Then Israel lingered long after the PLO had left. Lebanon's Shiites began to resist. And they got help, from Iran, further widening the war.

Ties between Lebanon and Iran dated to the 16th century when Iran converted to Shiism, with help from Lebanon's clerics, to hold off the encroaching Ottoman Empire. In 1982, Tehran dispatched 1,800 Revolutionary Guards to help its Shiite brethren. They didn't fight Israel. Iran instead culled defectors from Amal—which fragmented after Musa Sadr's disappearance—and trained, armed, and organized them. The underground cells were the nucleus of what evolved into Hezbollah, the Party of God. They changed the nature of modern warfare—in Lebanon and far beyond—by introducing the jihadi suicide bomb. Faceless drivers rammed trucks laden with thousands of pounds of explosives into an Israeli headquarters, the American embassy in Beirut, U.S. and French peacekeepers, and then a temporary American embassy that replaced the first one. Hezbollah's 1983 attack on the Marine peacekeepers produced the largest loss of U.S. military life in a single incident since World War II. The Marines slinked out of Beirut in 1984; the risks of staying were too high. Israel hunkered down in the south.

The Taif Accord ending Lebanon's civil war in 1989 required that all militias disarm within six months. With Israeli troops still occupying the south, however, Lebanon's Parliament let Hezbollah keep its weapons as a "resistance force." The Party of God survived the war with an edge unrivaled by any military force except the Lebanese Army. Under the new leadership of Hassan Nasrallah, it then moved into politics. When Lebanon held its first postwar election, in 1992, Hezbollah emerged from the underground and fielded candidates for Parliament.

"From 1982 until 1991, we were like the fetus in the womb of the mother," explained Naim Qassem, a white-turbaned cleric with a neat white beard who is Hezbollah's second-in-command. "After we ran in the elections, we started walking on our own feet." The Party of God has been a pivotal part of Lebanon's government—with seats in Parliament and cabinet posts—ever since. "Every step we took made us stronger than before," Qassem told me.

Israel finally pulled out in 2000—its first unilateral withdrawal from any Arab land in any war. It got nothing in return; it had lost hundreds of troops. In the meantime, it had signed a tentative peace deal with Arafat's PLO in 1994. The new Palestinian Authority set up in the West Bank and Gaza. Meanwhile, on the Lebanese border, Hezbollah was growing stronger.

Israeli Defense Minister Yitzhak Rabin once conceded, "Among the many surprises, and most of them not for the good, that came out of the war in Lebanon, the most dangerous is that the war let the Shiites out of the bottle.... In 20 years of PLO terrorism, no one PLO terrorist made himself into a live bomb.... The Shiites have the potential for a kind of terrorism that we have not yet experienced."

Rabin worried, "Terror cannot be finished by one war. It's total nonsense; it was an illusion." He was prescient.

In 2006, Hezbollah captured two Israeli soldiers in a cross-border raid. Its goal was to swap them for Lebanese and Palestinians imprisoned in Israel. Israel went back into Lebanon a third time. The 2006 conflict lasted 34 days—the longest sustained war that Israel has ever fought. Hezbollah missiles rained deeper than ever into Israel.

The war was something of a draw. A UN ceasefire called for Israel to withdraw (which it did), the Lebanese Army to deploy in southern Lebanon (which it did), and Hezbollah to disarm (which it didn't).

By 2018, Hezbollah was the most powerful party in Lebanon. It was also the nimblest political player; its Christian ally, Michel Aoun, had been elected president in 2016. It was Lebanon's largest employer—in a network of clinics, schools, businesses, and welfare services—after the government. It was also a major player in the Arab world. Thousands of Hezbollah fighters had deployed in neighboring Syria to prop up the government of President Bashar Assad during its civil war. They fought both U.S.-backed rebels and Sunni jihadis in ISIS. In Iraq, its commanders and advisers aided Shiite militias also fighting ISIS. Its advisers aided the Houthis in Yemen, too.

"In the eyes of the people, the political powers, the countries—whether friends or foes—we are an actual regional power," Qassem told me, "because now our positions have regional consequences."

Its power came at a price. Hezbollah created cemeteries for its own "martyrs" across Lebanon—some with Facebook pages. In Beirut, one graveyard was filled with the dead from wars with Israel. A second, around the corner, was for fighters killed in Syria. It was called the Garden of Zeinab, named after the Prophet Muhammad's granddaughter. The long marble slabs cited the battlefield where each had died, often with engraved notes such as "Performing his jihadi duties" or "Congratulations on your martyrdom."

The most enduring legacy of Lebanon's civil war may be a string of new wars— probably still not over. "An internal conflict? I don't see it," said Walid Jumblatt, the Druze leader, also head of the Progressive Socialist Party, his arthritic dog Oscar, a Shar-Pei, curled at his feet. "But nothing is ever over in Lebanon. This is your fate when you're squeezed between two big countries—Israel and Syria. An external conflict? I expect it at any time."

In the decade after the 2006 war, Hezbollah's arsenal increased sevenfold. It had 130,000 missiles deployed in strategic corners across Lebanon. "Hezbollah will only give up its weapons when we're convinced that there is no more danger," Qassem told me. "We will sacrifice until the end of eternity."

———

Lebanon has endured its wars. "We're not at peace," reflected Jean Kassir, the young activist with Beirut, My City. "Until today, nothing has really healed except a consensus, achieved through blood, that Lebanon is finally a country, that we're not fighting over borders. The war established that the game is played within these borders— inside these 10,000 square kilometers."

Over the decades, however, Lebanon's conflicts, spawned directly or indirectly by identity politics, have only deepened the sectarian ethos. Real reconciliation may still be generations away. The same issue infused the entire Middle East in the early 21st century, especially after the U.S. invasion of Iraq in 2003, the Arab Spring in 2011, and the ISIS caliphate between 2014 and 2019. The furies of identity politics— long repressed by colonial masters, then by the Arabs' own authoritarian rulers— were unleashed. The unraveling in one country infected or impacted others.

Iraq struggled with a virtual civil war after President Saddam Hussein's ouster, in 2003, over rebalancing political power: the Sunni minority and its long-ruling elite didn't want to cede power to the more numerous Shiites, and new Shiite politicos did little to include or reassure Sunnis. The divide was exploited by jihadi extremists in an al-Qaeda franchise, which lost the first round, courtesy of a surge of US troops in 2006. The jihadis went underground and regrouped in Syria. They returned after the US withdrew.

Syria began to unravel after the Arab Spring protests disintegrated into civil war. Politically, the issue was the Assad dynasty's despotic rule. But the subtext pitted the Sunni majority and ethnic Kurds—in dozens of disparate groups—against the minority Alawite regime in Damascus. In the chaos, ISIS emerged in 2014. The Sunni jihadis seized a third of Syria and Iraq for their caliphate. They temporarily

redrew borders that had been in place for a century.

The stakes are not just who prevails. As in Lebanon, the existential issue in countries from Libya to Yemen is whether there's sufficient consensus to hold them together at all. "The old Middle East that used to be—of the 1930s and 1940s, of mixed communities—is over," Jumblatt, who led Lebanon's second-largest militia, told me.

Ironically, progress in the Middle East—in literacy, technology, politics, even women's rights—has contributed to the disorder. The majority in all but one Arab country, Yemen, is now literate. They have access to information beyond neighborhoods, cities, countries, even continents. They're aware of change elsewhere: Communism's demise in Europe. Apartheid's collapse in Africa. The end of Latin America's military dictatorships. They're aware of global demands for rights—and they want to be part of it.

Technological changes have introduced new ideas and ways to spread them. In 1995, Al Jazeera was the first independent satellite television station in Arabic to circumvent government censors. Two decades later, the Arab world had hundreds of satellite television stations—with an array of religious programs (with clerics issuing diverse fatwas), talk shows debating politics, and soap operas taking on modern social issues. In a region where the majority are young, the idea of one path—in religion or politics or life—has been rejected by growing numbers.

Yet the demand for rights—so inspiring during Lebanon's Cedar Revolution in 2005 and the Arab Spring in 2011—spurred even more competition, more

divisions, and more conflict in places where primal identity was still clan or tribe or sect or ethnicity, dating back centuries, even millennia.

"This moment is turning out to be bigger than anyone anticipated," Tammam Salam, a Sunni and a former Lebanese prime minister, told me. "It might be as big, or even bigger, than Sykes-Picot," the European diplomatic process that divvied up the detritus of the Ottoman Empire after World War I. "Things are moving much faster today. In the past, decision-making took time. Now, you can make or break something or someone—or some country—just by injecting information."

The modern Middle East has never faced such turmoil. Syria's war created the greatest refugee crisis—more than five million people—since World War II. Lebanon took in more than a million when it already couldn't provide electricity, running water, schools, or health care for its own people. More than half of the Syrian population was dependent on international aid for daily food; more than three million children were out of school; and physical damage was estimated at $300 billion in a country the size of Washington state.

In Iraq, the Islamic State caliphate—and its tens of thousands of fighters—engaged in horrific beheadings, rape, ethnic cleansing, and slavery. Its four-year war with the Iraqi army destroyed swaths of the north and west, including Mosul, the second-largest city. Baghdad estimated reconstruction costs at $100 billion. The problem was not just rebuilding four walls in homes and businesses; it was recreating institutions, too. The Sunni jihadis of ISIS set fire to the University of Mosul's library and its million books, some dating back a millennium.

Across the Middle East, one question looms large: how much blood will be spilt just to be on a par with Lebanon's precarious state? The most haunting reflections today stem from a common theme: the folly of hate, the recklessness of war. "At the time, many people thought they were dying for the country—like martyrs," said Joyce Khouri Eid, the manager of an assisted living facility that takes in senior citizens of many faiths. "But if you look back on our war now, it's like their lives were wasted. Mothers lost kids. Kids lost parents. And it all happened for no reason."

Baalbaki, the young techie with the cellphone app for monitoring electricity, mused, "The Lebanese learned an important lesson in the civil war—that no one won."

Yet the human instinct for survival struggles to heal, nonetheless, in any war zone—or in life. May el Khalil is a runner who was training in Beirut when she was hit in a near-fatal car crash in 2001. She underwent three dozen surgeries; she spent two years learning to walk again. During her recovery, she came up with the idea of a marathon as an instrument of peace. In 2003, she founded the Beirut Marathon. More than 30,000 runners—including a prime minister—now turn out annually for the fall event. It is the largest race in the Middle East.

"It's also much more than that," Khalil said in a 2013 TEDGlobal talk. "It's a platform for hope and cooperation in an ever-volatile part of the world. We have seen that people ultimately do want to run toward something together. After all, peacemaking is not a sprint. It is more of a marathon."

Lebanon Now

by Nichole Sobecki

Lebanon is where I came into being as a journalist. As an intern at *The Daily Star*—the Arab world's storied English language rag—I published my first photographs. I even wrote the horoscopes briefly, confounding my friends with the specificity of their fortunes. In 2007 I saw war for the first time, as a battle broke out in the northern Palestinian camp of Nahr al-Bared. Fighting between the Islamic militant organization Fatah al-Islam and the Lebanese army began the morning of my 21st birthday. Though violence in Syria and other areas of the Middle East has since overshadowed the destruction of Nahr al-Bared, it was the most severe internal fighting Lebanon had seen since the civil war.

In 2017 I returned to Lebanon with writer Robin Wright to try to make sense of what peace means in a place so defined by conflict. As we met with former fighters and young creatives, I thought back to one of Aesop's fables, "The Oak and the Reed," and the countless storms this country has weathered without breaking. Peace here comes in shades of gray. It's the reason to bend with the next wind, to endure, and to embrace the present despite the fire under the ashes.

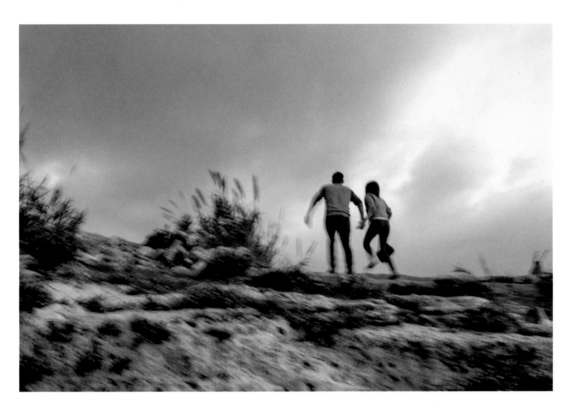

A young couple races up a hillside near Pigeon Rocks on Beirut's westernmost tip.

Pages 52-53. Traffic zips past Beit Beirut, a recently opened exhibit space and memorial to the civil war. The former apartment building sits at the Sodeco crossing, an area once considered too dangerous to risk passage even during ceasefires.

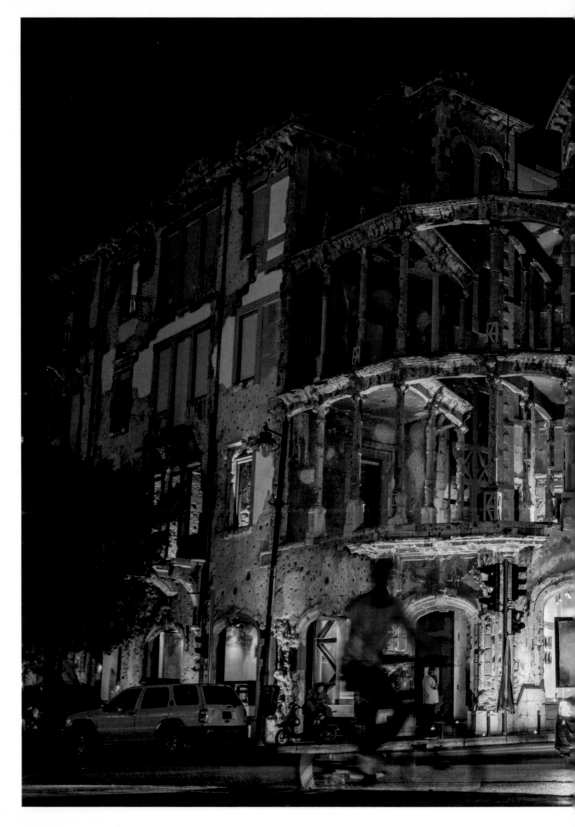

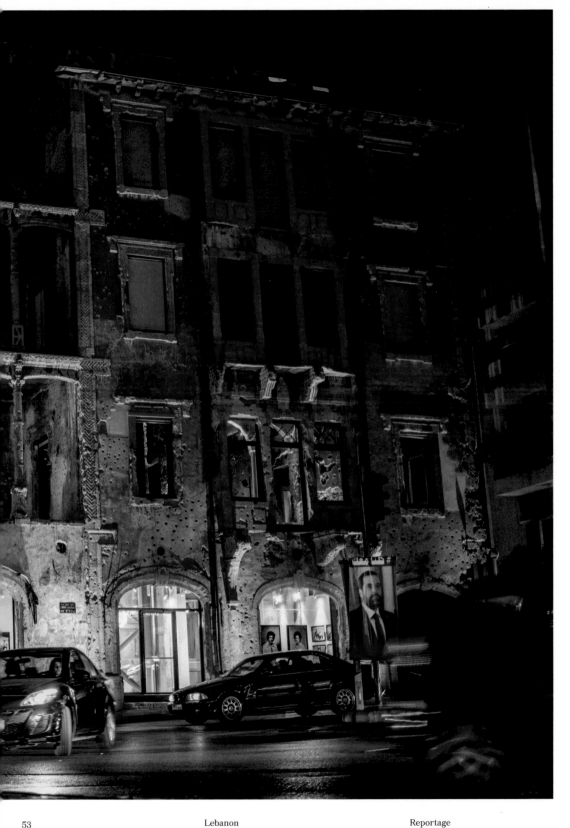

Lebanon

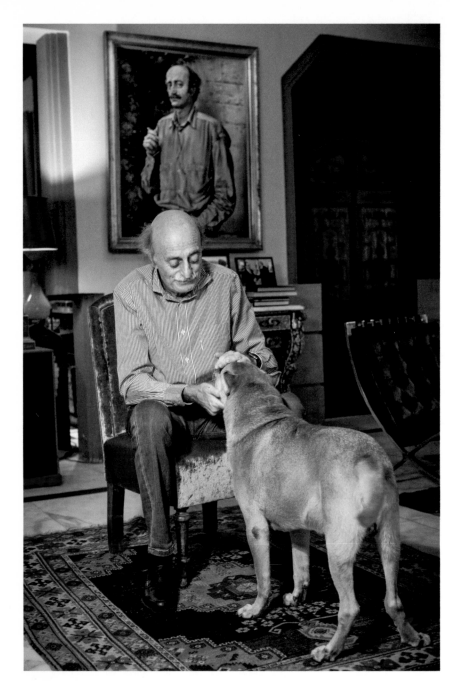

Walid Jumblatt, former warlord, leader of Lebanon's Druze community, and head of the Progressive Socialist Party, with his dog, Oscar, an arthritic Shar-Pei.

"It's hard to imagine going back to war," said Jumblatt. "Internal conflict again? I don't see it. But an external conflict? I expect it at any time. Nothing is ever over in Lebanon. This is our fate."

"Hamza" Akel Hamieh with his grandson and namesake. Hamieh became a legend in the Middle East after hijacking six planes between 1979 and 1982, to draw the world's attention to the kidnapping of Musa Sadr, his religious leader. When asked about whether he worries about another war in Lebanon, Hamza Akel Hamieh replied with a simple "For sure." "The warlords who caused such chaos and death in this country, now they run the country and they kicked out the ones who killed for them," he explained. "As long as they are in power, Lebanon is in danger."

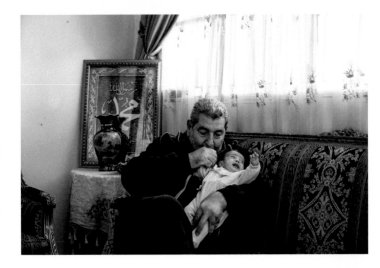

Chamran Hamieh (left), Hamza Akel Hamieh's son, goes through his father's collection of images from the civil war, stored in old suitcases in his home in the Bekaa Valley.

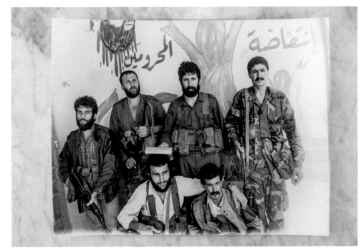

During the civil war "Hamza" Akel Hamieh was commander of an Amal militia unit representing the muslim Shia movement (Hamieh, second from right) Beirut. 1980's.

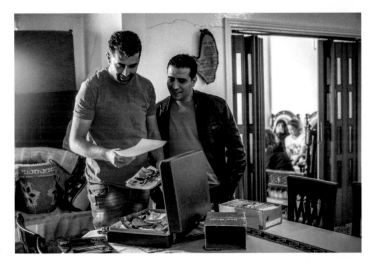

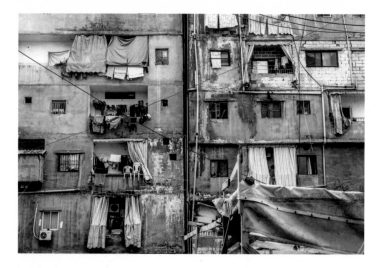

Weak infrastructure and poverty plague the Shatila refugee camp and the adjacent neighborhood of Sabra, where Palestinian residents remain marginalized and without legal status in Lebanon. The arrival of thousands of refugees fleeing the conflict in Syria has further burdened the neglected camp.

Mahmoud Sabha, 15, a Syrian refugee, releases a pigeon from its coop. Thousands of Syrian refugees live in informal tent camps in Lebanon's Bekaa Valley.

Revelers enjoy '80s night at B 018—one of Beirut's most legendary clubs—built at Karantina. In 1976 a Christian militia attacked and evicted the Palestinian refugee population, killing 1,500, in what became known as the Karantina massacre. (See Don McCullin photographs.)

Kids play foosball in a small shop in the Shatila refugee camp, still synonymous with the 1982 massacre of hundreds of mostly Palestinian people in the camp and the adjacent neighborhood of Sabra.

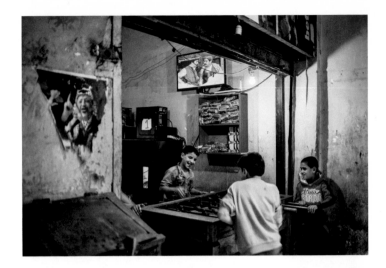

One of the byproducts of Lebanon's 15-year civil war was Hezbollah, which emerged after Israel's 1982 invasion and remains the last militia in Lebanon with arms.

Hezbollah runs special cemeteries—some with their own Facebook pages—for its fighters, including several in Beirut's predominantly Shiite suburb of Dahiye.

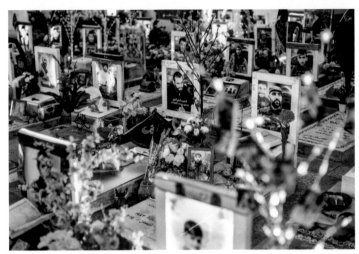

Hammad Atwee, 91, a former sea captain and resident of Moadieh Evangelical Center for Assisted Living, eats a solitary lunch in the center's cafeteria.

Moadieh welcomes all faiths and has led a movement in Lebanon pushing for interfaith elder care—because most of Moadieh's residents lived through Lebanon's deeply sectarian civil war.

In a war museum operated by Hezbollah, visitors walk through "the Abyss"—an installation featuring Israeli weaponry captured between 1982 and 2006. Dubbed "Disneyland for Jihadi fighters" and "Hezbollahland" by critics, the museum has been a source of controversy since its opening.

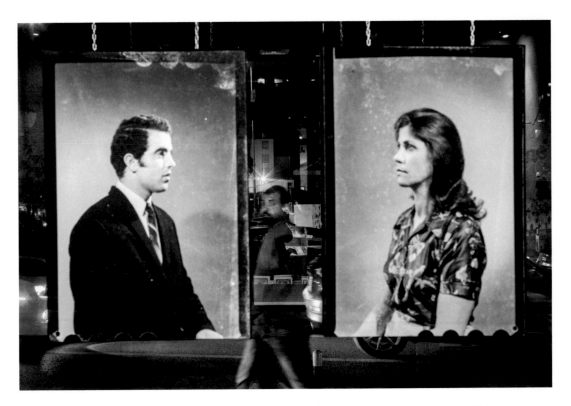

Beit Beirut recently opened as an exhibition space and memorial to the civil war. During
renovations, Mona El-Hallak, an architect and heritage preservation activist, discovered 11,000
photographic negatives—most of them portraits dating from the 1950s to the 1970s—in a photography
studio on the ground floor. Visitors are invited to take away a photo print and try to trace the
person in the portrait.

I Am a Refugee, Just Like Superman

by Mira Sidawi

W hen I was a little girl, I used to stand in front of a big wall in the Burj al-Barajneh refugee camp and whisper to the wind, praying that one day I would get out of the camp and see the city, Beirut. It wasn't easy back then to have such a dream. The wall between the camp and Beirut made us always realize that we, behind the wall, were in the second half, the hidden half, of the world.

My father left Palestine at 20 years old, during the Nakba, the exodus of 1948. He said that all the people living in the Sheikh Dannun village, located in Akka (also called Acre), the ancient port city in Palestine, started running, most of them without shoes. They were fleeing bullets and fire coming from Israeli soldiers. My uncle stayed in the village, hiding himself in an old cave. My father couldn't manage to do that; he just wanted to walk away. When he described the village, my father said it was all gray—gray because of fire and screams and dead people all over the place. My father said he kept walking for days until he arrived in southern Lebanon. For a while, he and others slept in valleys there.

After a huge struggle with all this fear of death and the unknown, my father finally arrived in Beirut, with not one penny in his pocket. There he and the people he was walking with found an empty area with no houses around. One of the old men said, "We'll stay here for a while." People close to the area gave them food and some blankets to sleep. They all thought they would go back after one week. It didn't work like that. The one week lasted for 70 years.

They built houses, first of wood, then stones, then metal. Houses became so closely packed that the sun couldn't enter. The water tasted salty. Rats grew up in the camp, and so did cats—they walk with people every day. Electrical wires run all over the camp, as if the place were a human body with its blood vessels on the exterior rather than within.

The camp was nothing like his village, my father said. "In Sheikh Dannun, we were so close to nature. We were farmers. But here we have become a part of a big machine called the city."

It's a miracle to survive in a place like this, but my father says we have managed to stay together, despite the bad conditions, without killing each other, because our old memories still live and keep us together.

———

This new life, however lamentable, was familiar to me, and safe. It was a closed area, full of people who shared memory, history,

Mira Sidawi grew up in the Burj al-Barajneh camp in Lebanon and has only known life as a refugee. She is a Palestinian actress, director, and writer who shares the plight of statelessness through her artistic expression. In 2015, she created her first short film, *Four Wheels Camp*. Her second film, *The Wall*, takes place in the Burj al-Barajneh and Shatila refugee camps.

and community. They also shared the status of refugee, which made them unwelcome elsewhere, even in Beirut.

We lived in Lebanon but were never given Lebanese citizenship. As I grew up and imagined places even farther away, I thought about how heavy my pocket is when it holds my Palestinian refugee passport. It makes me feel heavy. A refugee is not allowed to see the world—Spain, for example, or India, or Latin America. One moment, in the Canadian Embassy, I asked why. They said, "You are a refugee." I have been judged not fit to travel.

Yes. I am a refugee, just like Superman.

When I was 28, I managed to live in my car for some time, just to keep moving. I wanted to drive every day and practice all the details of my life inside my small car. My car was my home, my office, my everything. One night when I was listening to the car radio I heard a silly song, and I closed my eyes and envisioned myself flying away, in the car, over all walls, going back to my grandfather's land in Akka, now in Israeli territory. Everyone was amazed at my super-magical car, which could fly easily. The Israeli soldiers who were standing on the border tried to shoot the car, but nothing happened. I was just flying.

I came out of my reverie and smiled, for a secret had been revealed to me: it is a privilege to be a refugee. I am a free human being, even if the whole world, or the whole system, doesn't admit my existence; even if they tried to cut my wings and prevent me from traveling, working, making choices, or buying a home. All these constraints have made me the woman I am today.

While in my camp, I was able to make some choices, such as the decision to study the arts. I chose to study theater because I wanted to invade all borders by creating art. I could travel and move with no visa needed and with no fear of any borders. As an actress, I am working on creating Palestinian theater inside the camps. I have started to believe that the beauty inside of all the ugliness we live in is our best weapon. While some fight with their biggest army's power, some decide to respond with pure beauty.

Now I am directing documentaries, films that make people smile. They capture life inside refugee camps, of course. I am also writing, as I feel that writing stories is an act of survival. Writing also allows me to deliver my point of view on politics or life itself.

———

Living in a refugee camp developed in me a deep resistance. I always wanted in my

art to resist all the social judgments that are thrown on my shoulders. Being a refugee is a stigma that made me create all my art pieces.

My friends in the camp didn't understand my need to leave the place. The need deepened after one of my dear friends died. It was winter, when it is dangerous to walk in the camp, especially when it rains, with the naked, snaking electrical wires. Ahmad fell beside his house, right beside his mother. A young college man in his mid-20s, he died from an electrical shock. He was my closest friend; we used to climb the roof together and talk about poetry, freedom, and love. And he just died in front of me. At his funeral, I couldn't cry. We stood, shocked that humanity, as huge as it is, could permit such a thing to happen.

We knew that he would be buried in the only graveyard we have, inside the camp. But the graveyard was full—there was no place for new dead people. We waited. Ahmad's father figured out that his son could be buried over his grandfather. It was not easy to hear that from my friends.

I felt angry and humiliated. I said to myself, I must go now and fight the occupation. Blow things up, fight with stones, fire anything, just to feel relief.

But I didn't. I just packed up and left. My mother didn't understand me. And I didn't bother to explain. Working as a freelancer in the arts, I was able to rent a small house in Beirut, so I left the camp for a while. Then I returned with my camera and made a film, *Four Wheels Camp*. It was a black comedy that talked about my need to find a grave beside trees and birds, not inside a camp that looks like a grave itself.

I live this struggle every day: I wake up and wonder what I will have to do today to find inner peace. I have passed through a lot of angry moments. I remember that I have lived my life like a handicapped person, that I want to go back to my land. I remember my father and grandfather, who have nothing. I ask, Why does he have the right to take my land; why can't he accept me? Anger is like a sword that kills you. Anger is not a language. Anger must be redirected as energy. I do yoga, I meditate, I pray. Being a refugee allows you to dig deep inside to find satisfaction.

What is peace? You can't make peace if you know nothing about it. We can't make peace with Israel because the Israelis don't know this kind of inner peace reached through struggle—they haven't lived it. They did suffer through the Holocaust, but perhaps it just gave them a taste of revenge. A lot of them make us suffer now. Do you think you can make others suffer just because you suffered?

Peace needs equality. We all need to feel appreciated—not special because of superior religion, but because of our own distinct culture. How do we make peace? First of all, you have to learn to respect people. You have to keep breathing and breathing

with no need for any act of revenge.

I want to work in the path of peace. A
path to freedom for everyone. Perhaps
we should all lose the privilege of identity.
Why can't we all become refugees?

Today, I see that the wall of injustice
I came to know inside Burj al-Barajneh
camp is repeated in occupied Palestine.
The only difference is the idea of
limitations. In Burj al-Barajneh, we
were only allowed to be inside. In
occupied Palestine, you can be inside
or outside—but you cannot dream to
pass through both sides easily. The
Israeli soldiers will not allow you to
make your own choices.

The camp is like an ant's world. Small
alleys, tight houses, lots of pigeons all
over the houses' roofs. You might say
that we Palestinians are the victims of
the victims. But that doesn't mean we
can't breathe or dream. I refuse to be
the kind of victim who can survive on
the happiness and choices of others.

I will always imagine the country I deserve.
It stands freely embracing poor people,
tired ones, artists, mothers, children,
and all of humankind. I believe in justice
more and more, as I dream of getting rid
of all walls that separate humans from each
other. But living in these hard conditions
and questioning peace, or writing about
peace, is itself a kind of peace.

Roland Neveu and Gary Knight
**Cambodia Then
(1973–79, 1990–92)**

Jon Swain
Fragile As a Flower

Gary Knight
Cambodia Now

Sophary Sophin
**Excavating the Past,
Imagining a New Life**

In 1973, I was a student in sociology in Brittany and was very motivated to experience the ills of our world first-hand. During the summer break, a friend and I dreamed of getting to Cambodia to hone our skills as burgeoning photographers. We managed to fly into Phnom Penh a couple of weeks ahead of the end of the US B-52 bombing of the country.

That for me was a revelation in covering a conflict, a big leap after trailing my camera along the student protests of the early 1970's in France. It also became a jumping off point from university and the entry into a career as a photojournalist. Reporting that war became a passion, and with the fall of Phnom Penh to the Khmer Rouge on April 75, it altered my life forever.

Witnessing the tragedy of Cambodia over the years has taken me from the disembodiment of the country to the relatively prosperous time it has entered now. Peace has been a very long and tortuous road for the Cambodians, affecting many generations of its people.

Roland Neveu

Cambodia Then (1973–79, 1990–92)

by Roland Neveu and Gary Knight

I arrived in Cambodia in 1989, more than a decade after the Khmer Rouge had embarked upon its three years of slaughter, rewound the clocks to Year Zero, and taken the country back to the Middle Ages. The extent of the genocide they had perpetrated was exposed when Vietnam invaded Cambodia in 1978 and drove the Khmer Rouge over the Thai border. The remnants of their army were fed in the United Nations 'displaced persons' camps along with hundreds of thousands of starving civilians.

Within weeks of the arrival of these decommissioned troops, ruthless Realpolitik took over, and the Thai, Chinese, American, and European governments, resentful of the Vietnamese, rearmed and rehabilitated the Khmer Rouge and created an alliance of guerrilla groups to fight Vietnam in Cambodia.

The war that followed, between 1979 and 1991, was my first war. It was where I met and was mentored by Roland Neveu, Jon Swain, and other media veterans of earlier Indochinese wars. From them I learned the tradecraft of journalism.

Gary Knight

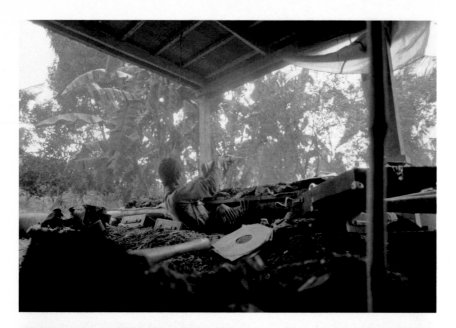

Top: A government soldier fires his outdated M1 carbine at the Khmer Rouge from a foxhole. Kien Svay, Route 1, August 1973. Roland Neveu

Bottom: Women leave their village as fighting takes place between armored government troops and the Khmer Rouge. Near Koki, Route 1, August 1973. Roland Neveu

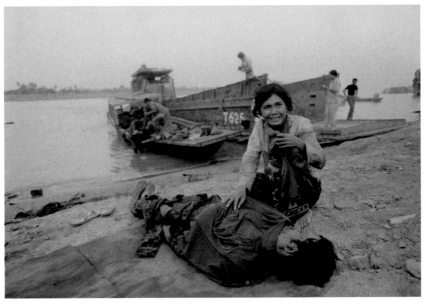

Top: A Government firebase set up to support the evacuation of US military and civilians from Phnom Penh as the Khmer Rouge encircles the city. April 1975. Roland Neveu

Bottom: Barely a week before the end, there was very intense fighting at the access roads to the city and along the Mekong River. A woman mourns a dead government soldier whose body was returned after a clash with the Khmer Rouge a few kilometers downstream from the capital. April 1975. Roland Neveu

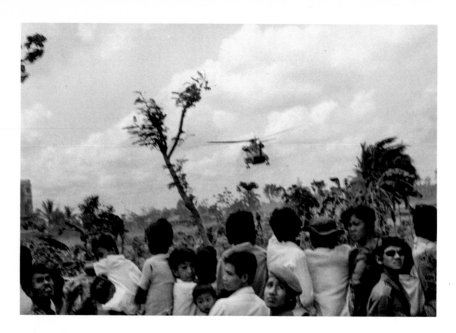

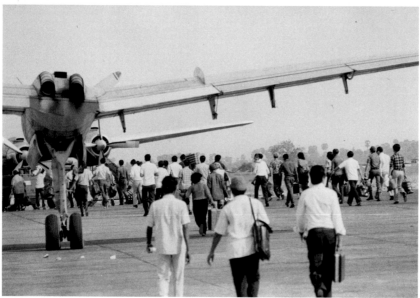

Top: Operation Eagle Pull. The US evacuation lasted all morning. Flights of US military helicopters landed at a school not far from the US Embassy to evacuate the last American military and civilian personnel from Phnom Penh, abandoning Cambodia to the Khmer Rouge. Cambodians are kept outside the fence. April 1975. Roland Neveu

Bottom: Pochentong International Airport, Phnom Penh. The day after the US evacuation, Cambodians flood to the airport to try to get on one of the last commercial aircraft out. A few days later, the Khmer Rouge enters the city and resets the date to Year Zero. April 1975. Roland Neveu

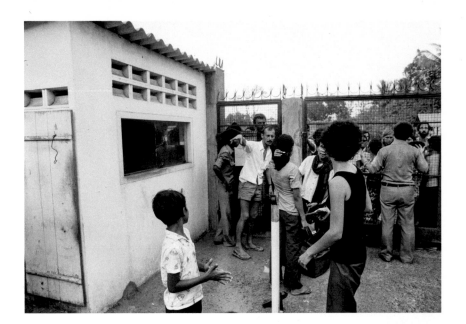

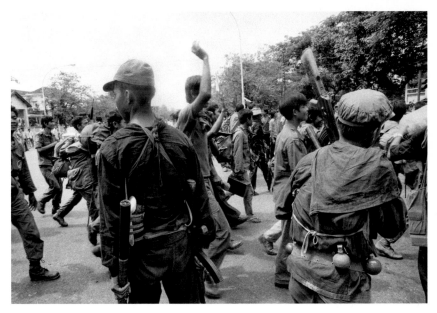

Top: The fall of Phnom Penh. The infamous gate of the French Embassy. Around 600 people, including many wealthy and powerful Cambodians, sought sanctuary in the French Embassy, along with remaining foreigners, including the press corps. The Khmer Rouge reached an agreement with the Embassy that all foreigners would be transported safely to the Thai border if the Cambodians were ejected from the safety of the compound. There are no known Cambodian survivors from the French Embassy compound, and they are assumed to be among the millions who perished during the Khmer Rouge rule of Cambodia. April 1975. Roland Neveu

Bottom: The fall of Phnom Penh. A unit of government soldiers surrenders to the Khmer Rouge and are marched through the city towards the Olympic Stadium, where thousands were bludgeoned to death. April 1975. Roland Neveu

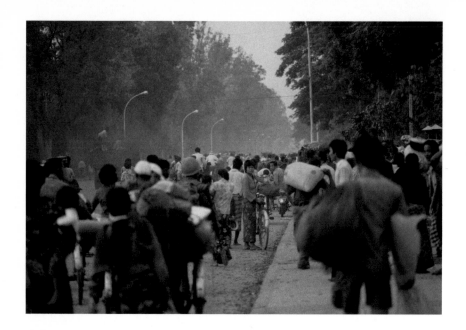

Top: On the eve of the fall of Phnom Penh, huge crowds move down Monivong
Boulevard, escaping the sporadic fighting on the outskirts near the Old
Stadium and the main power plant. April 1975. Roland Neveu

Right: During the heavy monsoon in the forest of western Cambodia, a family
struggles to reach the border with Thailand in search of aid. September 1979.
Roland Neveu

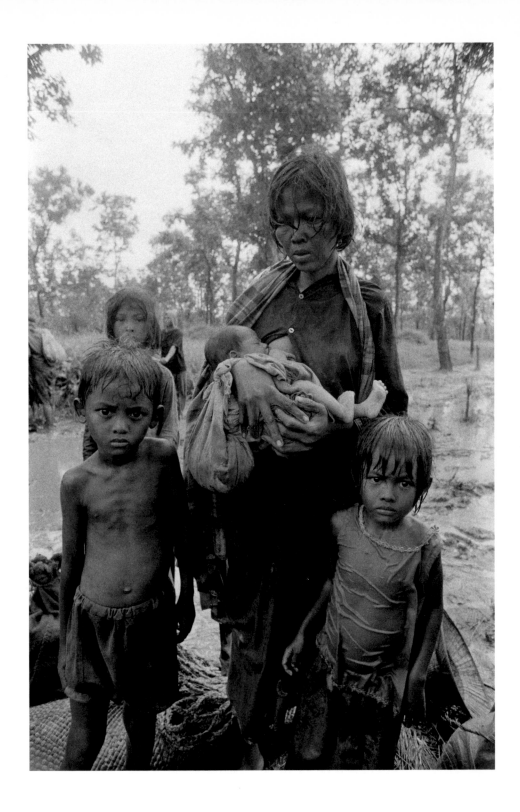

Cambodia Reportage

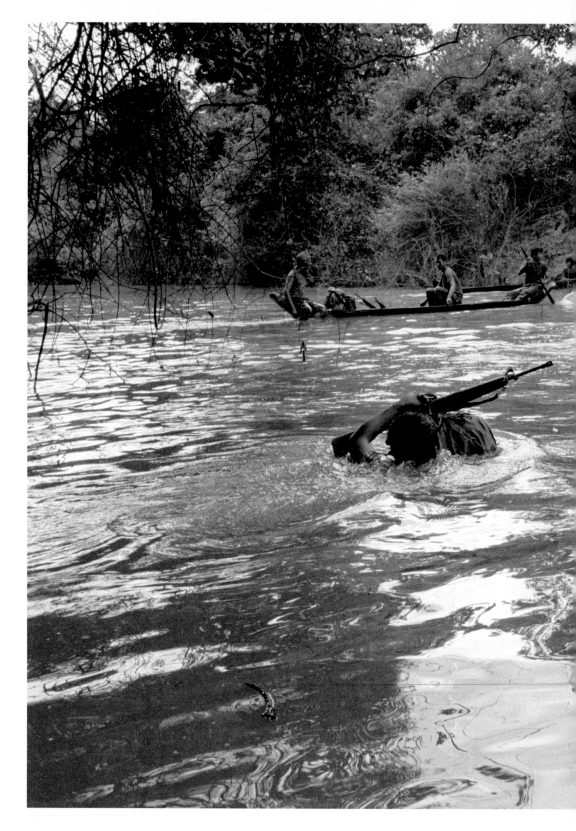

Cambodia

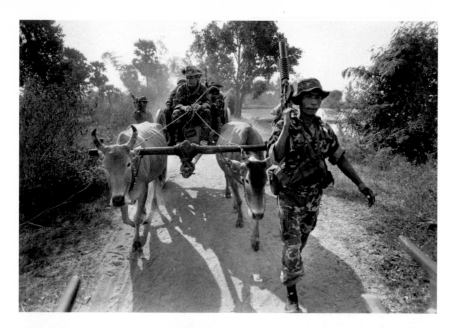

Pages 76-77: Khmer People's National Liberation Front (KPLNF) guerrillas cross a river in northern Cambodia on a long-range patrol. 1990. Gary Knight

Top: A long-range patrol with the KPLNF in rural western Cambodia. 1990. Gary Knight

Bottom: KPNLF soldiers use hand grenades and a mosquito net to fish on a long-range patrol in Siem Reap province, Cambodia. 1990. Gary Knight

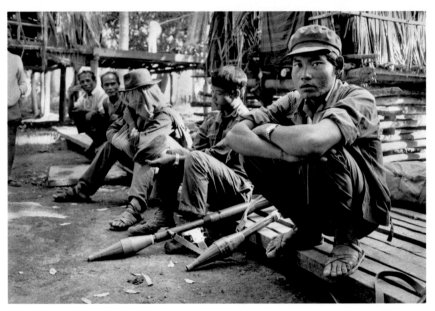

Top: A KPNLF guerrilla rests in a village a few kilometres from UN-run refugee camps in Thailand where he was based. The KPNLF and their allies used these UN camps as support bases in their fight against the government of Hun Sen. 1991. Gary Knight

Bottom: Khmer Rouge guerrillas in a remote village near Pol Pot's base in Anlong Veng, northern Cambodia. 1990. Gary Knight

Cambodia Reportage

Fragile As a Flower 80

by Jon Swain

N ever have I seen Phnom Penh so alive or joyful as at its annual water festival on a warm night of the full moon in November 2017. Tens of thousands of people flocked in from the countryside. Along the Mekong River front and the old Royal Palace, the streets teemed with happy couples, gaggles of children shrieking with pleasure, and groups of saffron-robed monks. Gold sparkled on the roofs of the temples. The scents of jasmine and frangipani filled the air. There were spectacular boat races, street stalls, cultural attractions, traditional drums, Brahman priests, and men dressed as the god Hanuman performing monkey dances.

On the last day of the three-day festival, Cambodia's King Norodom Sihamoni greeted racers from the Royal Pavilion in front of the palace. The blue and red Cambodian flag, the three towers of the Angkor temple decorating its centre, fluttered in the breeze.

I sensed a swelling of national pride. Necks craned as people tried to catch a glimpse of the king. Sihamoni lacks the charisma of his father, the late King Sihanouk, who enjoyed almost divine status. Sihamoni has spent his life away from politics, a large part of it in Europe as a ballet instructor. For as long as most can remember, real power has resided in the hands of Cambodia's long-serving prime minister, Hun Sen. Nonetheless, respect for their constitutional monarch was palpable. Mingling with the happy crowds, I found it hard to disagree with an old friend's remark that Cambodia is still a feudalistic society made up of people who would rather throw festivals and have fun than work too hard.

The festival, though, offers an image both idyllic and flawed. As older Cambodians themselves know well, their pleasure-seeking reputation belies their full history. Brutality has been shown to be in their genes. The turmoil depicted in the ancient frescoes at Angkor Wat, and the recent era of war and genocide, are evidence of an age-old propensity for savagery.

Behind the enigmatic Khmer smile have always been dangerous undercurrents of violence which can explode into the open. "Don't underestimate the ability of the Khmer to kill Khmer," said a Khmer friend who survived the genocide. "It is the only country in the world that has managed to destroy 25 per cent of its own population. Even though everyone is smiling and very sweet, underneath is a character we have to be cautious about. Is the violence really a thing of the past?"

This hidden menace haunts the land as much as do the thousands of landmines buried in the country's soil, remnants of its decades

Jon Swain was the only British journalist in Phnom Penh when it fell to the Khmer Rouge in April 1975. He narrowly escaped death in a scenario portrayed in the 1984 film *The Killing Fields* and his own memoir, *River of Time*. More than four decades later, Swain returns to Cambodia to find a ruthless government and a society of haves and have-nots. "This may be a country in which the words *peace* and *justice* do not go together," Swain writes. Prime Minister Hun Sen and his ruling Cambodian People's Party have stilled the chaos but installed repression and corruption. In spite of the brutality, Swain finds sublime beauty in this nation of survivors. Some people tell him they are content to be living without conflict, but amongst the young he finds discontent and a resolve to neither forget the past nor let it rule them.

of conflict. They continue to destroy lives years after the fighting stopped.

But in Phnom Penh during the festival, it was almost impossible to imagine three more beautiful days in a city I love and have visited over and over for more than four decades. As night fell, fireworks illuminated the sky in a glorious, dazzling, and deafening display. Buildings shuddered. With each shock, I was reminded that Cambodians are well practiced at making a big bang.

Mercifully, the big bangs at the water festival were peaceful. But this has not always been so.

A GENERATION OF TURMOIL

When I first arrived in Cambodia as a young journalist in 1970, the country was moving from peace to the inferno of civil war, revolution, and genocide. Since its independence from France in 1953, it had been presided over with ebullient flair by the feudal genius of one man. Monseigneur Sihanouk, as he liked to be called, was more than a mere monarch. The Cambodians believed their patrician ruler to be a god king with semidivine qualities. Despite his engaging and irresponsible nature—he was a composer, film director, and lover of women and the good life—he showed considerable statesmanship in trying to shield his people from the war that was ravaging neighbouring Vietnam.

Under his rule, Cambodia seemed an oasis of peace.

The calm was deceptive. Vietnamese communist forces had set up bases within Cambodia's borders, which the United States bombed in a secret and savage air war. Both were violating Cambodia's neutrality. Meanwhile, in the countryside, a clandestine group of influential Cambodian communists with ultra-Maoist beliefs, known as the Khmer Rouge, was radicalising the peasantry. When rural discontent finally boiled over into a peasant uprising in the remote northwest over the price of rice, Sihanouk's army ruthlessly cracked down. The scale of the brutality was a foretaste of the horrors Cambodians could inflict on themselves.

In Phnom Penh, too, political unrest was stirring. Sihanouk ruled like a feudal prince; he was no democrat. In March 1970, he was deposed in a coup by his right-wing defence minister, General Lon Nol, who aimed to abolish the monarchy and make Cambodia a republic. The coup was a disaster. Cambodia became embroiled in America's Vietnam War. The US armed the incompetent Lon Nol, who made himself president, while the Cambodian communists, the Khmer Rouge, armed and trained by communist North Vietnam, took to the battlefield. The exiled Sihanouk allied himself with his former enemies, whom he had previously sought to destroy, and called on Cambodians to fight against the Lon Nol government. The Khmer Rouge exploited this alliance to broaden their support. Hardened by the massive American bombing, they grew into a cruel, disciplined, and unstoppable force.

The war spread, and over the next five years hundreds of thousands of people fled from their homes in the countryside. Phnom Penh, famed for being one of the loveliest cities in Southeast Asia, a place where French and Oriental genius fused, changed into an armed camp swollen with refugees. Overland transport was cut off, and rice had to be brought up the Mekong in convoys running a gauntlet of heavy communist fire from the riverbanks.

The Lon Nol regime was dying. On April 12, 1975, the US abandoned it, closing the US embassy and evacuating its staff

in an ignominious helicopter operation. Five days later, the Khmer Rouge entered the besieged city.

I was in Phnom Penh on April 17 when the victorious guerrillas arrived and established their genocidal regime. In an unthinking act of madness, they emptied Phnom Penh. Forcing two million people out of their homes at gunpoint was the beginning of a terrifying attempt to create an agrarian communist utopia.

Pol Pot, the mastermind of the revolution, was a soft-spoken, French-educated radical with extreme revolutionary ambitions to restructure Cambodian society into a warped version of its former self. An ultranationalist as well as a crude Marxist, he blamed Cambodia's enfeebled state and class divisions (between urban rich and rural poor) on years of foreign interference, particularly by France, the former colonial power, and Vietnam. Historically, Cambodians have looked upon their dynamic neighbour as the arch-enemy, because centuries ago Vietnam annexed lands that had been part of the great Khmer empire. Pol Pot's hostility to Vietnam overrode any shared ideology. He believed the best way Cambodia could prosper was by giving power to the peasantry.

Accordingly, he set out to forge Cambodia into a perfect agrarian nation. Having forced the educated urban class who threatened his ideology into the countryside, where they were most vulnerable, he systematically wiped them out. They were not *borisot* (pure); they were the defeated "April 17 People" and deserved to perish.

Doctors, professionals, and even those who simply had soft hands or wore spectacles that suggested they could read were killed in droves. The executioners were often Pol Pot's child soldiers, indoctrinated to inform on their own parents. Everything that was dear to the people was abolished, including money, property, religion, marriage, normal childhood, books, music, medicine—even laughter. "To spare you is no profit; to destroy you is no loss" was one of the Khmer Rouge slogans. Cambodia became a giant labour camp. People toiled like ants in the field and died in the thousands from execution, starvation, and disease. (Even today you will find elderly women who cannot bear to talk about watching their children waste away.)

Like many revolutionary movements, the Khmer Rouge ended up devouring itself, unwittingly sowing its own demise by conducting bloody cross-border raids on Vietnamese villages they coveted because they had been a part of the ancient Khmer empire. This provoked a retaliatory invasion by Vietnam, by then united under communist rule. In a lightning assault starting on Christmas Day 1978, Vietnamese tanks stormed into Phnom Penh and overthrew their former friends.

The Khmer Rouge tyranny had lasted three years, eight months, and 20 days. Its legacy was nearly two million dead, tens of thousands of widows, at least 200,000 orphans, and hundreds of thousands of refugees. Many of the survivors bore psychological damage. In early 1980, I returned to see the entire nation on the move—people were trekking to refugee camps in Thailand or returning to the homes from which they had been uprooted. They were searching for their loved ones and scavenging for food. Phnom Penh was a wasteland of decaying and melancholy buildings, populated by traumatised people desperately trying to

rebuild their shattered lives. In vain, I searched for people I had known and loved. I visited their abandoned homes. They were empty and full of ghosts. I found only one friend from the past, a once-delicate city girl whom the Khmer Rouge had turned into a rough peasant. Her hair was clipped short, her copper-coloured skin had coarsened in the sun, and her beautiful hands were covered in sores. *"Maman morte, bébé mort,"* she said with a look of profound sadness.

In a kind of reverse image of this transformation, one person who returned stronger (arriving with the Vietnamese Army as it toppled the Khmer Rouge) was a young Cambodian named Hun Sen. Born into a peasant family up the Mekong River from Phnom Penh, he had, at the age of 20, joined the Khmer Rouge resistance against Lon Nol. Hun Sen lost an eye in the war. In 1977, as a battalion commander, he fled to Vietnam to escape the ever-deeper purges scything through Khmer Rouge ranks. As if from nowhere, the Vietnamese chose him as foreign minister of Cambodia, and then he became prime minister in 1985, when he was 32.

More than three decades later, Hun Sen is still in power, having outmaneuvered all his opponents. Although his long rule has been defined by repression and controversial election victories, the strongman is also recognised by many older people as Cambodia's saviour from the genocidal Khmer Rouge regime (to which he had nonetheless once belonged). He has always denied complicity with the regime and warns regularly that only his leadership stops Cambodia from returning to civil war.

As for Sihanouk, he finally came home in 1993 after years of absence, his political influence in decline. He was sidelined by Hun Sen as a figurehead king, a role that has now passed to his son, Sihamoni.

A NEW CITY

The Phnom Penh of today and the Phnom Penh of my memories are separated by almost four decades and by an eternity in mood. It is hard to find even traces of the beauty and the horrors I witnessed in the early 1970s in this changed and frenetic place, with its noise, its traffic-choked streets, its shopping malls, and its ever-taller skyscrapers. The fine French colonial buildings that gave it old-world grace are falling victim to modernisation's wrecking ball. The dollar is king, and it can sometimes seem as if the nightmare had never happened.

On a small island on the Mekong linked by a bridge to Phnom Penh, developers are constructing a residential and commercial district based on Haussmann's Paris, complete with its own Arc de Triomphe. The idea is to sell the district's Parisian-style apartments to the Chinese investors who are thronging to Cambodia. Perhaps the developers were tempted to show that with peace, Cambodia is so successful that it can construct its own mini-version of the French capital. I cannot help recalling Oscar Wilde: "Imitation is the sincerest form of flattery that mediocrity can pay to greatness."

They could have built something distinctly Cambodian. The country has been blessed by fine architects, most famously the late Vann Molyvann, who took his inspiration from the Angkor temples but also applied modernistic principles to pioneer a style known as the New Khmer Architecture movement. The originality of his buildings enriched the landscape of Phnom Penh. But the lack of properly enforced historical-conservation laws means that many have been dismantled. It is the story of Cambodia.

The city is expanding at breakneck speed to become another seething Southeast Asian metropolis and a favourite stop on the Asian tourist circuit. Luxury riverboats cruise up and down the Mekong, which during the civil war was the world's most dangerous river journey. But step into the backstreets, piled high with rubbish, and the poverty bites. "I love it, but it breaks my heart," said a Cambodian I had known in the 1970s. "At its best, it is truly beautiful; at its worst, it can be truly ugly."

I caught a glimpse of Cambodia's most beautiful side early one morning at a hall in Phnom Penh filled with dozens of dazzling girls aged 7 to 17. These Cambodian classical dancers had exchanged their school uniforms of blue skirts and white blouses for bright satin bodices and long silken swathes of reds, blues, and purples—half skirt, half trousers—bound tightly round the thighs and legs. The ghostly sound of bells, rising and falling unexpectedly, filled the hall, and from all corners, dancers glided onto the dance floor, their arms raised and their hands unfolding with the grace of a blossoming flower.

I was witnessing an amazing revival of Khmer classical dance. In 1975, in order to sever Cambodians' links with the past and start at Year Zero, the Khmer Rouge had done away with traditional musical instruments, abolished festivals, burned books and records, and confiscated Buddhist manuscripts. The Royal Ballet of Cambodia was dissolved, and 90 per cent of the dancers perished. It was an irreparable loss. One thousand years of rich and vibrant culture had been all but destroyed.

However, a few surviving dancers of the Royal Ballet (including Pol Pot's sister-in-law) lingered for a generation, passing on their secrets, teaching children how to perfect the elaborate steps. Few visions in the world are more enchantingly romantic than these graceful and perfectly poised dancers who seem to be the sisters of the bare-breasted *apsaras* (the celestial concubines of Indra, the king of the gods) sculpted in stone on the walls of Angkor Wat.

Watching them practice, I was reminded of Auguste Rodin's remark when he saw Cambodian dancers in Paris in 1906. It was "impossible to see human nature brought to such perfection," he said. "There are these and the Greeks."

That the modern revival of Cambodian dance is so successful is due in no small way to Princess Bopha Devi (whose name translates to Goddess of Flowers), Sihanouk's daughter and Sihamoni's half-sister. She had been the leading dancer in the Royal Ballet before it was smashed by the Khmer Rouge; during her tenure as minister of culture from 1998 to 2004, she used her stature to promote the ballet's revival, turning up at training sessions to lend a hand teaching the girls. Even now, in her 70s, she continues to serve as a teacher and mentor for the dancers as the director of the Royal Ballet of Cambodia.

"Dance has been in my family for generations," she told me. "My mother, my grand-mother—my father even played a musical instrument to accompany the Royal Ballet. But then it belongs to all Khmers. As I see it, our principal aim now is the preservation of classical dance—not only dance but all of our culture. You can say that we will have to be very brave and ingenious. We are a small country with little means at our disposal, but we'll manage somehow because we have to. It is our lifeblood we are preserving here."

A NEW POETRY

If the renaissance of classical dance is one marker of the new Cambodia, the emergence of a vibrant film industry is another. But if dance looks mostly to the Khmer past, film, especially in the hands of certain filmmakers, is a milestone on the road to recovery. The leading light in this regard is Rithy Panh, a documentary filmmaker who has trained his lens on the memory and aftermath of the Khmer Rouge regime.

The genocide left Panh not just an orphan but a witness: he watched as his entire family died in the killing fields. He alone survived, and after the fall of the Khmer Rouge, he went to Paris, where he studied cinematography. His latest project is _Graves without a Name_, a moving feature film about the fate of his parents, who starved to death in Battambang province. He hoped that making films would be cathartic, but they have so far failed to exorcise the regret he feels at being his family's lone survivor. He blames himself for not knowing how to forage for food to keep them alive. "Having grown up in Phnom Penh," the filmmaker lamented, "I did not know the ways of the countryside, how to catch fish in the water using my hands. It took me two years to learn. By that time, I had already lost half of my family."

Shedding light on this tragic period through film is Panh's personal obsession. He is a fervent believer in reconciliation without vengeance. This does not mean that victims of the Khmer Rouge have to forgive the killers. "It is art that recounts the truth," he told me in an interview in Phnom Penh in 2017. "Art is there to help you stand up and speak."

I am reminded of what the German philosopher Theodor W. Adorno famously said: "There can be no poetry after Auschwitz." Panh said he emphatically disagrees.

"After a genocide we need more poetry," he told me. "It proves that we Cambodians are capable of speaking and expressing ourselves about our history. At last we can discuss what happened and thereby begin a process of reconstruction of our identity."

Panh has played a critical role in mentoring new Cambodian directors and encouraging others to "make poetry"—or at least record the country's tortured modern history. One enterprising endeavor, tucked away in a Phnom Penh side street in a modest building, is the Bophana Audiovisual Resource Centre. Under Panh's direction, the

centre has amassed an extraordinary film, television, photographic, and sound archive to which all Cambodians have free access.

Since the centre's opening, more than a quarter of a million people have visited its archives. Sopheap Chea, the young executive director, has been involved in developing a Khmer Rouge app for the benefit of today's media-savvy youth.

For Panh and his fellow filmmakers, all this forward-looking effort, as well as Cambodia's rapid change, only reinforces an insistence on remembering the past— and not just in film. For them, William Faulkner's aphorism "The past is never dead. It's not even past" holds true. The genocide and decades of war still inhabit the present, living on in their minds as they go about their daily lives.

The efforts to educate young Cambodians about the country's Khmer Rouge past are moving to new venues beyond the arts and places like the Bophana Audiovisual Resource Centre. In 2009, the same year that a UN-backed tribunal belatedly began prosecuting the crimes of the Khmer Rouge, the history of that terrible era was made a part of the secondary school curriculum. The Documentation Center of Cambodia and the Ministry of Education together produced a teacher's guidebook titled *A History of Democratic Kampuchea (1975–1979)*. Thousands of copies have been distributed. Genocide education memorials are being established in schools up and down the country. They emphasise that "preventing genocide in Cambodia and the world at large" is best achieved by having children learn and discuss with their parents and grandparents what happened during the Khmer Rouge rule.

In the forefront of this programme is Youk Chhang, the American-educated genocide survivor who heads the Documentation Center, which is the country's principal repository of records of the Khmer Rouge period. Chhang has also established a peace centre in Anlong Veng in the north of the country close to the Thailand border. (Anlong Veng was the Khmer Rouge's final stronghold before the last guerrillas surrendered in 1998, 20 years after the Khmer Rouge government was overthrown.) It is the site of Pol Pot's grave and was the home of Ta Mok, one of his most brutal henchmen.

Eighty per cent of the local population of 55,000 are former Khmer Rouge. They live simple lives in scattered villages, some consisting of fewer than 20 people. Not much has changed for them. But every month, groups of 50 to 100 students arrive as part of their education to tour 14 different Khmer Rouge sites, talk to former cadres, and write up their impressions.

Ngov Chihor, a student from Phnom Penh, noted that while most people thought the Khmer Rouge leaders were cruel, the local people in Anlong Veng still thought differently. He was surprised to find that they considered even murderous Ta Mok, a brutal killer in the eyes of most Cambodians, as "a father, a community builder, and a good leader." They talked to Chihor openly about their daily lives, jobs, and families but were reluctant to speak in depth about the Khmer Rouge regime.

"The nature of the residents, their perception, and the development of the area has changed my mind from what I had thought about this former Khmer Rouge stronghold," he said. "Peace needs to be built, and reunion has to be created in Anlong Veng.

Discrimination has to be abandoned and reconciliation is a must."

Survivors, too, are encouraged to visit and share their memories. Chhang's dream is to turn Anlong Veng into a "City of Understanding." He believes his project has changed the way people think, altering their understanding about peace and about the Khmer Rouge themselves.

"Peace is not just about reconciliation and right and wrong," he said. "For Cambodians it is about understanding and deepening their own identity. Our two great rivers, the Mekong and the Tonle Sap, meet and split at Phnom Penh. But they are still the same river. They are together. That is how Cambodians think about reconciliation."

To Western eyes, the preservation of Pol Pot's cremation site is wrong. He was responsible for one of the worst mass killings in modern times. But Cambodians reason differently. Even survivors express approval. Still, I was surprised by the response of a teenage girl passing by Pol Pot's grave when I visited. "Pol Pot was trying to do something good for Cambodia and was betrayed by Ta Mok," she said to me.

"For Cambodians it is preserving evidence that is important," said Chhang. "It is the fear that the world will not believe. The gravesite is just to show Pol Pot lived here, Pol Pot died here. It is evidence, and people do not want it removed.

"We are very graphic," he added. "We Cambodians love blood. If something has the word blood in it, Cambodians like it. Even our songs are about blood." His words sent a shiver down my spine, bringing back the memory of a particularly poignant moment in Paris a few years ago, when I was reminiscing about Cambodia with Denise Affonço, a genocide survivor and friend. We had both been in scarred and war-battered Phnom Penh at the time of the Khmer Rouge victory, and each of us had witnessed its terrible horrors, although we did not know each other then. Suddenly she began to sing, quietly, the Khmer Rouge national anthem, which uses the communists' preferred name for the motherland:

> *"The bright red blood was spilled*
> *over the towns*
> *And over the plain of Kampuchea,*
> *our motherland*
> *The blood of our good workers and*
> *farmers and of*
> *Our revolutionary combatants,*
> *both men and women."*

"I remember it by heart," she said, sadness and a slight embarrassment crossing her face.

To survive, Affonço said, you had to do three things: "Know nothing, see nothing, hear nothing." Though she clung to life, she lost the father of her two children, as well as her nine-year-old daughter, Jeannie, who starved to death. She told me she could not forgive herself. Nor could she forget. She buried Jeannie and a young niece on the same day. "The morning she died, the only thing she asked me was 'Mummy, I want one more bowl of rice,'" Affonço said. She wrote a book, *To the End of Hell: One Woman's Struggle to Survive Cambodia's Khmer Rouge*, and she has given powerful evidence at the UN-backed tribunal trials of Khmer Rouge leaders.

LIKE WATER BUFFALO—PLACID, BUT WITH A TERRIBLE ANGER

The tribunal trials, called the Extraordinary Chambers in the Courts of Cambodia (ECCC), have been a major component

of a huge UN effort to help Cambodians come to terms with their bloody past and bring about healing. Perhaps its overriding virtue is that it sits in Cambodia, where the genocide was committed, unlike the tribunals for Rwanda and Yugoslavia. As a result, there has been tremendous public interest. More than 200,000 people have attended at least one session hearing. This is more than for all the other tribunals combined. The American academic Craig Etcheson, who played a leading role in its establishment and was for many years a tribunal investigator, believes that its single biggest achievement, more than its verdicts, has been that its proceedings have at last given the Cambodian people permission to talk freely to each other about what happened.

But after a decade and a cost of some $300 million, the tribunal has convicted just three people for crimes against humanity. Two were amongst the most senior leaders of the Khmer Rouge under Pol Pot—Khieu Samphan and Nuon Chea. The third, Comrade Deuch (aka Kang Guek Eav), was the chief of the secret police and the commander of Tuol Sleng, the notorious prison in Phnom Penh, now a museum of genocide, where 17,000 prisoners were tortured before being murdered.

Just a few other Khmer Rouge suspects are under investigation for their roles in the genocide; they will never face trial as long as Hun Sen rules. He has made clear his opposition to further prosecutions. The Cambodian legal establishment has stalled proceedings amid dire official warnings that pursuing these cases could destabilise the country.

No one seriously believes it. Critics think it is because the government is largely made up of former Khmer Rouge people, starting with Hun Sen, who want to control the trials to protect themselves and their interests.

While the tribunal's work is focused on the crimes of the past, worry about the present occupies most people's minds.

Back at the water festival, I had met an old fisherman, a genocide survivor, accompanying his granddaughter. He greeted me with a traditional Khmer *sampeah*—putting his palms together, with a slight bow of his head. He was still poor, his life much the same old struggle, but he immediately expressed pride and pleasure at seeing his king close up, and he rejoiced that Cambodians were no longer killing each other. "We Khmers don't want any more violence," he said. "We must unite together, listen to each other, or there will be no peace and no dignity. It is wonderful that we no longer hear gunfire. But peace is as fragile as a flower."

It is a refrain I heard time and again. If there is a threat to peace, to echo the old fisherman's concern, it is Cambodia's unending capability for political violence.

The nation's politics are ugly. Those politics start with Hun Sen, the self-proclaimed supreme leader. The victory of his ruling Cambodian People's Party in the July 2018 elections confirmed Cambodia as a one-party state. As he has grown older, he has become more and more self-obsessed and self-aggrandising. His will to hang on to power is undiminished, and he has dynastic ambitions for his family. Hun Sen has

shown no desire to stem rampant government corruption. "The way he leads the people is about power and money," said a bright young woman in the countryside. "He has shown people that when you have power and money, you can do anything, and that is not healthy for the country."

Some point to how this corruption undermined the work of the tribunals. The ECCC was seen by some as not so much a way to achieve justice as a way to line the pocket. An authoritative source who asked not to be named told me, "The tribunal can also be seen as a microcosm of what has been going on in Cambodia—the successful manipulation of the international community to extract more money." He pointed out that at one time, Cambodians on the tribunal staff were paying, "in typical Cambodian fashion," 20 percent of their salaries to the administration for their jobs. "The level of greed is mind-boggling, and especially in this case it is particularly sad," he said. "People suffered, and the authorities just treated the tribunal as another way to make money out of the international community, to steal more and more and more."

Hun Sen has been no more inclined to curb state-sponsored violence than he has been to counter corruption. Critics and human rights activists have been killed, locked up, or driven into exile. NGOs have been targeted, independent media forced to close, and opposition parties intimidated or dissolved. In June 2018, Human Rights Watch issued a 213-page indictment of 12 senior security officers who "form the backbone of an abusive and authoritarian political regime." The report said that each "owes his high-ranking and lucrative position to political and personal connections with Hun Sen dating back two decades or more [and]

has demonstrated a willingness to commit [human] rights abuses on behalf of Hun Sen." Throughout their careers, the report continued, they have been paid modest official salaries while amassing large amounts of unexplained wealth.

Repression and strife have long been part of Cambodian society; this may be a country in which the words *peace* and *justice* do not go together. In the 19th century, King Norodom, the great-great-grandfather of Sihamoni, warned that Cambodians were like buffalo—placid but with a terrible anger when pushed to the limit. French officials, too, were aware of the suddenness with which Cambodians could switch from docility to furious acts of cruelty; the French colonial period saw many violent peasant protests and insurrections over injustices. In the 1960s, reverence for Sihanouk did not prevent farmers from demonstrating violently against his government; nor did the civil war stop Phnom Penh university students from protesting against Lon Nol's assumption of dictatorial powers.

EATING THE LAND

The legacy of violent protests continues, fueled today by economic injustice. Workers in the garment industry, who generate billions of dollars for the economy, have been particularly vociferous in their demands for a decent salary. A number have been shot dead by police in protests over the years. (Needing their vote, Hun Sen boosted their minimum wage before the recent election.)

But it is a much larger section of the population—the victims of land grabbing— who point to the real villain in the age-old struggle for economic justice: the government. If the tribunals were seen by some as a way to line their own pockets, the idea of profiting by seizing

land has been an even greater temptation. Activists accuse the official security forces and politically connected business elite of robbing the civilian population for their own enrichment and preservation of power.

About three-quarters of a million people have been adversely affected by the stealing of land in the last 20 years, many forcibly evicted from their homes. This is according to Richard Rogers, a British human rights lawyer who has filed a case at the International Criminal Court (ICC) at The Hague alleging that the land grabbing in Cambodia exists on such a "truly massive scale" that it amounts to a crime against humanity. It involves murder, forced evictions, and illegal imprisonment, he argues, and should be punished under international law. The government has dismissed the charges as exaggerated and politically motivated. As of July 2019, the ICC prosecutor had yet to decide whether to launch an investigation.

In Phnom Penh, the destruction of the Boeung Kak lake is the most striking emblem of forced evictions—and the one that has caused the most outrage. Once the largest urban wetland in Cambodia and rich in fish and plant life, the lake provided a livelihood for 4,000 families, approximately 20,000 people who lived around its shores.

In 2007, without any consultation, the Phnom Penh municipality leased the lake and surrounding area to Shukaku, a development company controlled by Lao Meng Khin, a powerful ruling party senator and strong ally of Hun Sen. The company paid $79 million, well below the market value for such a prime piece of land near the city centre.

In 2009, protected by armed police, construction workers moved in and started pumping sand into the lake. The displaced water flooded the surrounding homes. While about 1,000 families accepted an offer of resettlement or compensation from the municipality, many others who were forcibly evicted and their homes demolished were left with little or nothing.

A group of local women activists under the leadership of Tep Vanny, a grocery seller and mother of two, refused to reach a settlement. They said the compensation offer was below the true market value. Their struggle and the surrounding media storm made such a strong impact that in 2011, the World Bank froze lending to Cambodia until proper compensation was paid, embarrassing Hun Sen's government. The bank finally lifted its suspension in 2017, arguing that "substantial progress" had been made in settling the dispute. Tep Vanny might have vigorously disputed the World Bank's claim if she could have spoken out, but she was serving a 30-month prison sentence for "intentional violence with aggravating circumstances" after a dubious trial. Nevertheless, the Boeung Kak lake evictions have made her one of the leading activists for land rights in the country. (After 700 days in prison, Tep Vanny was released in August 2018 through a royal pardon.)

Human rights activists hope that launching a case at the ICC at The Hague will have a moderating effect on land grabbing. But pushing out the poor for the benefit of the rich and powerful seems like an incurable Cambodian disease. In 2009, a report by Global Witness, the international NGO which has exposed many environmental abuses in Cambodia, found that Lao Meng Khin, with his wife,

Choeung Sopheap, held the rights to at least 7 percent of all land in Cambodia. Lao is one of the most egregious offenders amongst Hun Sen's coterie of cronies. There are numerous others.

Unfortunately, the chances for justice in Cambodia seem remote. Hun Sen's ruling party controls the courts and security services, and bribery is rampant. In its 2017–18 report, the World Justice Project placed Cambodia second to bottom in a table of 113 countries ranked according to the rule of law, just above Venezuela and below war-wrecked Afghanistan. Surveys have shown that Cambodians themselves regard the judiciary as the most corrupt institution in the country.

Hun Sen's defenders say that he ended a violent path of chaos and disorder, that he has overseen the country's transition from civil war to peace, and that he brought the Southeast Asian nation into the modern age. That last is a major achievement in itself. But between the ineffectuality of the tribunals, the corruption, the human rights abuses, and Hun Sen's iron grip on power, the argument can be made that peace has come at the expense of egalitarian, Western-style democracy.

"We are seeing the next chapter of abuses against the majority of the Cambodian people," a Phnom Penh academic who declined to be named told me before the 2018 election. "To be blunt, the aim of the leadership is to consolidate power, close down democratic space, kill dissidents, imprison opposition, and grab resources."

In his view, this exploitation of ordinary Cambodians by the ruling elite was a depressing repeat of what Cambodia had always been about—whether it was Sihanouk's obsession with control from the centre, patronising the peasants and allowing them to work in the fields while offering them little or no education, and stamping out any opposition; or the actions of Lon Nol, who led the country into war; or the Khmer Rouge, who took everybody's land, moved people around, and forcibly ended private ownership.

"They have no interest in education. They have no interest in property rights. They have no interest in promoting business unless they have a part of it," he said.

No one profits more than those at the top. Many of Cambodia's kleptocratic leaders are "eating the land," to use the ancient Cambodian description for how the kings of old took and consumed whatever they wanted. "Whatever it was, was theirs, and I am afraid the idea of 'eating the land' still applies today with Hun Sen, who sees himself as almost the next god king," said a critic, speaking off the record.

China has proved to be a hungry neighbor. It has invested billions of dollars with relatively few strings attached. Human rights organisations report that vast tracts of land have been corruptly sold off to Chinese businessmen for development and the proceeds pocketed by Hun Sen's cronies. (Not surprisingly, the government emphasises the positive effects of this massive Chinese investment.) China has provided loans for dams, roads, and factories. It has also always provided Hun Sen with political backing while the West has condemned his crackdowns. However, on the local level there are signs of a backlash. Residents of the port city of Sihanoukville, where China is building a resort with dozens of gambling casinos and luxury apartments, complain that they are being priced out of their homes and businesses by Chinese money. The contrast between the sparkling new Chinese resort and a crowded Cambodian shantytown nearby is stark. The Chinafication of Cambodia

looks unstoppable—the latest example of how this small and weak country has been undermined by a powerful foreign state.

URBAN DREAMS, RURAL REALITY

Cambodians are being pulled in different directions by the rapid changes caused by Western globalisation. While the old Sihanouk generation has hung on to its more conservative and traditional ways, a new dynamic class has emerged—independent, running their own businesses, travelling the world. There is a small but growing group of very Westernised urban young.

"They dye their hair. They go to pop clubs and do not stay at home with their parents," a businessman said to me. "They want to get their degrees and study abroad and hang around with foreigners. They have their own dreams, but they still have respect for their parents."

He said the lure of power and money and the desire for stability was also persuading a lot of young people to join the government. They sought a position that brought honour to the family. They also saw that engaging with the government gave them business opportunities that allowed them to put their children in better schools.

The growing middle class enthuses that peace has enabled them to do things people in other countries take for granted. They can go overseas, not as fearful refugees seeking asylum as Cambodians did before, but in their own time and way. They can enjoy holidays like the spectacular water festival. They can spend the weekend at the beach resorts of Kep and Kampot, and they can go out into the countryside and explore its ravishing beauty without danger. There are no such opportunities for many of the young rural poor, however. Thousands have been driven out by poverty to become migrant workers in Thailand.

After a few days in Phnom Penh, I left the hurly-burly of the capital to meet old soldiers in Neak Leung, a key Mekong River port an hour's drive away. The countryside had lost its mystical silence. The traditional buffalo carts, their design almost unchanged since Angkor times, had been replaced by noisy hand-ploughing machines. Factories and housing estates blotted the landscape.

It was a pleasure to meet a former Lon Nol soldier sipping tea with friends at a shabby café. Who knows—he might have been a soldier fighting in one of the highway battles I had reported on. His home was still dirt poor. Dogs roamed, and children, at once grinning and shy, were playing. His life in all its simplicity was unchanged.

But he acknowledged that things were improving, generation to generation. Unlike him, his grandchildren were educated to high school level and working in Phnom Penh. Some things had not changed, however: he was nervous about being seen talking to a Westerner and would not be drawn into politics, gesturing to the nearby poster of Hun Sen's ruling Cambodian People's Party.

The terrible destruction wrought by a US B-52 bomber which had mistakenly dropped its 30 tons of bombs on the main street of Neak Leung during the Lon Nol war, killing and wounding 400 people, had long been covered up by new buildings, and the town was flourishing. But the human cost of Cambodia's wars was easy to find amid this new prosperity. After we had been speaking for a few minutes, we encountered Heng Sokha, 55, an amputee begging in the street for money. He stood on his one good leg and supported himself with a crude wooden crutch as he held out his faded army cap for money. Conscripted at the age of 23 into Hun Sen's army, he had been sent to the border with Thailand to fight the remnants of the Khmer Rouge who had retreated there after the Vietnamese invasion.

Shrapnel from an exploding artillery shell had smashed his leg. He had a hopeless air. As with the former Lon Nol soldier, his life had not improved in peacetime, despite his having given a leg for his country. His government pension of 400,000 riels a month (about $100) was not enough to live on. To survive, his wife was selling corn at a street stall.

"My children do not want me to beg for money, but I am desperate," he said. "If I do not beg, I do not have enough money to buy medicine. I do not know how to make money. I only had three years' education.

"I have struggled all my life and lost a leg, but I do not feel disappointed," he said. "Many people were wounded in the war. This is how life is. Now Cambodia is at peace, and I feel happy about it."

A VERY DIFFERENT VILLAGE GIRL

The majority of survivors of the Khmer Rouge genocide were women. And women have been a driving force behind change. Their role in rebuilding the country is often unsung. One shining example is Sophary Sophin, who works clearing unexploded mines in rural areas around Siem Reap.

Her father, Tuon Sophin, was an April 17 Person—an "impure," educated schoolteacher whom the Khmer Rouge forced to labour in the countryside and marry a peasant woman. Lined up for execution the day the Vietnamese invaded, he barely survived the ordeal. He stayed in the village after the fall of the Khmer Rouge, having nowhere else to go, and raised his children there, educating them himself. Though poor, he refused to shrink into hopelessness as the civil war continued and the promise of peace faded.

As a baby, his daughter Sophary was hidden in a pond by her mother during a Khmer Rouge attack. Her education was minimal; she was expected to marry, have babies, and be an obedient wife. To her father's fury, she left home for Siem Reap, disobeying him and challenging the village's social convention. There, in the city in the northwest known as a resort town and gateway to the fabled Angkor region, she continued her studies, determined to go to university. Her brother helped pay for her education, and she also worked extremely long hours as a waitress and in the office of the Cambodia Landmine Museum to finance her studies.

She got her degree, rare for a village girl. "Girls in cities have changed a lot," she noted when we met in Siem Reap. "They have a modern life. But in a small village like where I was born, we have to live in the old way, with the old customs and culture. The villagers do not believe women can do better than men. Women are always behind men. They are considered less than men."

Courageously, Sophary decided to become certified to remove mines. Childhood memories of villagers crying over the bodies of young men who had been blown up by mines while gathering firewood haunted her. "I wanted to do something to help to save lives," she said. "What motivates me more is when I go to the minefields, and after we have cleared the land we hand it over to the villagers. They have a big smile and say, 'Thank you.' They say, 'You are not just helping to save our lives but also helping our families to live because you have given us safe land to farm and feed our families.'"

Sophary was one of very few women to qualify to become deminers and bomb disposal experts. As someone who not only understands the value of an education but also used personal capital to get one, Sophary sees schooling, especially for women, as critical to the future of Cambodia. So she is proud of her work. After all, when mines are cleared, schools may be built on the safe land.

Men still find it difficult to accept her doing what they consider to be a dangerous job, only appropriate for a man. Even her husband, who works in Phnom Penh, tried to stop her. He doesn't anymore.

"Like people who follow the old culture, he wants a wife who stays home and cooks and does the washing for him," she said. "He wants me to move to Phnom Penh. I say, 'No. I have my job here.'" She has explained to him how many schools have been built on land cleared of mines, and has told him that of the thousands of children who now attend them, one might become a new leader of the country. "I cannot give them up."

She added, smiling, "So now he understands. And I say to him, 'If you make me angry, I will blow you up!'"

In peace, Cambodia remains an impoverished and exploited country. The genocide, obviously, still casts its shadow. Unexploded ordnance continues to kill and maim. Cambodia is one of the most bombed and heavily mined countries in the world. It has been fought over, betrayed, and abused by foreign powers. Conflicting Cold War ideologies, self-interest, and superpower machinations have kept the country bleeding. And when the United Nations intervened, at last, to organise the first free

and fair elections in Cambodia's history, it controversially let the final outcome be decided in Hun Sen's favour in the interests of peace, paving the way for the establishment of today's repressive one-party state. Equally, Cambodia's own leaders have been unable or unwilling to recognise their complicity in Cambodia's destruction. Hundreds of thousands of foreign tourists bring much-needed currency to visit the Angkor temples, but where has all the money gone? Even the notion of reconciliation and justice is unresolved. There is understandable disappointment that the special UN-backed tribunal started its work far too late for many survivors of the horror and prosecuted only a handful of high-profile leaders.

Thousands of former Khmer Rouge live untroubled lives, including those in power. Their victims' descendants have never found justice in a conventional Western sense for the terror inflicted, nor have they received compensation. But it is hard to see how it could have been otherwise without tearing the country apart again. A lot of Cambodians were both victims and perpetrators and are trapped in feelings of unbearable pain and guilt over what occurred—an explanation, perhaps, of the relatively few cases of revenge killings in comparison with the number of deaths in the genocide.

Sophary Sophin has witnessed this absence of vengeance. "In our village a lot of former Khmer Rouge are living, including a soldier who killed many people," she said. "The killer is now just a simple man. But during the genocide he had a high position in the area, which he was afraid he would lose if he did not kill more people. He even dared to kill his parents. Maybe some of the other Khmer Rouge also had no choice. Who are we to judge? Perhaps they tried their best. But in the end, they could not say no."

She said her father also knew the former Khmer Rouge soldier, who had tried to kill him. "Not surprisingly, he does not like him. But what can he do about it?" Her father, like many of his generation, prefers to duck the subject of the Khmer Rouge. "Most of our parents and grandparents do not want to open up," said Sophary. "They still want to hide their suffering and bury it."

In the end, for every former soldier and civilian who still suffers, and every traditionalist ready to accept his fate, there is a Sophary Sophin—brave, resourceful, and talented.

Filmmaker Rithy Panh believes the overall suffering was so great that it exceeded the desire for vengeance, and neither the genocide nor the decades of war should define Cambodia. "We have got our dignity back," Panh said. "We have been able to come out of this hell despite everything. The genocide lasted four years. We had a history before, and we will have a history afterwards."

Cambodia Now

by Gary Knight

The story of peace—much like the story of war—is personal. Everyone who lives through it has a different experience, and the breadth of those experiences cannot all be expressed within one photo essay.

In creating this work, I revisited places that I came to know during the wars of the 1980s and 1990s, when I started my career in Cambodia. I spoke to men and women of all generations and wrote down what they told me. Some had lived through the civil war of the 1970s and the Khmer Rouge genocide that followed. All had lived through the years of violence and deprivation that was the post–Khmer Rouge period. All had expectations of the peace that followed. For many, the reality of that peace was desperately inadequate.

There are people in Cambodia for whom peace has been a great benefit, such as the family members and associates of the political classes, the military, and the police. But sit on a stool next to a Cambodian villager and ask about the peace, and a more complex picture emerges. No one would argue that peace has been less favorable than war, especially *that* war—but listen patiently, and the stories of suffering and injustice will soon begin to flow.

A spirit house at the grave of former
Khmer Rouge leader Pol Pot. After his
death, the grave became a shrine for Thai
gamblers who routinely pray there for
good luck in the lottery.

One of Prime Minister Hun Sen's houses in Phnom Penh.

Hun Sen has been in power since Vietnam overthrew the Khmer Rouge in 1979. A former Khmer Rouge commander himself, he fled to Vietnam to escape the disintegration of the Khmer Rouge regime and was later installed in the new government when Vietnam invaded Cambodia. He and National Assembly President Heng Samrin control the military and police, suppress opposition and the press, manipulate the justice system, and do not shy from committing murder to maintain control.

A billboard shows the images of President Heng Samrin and Prime Minister Hun Sen.

Hun Sen declares an income of $1,150 per month but has amassed a vast personal fortune while Cambodia has remained one of the poorest countries in the world. His family members either hold shares in or directly own about 114 private domestic companies with a listed value of $200 million. Their total wealth is estimated to be between $500 million and $1 billion.

The military and police are at the center of politics in Cambodia, and hundreds of police and military officers serve on the central committee of Hun Sen's political party.

His bodyguard unit—a military force personally under his control—went from approximately 60 people in the mid-1990s to around 23,000 soldiers by 2015.

"Elite Town" housing development, Diamond Island, Phnom Penh

The island's previous residents, small-scale farmers, were either bought out or evicted. The plan is to construct more than 1,000 condominiums, hundreds of villas, two international schools, a replica of the Arc de Triomphe, a near-clone of Singapore's Marina Bay Sands Hotel, and one of the world's tallest buildings.

Shelter, Battambang Railway Station

Cambodia's economy is growing 7 percent per annum, driven by Chinese and foreign investment, tourism, and the exploitation of lowcost-labour. While Cambodia met its Millennium Development Goal of halving poverty, about 4.5 million people are what the World Bank refers to as "near-poor," vulnerable to falling back into absolute poverty when exposed to economic and other external shocks.

Professor Sophal Ear of Occidental University in Los Angeles said, "Only those at the top of the pyramid truly benefit from Cambodia's rapid growth," through their access to political power, ability to create a monopoly, and control of trade. Cambodia, he added, "is a gatekeeper economy."

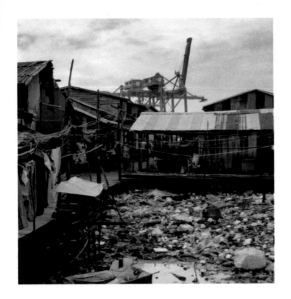

Cambodian fishing community, Sihanoukville

According to a recent report by the Sihanoukville provincial authorities, Chinese nationals now own more than 90 percent of businesses in Sihanoukville, including hotels, casinos, restaurants, and massage parlors— fueling concerns and anti-Chinese sentiment over Chinese domination of the local economy at the expense of local Cambodians.

Reports of sexual harassment, kidnappings, and traffic accidents involving Chinese nationals are rife.

A microfinance bank, Western Cambodia

According to the human rights groups Licadho and Sahmakum Teang Tnaut, Cambodia has about 2.4 million borrowers (out of a population of 15 million) with $5.4 billion in outstanding microloans. At the end of 2018, the average loan size was $3,370, more than twice the country's gross domestic product per capita of $1,384 in 2017 and one of the highest levels in the world.

High interest rates, the use of land titles as collateral, and pressure to repay loans have led to a "predatory form of lending" by microfinance institutions, the human rights groups said. Cambodian farmers have lost about 10 to 15 percent of their land holdings due to inability to repay microloans.

Top: Leap Soroen, who manages this pushcart at the Angkor Wat Temple, said, "I sell about $5 worth of products a day in the tourist season. My profit is normally $1 per day. I can live on that but it is a struggle."

Right: Banteay Chmar. Life in rural Cambodia is hard, and there are few opportunities for commerce, except farming, particularly for women. Education is poor and many rural Cambodians only attend school until they are 12 years old. Hairdressing salons are frequently seen in small villages, and they are one of the few opportunities for young women to own a business and make an income.

Cambodia Reportage

Opposite, left to right: Opposition political activists Sin Chanpouraseth, Chay Vannak, Ney Leak and Douch Sovunth.

Sin Chanpouraseth: "Children in rural Cambodia go to school for two hours, and often there are no teachers. I went to a university that closed because it was bankrupt, then I went into politics. Meanwhile in Phnom Penh the government builds skyscrapers. The well-being of the people doesn't require skyscrapers, it requires jobs. We work in the morning to eat in the afternoon. We are victims, we are poor and we want change.

"We do not have peace, there is no fighting anymore, but there is a spiritual and physical war being fought against us. Politics here are so tense I am not sure if I will be killed. The government rules by fear, and will do anything to maintain power. If we are strong, maybe change will materialize."

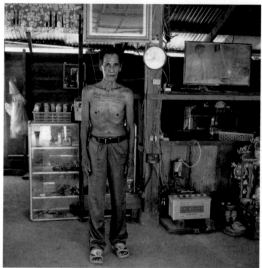

Bou Meng

One of two men who survived extermination in
S21 Toul Sleng Prison, where the Khmer Rouge
killed approximately 12,000 prisoners between
1975 and 1978.

"My freedom now is not good and freedom is the
most important thing for anyone, more than
anything. I have the UN Treaty of Human Rights
on my desk, I wish every country would follow
that. The Khmer Rouge Tribunal has had limited
success, they rejected the demands of the
victims for compensation, and none of the aid
that went to the tribunal went to the victims.
I am very angry about that. We deserve
compensation. Compensation is the most
important part of justice and with no
compensation there is no justice. Compensation
could help the victims survive the peace."

Pou Pam. Trader, Anlong Veng

"I fought against the French with a fake wooden
rifle, fought for Lon Nol against the Khmer
Rouge, and then fought against the Khmer Rouge
with the Vietnamese. I hate fighting.

"I wanted to be a rice farmer. We survive, but
we have no surplus, we live from hand to mouth
like everyone else here. Under Sihanouk we had
little but we had our land. Now big companies
wait for the poor to clear the land then they
come and take it. There is no security here."

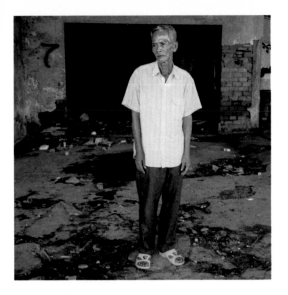

Phon Phuong, 77. Neak Leong Ferry

"You see development here but we still suffer.
We have to pay kickbacks. We are in debt. Most
of the rich people are government officials. We
are afraid of the possibility of being arrested
or having our land confiscated. People are
pressured to sell land. Rich people will buy
all the land around ours and not allow us
access. The people say it is development. When
there is development we cry. When there is
development we lose our homes.

"I had better living conditions in the war than
I do now. I feel very disappointed but I cannot
discuss why, it is hard to discuss these
things. We are afraid of our freedom. We have a
problem with freedom of speech. Radio Free Asia
has been closed down. We all used to listen to
it to find out what was going on."

Van Rouen. Journalist,
formerly of the *Cambodia Daily*

Raised in Site II Displaced Persons Camp, on
the Thai Cambodia border in the 1980s.

"It was like a prison. I focussed on getting an
education because we had access to it. I
listened to VOA Radio. I hoped for a reunited
Cambodia at peace.

"I don't think real peace has been achieved.
The people here suffer. There is land confiscation,
corruption, and people are leaving their homes
to work in Thailand or in the capital. We see a
physical peace, but inside our minds and hearts
there is no peace at all. To solve that we have
to solve the problem of patronage. If Cambodia
is a family business it will never improve. The
Government just amends laws to benefit itself
not the people. My hope is that one day we will
have real peace and real freedom but I am not
very hopeful. We need better education, health
care and access to jobs. The old people are
easier to scare because they lived under the
Khmer Rouge, the young people are not so easy
to scare. Hun Sen is afraid of the young
people. The party that won the UN Election was
forced to share power with Hun Sen who lost.
That's why we're in this situation."

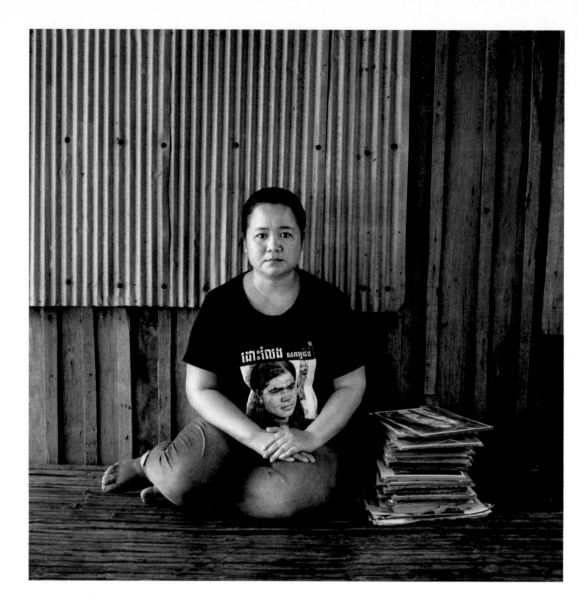

Top: Song Srey Leap. Land Activist.
"The closure of the *Cambodia Daily* is the closure of the voice of the people. Peace is a facade, roads, buildings and bridges do not reflect peace. The schools are not good enough, the hospitals are not good and you need money to buy care, the poor die at home in pain. The poor are evicted to benefit the rich. We have no right of assembly and cannot get involved in politics. What this government is doing is similar to the Khmer Rouge, eviction, murder, just not on the same scale. This country is a fake democracy and there is great suffering here."

Right: Nguon Lap. L'Vea Village. Siem Reap Provence. Fisherwoman. Single mother of three children.
"In this area there has been a lot of fighting and we could not move freely. Now there is no fighting and my children can attend school. What we need the most is good roads so we can trade, and clean water. Here we drink rain water or water from the fields. I know nothing about politics, the politicians only visit when they want something."

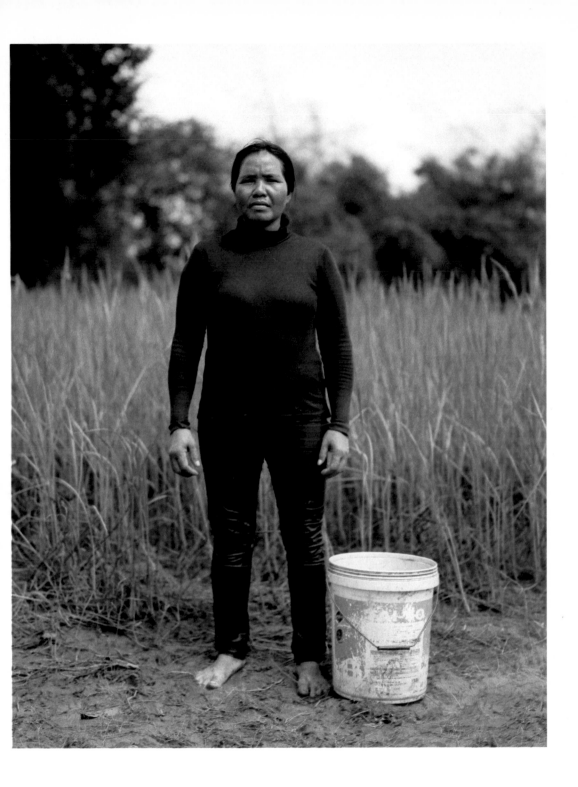

Cambodia Reportage

Cousins Dy Tin (R) and Sram Phoen (C)
with lifelong friend Long Chlaun (L) in
Banteay Chmar Village in North Western
Cambodia, where Gary Knight spent a lot
of time in the civil war. These three
farmers have lived under the regimes of
Sihanouk, Lon Nol, Pol Pot, and Hun Sen.

"We have a long friendship. When we need
help we can depend on each other
especially in hard times. We cannot
depend on the government. We have 50 per
cent of what we need. We need access to
clean water and good roads to transport
our produce to market but we depend on
the rain as there is no irrigation and
the roads are… bad."

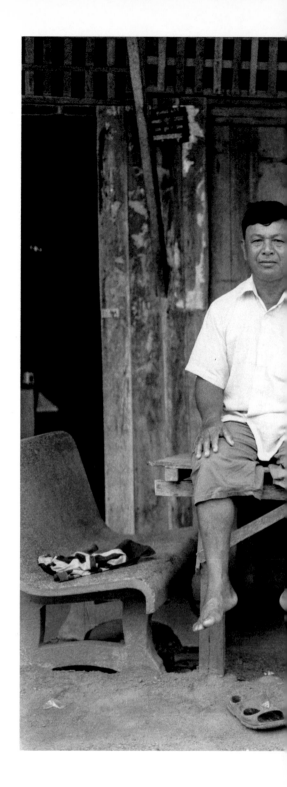

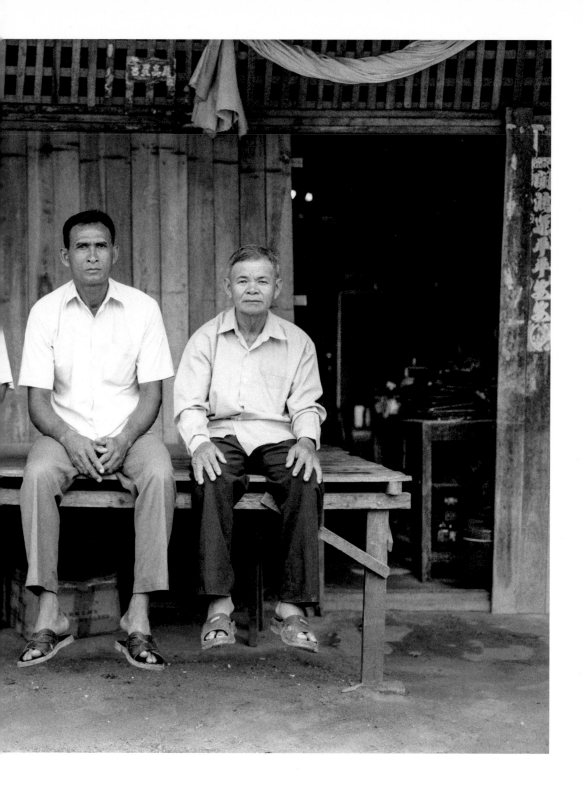

Right: Roeung Heng. Rohal village, Siem Reap. Former Khmer Rouge soldier.

"I was forced to join the Khmer Rouge in 1972 because my village was controlled by the Khmer Rouge.

"In 1974 I was arrested by the Khmer Rouge because I was accused of being a spy for the Lon Nol regime. But I was set free because I was so young. That is the worst memory I could remember. I was serving them but instead they accused me of being a spy. We had very little to eat. I was so depressed. Between 1975 and 1979 I was forced to work as part of a mobile team working on irrigation and dam projects.

"At that time, I was feeling that my life was in darkness with no hope of being alive. Everything seemed hopeless.

"After the Vietnamese army occupied Cambodia, I felt relief because I could continue to survive.

"I was born under a clean regime under Prince Sihanouk. I say clean because at that time I never saw any robberies. I never saw any gangsters. The young people respected the older people. Morality was good. The way of living was very dignified. People supported each other.

"But after all that has happened to Cambodia during the Lon Nol regime, the Pol Pot years and the present day, things are different now. The mass tourism in Siem Reap has improved the economy but morality is very low. There is a big drug problem among the youth with amphetamines in the city and the respect for the older people has declined.

"Life is not equal at all. There are a lot of things we still need. Naturally, bad things and good things can happen at the same time. The bad things need to be corrected. I do not praise anyone nor do I speak ill of anyone. Some need less and some more. Even the tycoons also need something. There are no boundaries about what people need or want."

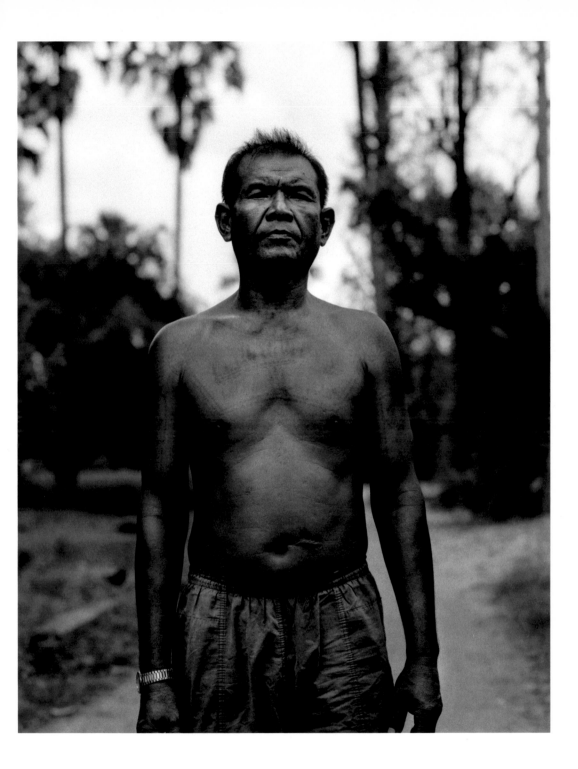

Cambodia Reportage

Boran Sophin, student and sister of Sophary Sophin

Among the young women who are stepping away from traditional female roles in
the patriarchal society are sisters Boran and Sophary Sophin.

Sophary Sophin, bomb disposal engineer

Sophary tells her story to Gary Knight and Jon Swain in the following essay.

"I give classes about mine education, the danger of the land mine. I try my best. I think some parents understand what I have done, because sometimes in my village, they come to me and say, 'I really want my daughter to be like you.' I say, 'Send her to school.'"

Excavating the Past, Imagining a New Life

by Sophary Sophin

I was born in 1987, at a time when we didn't have birth certificates. It was during the war, so my parents did not exactly take note of the date. In the year 2000, the government started to issue birth certificates, and we could pick any day we liked. I picked the sixth of February. Even for my youngest sister, Boran, born in 1994, we didn't know her day of birth. My father taught primary school, but at the time of the harvest he had to work in the rice field. He was collecting rice the day my sister was born. So it had to have been on a Sunday.

My mother is a farmer, a simple villager from Kor Koh in Siem Reap Province. She is the second of eight children. She never left her native village and she bore six children.

My father is a teacher. He is from Takéo Province and went to Phnom Penh to study. On April 17, 1975, the Khmer Rouge made him and other city people move to the villages. They call them the April 17 People—people with good educations, people the Khmer Rouge tried to kill. One day, the Khmer Rouge rounded up hundreds of people to kill. He was one of the last 10. After a day of killing, the Khmer Rouge men said, "Oh, my arm got tired, I will get some rest and then continue." That day, the Khmer Liberation group came, together with Vietnamese soldiers, and he survived.

Because he had a better education than others, he understood education could help us. He pushed us to go to school. If we didn't go, he would hit us. My mother is a positive lady, not educated, but she saw school would benefit us.

In my village, we had up to grade 11, and if we wanted to continue with 12, we had to move to Siem Reap. My father said, "OK, you can go." But some villagers and relatives came to my house and talked to my parents. "She doesn't need to study more," they said. "There is nothing she can do with education. She is old enough to get married, and after she get married, she will just take care children, stay home, cook. It is not good to let your daughter stay away from home. It will be bad for the family." My parents changed their minds.

I cried very bad. I just wanted to move to Siem Reap for school. I wanted to go to school with my friends; I didn't want to get married. I was 18 years old.

My mother was a peasant, very low, and he was very high. She could only read and write a little. She couldn't go to the market. She couldn't share ideas. She didn't know enough. She was really hurt, but she couldn't do anything;

On the reporting trip that Jon Swain and Gary Knight took for this project, the two journalists met **Sophary Sophin**, the daughter of an educated man purged from Phnom Penh and forced to marry a villager. Sophary's life reflects the legacy of the Khmer Rouge: from the clash of cultures between her father and mother, and from the bitterness of the genocide, she emerged unafraid to take her own path. The second woman in her village to graduate from high school, and the first to graduate from university, Sophary received a BA in accounting. She decided to work in explosive ordnance disposal, becoming a deminer, and she now assists philanthropic organizations that build schools throughout the countryside. Sophary embodies a new kind of woman, one who has a fresh vision of democracy and peace for her country, which is still struggling to find a way out of its brutal history. Here is Sophary's story, as told in English, in her own words.

she had to keep quiet and rely on my father to support her children. I didn't want to be like my mother. I didn't want to have no education, stay home, and ask for money from my husband.

My older brother had moved to the city one year before. He stayed in the pagoda with the monk and went to school. He said, "I will help you. I will earn money and support you." He is a boy, he can stay with the monk in the pagoda. But me, a girl, I cannot. I had to rent a room. I decided to go to school early in the morning, and then from about 4 o'clock to 12 o'clock at night, I worked serving food to the tourists. That's when I learned English. I worked seven days a week, eight hours. They paid me $30 a week.

We had a bad condition in the family. My father, he did not respect my mother. He cheated on her; he didn't listen to her. There was violence. Late at night, when we were sleeping, my father would come back from hanging out or partying, and when he came home, the violence started. We were small—just hiding somewhere in the house. Nobody cared about us. My parents just fought. We did not have that warm feeling in your heart because your parents take care of you. We just felt lonely, even when we were small.

When I graduated from high school and passed my exam, my father said he wanted me to be a teacher like him, like my two other older sisters. I said no, I want to go to university. He got really mad with me. He said that I am not a good daughter; I don't follow what he wants. He stopped supporting me. So I had to earn money and save. But I worked at a restaurant, so I could not earn much.

I talked to my older brother, who was then a university student. He said, "OK, I will help to pay the first semester, but

you have to work and save the money to pay for the second semester." We kept doing that, and finally I graduated from university in the year 2010.

My parents are still feeling scared of the situation they faced in the Khmer Rouge time. So when we talk about my sister Boran or their other children going somewhere far from them in the village, it makes them feel unhappy. But for us, we are the young generation. We think it is good to learn something new and improve ourselves.

I had learned English at the restaurant. But for Boran and my brother I wanted something better. So I saved money. She went to a really good school in Phnom Penh, then university and also English classes. I would go on Saturdays and Sundays to be with her, to make sure she was fine. Once she had a burglar come into the room and steal things, a very big challenge for her. She had never faced such a situation before. Now she rides her motorbike to the village, and my parents almost have a heart attack. "She's a girl, why she ride the big motorbike?" That is a big thing in the village. ["It's like weird," Boran interjects. "Nobody does that, especially a girl."]

In the city like this, girls change a lot. They have a modern life. Boran is very independent. She works as a physical trainer in a gym.

———

I got a job working in the daytime at the land mine museum and going to school in the evening. I would ride a motorbike back and forth. I had a bad accident and almost lost my leg. I told my boss that I could not go there anymore. She said, "You rest for a while, because we are preparing to start the mining team. If we get the official letter from the government,

we would like you to be with us again, because we like you." So in 2009, I joined the mining team.

At first, I just worked in the office. I remembered that in my village, the soldiers had left land mines to protect the village. When I walked to school, I saw anti-tank mines. When I was seven or eight years old, coming back from school, I would run, play; I had no idea. Then a man in my village got exploded by an anti-tank mine. A lady lost two sons. So she became—well, her brain was not good, because she lost two sons. When they carried the second son's body to the village for the funeral, I saw the relatives cry, and I saw a piece of the body and I felt very sad. But because I was young, I didn't know what to do.

I started to learn more about how many land mines and unexploded ordnance there are in Cambodia and how many people they kill. I decided I wanted to be a deminer.

In my training class was a general. The first day, there were only two women out of about 20 students. The men were like, "What? You are a girl, you come and do this job?" We were a joke to them. During the training, you had to role-play. Me and the general—he wanted to be number one, I wanted to be number one. So we fought very hard in the class. When we role-played, one day he is my team leader, the next day I am his team leader. I ordered him to do this, do this, do this, and then he said, "Oh, I understand." Even though I am small and I am a girl, he saw that I wasn't a joke. In the end he was number one in the class and I was number two. In 2011, I became a qualified deminer.

Some men still tease us; they cannot believe we can do that job. One day I was driving a truck from here to the Laos border. One of our donors—the American, Bill Morse—was with me, coming to see our fieldwork. He founded the Landmine Relief Fund to support Cambodian Self Help Demining, where I work. When we stopped to use the bathroom, a man asked, "Oh, you come with *farang* [a Westerner]. What is your job?" I said, "I work for a demining team." And he said, "You should not do that! You should do a small thing at home or at the office." He could not believe that I drove a truck by myself and that I drove for the big man. I said, "You have two hands, I have two hands. Our brains are the same size. Why not?"

Now we have 36 colleagues, with one demining team and three bomb-disposal teams. The women in my team are very strong. But when I go to the small villages, the women don't understand about themselves, about women's rights or about what they can do. That's why I try very hard to meet with the villagers, to motivate the young women. Some ask me, "What about your job?" I say I am bomb disposal or demining. They say, "Women can do that?"

Right now we have women in political life and in government, but it's not a big number. The balance is not there yet. It would be better if we women were more active. An easy example, a very simple example, is in the family: if wives and husbands both earned money, they could both support their children to go to school, and even if they are divorced, wives could send children to school. I believe a husband and wife can be happy together if they can be partners, share an idea, or together earn money to support the family. Then they may feel close and respect each other. That

is a small case, but, you know, very simple, big effects.

———

I go back to my village one or two times a month. I'm not in a good relationship with my father. We never hug. I support my father because he is old—take him to see the doctor, visit him. But it's my brother and sister and me who save money, buy school supplies, and give them to the children. I give classes about mine education, the danger of the land mine. I try my best. I think some parents understand what I have done, because sometimes in my village, they come to me and say, "I really want my daughter to be like you." I say, "Send her to school."

Sometimes the villagers ask—because they are in a small village, in the remote area, without schools—if we can help them put up a small school. Many children come to us and say they want to go to school. They ask if we can build a school for them.

Some villages have a school under a big tree, with a big tent on the top of the tree and a mud floor. We paid $4,000 to build one school from wood, with a thin roof—open, no windows, no door, but it is better than a tree. And then after that, Bill Morse started to raise more money for schools. So far, we have built 22 schools for about 3,000 children, village children. In September 2019, we are going to build another school with the support of a Rotary Club in Canada.

What I want to see: my country change to be better. I never get tired, you know? I work in bomb disposal. I also work for the school—no pay, but I don't mind.

Yes, if there is anything I can do for my country, I will be happy.

The Essential Influence of Women in Peace: The Liberian Example

by Marie O'Reilly

Marie O'Reilly is a researcher who studies how gender affects political and social thinking. She examines the positive correlation between the inclusion of women and the overall success of peacemaking, with a specific focus on women who have real influence over decision-making.

I n January 2018, the West African nation of Liberia experienced its first peaceful transfer of power in more than 70 years. Africa's first female president—the turbaned, charismatic, and steely Ellen Johnson Sirleaf—stepped down following free and fair elections.

While across Africa and beyond, strongmen continue to cling to power after wars end, Johnson Sirleaf's release of the reins means Liberia has reached a key marker of democracy. It also reminds us of the role Johnson Sirleaf played in establishing and enhancing the peace there. Many factors have contributed to the country's progress since its brutal civil wars ended in 2003, but the role of women in breaking the cycles of conflict cannot be overestimated.

Johnson Sirleaf rose from the position of bookkeeper to that of international banking executive. She was the victim of domestic violence who became a political icon, the postwar president who received a Nobel Peace Prize in 2011. Importantly, she shared that Nobel with two other women: Leymah Gbowee, who also helped end the Liberian war from the ground up, and Yemeni human rights activist Tawakkol Karman. These three join other women around the world who are leading peace from the grass roots by mobilizing coalitions, bridging divides, and advancing dialogue.

Johnson Sirleaf, Gbowee, and Karman may belong more to a secret society than to a hall of fame. Women's influence on peacemaking tends to get overlooked when men in suits broker deals with men in fatigues. According to a study by UN Women, 96 percent of those who sign peace treaties are men. Since 1901, a mere 13 percent of Nobel Peace Prize laureates have been women. Yet research shows that where women have access to power, war is less likely to break out in the first place.

Research into four decades of international crises by Mary Caprioli and Mark Boyer demonstrated that as the percentage of women in parliament increased by 5 percent, a country was five times less likely to use violence against another country ("Gender, Violence, and International Crisis," *The Journal of Conflict Resolution*, 2001). And Swedish scholar Erik Melander demonstrated that having a greater proportion of women in parliament also reduced the risks of civil war and domestic human rights abuses ("Gender Equality and Intrastate Armed Conflict," *International Studies Quarterly*, December 2005; "Political Gender Equality and State Human Rights Abuse," *Journal of Peace Research*, March 2005).

Moreover, evidence is mounting that women's participation is essential if peace is to last. While warring parties traditionally focus on dividing power and territory in peace negotiations, when women get involved, they consistently emphasize the need for human security—prioritizing social and economic needs, as well as advocating for marginalized groups. This was the case in Liberia as well as Colombia and Northern Ireland. Frequently, these underlying grievances and inequalities drive conflict, so women's participation, by addressing them, often helps to build a more robust peace.

A closer look at the Liberian experience shows how some of these realities played out in this nation of 4.5 million that is bordered by Sierra Leone, Guinea, and Ivory Coast. Like most countries, Liberia did not have many women in government when

its first civil war broke out in 1989. But even as they found themselves targets of violence, women began to organize for peace.

In 1994, amid a stalemate in peace negotiations, Etweda Cooper—a Swiss-educated human rights activist—co-founded the Liberian Women's Initiative. Cooper and her colleagues led street demonstrations and approached militia leaders to pressure them to return to the stop-and-go peace process. The women also arrived, uninvited, at the peace conferences and sometimes persuaded mediators to allow them to present position papers. When the first civil war ended in 1996, Ruth Perry— a member of the Liberian Women's Initiative—became head of the interim government. (Perry was the first female head of state in Africa; Johnson Sirleaf became the first female elected president.)

But the peace did not last long. Many feared warlord Charles Taylor would return to waging war if he did not win the presidency, and they thought that, anyway, he should fix what he had broken. In 1997 they voted him into office, singing, "He killed my ma, he killed my pa, I'll vote for him." The gamble did not pay off. Two years later, the second civil war began. The Liberian Women's Initiative had been persistent and creative, but its influence remained limited. Tens of thousands of men again chose the well-worn path to politics and militia groups to address their grievances. More and more women wondered how they could change their country's trajectory with so little access to the levers of power.

More arms flowed into and out of the country; more peace activists were needed. In 2000, women around the region joined the Mano River Women's Peace Network, as conflict had spread across the Mano River into Sierra Leone. One year later, a second West African initiative emerged, the Women in Peacebuilding Network, with social worker Leymah Gbowee at the helm.

Gbowee, a mother of four who had focused on trauma and reconciliation on the heels of the first civil war, gained courage from her West African sisters. In 2002, she began to gather Liberian women in the capital, Monrovia, to pray for peace. As Gbowee's Christian Women's Peace Initiative took off, a Muslim policewoman named Asatu Bah Kenneth brought Muslim women together with the same purpose. The two groups joined forces to form the Women of Liberia Mass Action for Peace campaign.

By 2003, a quarter of a million people had died from the conflict in Liberia, and the second civil war raged on. Thousands of Christian and Muslim women began daily demonstrations for peace. This nonviolent movement drew on religious convictions across faiths to bridge divides and push for peace. The women capitalized on their religious networks and mobilized male religious leaders in support of their cause.

They also exerted influence by exploiting gender dynamics in society. The women did more than just list demands; they invoked their roles as mothers, wives, and sisters when articulating their positions. This allowed them to capitalize on the moral authority associated with these roles in Liberian society. It also enabled them to position themselves as nonthreatening in a context where other civil society activists, journalists, and human rights advocates were being intimidated, tortured, and killed.

And, in a nod to the kind of subversive tactics once imagined by Aristophanes in *Lysistrata*, the women undertook a sex strike. Beginning in April 2003, they vowed to withhold sex from their husbands and partners until they acted to promote a peace process. Individual inaction, they announced on the radio, was tantamount to complicity. They encouraged women to withhold sex until their partners took action to advance peace. (The media attention that followed eclipsed the gains from the strike itself.)

In the face of a government rife with power grabs and political machinations, the movement leveraged perceptions of women's neutrality to position itself above the fray, adopting one clear, nonpartisan message: "We want peace, no more war." Beyond this, they demanded an immediate cease-fire, peace talks attended by both government and rebels, and the deployment of international peacekeepers in Liberia.

As the women's protests grew and drew international attention, president Charles Taylor agreed to meet them. Gbowee reiterated their demands unequivocally. Shortly thereafter, bowing to both international pressure and the women's domestic campaign, Taylor agreed to attend peace talks.

Cooper and Kenneth were dispatched to Sierra Leone to meet with opposing rebel leaders there. Calling on their moral authority as mothers and sisters, they insisted that the men attend the talks. The leaders of different factions acquiesced.

In June, as the warlords took up residence in a comfortable hotel in Accra, Ghana, to negotiate peace, progress stalled. Though not invited to participate in the talks, women from various groups arrived to push for peace. Staging a sit-in outside the room where the peace talks were being held, they refused to let the negotiators out until they had committed to reaching an agreement.

When it looked as though she and her fellow campaigners would be arrested and forcibly removed, Leymah Gbowee threatened to strip naked—applying an African tradition of symbolic protest that exposes the female body in the public arena to shame powerful men into submission.

After the sit-in, the momentum of the negotiations shifted. Two weeks later, on August 18, 2003, a peace agreement was signed. This one stuck.

Just as women so often curb the urge to go to war, instead encouraging peace, their role in the peacemaking enhances the chances that peace will last: A study of 40 peace processes in 35 countries by Swiss scholar Thania Paffenholz (Reimagining Peacemaking: Women's Roles in Peace Processes, International Peace Institute, 2015) showed that when women's groups influenced a peace process, an agreement was almost always reached and was more likely to be implemented. An analysis of 182 peace agreements by Laurel Stone found that when women got a seat at the peace table (rather than performing a sit-in outside the room), a peace agreement was 35 percent more likely to last at least 15 years. This may be because women typically raise overlooked issues that are crucial to long-term peace. On average, women experience war differently from men. While men are more likely to take up

arms and die on the battlefield, women are more likely to be responsible for caregiving during and after conflict, and they die at higher rates from human rights abuses, the breakdown in social order, and economic devastation.

Of course, individual women play myriad roles during conflict—they can be perpetrators or victims, peacemakers or politicians. But women who stand up for peace can have a lasting effect if they are able to exert influence.

Again, the Liberian experience proves instructive. After the guns were silenced, Liberians elected Ellen Johnson Sirleaf as their president. The Harvard-educated economist had been known as the Iron Lady during her time in opposition. (In fact, the dictator Samuel Doe imprisoned her for her dissidence, underscoring that she wielded enough power to constitute a threat.) Now, she became "Ma Ellen," the caretaker of the country, who would put it back on its feet.

"Vote for Woman" became the slogan associated with Johnson Sirleaf's campaign in 2005. Women came out in droves to vote in the election, and 80 percent of them voted for Johnson Sirleaf. Sufficient numbers of men did too, allowing her to comfortably beat her opponent, professional soccer star George Weah.

Johnson Sirleaf's greatest accomplishment as president was ensuring that the fragile peace held. This was a significant feat. Countries that have recently been at war are more likely to backslide. Parliamentary representation and female literacy are particularly significant when it comes to reducing the risk of relapse into war: a study found that when 35 percent of parliamentarians were women, the risk of relapse was near zero ("Female Participation and Civil War Relapse," *Civil Wars*, 2014). Rwanda is an instructive case. During the 1980s and early 1990s, women were 58 percent as likely as men to be literate, while they held just 13 percent of parliamentary seats. In the decade following the 1994 genocide, women became 85 percent as likely as men to be literate, and they made up 21 percent of parliament on average. Women's representation now stands at 61 percent—the world's highest percentage of women in parliament. Rwanda's peace has held.

Research by University of Essex professor Theodora-Ismene Gizelis showed that UN peace operations in Liberia were more effective in districts where women enjoyed a relatively higher social status ("A Country of Their Own: Women and Peacebuilding," *Conflict Management and Peace Science,* 2011). Gizelis also conducted a cross-national analysis of postwar contexts since 1943, and she found that there, too, UN peacekeeping was more effective in societies where women were more empowered ("Gender Empowerment and United Nations Peacebuilding," *Journal of Peace Research*, 2009).

As president, Johnson Sirleaf articulated the need to increase women's leadership, linking it to effective democracy. She appointed record numbers of women to top government posts, including one-third of ministerial positions. But her major focus was on stabilizing the state after war, attracting international investors, and persuading international lenders to cancel Liberia's crippling national debt. Nonetheless, Johnson Sirleaf faced significant challenges as Liberia—one of the least developed countries in the world—sought to recover from 14 years of war. After her reelection

in 2011, the Ebola epidemic wreaked havoc on the country, and poverty remained endemic. Critics said she hadn't done enough to crack down on corruption.

In addition, female parliamentarians remained scarce during Johnson Sirleaf's tenure, hovering between 10 and 13 percent. Despite the presence of a female head of state, social, economic, and cultural barriers to women's participation in politics proved persistent in Liberia—as happens around the world. On the one hand, research shows that female presidents inspire more women to run for politics in the long run. On the other, a macho political culture, social bias against women's involvement in the public sphere, and practical constraints (caregiving, poverty, and lack of literacy) continue to depress their election in practice.

As social norms and roles are upended during war, women frequently find opportunities to overcome traditional gendered barriers to their meaningful participation in public life. But when social order is restored, this space often closes again. And as individual female leaders face challenges to their legitimacy in a male-dominated field and are forced to compromise, they often find it hard to make sustained, transformational change for gender equality.

Even as Cooper and others in the women's movement lobbied for a 30 percent quota to even the playing field—quotas have helped bring the proportion of female parliamentarians in Rwanda and other countries to record highs, far beyond the number of seats reserved for women—the Liberian House of Representatives reserved just 5 out of 73 seats for women in 2016.

Individual female leaders are unlikely to change the macho political culture that makes war more likely. The women's chant of "We want peace, no more war" continued to be heard in the 2017 Liberian elections, but strongmen may come to haunt the country again. George Weah won the presidency in 2017, as Johnson Sirleaf's constitutionally mandated two-term limit neared its end. Charles Taylor, serving a 50-year term for war crimes in a British prison, was suspected of meddling in the elections and may well do so again. And Weah's base includes many disaffected young men.

Building and sustaining peace anywhere is an intergenerational undertaking. The Liberian case shows that it takes an entire movement to bring peace. Women's movements around the world have ushered in new eras of peace, even as they struggle to sustain and build on gains for gender parity.

In the delicate dance between equality and peace, it's hard to tell which must come first, and progress is unlikely to be linear. Using the largest data set on the status of women in the world today, Texas A&M University scholar Valerie Hudson has shown that the way a society treats its women is a greater predictor of peace than its wealth, religion, or level of democracy (*Sex and World Peace*, Columbia University Press, 2014). Where there's more gender equality, there's also more peace—within and between nations.

Philip Gourevitch
**The Burdens of Memory
and Forgetting**

Jack Picone
**Rwanda Then (1994) and
Rwanda Now**

Dydine Umunyana
**Butterflies Sat Next
to My Heart**

The Burdens of Memory and Forgetting

by Philip Gourevitch

I n Rwanda, in the spring and early summer of 1994, around a million people were massacred in a hundred days, mostly by their neighbors, using household tools—machetes and hoes and hammers and clubs—in the most unambiguous case of genocide since the crime was defined by international law in response to the Holocaust. Never before were so many people murdered so fast or so intimately. The killing was programmatic, a campaign orchestrated by the state to unify the Hutu majority by exterminating the Tutsi minority in the name of an ideology known as Hutu Power. The outside world watched and did nothing serious to stop it. Tiny, landlocked Rwanda was of so little strategic or economic interest that Rwandans' only claim on international attention was one of common humanity—and the pledge of "never again" proved empty.

The genocide came on the heels of a civil war, which started in 1990, when the Rwandan Patriotic Front (RPF), a rebel movement founded by Tutsi refugees who had fled earlier ethnic cleansing campaigns, attacked on the northern frontier, demanding an end to three decades of Hutu-supremacist rule, and the right to return and share power. The RPF struck just as Rwanda's Hutu dictatorship, under intense pressure from its foreign patrons, agreed to allow multiparty politics. Members of the ruling party elite moved swiftly to undermine Rwanda's political opening, exploiting the war as a pretext to rally Hutus under the banner of Hutu Power against the specter of a common Tutsi enemy. But it was the threat of peace that spurred the apocalypse.

In August of 1993, when the president, Juvénal Habyarimana, again capitulating to international pressure, signed a power-sharing peace accord with the RPF, top Hutu Power propagandists launched RTLM, the infamous genocidal radio station, which depicted the deal as a sort of Trojan horse. While the United Nations sent in a peacekeeping force, RTLM called for all Tutsis, and all Hutus who accepted them, to be treated without mercy. Violence escalated, arms were stockpiled, civilian militias were recruited and drilled. Then, on April 6, 1994, President Habyarimana's plane was shot down over Kigali by an unknown assailant, killing all aboard. Within a few hours, Hutu Power had seized control of the state; Hutu leaders who opposed the coup were hunted down and killed; 10 UN peacekeepers were taken captive and massacred at a Rwandan Army barracks; and the leader of the RPF, General Paul Kagame, began redeploying his forces for a fight to the finish. The next morning, the wholesale liquidation of Tutsis got underway. By the time the RPF brought the genocide to a halt and declared a new government, in mid-July of 1994, three-quarters of the Tutsi population in Rwanda had been wiped out. Tens of thousands of Hutus had also been killed as Tutsi "accomplices" or because they were mistaken for

After the most comprehensive genocide since the Holocaust, Rwandans have managed to move on—compelled by the heavy hand of the state, which required them to reckon with the past, as well as by their own need to find a way to live together. **Philip Gourevitch** first visited Rwanda in the aftermath of the genocide in May 1995. For the next three years, he devoted his reporting to the tragedy, which caused a million deaths. His book *We Wish to Inform You That Tomorrow We Will Be Killed with Our Families* was published in 1999. Since then, Gourevitch has returned multiple times to witness Rwanda's rebirth. He finds that imagining a shared future involves a willful forgetting and a resolve to move on.

Tutsis, and tens of thousands more had been killed by advancing RPF forces.

And the war wasn't over. As Kagame's army had moved into Rwanda, some two million Hutus had moved out and regrouped in camps just across the border: roughly a quarter million in Burundi, half a million in Tanzania, and more than a million in Congo. The camps were officially administered by the UN refugee agency. In reality, however, the political, military, and militia forces that had carried out the genocide remained in control, presiding from their headquarters in Congo over what was effectively a rump Hutu Power state, as they recruited and rearmed, and prepared to reinvade Rwanda to finish the job they had started.

Nobody could tell me, when I began reporting in Rwanda a year after the genocide, how a nation that had been so diabolically hacked apart could ever be put back together. Nobody spoke of peace except as a bitter illusion. General Kagame's army had imposed a rough control over most of the national territory, and one of the first acts of the new, RPF-led government was to abolish the apartheid-like system of ethnic identity cards that had been introduced under Belgian colonial occupation and maintained by the postcolonial Hutu regimes. Even before the genocide, the RPF had argued that Rwandans should reject the colonial construct of ethnic division, and identify, first and foremost, as Rwandans. But if the genocide made the case for such a new nationalist identity more compelling than ever, it also made the prospect of realizing it seem more far-fetched.

Rwanda, for all its Edenic natural splendor, was a wasteland. Death and flight had emptied the country of close to 40 percent of its population, and as many as half of those who remained were displaced from their homes. Hutu Power, in its rout, had systematically reduced the country's physical, economic, social, and administrative infrastructure to wreckage. Hospitals, banks, schools, farms, courts, markets, churches, municipal halls and national ministries, public utilities and private enterprises— nearly everything was stripped and broken. A team from the World Bank had just pronounced Rwanda the poorest country on earth. A government spokesman told me that some of the World Bank team had gone further, declaring Rwanda "nonviable."

The prisons were the first public institutions to start running again at full capacity, and by the time I arrived they, too, had already proven inadequate, as they were packed wall to wall with nearly 100,000 men, as well as thousands of women and children, all accused of genocide. When international observers protested the hellish conditions, they were urged, ominously, to consider the alternatives. Rwanda's violence was far from spent. Every day, from all quarters, there were reports of killings. Every day was an existential political crisis. Every day there were rumors of war. *"Ça va éclater"*—"It's going to blow up"—was the refrain.

Today, Rwanda is one of the world's safest countries, according to the *Gallup Global Law and Order Report*, which scored it, in 2015, on a par with Luxembourg and Portugal and several points ahead of the United States. Nearly a million tourists a year visit the country, spending more than $400 million, 12 percent of the GDP. According to the World Bank, the percentage of Rwandans living in extreme poverty has been cut almost in half since 1995, even as the country's population and the life expectancy of newborns have both doubled. Rwanda has universal national health care, and the child mortality rate has dropped 60 percent since 2000,

while HIV infection, deaths from AIDS, and malaria have seen similar, or steeper, declines. There is mandatory public education and a rapidly improving high-tech infrastructure, and the World Economic Forum rates Rwanda the fourth-best country on earth for gender equality, better even than Sweden. Rwanda's economy has grown over the past 20 years at an average annual clip of more than 5 percent—in 2018 it grew more than 8 percent—and the country is consistently listed, in international indices, as one of the least corrupt in Africa. As its tax rolls have increased, the government's dependence on foreign aid to fund its budget has been reduced from 86 percent in 2000 to 32 percent today. In 2016, when the authors of the UN's Human Development Index crunched their data to identify the world's fastest-developing countries of the past 25 years, Rwanda topped the list.

President Kagame has promoted the order he has imposed and his ambitions for Rwanda's future by evoking the example of Singapore under the authoritarian leadership of Lee Kuan Yew. And international headline writers have taken Kagame's cue, branding the country's against-the-odds reversal of misfortune as the "Rwandan miracle." But Rwanda's steadily accelerating progress, and the hope it carries, is still brittle. Forty percent of Rwandans remain in extreme poverty, which means they are subsisting on less than $1.90 a day, and many whose lot has improved are only doing slightly better than that. In June 2019, the government reported that 38 percent of Rwandans under the age of five were stunted by malnutrition. Education, while inclusive, remains woefully inadequate to prepare most Rwandan students for modern employment, and job creation lags far behind other measures of economic growth. The same Human Development Index that hailed the speed of Rwanda's improvement listed Rwanda's overall development in 159th place out of 188 countries. And, in a nation that has never in its history experienced a peaceful transfer of power between living rulers, it is impossible, even after 25 years, to reckon the solidity and sustainability of Kagame's achievements until he is succeeded—and there is no known plan for how or when that may happen.

Still, what no international index accounts for is the extent to which killers and survivors, as well as their respective kin, today live again as neighbors, intermingled in the same communities, building their lives and their nation in conditions of shared physical security, even as they grapple with the burdens of memory and forgetting, of bloody division and enforced civic and political unity, of the bitter impossibility of justice, and of extraordinary clemency. For Rwandans, after all, the question was never how to purge the horror from their beings. The genocide was bound to define Rwandans' experience for generations to come. They had no hope of getting over it. The question was only how to get on with it—how to live with it—and that meant how to live with one another.

———

In 1996, I met a woman named Chantal, who was squatting with her two-year-old daughter in the ruins of her little village in Rwanda's central highlands, where she had been born and raised next door to the man who'd killed her family. She told me he had always been a good neighbor before he turned, and she said, "How can a man you took for a friend change all at once, and take you and kill you? How? There's no making sense of it."

Chantal was right. It was absurd. And yet hers was a typical story. The same thing had happened all over Rwanda in 1994: from one day to the next, it seemed, hundreds of thousands of apparently decent, moderate, sympathetic, even principled people, at every level of society, had become avid murderers, rapists, torturers, thieves, and vandals. And now, two and a half years later, most of the Rwandans who had fled after the genocide, including many of those who'd had a hand in it, had just as suddenly returned to their homes.

In the fall of 1996, Kagame had sent his army into Congo to head off the escalating Hutu Power threat there by breaking up the UN border camps, pushing a great mass of the people in them—at least 600,000 in the course of a few days in November—back to Rwanda, and pursuing the rest deeper into Congo. A few days before I met Chantal, the neighbor who had killed her family had reappeared, and she couldn't understand why he hadn't been arrested.

She waved in the direction of his house, and her voice rose sharply: "That man killed everyone he found in his path." She'd heard that he was now saying that he'd had no choice but to kill, because he was told to do it by local officials. She said that was a lie. That man had never obeyed anybody but himself, she said: "In his mind, he is the highest authority."

Chantal understood that the genocide had come from above. Everyone in Rwanda knew that. And the country's law for prosecuting *génocidaires* reflected that knowledge, imposing much heavier blame and harsher punishments on those who had operated from positions of power and influence than on the common folk who had physically performed most of the killing. But those leaders were strangers to Chantal. She could not accept that their responsibility for their crimes made her neighbor any less responsible for his. He had been the first person to kill on her hill. Nobody had ordered him to. He took the initiative. And the first person he killed was Chantal's cousin. Chantal saw him do it. She was hidden in a nearby stand of eucalyptus trees, and from the moment her neighbor's club came down on her cousin's head, she said, "Everything changed completely." The hunt was on, and when it was over so was Chantal's family.

In the family she was born to, she told me, her parents were killed, and her grandparents were killed, and so were nearly all of her aunts and her uncles, and her nephews, nieces, and cousins. She began reciting their names, but after a few names she stopped. She said she couldn't remember all her dead kin, by which she meant she couldn't bear all that memory. Then she said, "In the beginning I had a husband and five children, and only the newborn baby I had on my back remains." She told me her firstborn was a boy. She said, "He was seven." And she said, "His name was Jonathan." And again she fell silent.

I asked Chantal what should happen to her neighbor, the killer. She said, "All I know is that if I don't see him, I can feel a bit better." She said, "The fact that he's there disturbs me." She said, "It's like having a wound that was healing reopened." She feared him still. "He could kill me in my fields," she said.

Nobody knew, back then, when genocide trials would begin, and in the meantime new jails kept being built, and filled, and violence was once again escalating. Rwanda's army was pressing deeper into Congo, fighting the remnant Hutu Power forces there, and as they went, they and their Congolese allies killed tens of thousands of Rwandan Hutus who had

fled the breakup of the camps. At the same time, many committed Hutu Power fighters had joined in or followed the mass repatriation from the camps, bringing the war home again. A genocidal Hutu Power insurgency, and a ferocious RPF counterinsurgency campaign, soon consumed a large part of the north and west of the country, and once again tens of thousands of Rwandans were killed, and hundreds of thousands were displaced from their homes.

A few days after I met Chantal, her neighbor, the killer, was arrested, and on a nearby hill, a survivor was killed while tending her crops. Chantal stopped going to her fields. "I just eat what I can find," she said. Soon after that, Hutu Power insurgents cut the road to her village, and I lost touch with her.

—

In those early years of aftermath, when Rwanda was still palpably haunted and lurking with menace, it seemed that nothing anyone could do or say could bring relief from the memory of the genocide. In 2000, the army finally put down the insurgency in the northwest, driving the Hutu Power forces back into Congo, and a decade after it began, the war in Rwanda could at last be said to be over. But there was no celebration. The damage was too great. The divisions were too deep and too raw. Everyone was in shock. The past was omnipresent. There was no other subject. There was nowhere to turn without slamming into it. As Assumpta Mugiraneza, a social psychologist in Kigali, put it to me, "The wounds were such, the passions were such, the enormity of the thing was such, the proximity of this crime, which had gotten into every crevice of society, was such that it was never clear how Rwandans might come to terms with their past without being consumed by it."

"We had been submerged by the enormity of the crime," Assumpta said. "And everything became enormous after the enormous genocide—the massive flight to Congo, the things that happened there, the arguments it provoked, the years of infiltration and massacre, the two Congo wars. All things here have something enormous about them. It's like when you open a mass grave—there's always something enormous, but people must accept it as the most ordinary thing there is. Because without that, you cannot live. I was always struck by the banality, or ordinariness, of opening mass graves. One can open graves thinking there are two

people and end up happening upon 10, 30, 100, 600. It's spoken about, but the next day you move on. The grave is closed up, and you go farm beans or—voilà. You don't dwell on it."

To complicate matters, the RPF doctrine that "we are all Rwandans now," coupled with strict laws against "divisionism" and "genocide ideology," had created strict taboos around speaking publicly about Hutu and Tutsi. It was true that those identities had been transfigured during Rwanda's colonial occupation into artificial political constructs, and what Rwandans have in common as a people is more essential than what divides them. But decades of structural violence and its traumas had made those artificial identities all too real and meaningful. So, even as the government pursued an aggressive policy of "unity and reconciliation," the question remained: how to reckon with the inheritance of Hutu and Tutsi if it was taboo to speak about it openly.

"The reality is that at one time we spoke of ethnicity too much," Naasson Munyandamutsa told me. "We spoke of it so much that at a certain point some of us wanted to vomit. We spoke of ethnicity so much, it became the national anthem. So someone who comes out of the genocide—does he really need to hear more of that? Even if that is all that exists—if he knows it—does he need to hear that spoken of publicly?"

Naasson was a psychiatrist. He had trained in Switzerland and returned to Kigali after the genocide, and he reminded me that, at that time, there had been a lot of criticism of the new government's decision to do away with the mention of ethnicity on ID cards: "People said, 'That's how they're going to efface people's history, that's how they're denying reality.'" But what was being denied? Why should the state be in the business of dividing and branding its citizens at birth? "Ending that was a responsible act," Naasson said. Hutu Power had "polluted identity. So we were forced politically after the genocide to wear another identity altogether. We said: 'We are Rwandans.'"

Naasson regarded this inclusive national identity as a "noble concept." But it troubled him that it had been politically imposed with a heavy hand. He worried that when people feel pushed around, they resist policies that they might otherwise welcome. For instance, he told me, he had found in his research that Rwandans were less likely to say that they had chosen unity and reconciliation than that they had had no choice. "It's altogether laudable to aim to turn the page on the question of ethnicities," Naasson said. "But one must turn the page, not tear it up. Never. Because at some point one may have the need to turn it again to the other side to see what was there."

———

In 2002, the government launched a system of community genocide courts, known as *gacaca*, that required Rwandans to confront their past more directly before they could move on, much less leave it behind. The gacaca courts operated without lawyers, as open community forums, in which ordinary citizens, who were elected by their neighbors to serve as unpaid judges, were in charge of investigating and adjudicating Rwanda's staggering genocide caseload. The public was compelled to give evidence, to attend the trials, and to speak out during them as witnesses,

whether to challenge, corroborate, or comment on the testimonies of accusers and accused. And, because gacaca was intended to pursue the often-incompatible ends of accountability and reconciliation, génocidaires who confessed and repented their crimes were rewarded with substantially reduced sentences, while survivors were called upon, in turn, to forgive them.

Gacaca constituted the most ambitious and comprehensive exercise in accountability for crimes against humanity that any country has ever undertaken. In the course of 10 years, 160,000 citizen judges, in more than 12,000 jurisdictions, decided more than 600,000 cases relating to violent genocide crimes—killing, rape, and torture. Twenty-one percent of these were resolved by confession, 44 percent resulted in a conviction at trial, and 35 percent ended in acquittal. (By way of contrast, Rwandan officials liked to note that the UN's International Criminal Tribunal for Rwanda, which sat in Arusha, Tanzania, for 17 years, had convicted 61 individuals and acquitted 14, at a cost of about a billion dollars, which was roughly 20 times more than Rwanda spent on the entire gacaca system.)

The most persistent complaint leveled against gacaca, particularly by foreign observers, was that it dealt exclusively with the genocide, while war crimes and atrocities committed by RPF elements before, during, and after 1994 have, as a matter of unwritten policy, been left almost entirely unaddressed. What is rarely ever mentioned, however, is that a practically identical blind-eye policy applies to war crimes and atrocities committed before and after the genocide by Hutu Power forces, tens of thousands of whom eventually deserted or surrendered and chose to rejoin Rwandan society. Not only are these former enemies of the state granted a de facto amnesty and reabsorbed

into post-genocide society, but many have also been reintegrated into the army, including a number of senior commanders notorious for ghastly outrages. This is the hard political bargain on which Kagame's RPF staked its improbable bid for peace and reconciliation in Rwanda: that if there was to be an end to the war, there must be no accountability for its iniquities, and if there was to be an end to the genocide, there must be accountability.

As with any judicial apparatus, the gacaca process proved vexing for both accusers and accused—in countless ways dissatisfying, and often deeply traumatizing, even before the tribunal delivered judgment. In addition to addressing crimes of violence, the courts handled more than a million cases of alleged property crimes, in which perpetrators were often ordered to pay compensation to the victims. The burden of those fines, and the fact that they often went unpaid, created additional layers of conflict around gacaca. Over the past decade, I have had hundreds of conversations with Rwandans about their experiences of gacaca, and they often spoke at length of their frustrations and resentments: how the demands of reconciliation, through politicized, transactional formulas of repentance and forgiveness, chafed against their own memories and could feel false—not only insincere, but, worse, a betrayal of the dead, or a humiliation, or both. But then, almost without exception, they would conclude by telling me that nevertheless they thought that for most Rwandans things were better now.

One evening over beers in Kigali, while the trials were still in progress, I had a conversation about these conversations with a professor, yet another social scientist. "Gacaca got tripped up by a number of things," he said. "And it created resentments beneath the surface—

ethnic tensions mainly, familial tensions, too—which manifest themselves in the form of mistrust, in the form of suspicion and fear, in the form of rage." The professor was sympathetic to these reactions. The confrontations of gacaca had made him deeply uneasy, too. But he had come to see it as "a necessary process" and ultimately "a good thing," and he anticipated that, with time, much of the heavy residue of ill feeling that gacaca had churned up would be cleared away in its wake. After all, the professor observed, gacaca's project of determining individual guilt worked against the stigma of collective Hutu responsibility for the genocide, which Hutu Power had done so much to create, and which had kept Rwandans riven by mutual suspicion in the aftermath. "For a time, everyone was considered a génocidaire," he said. "Now I think we've begun to breathe again."

I remarked on how consistently I had encountered the sort of mixed feelings he described: individual frustration and dissatisfaction combined with a sense of positive collective progress. "Absolutely," the professor said. "Translating it into sociological terms, the micro doesn't always work out well and the macro offers the chance to survive. That's Rwanda. It's as though the national destiny, the future of an entire people, is given preference at the public level over people's little pains. And there are a lot of these little pains, let me tell you."

———

I wanted to know what had become of Chantal's family's killer at gacaca, and in 2009, more than a decade after I'd last seen her, I found her again, and asked her. She said she had gone to her neighbor's gacaca prepared to testify that she had seen him kill nine people. But there had been no need for her testimony. He admitted everything freely on his own. "He was accused of killing many, many people, and he always said yes," Chantal said. "And he named all his accomplices." His confession went on and on. "It disturbed my heart," she said. "I was so upset that I left before his gacaca was over." Later, she heard that he'd been released from prison shortly afterward. She felt that he had deserved a much heavier sentence. But Chantal had been a gacaca judge herself, and she said, "He was a great witness, so the rules of gacaca let him go."

As a judge, Chantal said, she had often been hurt by the things she heard at gacaca, but the pain always passed. "Since I was with the other judges, and since the problems had to be resolved, it wasn't a burden on me," she said. "We were a team. The

people came before us—the whole village was there—we asked them questions, and they responded. It was about justice, not emotion, and I think people got justice." But in the case of her neighbor, her experience was the opposite: all emotion, no justice. "I was never satisfied by it," she said. "But there's nothing more I can do. I have to live too." And she said, "I've tried to erase it from my memory. It's of no use to me anymore."

A cousin of Chantal's, a somber man named Marcelin, had stopped by to see her, and stayed to listen to our conversation. Now he said, "To live with the killers is not easy. But you have to be strong because if you can find it in your heart, you have to confront them every day with your life, your determination to live. You have to face them and show them that even if they killed your family, you are here and you live. Because otherwise you just throw yourself away, too." After all, he said, "none of us—survivors or killers—has a choice but to live together. That's the problem. We have no choice."

As the psychiatrist Naasson Munyandamutsa observed, Rwandans often speak of coexistence and reconciliation this way—as an absence of choice, which could make it sound like they were merely going through the compulsory motions. But when Marcelin spoke of his daily encounters with killers as both a necessity and a punishment, he was telling me that he had seen what happens when people choose not to accept living together, and that he had chosen to reject that choice.

———

In 2012, 10 years after the launch of the gacaca courts, the government declared that the system had served its purpose and closed it down. To mark the significant occasion, a conference was convened at Parliament. It was a daylong program of political speeches, academic panels, diplomatic tributes, and personal testimonials about the gacaca experience and its legacy. Midway through the morning session, a small, simply dressed woman appeared at the microphone. Her voice, high and clear, rang with a commanding urgency that immediately set her apart from the public figures who had spoken before her. "I'm Alice," she said. "I'm 42. I come from Nyamata. I have five children and a husband. He came here with me." She raised her right arm to point him out in the audience, and went on, without a pause, delivering her quick staccato phrases: "They cut my hand"—she meant that they cut it off; the arm ended in a stump just below the elbow—"I was beaten with clubs. My child was killed. Thirty-five of my family were killed. This was in Ntarama, where we used to live."

The towns of Nyamata and Ntarama sit side by side at the heart of the Bugesera region south of Kigali. It is estimated that as many as 60,000 Tutsis lived in Bugesera when the wholesale extermination began there in April 1994, and by the end of the month 50,000 had been massacred, nearly a third of them in the course of just a few days at the Catholic churches of Nyamata and Ntarama, where they had sought refuge. Alice was at the Ntarama church when it was attacked. "Our families were killed," she said. "They were inside. We were outside, I and my kid and my husband. We ran through the bush to the marshlands." It was in the marshes that Alice and her baby were eventually caught, or, as she put it, "they murdered us."

She said, "One person cut me here"—she touched her forehead—"and my arm. Others clubbed me. My kid was killed. My niece was cut. Now she's handicapped. My husband was thrown in the river. After the 29th the RPF came. God used them. God bless them. God bless the government of Rwanda. I was elected a judge of gacaca. Then this person who'd been in prison came to me. He asked me for forgiveness. It was hard for me and for my family to forgive him. Now we share life. And he comes to visit us."

When Alice left the dais, a man took her place at the microphone and said his name was Emanuel. His voice was fainter than Alice's, more distant, and he spoke more slowly, but no less deliberately: "I am a genocide convict. I come from Nyamata in the Bugesera region. On April 11 many soldiers came. They told me to come and I went with them. It was to kill people. We went to the home of a man named Utasa. I killed 14 people. Then we butchered cows. On the 12th I killed a doctor called Gikangwa. I was able to steal a case of Fanta. On the 13th I killed three women and one child. Then on the 29th we were loaded on buses to Ntarama. We were able to kill so many there.... In prison I confessed. So by the president's order I was released. In my heart I wanted to ask forgiveness but I was afraid. This lady who is here, I cut her and left her for dead. How could I go to her? Gacaca made that easier. Now I stand before you guilty of horrible crimes. You, too, all of you here—I ask you for forgiveness."

The motto of the gacaca courts was "Truth Heals." But how could such recitations of annihilating brutality close the wounds they described? Against Alice's and Emanuel's bloody memories, their few words of reckoning and rapprochement seemed, at best, wishful thinking. And through the ensuing five or six hours of panels and lectures, none of the speakers at the conference mentioned them again.

But toward the end of the day, a brigadier general who was seated near me in the audience, a political commissar of the RPF old guard, asked me what I'd thought of Alice and Emanuel. Without waiting for an answer, the general told me that he'd been inclined to regard them cynically. He figured they'd been set up to perform "the official regimen." He said, "I'm a politician. I know how it's done. And why not? The organizers of gacaca were showing us that Rwanda had known the extreme, but these Rwandans have decided to live together despite all." But then the cumulative power of their testimonies had made him wonder, "Can it be?" So when the conference broke for lunch, the general had followed them out of Parliament and spent the hour talking with them. "I wanted to see who they are," he said. He had returned convinced that "despite the scars, despite dehumanization, despite everything," they had "at terrible cost, but in their own perspective, in their own understanding," truly "come to terms with what they come from and with each other."

The general said he still found such reconciliation alien, but he no longer doubted that it was real. "My goodness," he said. "Who am I to say those guys aren't liberated? It's me who is imprisoned by my baggage, because I'm saying I can't relate to this, while those guys say, 'No—we've decided to move on.'" And he said, "It's incredible. I see it, but I don't understand it."

———

I didn't understand it either, and when I returned to Rwanda I tracked down Emanuel's phone number, and he invited me down to Nyamata to see him. We sat in the quiet garden of a snack bar, where

he sipped lemon Fanta and told me that he'd never had any problem with Tutsis before the genocide. He said that in primary school, his teacher had said he needed to know who was who: "He told Hutus to go to one side, Tutsis to the other side. Then he explained to us that Tutsis are evil, that they're the enemy of Hutus.... We learned that Tutsis were like snakes." This was the standard pedagogy in Rwanda in those days, and Emanuel allowed that it was frightening, but he said he didn't believe it. "Tutsi children came to my house and we played together, and I went to the houses of Tutsis to play together," he said. "We didn't care at all." Anyway, he said, he'd only gone to school for four years before his family put him to work, helping to tend their crops. That was how he remembered himself—as an apolitical young peasant, who lived with his parents, and whose chief pleasure in life was singing in the Adventist church—until the day the soldiers came to his door, and he took his machete and became a big killer.

Emanuel said that he was not forced to join the killers; he did not feel obliged. He said that the soldiers told him, "Come, we'll give you something that will really interest you." So he went. That was the day he killed 14 people. I asked what it was like for him to kill them. He said, "It was like I had cramps in my hands. It was very hard. Even after I finished, my heart felt bad." But he liked having meat to eat at every meal—"Everyone took a cow home"—and, although he felt "a bit messed up in the head," he didn't hesitate to kill again the next day, and the next. "I always went right away," he said. "I always wanted to go." After the first time, he told me, killing became "a lot easier." And he said, "It was fun."

To his family and neighbors, Emanuel's behavior during the genocide was just as normal as it had been when he was a choirboy. What set him apart, he said, was that a year after the genocide—before anyone accused him, and before Rwanda had a policy to encourage and incentivize repentance—he had presented himself to the local police inspector and confessed his crimes. The police inspector was baffled. "He asked me, 'Why?'" Emanuel said. "'What made you come in?'" And Emanuel told him, "'My heart.'" He explained that he was haunted by the people he had killed, and he said that when he remembered them, "it was as if my heart became very heavy and moved all around." But as he recited his crimes to the police inspector, Emanuel said, he felt his heart returning to its normal form. That was all he had wanted, and he said he was ready to be arrested.

In prison, surrounded by unrepentant killers, Emanuel felt his heart churning again in his chest, and he wrote out his confession, enumerating his killings, taking inventory of everything he'd looted, and naming everyone else he remembered who had killed with him. And again, he said, owning up to his guilt brought him such immense and immediate relief and release that he couldn't understand why others resisted coming clean: "I told everyone, 'We must confess what we did.' And they said, 'Are you crazy?'" They called him a traitor and made him fear for his life. But he experienced his unburdening as he'd experienced killing, as a pleasure, and not long after his release from prison, he joined a voluntary association of repentant génocidaires and forgiving survivors, a sort of reconciliation club, where he made his first public confession. He found that experience even more restorative than confessing to the authorities; and he had a much bigger crowd the next year, when

he bore witness against himself and accused many others as well at his gacaca trial.

In his confessions, Emanuel always said that he had killed a woman in the marshes. But he had no idea who she was until the year after his gacaca, when he saw a one-armed woman on the street and recognized her as his victim. It didn't take him long to learn her name, and to find his way to her door. Rather than telling Alice that they'd met before, however, he recruited her to join his reconciliation group. Then, for nearly two years, Emanuel cultivated her friendship and trust, before he decided one evening to reveal himself: "I got on my knees before her. I said, 'Forgive me.' She said, 'For what?' I said, 'It's me who cut your arm.' And Alice fell on the ground. She lost consciousness."

As Emanuel told me this story, Alice joined us at the snack bar. She and Emanuel greeted each other with a quick embrace. She told me it was true that she had gone into shock when Emanuel—"my killer," she called him—had declared himself on his knees. She said, "It was like a short circuit in my body." She'd had to be carried home, and she had stayed there, bedridden, for days, feeling nearly as lost to the world as she had after she was found lifeless and beginning to rot where Emanuel had left her in the marshes.

For three years after the genocide, Alice said, her trauma had effectively rendered her mute. Of her parents and their nine children, only Alice and one sister had survived, and she said, "I couldn't speak to anyone. It was only when I had my second child that I began to talk." And it was only when she served as a gacaca judge, she told me, that she fully found her voice again. Sitting on the bench, among the other judges, she had learned to practice forgiveness as the law required,

impersonally, and she had come to believe that "not forgiving everyone would repair nothing." Now Emanuel had put that conviction to the test. If Alice had heard his confession as a gacaca judge, she would have found no reason to reject him, but she was hearing it as his victim, and she wanted me to understand that although that made it easier to accept him, in the end, she did so for other reasons—not because she had to but because that was her choice.

"I forgave because I wanted to save my life," she said. "Because I didn't want to not forgive. Because if I didn't forgive, I would recultivate the hatred in my children. I wanted to cultivate happiness among my children. I wanted to have peace in my heart. Because I know lots of people who have problems of trauma in their hearts because they don't forgive. I wanted to save my own heart."

So Alice had forgiven for the same reason Emanuel had confessed, as a sort of exorcism. His heart, her heart: when they made their peace, neither was really thinking about the other. They weren't coming to grips with the past so much as they were seeking release from its grip. They were imagining the future. That was the only way that reconciliation made sense. By their words and by their example, Alice and Emanuel could not have made this point clearer. And yet the paradox remained that in banding together in pursuit of that redeeming future, they had also bound themselves more tightly to their annihilating past.

——

When I had last seen Chantal, I would have described her as being reconciled to being unreconciled and unreconcilable. But shortly after I met Alice and Emanuel, I stopped by to see Chantal again, and when I asked how things were going for

her, she told me, "There's a good atmosphere since gacaca. These days, people speak to one another. People have gotten out of prison, and there are sometimes even cases today where killers come to visit survivors."

I reminded Chantal of how unhappy her neighbor's gacaca had made her, and she said that was true, but she had only come to recognize gacaca's consequences in the years after the trials concluded. She described gacaca now as having brought a great relief. Innocent people had gotten out of jail; guilty people had been given a way to repent and to rejoin society. Above all, she said, it was now apparent to her that gacaca had lifted the threat of retaliation that had so bitterly divided the families of survivors and the families of génocidaires.

"There's no fear," she said. "After gacaca, it's calm. There are génocidaires who live with us, and we talk, we share what we have—there's a fairly good feeling. When there's a wedding, they come. When they have a wedding, we go. There are even some mixed marriages again these days. You can't look inside each person. There may be some who have problems because they killed. They don't want to talk to us. But those are personal problems. I can't tell you every single person is doing well, but overall, since gacaca, things are good. We've found trust again."

Except for Alice, I had never heard anyone who had endured anything like the losses and betrayals Chantal had known in the genocide sound so broadly, unreservedly reconciled. And unlike Alice, Chantal had never made peace with the neighbor who killed her family, or with his accomplices. They had never asked her personally to forgive them, and she had never felt the need for them to do so. On the contrary, her sense of peace depended on not having anything to do with them—on being able to dismiss them as what she called personal problems, rather than feeling saddled with them as her fate.

"What use is it today to be stuck with history?" she said. "The genocide came to pass, it's done, that's it. There's no choice. There aren't many choices. The only choice we have is to live together again in a good atmosphere with the others. If not—if you create problems in your heart—you'll always have torments. It's better to calm yourself and give yourself peace. That's the only way of getting over the thing."

Rwanda Then (1994) and Rwanda Now

149

by Jack Picone

In 1994 as Rwanda was in the throes of genocide, I illegally crossed the Ugandan border to document one of recent history's darkest events. I witnessed a broken country gouged, burnt, scarred, and littered with corpses.

Twenty-five years later, I revisited Rwanda and found a very different country—a country that carries the genocide with it in its collective memory but refuses to be defined by it. Instead, Rwandan people have been transformative and accomplished the impossible, turning the darkness of the genocide into light. A country once empty is now full; a country once broken is now whole; and scars once obvious are fading. Rwanda's transformation is squarely rooted in the Rwandan people's unparalleled ability to forgive.

Rwanda Reportage

Pages 150-151: An RPF soldier (Rwandan
Patriotic Front) advancing in Gikoro
district, Rwanda. 1994

Page 153 Top right: 'Liberating'
RPF soldiers advance towards Kigali.
Northern Province

Bottom right: RPF rebel leader Paul
Kagame during a meeting as he leads his
forces in a fight to overthrow the Hutu
Militia. Kagame went onto become president.
Northern Province

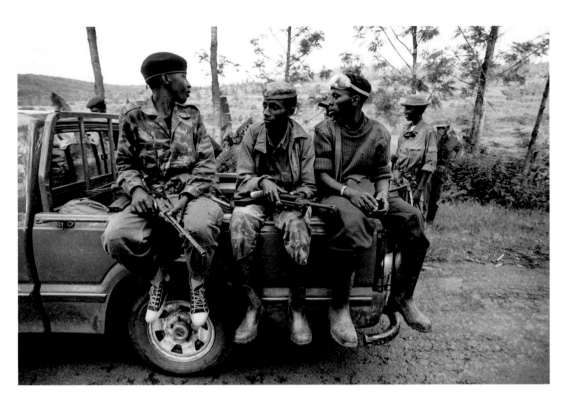

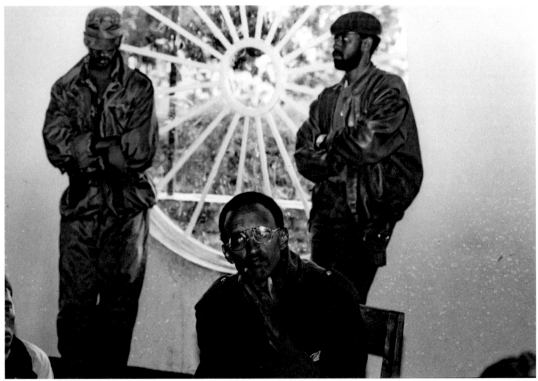

Rwanda Reportage

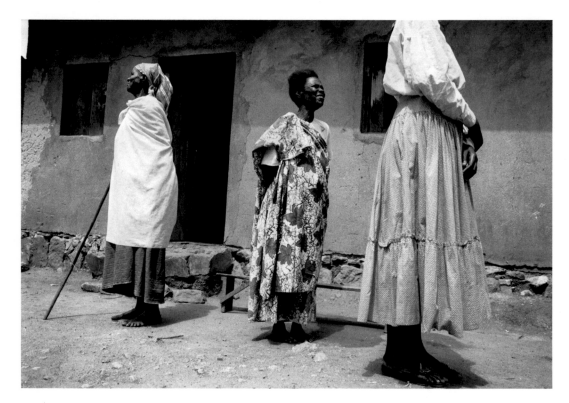

Left & right: In 1996 Laurencie Nyirabeza was shocked to find that her former neighbour, the génocidaire Jean Girumuhutase (opposite picture), had returned to live in her village. She claims Girumuhatse killed 10 members of her family, including her children and grandchildren. He did not deny the claims. She and Girumuhatse were both interviewed by journalist Philip Gourevitch with Picone. When Picone returned later on this trip, Nyirabeza had died. Her surviving granddaughter said that her grandmother was never able to move on with her life and always resented the proximity of Girumuhatse.

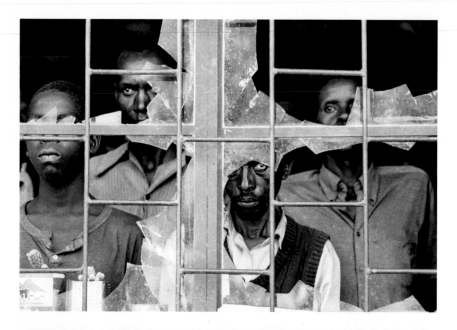

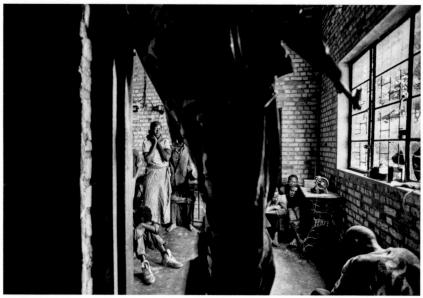

Top: Accused Hutu killers held captive in the vestibule of a Catholic Church in Gikoro district east of Kigali.

Bottom: The woman clasping her neck (at the precise moment this photograph was made) had just confessed to the RPF officer (framed by the door) to personally murdering seven Tutsis. She was being held prisoner along with other government-sponsored militia responsible for mass killings in Gikoro district.

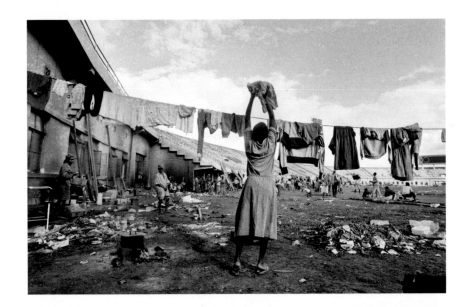

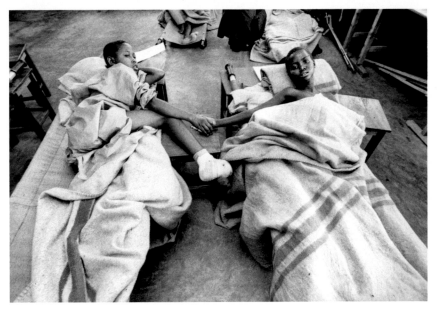

Top: The Amahoro Stadium, Kigali. During the genocide the stadium was temporarily a "UN Protected Site" hosting up to 12,000 mainly Tutsis refugees. A woman hangs her washing as shelling and killing continued outside the stadium's walls.

Bottom: Deeply traumatized children at a Red Cross hospital in Byumba, north of Kigali.

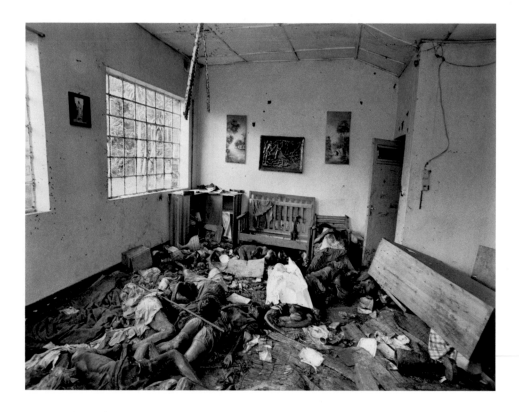

Corpses of Tutsi massacre victims inside the vestibule of a Belgian Catholic Church in Rukara.

Religion plays an important role in the lives of Rwandans, and throughout the genocide many sought refuge in churches. In a terrible irony the churches were then often the location of appalling massacres.

Top: Today, the clothing from victims is often preserved as a shrine.

Pages 160-161: Hon. Cécile Murumunawabo sits in Parliament. Murumunawabo is one of the 61 percent of female parliamentarians who dominate the Rwandan Parliament.

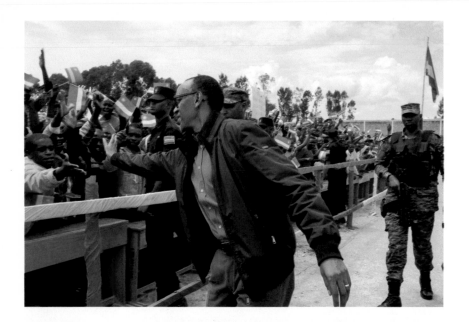

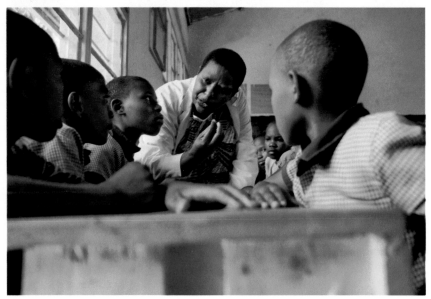

Top: President Paul Kagame interacts with his constituency at Nayamagabe District, Southern Province. He's seen as an authentically popular figure within Rwanda and his single-handed leadership is credited with the considerable economic and social progress the country has made over the past two decades. However, political opposition is suppressed. A constitutional amendment was passed in 2015 that paved the way for an extension of Kagame's term, possibly to 2034.

Bottom: Schoolteacher Ruth Mukankuranga in a Kigali school today. Prior to the 1994 genocide, discrimination was taught as part of the school culture, written into school history books and perpetuated within the educational system. Today it is illegal to identify by ethnicity.

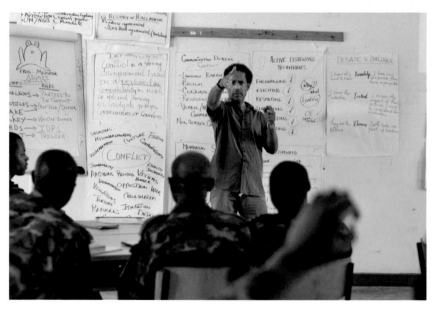

Top: Radio Stories. Radio was a persuasive form of communication during the genocide, using hate speech to encourage citizens to rise up and murder hundreds of thousands of their compatriots. In the same way that the radio had encouraged violence, post genocide, a Dutch NGO saw the possibility of using it to debunk prejudices and encourage reconciliation. Radio La Benevolencija launched the radio soap opera *Musekeweya* or "New Dawn" in 2004. The weekly episodes continue to discuss issues of trauma and distrust through their soap opera characters and inspire dialogue and conversation.

Bottom: Rwanda Defense Force (RDF) soldiers take anti-riot and anti-terrorism training at the Gako Military Academy, Rwanda. "The Rwanda Defense Forces do not start wars with anyone but are highly trained and always prepared to fight and conclude these wars for those that start them." - President Paul Kagame.

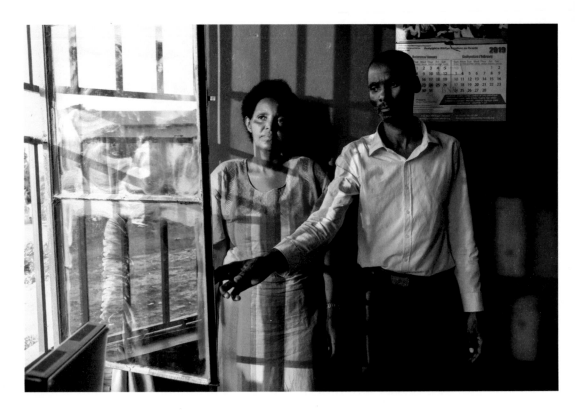

Alice Mukarurinda and the génocidaire Emanuel Ndayisaba. Ndayisaba admits to killing dozens of people during the genocide. Alice is just one of his victims, left for dead in a swamp after he cut off her hand. Ndayisaba was imprisoned for his crimes, but under the laws of *gacaca*, the local courts set up to encourage truth and reconcilliation, he confessed to his murders and was released. He later recognised Alice and admitted to her it was he who had tried to kill her that day in the swamp. In an unlikely partnership they have both reconciled and now work in a restorative group teaching reconciliation within the community.

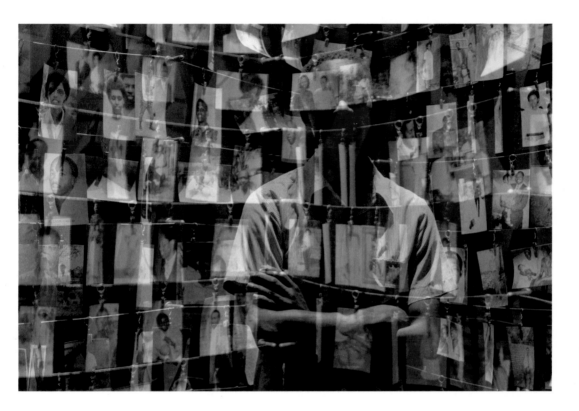

The Kigali Genocide Memorial includes exhibitions to inform and educate about the causes and consequences of genocide. The remains of over 250,000 people are interred here.

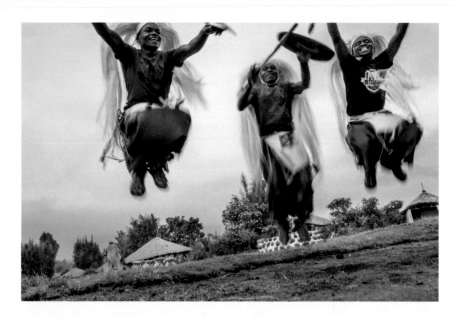

Top: The Guardian Village, an Eco lodge in Ruhengeri. Eco-tourism and high-end travel are a large part of the developing Rwandan economy.

Bottom: Great roads and the inclines of Kigali, the city of a thousand hills, have made the Tour du Rwanda the most prestigious cycling race in Africa. The race sets off from the Amahoro Stadium in Kigali, the site that in 1994 hosted up to 12,000 genocide refugees.

Top and bottom: Kigali is known as the cleanest and safest city on the African continent.

Pages 168-169: Motorcycle taxis operate in Kigali's Central Business District. The mototaxi culture has allowed tens of thousands of Rwandans to become small-scale entrepreneurs. Legislation enforces the use of motorcycle helmets by all riders. The government now wants to convert gas mototaxis to electric mototaxis.

Rwanda Reportage

Butterflies Sat Next to My Heart

170

by Dydine Umunyana

O n the morning of Thursday, April 7, 1994, I walked, still half-asleep, into the living room of my grandparents' house. I was yawning and desperately wanted to go back to bed, but my Auntie Agnes was waking everyone up. My older cousins sat together on the mat in the living room.

My parents had fled Rwanda when I was barely two. First, my father left to join the Tutsi-led Rwandan Patriotic Army (the armed forces of the Rwandan Patriotic Front or RPF). Soon my mother joined him, leaving me and my newborn brother, Fils, with my maternal grandparents.

Something strange was happening. I looked to see if it was morning, but the lantern on the table was lit and no light came through the windows. Auntie Agnes told us not to look outside, to sit quietly on the floor. She seemed to be the only adult in the house. I saw no sign of my grandparents. Auntie paced back and forth, wringing her hands. I had never seen her like this.

The day before, a plane carrying Rwandan president Juvénal Habyarimana and Burundian president Cyprien Ntaryamira had been shot down over the interior city of Kigali. Within an hour of the plane crash, the Presidential Guard, together with members of the Rwandan Armed Forces and Hutu militia groups, set up roadblocks and barricades and began slaughtering Tutsis and moderate Hutus. Local officials and government-sponsored radio stations called on ordinary Rwandan civilians to murder their neighbors.

I was almost four years old. I watched Auntie Agnes put Fils in a sling on her back. Almost two, he stayed asleep. Auntie moved with a nervous rage. She was far different from the Auntie Agnes who hummed happily while doing housework. She peered through the window again and again, as though she were waiting for something or someone to arrive. I looked around at my cousins, trying to uncover some information about what was happening, but their expressions were blank. No one dared even whisper.

The silence broke when a voice boomed across our little black Sony radio. "Our president's plane has been shot down by RPF-Inkotanyi. Our father has died. In the name of God, his children are to seek revenge and kill all the snakes and cockroaches immediately."

Trying to protect us, Auntie flipped the dial on the radio to another channel, but the same emergency warning was blasting on every station. That hateful voice was the only song we could hear.

"Let's get ready—we're going to Rwamagana Cathedral," Auntie Agnes said. My favorite activity was going to church

Dydine Umunyana, three and a half years old when she witnessed the Rwandan genocide, is the author of *Embracing Survival*. Her memories of narrowly surviving the genocide remain as fresh as the milk she carried on one fateful day, but the fright did not end there. While the killing stopped, the violence didn't—she spent much of her childhood avoiding the anger of her traumatized father. In a seminal moment, she decided to see her experiences not as a curse but as an opportunity. Umunyana is now a motivational speaker, committed to establishing a dialogue between people for understanding their shared histories and cultural differences.

with my family on Sundays, when I would choose what to wear to services. I spoke up, loud and proud, "I want to wear the dress Grandpa got me last Christmas."

Auntie Agnes whirled around and told me to shut up, which made me start to cry. She put her hand over my mouth and whispered, "What dress is it you want? If you have to say something, you whisper from now on!"

I looked deeply into her eyes. I'd never seen her this serious. I leaned closer and whispered, "The one that is white with the butterflies."

She disappeared for a moment and returned with the dress, which had three butterflies on the left side, one light pink, one mint green, and one baby blue. When I wore it, the butterflies sat next to my heart. In this dress, I was the happiest girl in the world.

Agnes instructed the older kids to carry us younger ones, and she organized us into a line. My cousin Mignone was eight years old, and she held my hand. I clutched a small jar of milk in my other hand. As we got outside, Auntie Agnes told us, "I want you all to stay together and make sure you're all following me. We all need to hold each other's hands, do you hear me? Let's go."

The main road was crowded with Tutsis. Women, children, babies, men, elders, and their animals clogged the street. Their baskets were stuffed with blankets and food. They carried mattresses, and some of the old men carried bottles of beer. Some of them looked like they had been walking all night. Everyone looked like they were leaving something behind.

Thousands of us were walking toward Rwamagana Cathedral and government district offices, designated as safe zones. Auntie Agnes told us to continue walking with the other Tutsis, even though she didn't know where they were all going. Only a half mile down the road from my grandparents' house, I heard whistles and the faint strains of Hutu hate songs.

The sounds grew louder, and without knowing exactly why, I felt my heart begin to race. Someone near me cried out, "The Interahamwe are coming to kill us!" An attack must have broken out right in front of where we were walking, for the people ahead of us bolted in a mass of confusion. Suddenly the street was full of killers, singing songs of hate in the name of Jesus.

I lost my cousin's hand. In a split second, I realized that I was alone, separated from my family. I was swept along with other people fleeing for safety. The next thing I knew, I was in the front yard of one of our Hutu neighbors. I looked down to find my beautiful white dress stained bright crimson with blood. I wasn't little Dydine anymore. I looked around, but my family was nowhere to be found.

—

Only minutes after being separated from my family, I'm lined up with many other Tutsis in the front yard of one of the Hutu perpetrators, waiting to learn our fate. I'm still clutching the jar of milk I was drinking when my Auntie Agnes rushed my cousins and me out of the house. I look down and see dead bodies at my feet. In the distance, people wail as they are slaughtered. Whistles, blown by Hutus celebrating the massacre, echo across the hills.

My small body trembles. I am sweating. What have I done to be hunted this way? Something big is about to happen.

My captors tower over me. They are drenched in blood and look like *malumba* (demons) in horror movies. But this house is familiar. It belongs to one of my neighbors, and I am friends with their children. I am too young to know what death means, to understand the difference between good and evil. I'm a small child, the only little person in line with many adults.

The Hutu Interahamwe ("those who attack together") begin moving down the line, hacking at people with machetes, one by one. I shake harder. The sounds people make as they die are horrifying. With a timid voice I ask, "Would you please let me drink my milk?" Auntie Agnes taught me that if a child wants to eat or drink something, she or he must ask an adult first. One of the men mocks me: "Would you please let me drink my milk?" The other men join in: "Of course you can have your milk, darling; you would not be a Tutsi child if you didn't ask for milk!"

I raise the jar to my lips, but I am so scared that I cannot drink. The Interahamwe discuss in what way they are going to make me suffer before they kill me. I fake drinking. An elderly Hutu man steps out from inside the house. Those before me in line have died, and those still alive are badly beaten by machetes and barely breathing.

"You are wasting time!" the elderly man scolds. His eldest son, the leader of this Interahamwe group, speaks: "This is Mapuwa's daughter." The older man's eyes widen with familiarity, and with a sudden change of heart, he speaks again: "You should be ashamed of killing an innocent child like this one, while your wives have children no different from her. No one touch her—you will have to go through me first!"

This is the very first morning of the Tutsi genocide. There are 99 more days to go.

—

My country had once been called the land of milk and honey, but overnight it became a land of blood and sorrow. By the end of time the genocide had ended, I had seen things that I would never hope for any child—or anyone, for that matter —to see. The whole country was in ashes, everything was destroyed, the hearts of those left without families or friends were broken. Young girls, orphans, widows were raped. The lives of those of us who survived would never be the same.

But I was still a child, and I was excited to see my parents for the first time in memory. I looked forward to the love and happiness that I had never had, since they had been away in the army. But things were different in the aftermath of the genocide. Though my parents and my brother and I had survived the massacre, and over time new children were born into our family, we were forever changed. Our home no longer existed. Sleeping through the night was a luxury. No one had time to sit still and reflect.

Post-traumatic stress disorder was not something many people in my country understood. Instead we just talked of trauma. My dad had returned to our home in Ruhengeri to save his family, but the entire family had been brutally killed. Nobody had survived. It seemed reason enough for a person to go mad, although my mother insisted that it wasn't madness, that he was getting better.

"There is no life after this mass killing," my dad would say, sounding like a very old man. "When I close my eyes at night, I dream the Interahamwe are here. I see them raise their machetes to kill my children. My only comfort is the thought that I can take my gun and kill us quickly, before they hack us to death."

I was always puzzled by my father's dark dreams. Why did he want us to die when we all had fought so hard to live?

After one too many bad nights, my mother left my father, taking us children with her. We moved to new houses constantly so that he wouldn't find us.

I was in a deep sleep one night when an arm came through the window, trying to grab me. I heard a voice whispering my name and asking for help. I screamed so loudly that my mother woke and ran into my room. She shrieked when she saw my father trying to squeeze through the bedroom window. She corralled all the kids into her room. How had he found us?

Dad's voice called out, "Dydine, my darling, open up for me—you know I love you so much. Don't be like your mother. It's so cold outside." These were the first tender words I'd heard from an adult in so long. I started crying and trying to pull away from my mother to open the door. Mom wrenched me back so forcefully that I thought my arm would tear from its socket. Dad began gathering stones and throwing them through the windows. He smashed every window in the house. Terrified cries rose from the houses of our neighbors. No one knew this madman in the night.

In the morning my father was gone. He would be back, though—again and again, always at night, always drunk, cursing my mother and screaming for his children.

No one spoke of my father's "episodes" outside the family. My mother stressed that it was important we keep his sickness secret to preserve the pride of the family name. Life was miserable for me and Fils, but we accepted that we simply had to deal with it. We thought every family was just like ours.

———

We had to live together as Rwandans right away. There was no time to commemorate the dead or bury their bodies. No time for revenge. No time for families to grieve. We were tired of fighting, so there was a *willingness* to live together as one and to figure out how to do that.

There were 300,000 to 400,000 survivors, mostly women and children. Women faced a particular loneliness, as so many men had been killed. They had no choice

but to be strong and bring the country back from its darkest time. Women had to step into new roles because there were so few men.

My grandma had just lost six of her children, but every time we went to visit her home, it was full of children we didn't know. "My home is a home for everyone without a home," she would say.

Women took in orphans, educated youth, created small businesses, and were part of decision-making at the highest levels. My mother had joined the army, and I watched her and so many others rebuild the country from the fertile ground up.

I hadn't chosen to be born in this country in its darkest moment, with Rwandans killing other Rwandans. But this ethnic massacre nobody could name, categorize, or explain was stopped—not by the watching world, but by Rwandans themselves.

It is one thing to know and live through this terror and another thing to gain strength from it. For me, the moment I turned from pain to positive action came in a school field trip to Kigali Genocide Memorial when I was 18 years old. We wandered into an open room with walls lined with photos of the devastation. Then we all sat and the guide began to tell us the history of the Hutu-Tutsi conflict. Suddenly, everyone seemed awake. We had never known the story behind the hatred. It was simply something we'd grown up accepting: Hutus hate Tutsis and Tutsis hate them back.

I learned that in Rwanda's early history, there had been no tribes. It's impossible to overstate the effect this had on me. It was as if everything we'd been taught about who we were had been a lie. We started asking questions. My fellow students were excited, but I was overwhelmed. I tried to slip away from the group and got lost, finding myself alone in the children's room, a circular space filled with photos. The children were beautiful. Captions told their names, what they loved, what their dreams were, and their last words before they were killed. Most of them had begged for their lives. "Please forgive me" was a phrase I saw over and over along the walls.

Whenever I turned my head to look away, I was confronted with a new face, a new story. The children's faces were so full of joy and light. I sat down and buried my head in my knees, and all my memories came rushing back. I saw myself at three and a half years old, lined up with others in the neighbor's yard. I felt the cold glass of the jar of milk. For the first time, I cried about everything.

And I talked to myself. "Dydine, you survived. Look at these children. They never had the chance to grow up and realize their dreams. You've been feeling so sorry for yourself, blaming everyone else for what's happened in your life, but you have a chance. You can make the choice to change everything."

One of my friends came to find me and tell me that the second session had started. When I stood up, I was a different person. I realized how fortunate I was. My life no longer seemed a curse, but an opportunity. I vowed that from that day forward, I wouldn't blame others for my fate or my failure to shape my destiny. I would live life joyfully.

It's in the Mind: How PTSD Affects Peace

by Elizabeth D. Herman

A photojournalist and writer pursuing a PhD in political science at the University of California, Berkeley, **Elizabeth D. Herman** examines how a national narrative of conflict may discount the trauma that individuals experienced, and how victimization actually changes brain chemistry and the way we think. No reconciliation process is complete, she writes, without a consideration of mental health and a recognition of the effects of post-traumatic stress disorder (PTSD).

E ach year, on the evening of March 25, students at Dhaka University in Bangladesh reenact the massacre that occurred on that night in 1971, carried out by the Pakistani army against the university's faculty and student body. The attack was the first phase of Operation Searchlight, an ambush on the residents of what was then East Pakistan, and it marked the start of a nine-month conflict referred to in Bangladesh as the Liberation War. Survivors recount stories of tanks rolling through the streets and rounds of bullets being fired throughout the night. Sharmeen Murshid, a Bangladeshi writer and activist who grew up in the university area with a professor father and a politician mother, recalled that the following morning, "when daylight came, we could see how terrible everything looked—dead bodies everywhere."

As the war progressed, the violence reached nearly every corner of the country, with estimates of between 300,000 and three million people killed. Men and women across the nation mobilized to protect their families and homes, forming guerrilla forces and taking up arms. An estimated 30 million Bangladeshis were internally displaced during the war, and hundreds of thousands of women were raped by Pakistani soldiers. The conflict eventually ended on December 16, 1971, with a Bangladeshi victory, achieved with help from the Indian army.

The Liberation War serves as the defining moment of national identity in Bangladesh, powerful in its ability to simultaneously evoke the narratives of both victims and victors. Its memory is publicly celebrated in national holidays and monuments, mobilized for political purposes, and held up as an instance of good triumphing over evil in the birth of a nation. Bangladeshi citizens can recite the chronicle by heart, as if it were taken from a storybook.

Privately, however, individuals have their own recollections of the war—more complicated narratives of struggle, loss, confusion, hope, trauma, and even coming of age. The official remembrances, which leave little room for deviations from the dominant memory, do not reflect these personal details.

In their own stories of living through the war, as recounted in dozens of interviews, which I conducted from 2010 to 2011, Bangladeshis emphasize that because of the way the war is memorialized, individual traumas remain unaddressed nearly five decades after its conclusion. One prominent Bangladeshi activist told me about loved ones she had lost to Pakistani forces and also described the memory of a friend slain by Bangladeshi guerrilla fighters: because of his tall stature and light skin, the guerrilla fighters mistook him for a Pakistani and killed him on the spot. In retelling the story, she began to cry. Even though she had reflected on the war for decades and attended public memorial events, she had never been allowed to openly name her own personal traumas.

Forty-eight years after the war, political violence persists in Bangladesh, and the nation's democracy faces significant challenges, with strikes, political violence, and

persecution of dissident voices and political opponents impacting daily life and democratic processes. Similar patterns are seen in other post-conflict societies—peace is achieved, but that peace is neither stable nor robust.

Experts and academics often explain the instability by pointing to weak institutions, undeveloped political parties, a lack (or excess) of natural resources, and social ills such as persistent crime. But in identifying these causes of failed reconciliation, they seldom consider the impact of conflict's psychological aftereffects. Psychology and neuroscience research have increased understanding of the legacy of violence and trauma on brains and bodies, which may help to explain why and how peace works or fails after conflict. "We know from research that living through a war, that having strong enemies, that being victimized actually changes the way you think," said Mike Niconchuk, senior researcher at Beyond Conflict's Innovation Lab for Neuroscience and Social Conflict. "Beyond the way you think, it changes aspects of brain chemistry; being a victim of conflict can affect the size of parts of your brain."

Thus, even in places where people and communities desire to work together, psychological and physiological factors can impede the ability to heal and to participate in reconciliation processes—at both the individual and the community levels. In post-conflict societies where there is no support for reconciling past traumas, and where there is no way to examine the effect of exposure to violence, the aftereffects can persist for decades beyond a war's conclusion.

———

Research on the ways in which mental health and individual experiences of war affect peace building is scant, for several reasons. First, there is what scholars call a *unit of analysis* problem. Peace is considered a national or at least subnational issue, whereas mental health is commonly conceptualized as an individual-level issue. Second, there is the problem of determining the appropriate discipline. Mental health is most often regarded as a problem outside the realm of political science or government, while scholars of psychology or neuroscience regard war as outside the scope of their work. Third, mental health is widely under-addressed in post-conflict situations in general, since physical safety and health are often given paramount importance. Increasingly, researchers are challenging such boundaries. But the research is still preliminary, and many questions remain unanswered.

Predictably, the few studies that have begun to examine the links between individual exposure to conflict and prospects for peace have reached somewhat divergent findings. Political scientists have found that individuals exposed to violence are more likely to support reconciliation efforts. Psychologists, on the other hand, have found that adverse responses to exposure to violence, characterized by post-traumatic stress disorder (PTSD), decrease support for reconciliation and increase support for continued violence. This discrepancy suggests that perhaps it is not enough to understand in a generalized way what impact living through violence has on the prospects for peace. Rather, we must examine individual responses to living through violence and how they affect peace.

It makes sense that people would respond differently to living through war, but this notion has often been absent from both academic research and popular narratives. In reality, people have vastly different reactions to experiencing traumatic events, from adverse responses characterized by the onset of PTSD or other trauma-related disorders on one end of the spectrum, to no change in functioning in the middle, to post-traumatic growth, or functioning that exceeds that of pre-trauma exposure, on the other end.

For those individuals who react adversely to being exposed to trauma, the onset of PTSD can emerge fairly immediately after the conflict or anytime in the years to come. The precise symptoms differ from person to person, but they may include nightmares, flashbacks, intrusive thoughts, and outbursts of anger. Importantly, PTSD is commonly characterized by what psychologists call *abnormal threat reactivity*. This most commonly manifests as a kind of hypervigilance, in which individuals have a heightened threat response: stimuli that people with normal threat reactivity would be able to identify as nonthreatening (for example, fireworks) trigger a full threat response. (Sometimes the opposite—a shutting down of threat reactivity—characterizes PTSD: individuals do not react to actual threats with appropriate vigilance or fear.)

In neuroscience, studies have found that individuals with increased activity in the amygdala, the portion of the brain that governs threat awareness and fear responses, show increased distrust of out-group members. Thus, individuals who develop PTSD characterized by increased threat reactivity may be less willing to interact with individuals perceived as enemies, especially members of out-groups with whom they have engaged in conflict—precisely those with whom they may need to reconcile.

This neurological reality raises questions not only of how to build peace, but also of what kind of support individuals and communities may need as a foundation before they can really start to address the traumas of war.

———

In Jordan's Za'atari refugee camp, which houses people who have fled the ongoing conflict in Syria, the wounds are fresh and the ability to move on is hampered both physically (stringent rules restrict leaving the camp) and psychologically (access to any kind of mental health or psychosocial support is severely limited).

In a recent small-group conversation with Syrian refugees working with Questscope, an NGO that focuses on conflict-affected youth and young adults, one 30-year-old Syrian refugee living in Za'atari reflected on what he would want to say, given what he knows now, to the version of himself that arrived at the camp four years ago. He

answered that the idea that mental health is not a first-order need, like the need for shelter or water, is unfounded. Without the ability to address the psychological wounds of war, he added, little else can be accomplished. He recalled all the issues among the youth in the camp when they first arrived—violence and conflicts and unrest—but noted that after the community and local organizations began to provide both literal and figurative space to address individual traumas, social networks began to reestablish themselves and violence gradually subsided.

In his paper "A Theory of Human Motivation" (*Psychological Review*, 1943), Abraham Maslow proposed a ranking of the various needs of humans. The concept of Maslow's hierarchy of needs is often presented as a pyramid, with five levels organized in order of importance. Maslow theorized that the bottom four categories—from lowest to highest, biological and physiological needs, safety needs, love and belonging, and esteem—are *deficiency* needs (if they are not met, the individual will feel anxiety). Further, these needs must be largely satisfied before the individual can realize self-actualization—the fulfillment of one's true self, the only growth need, located at the top of the pyramid.

Post-conflict relief is often structured to meet the bottom two levels on Maslow's hierarchy of needs, which prioritize shelter, water, food, and physical medical assistance. This is partly because these are the most obvious necessities in post-conflict situations and partly because they are the needs that the largest aid organizations are trained (and funded) to provide. "There's no question of us treating physical injuries that we see in war, but yet we get so suspicious when we talk about mental injuries," said Niconchuk of Beyond Conflict.

Modern conflicts are increasingly protracted, however, and people forcibly displaced in these circumstances experience an indefinite state of limbo. According to the World Bank, two billion people currently live in places affected by institutional fragility, conflict, and violence. Currently more than 65 million refugees, asylum seekers, and internally displaced persons are scattered across the globe. Most refugees in Za'atari have been there upward of four years; they are still not allowed to build permanent shelters, and a working sewage system was installed only in 2017 (the camp was established in 2012).

Why is psychological well-being seen as something that can be addressed down the road? "Logic would say that you have to start by ensuring people's survival.... before you can undo the damage [to mental health] that was done by a lack of safety," said Niconchuk. "I understand that, but the reality of conflict zones is so different, and the creation of safety is such a subjective notion, that it could take decades to accomplish. Look at Afghanistan. Should we still not be taking care of mental health because it's been 25 years of conflict?"

When a refugee is resettled, or after a conflict ends, the trauma experienced during the war does not disappear. In fact, it can intensify. Individuals can be left feeling that they are wrong or "crazy" to still feel anxious or depressed after escaping the immediate threat of conflict. They can be beset by feelings of loss or survivor guilt. They can feel more unsettled and even more unsafe in peace than in war.

But healing can take place in many ways. Telling one's story and—crucially—being heard is one of the most readily possible and most important modes of confronting trauma. Research has found that narrative exposure therapy, which asks individuals to place past traumas within the larger narrative of their lives, allows them to integrate such events as part of a coherent life story. Nonclinical approaches have also adopted storytelling as a way to confront past traumas and reimagine future possibilities. #MeWe International Inc. works with young people affected by forced displacement, using storytelling to redefine a community's narratives and to help youth and young adults envision themselves as agents of change.

"Storytelling is extremely important for self-awareness, for resilience building, and for forming pro-social relationships," said Mohsin Mohi Ud Din, founder and chief executive officer of #MeWe. It reinforces a sense that the person can exercise the right to form his or her own narrative; the story, he added, is not just "a consequence to things, but a living, breathing choice."

To date, much of the existing research on the psychological aftereffects of conflict comes from studies carried out in Western countries. Whether the findings from this body of research translate across cultures, and whether the known gold standard of PTSD treatments applies in all post-conflict societies, are open-ended questions. More research is needed to identify and test the efficacy of locally established ways of addressing the legacies of violence, as well as to empower community leaders in facilitating treatments. The research also needs more funding: only 0.4 percent of all development assistance for health worldwide is dedicated to mental health.

Whether violence is ongoing, as it is in Syria, or decades old, as it is in Bangladesh, deepening our understanding of how the psychological legacies of war affect healing among individuals and communities is key to knowing how to build lasting peace. With the new landscape of protracted conflicts and unstable peace, mental health care is a first-order need, and understanding the nuances in human responses to violence and trauma will amplify prospects for peace after conflicts.

"Peace comes from people collaborating with others and creating something from nothing," said Mohi Ud Din. "That's what makes humans human. That's why we've survived—because we have that ability to create in a way that other creatures do not." He added, "Peace is an imagined reality, one that for generations communities and peoples and cultures have been trying to build with their words and stories."

BOSNIA AND HERZEGOVINA 182

Ron Haviv
**Bosnia and Herzegovina Then
(1992–96)**

Anthony Loyd
God Won't Have Forgotten

Ron Haviv
Bosnia and Herzegovina Now

Elvis Garibovic
The Wolf You Feed

Pedrag Peđa Kojović
The Perils of a Peace Imposed

Bosnia and Herzegovina Then (1992–96)

185

by Ron Haviv

When I arrived in Yugoslavia in March 1992, I did not anticipate that the moment would mark the beginning of a journey that would last for more than 25 years. Tensions were already high, and violence was breaking out in the town of Bijeljina on the Bosnian-Serbian border. The community quickly split along ethnic lines, and the hatred and barbarity that was to became normal during the years of this war began here: the banker fighting against the barber, the school teacher fighting against the grocery clerk. I was witnessing a complete breakdown of civil society.

The violence escalated with the arrival of the former Serbian football hooligan and now warlord Arkan and his paramilitary unit, the Tigers. Within hours of arriving in Bijeljina they accomplished their mission of clearing the town of what they called "Muslim fundamentalists." What I photographed was the paramilitaries executing unarmed Muslim civilians and taking prisoner a young male civilian, who was later found dead.

Ethnic cleansing was born.

These images, published around the world, were a portent of what was to come. The war lasted for almost four years, with more than 100,000 killed and nearly two million displaced.

Bosnia and Herzegovina Reportage

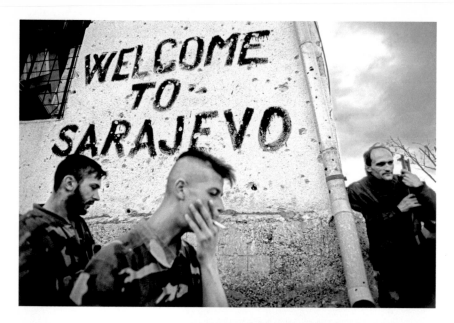

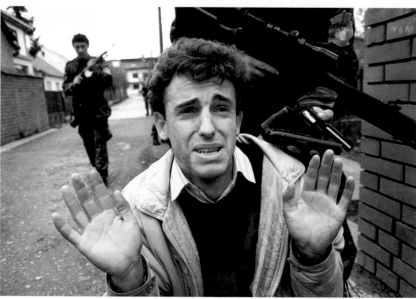

Pages 186-187: Bosnians dodge sniper fire at a peace rally in Sarajevo, Bosnia. They had been calling for the preservation of a multiethnic society when gunmen from a radical Serb political party opened fire on the crowd. Later that day the crowd stormed the parliament building in protest. April 6, 1992

Top: Graffiti on a wall outside Sarajevo, 1994

Bottom: Harush Ziberi, a Muslim man, begs for his life from the Serbian paramilitary unit led by warlord Arkan during the first battle of the war in Bosnia. He was later thrown from a window during an interrogation and was eventually found in a mass grave. April 2, 1992

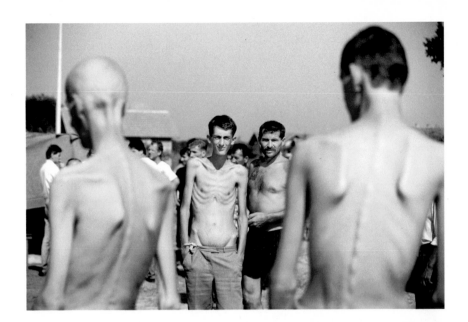

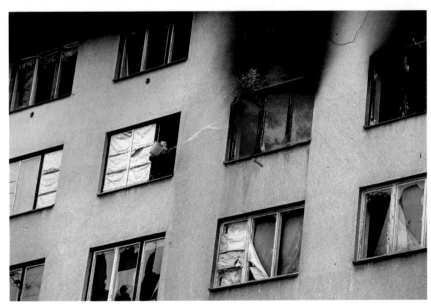

Top: Trnopolje POW Camp. When the Bosnian Serb prison camps were revealed by the press in early August 1992, Ron Haviv was with a handful of journalists who gained limited access for a couple of hours. He photographed emaciated men who were desperate to tell their story but knew that to do so would probably lead to their deaths. Elvis Garibovic is on the right side of the frame with his back to the camera. Read his personal story on page 228.

Bottom: Sarajevo suburb of Grbavica. A Serb man attempts to put out a fire in his block caused by Serb arsonists. The arsonists were trying to force the man to leave the city rather than let him stay under the Muslim-led Bosnian government. March 1996

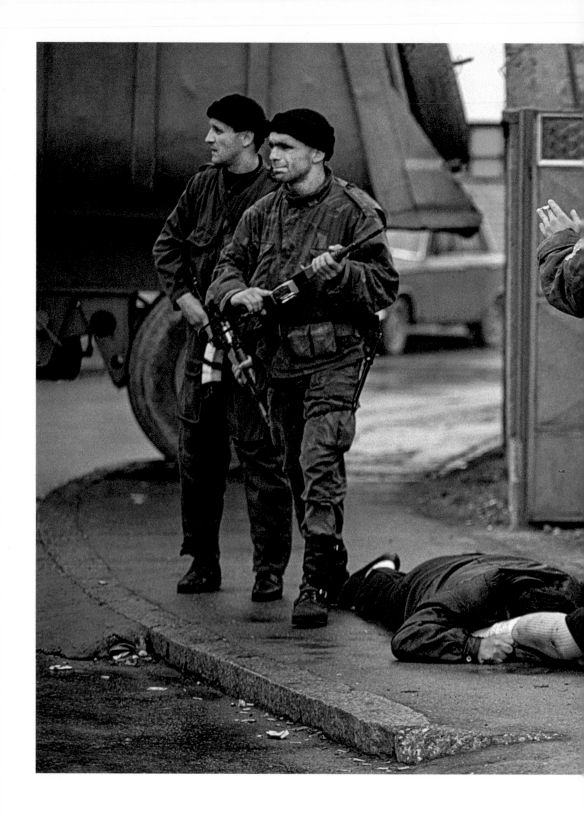

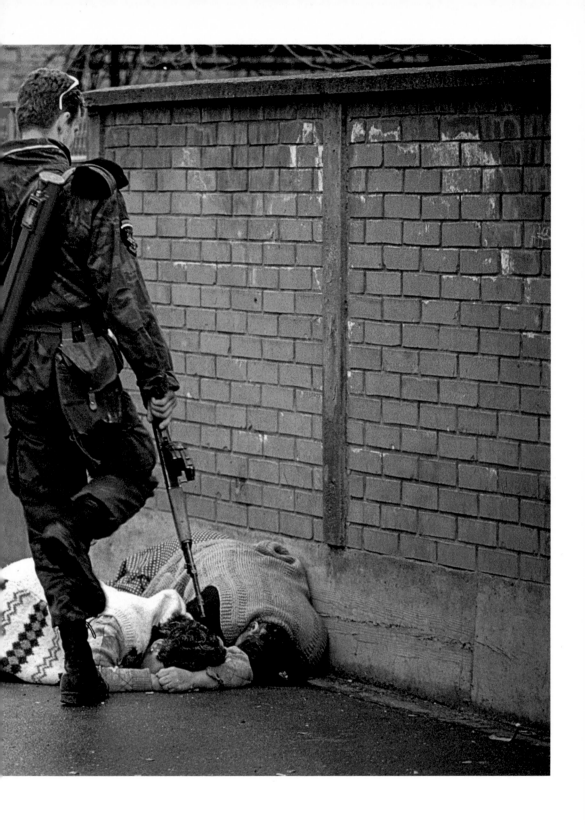

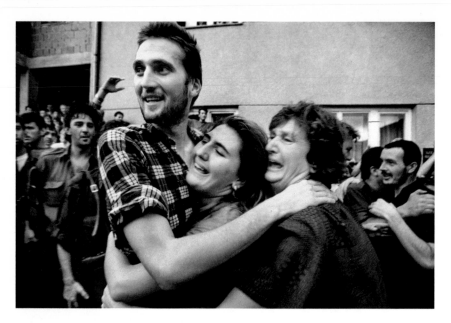

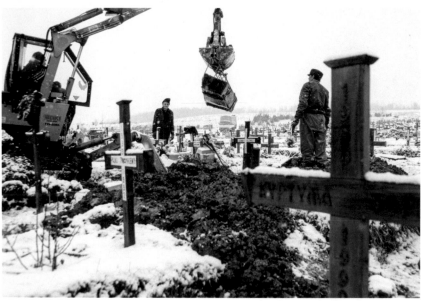

Pages 190-191: Željko Ražnatović, known as Arkan, was a Serbian paramilitary commander whose unit, the Tigers, was responsible for killing thousands of people during the Bosnian war. Here, Abduraham and Hamijeta Pajaziti, along with Ajša Šabanović, were pulled by the Tigers from the house behind and killed on the street during the first battle of ethnic cleansing in Bijeljina. Arkan was later indicted for war crimes. April 2, 1992

Top: A Serb prisoner is reunited with his family after being released from a prison camp in central Bosnia, August 1992

Bottom: Serbs use a digger to exhume their relatives from graves in a local cemetery in Ilizda before fleeing Sarajevo. March 1996

The Serbian leadership decided to leave Sarajevo when the Dayton Accords reunited the city under the Muslim-led Bosnian government.

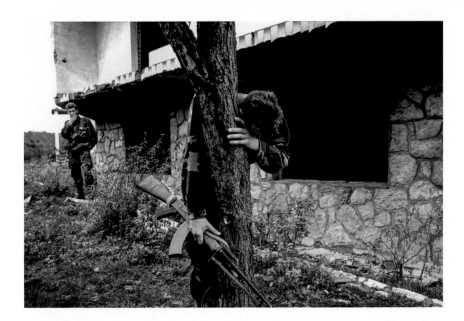

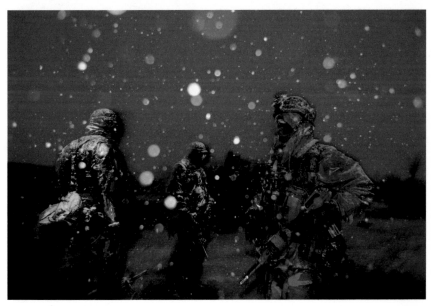

Top: Senad Medanović, survivor of a massacre, finds his home in ruins after the Bosnian army recaptured his village from Serb forces. He collapsed after realizing he was standing on what is believed to be a mass grave of 69 people, including including members of his family.

Bottom: US soldiers in the Brćko Corridor, in the winter of 1995. They arrived to enforce the Dayton Accords ending the war in Bosnia. Over 30,000 troops from different nations made up the peacekeeping force.

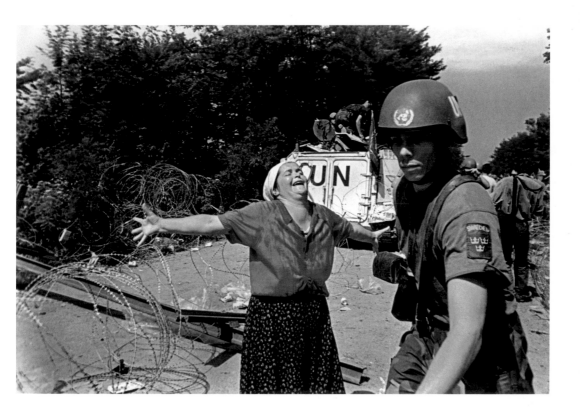

Left: The Fako family discovered a defaced family portrait when they returned to their home in a suburb of Sarajevo. The Serbs who had occupied the house left as the Muslim-led Bosnian government reunified the city. They took the Bosnian family's furniture and the rest of their belongings from the house and left only this photograph.

Top: Nedžiba Salihović, who lost her husband and son in the Srebrenica massacre, screams at a UN soldier in a refugee camp in Tuzla, July 17, 1995.

Over 7,000 men were executed as Serb forces overran the UN Safe Area in Srebrenica, and thousands of bodies found in mass graves around the city still have not been identified. (See Salihović 23 years later in Ron Haviv's "Bosnia and Herzegovina Now" essay, pages 212–213.)

God Won't Have Forgotten

196

by Anthony Loyd

I n 2016, a middle-aged man and his young son stepped aboard the Vitez bus bound for Sarajevo, as they did every Tuesday for a standing appointment. The boy, around 10 years old, was seeing a specialist in the city. Watching them from her seat on the bus, a woman named Irena noticed that the father had an attentive, gentle, and concerned attitude towards the little boy during the hourlong journey to the Bosnian capital.

"I saw him bend down and say something like, 'Darling, who tied your shoelaces like this?'" recalled Irena, now 38 years old, who then worked in a public relations position in Sarajevo and travelled there each day from her home in Vitez. "And the little boy would say, 'Oh, mummy did!' Then the father would gently retie the laces in a bow."

Sometimes, when she got the chance, Irena looked the man in the face as he boarded the bus and said "Good morning" to him. When she greeted him in this way, the man mumbled and gazed down at the floor.

They had never had a direct conversation, but Irena had learned much about the man since the day in 2015 when she went to the opening of a trial in Sarajevo. Six men, all former Bosnian army personnel, stood accused of beating to death a Bosnian-Croat soldier after they had taken him prisoner, 22 years earlier—in September 1993, at the height of the conflict between the state's Muslim and Croat communities. They also faced accusations of having abused other Croat detainees.

The dead man, Ilija Omazić, was a civilian conscripted into the local Bosnian-Croat forces, the Hrvatsko Vijeće Obrane (HVO, Croatian Defence Council) at the start of the war. He had been captured in an early morning attack on the village of Vitez by Muslim troops, less than two kilometers away from his house. Witnesses recalled that Muslim fighters—apparently recognizing Omazić, 40 years old and the father of four young children— surrounded him and called him by name. They captured him alive.

It was 18 September 1993. The sound of the attack, the shooting and explosions, carried clearly to Omazić's family at home on the southern edge of town. His wife, Smiljka, tried to ignore the sounds as she got ready to bake cakes for a joint birthday party for two of her daughters.

"Then, around 2 p.m., a neighbor came around and knocked at the door," Smiljka told me when we met years later. "They just said, 'Ilija has been captured.' The longest night of my life passed. I sat in the house, with no electricity and all of my children

Bosnia and Herzegovina

Reportage

there, desperate for more news, knowing only that my husband had been captured."

Ten days later, there was an exchange between the opposing forces, the HVO and the Bosnian army. Such arrangements, in which prisoners or the bodies of dead soldiers were swapped during a localized ceasefire, were regular occurrences during the war. In this way, Ilija came home. Yet the man who was captured alive came back as a corpse, so hideously disfigured by beating and torture that his body was barely recognizable.

Rage sprang up quickly on the heels of his family's grief. Smiljka said she felt "disgusted" by all Muslims and wished never to communicate with one again. Her fury knew no confines. For a long time afterwards, she would even swear at Croatian vehicles passing her home to drive uphill towards the village where her husband had been captured.

"The road up there passes right by our house," she said, "and whenever any adult male of military age passed by I'd swear at them: 'How the fuck are you still alive when my husband is dead?' It has taken years for me to accept that not everyone has to die in place of him."

Ilija's children were unable to comprehend what had befallen the man they adored. For over a year after his murder, his eldest daughter, just 12 years old when he was killed, would go missing, only to be found weeping at her father's graveside.

Two decades later, now an adult woman with a young child of her own, she finds the sense of her father's absence a constant in her life.

"I miss him," she told me as we sat talking in the family home in Vitez, in the autumn of 2017, 24 years after her father's murder. "I missed him for things like my birthdays,

for my graduation, for the birth of my own daughter. I miss him still. That missing will never change.

"But I remained incredulous, too," she added. "I mean, what kind of animal must you be to beat a prisoner to death? A monster, right?"

The question came back to haunt her on Tuesdays when she saw the man and his boy on the bus to Sarajevo.

She is Irena. And the man with whom she shared her Tuesday commute on the bus was one of the six accused of beating her father to death.

"I'm not angry anymore," she said evenly. "I expected a monster, but instead I saw a concerned father worried for a sick son. Sometimes we sat near one another. I'd say 'hello' and he would look afraid. It seems that it was harder for him to look me in the face than it was for me to look at him. But really, I don't hate him."

The man no longer takes the bus. In the autumn of 2018, the trial against the six former soldiers ended. Two were acquitted. The man on the bus was one of four who were sentenced to a total of 27 years in prison for their part in the systematic mental, physical, and sexual abuse of Croat detainees. The charge for the murder of Irena's father was dropped due to a lack of evidence.

ON THE ROAD TO RECONCILIATION

Reconciliation remains an orphan in Bosnia, lingering in the shadows of a war that still haunts a traumatized population after more than two decades of peace. Hatred, by contrast, is its advantaged sibling, which makes Irena's attitude all the more remarkable.

Though the Dayton Accords ended hostilities on November 21, 1995, halting nearly four years of bloodshed, which had cost over 100,000 lives and had seen genocide committed for the first time in Europe since World War II, in many respects the conflict was frozen rather than finished. A generation after the fighting ceased, the driving forces behind the war—nationalism, separatism, and ethnic intolerance—not only remain but flourish, dwarfing chances for reconciliation and forgiveness, the two essential components to an enduring peace.

Many see the Dayton Accords as the root cause of Bosnia's paralysis, putting it in a state of neither war nor peace. The accords were built on the recognition of two distinct sectarian entities in Bosnia and Herzegovina: the mainly Muslim and Croat Federation of Bosnia and Herzegovina, and the almost exclusively Serb Republika Srpska. The architects of the Dayton Accords did not intend these structures to be permanent, and the deal did include mechanisms for constitutional change based on political consensus.

But Bosnia's political leadership never reached any consensus, so—22 years after the war's end—the core disputes regarding the composition of the state remain unresolved. By dividing the country politically along ethnic lines, the peace deal that ended the conflict also embedded into Bosnia's new identity the very nationalist ideologies that caused the war.

Four different layers of government bodies—a directly elected tripartite presidency, an executive branch (the Council of Ministers of Bosnia and Herzegovina), a bicameral parliament (the Parliamentary Assembly of Bosnia and Herzegovina), and the autonomous local government structures of each of Bosnia's two entities (the Federation and the Republika Srpska)—have cemented these divisions into place, creating gridlock. The overall result is a hugely complicated, deeply inefficient form of hybrid governance, dominated by sectarian politics in which the Republika Srpska still angles for separation, Croat parties agitate to leave the Federation, and Bosniak, or Bosnian Muslim, politicians struggle for a greater share of central power.

Some manifestations of the state's internal divisions are laughable. Bosnia's competing authorities, for example, have never managed to agree on the lyrics for the national anthem. In the wake of the country's declaration of independence in 1992, Bosnia's first national anthem was "You Are the One and Only." But that was scrapped after the war because of complaints by Bosnian Croats and Serbs that the song only represented the Bosniaks. Next, in 1999, Bosnian authorities adopted another anthem, "Interlude." This time they were unable to agree on lyrics. In 2009, hoping to have found compromise, a parliamentary commission accepted a text that ended with the rousing invocation, "We're going into the future together." But the parliament never approved these lines either—so the matter remains unresolved, the anthem wordless.

Others aspects of Bosnia's division have more damaging long-term implications. Much of the country's schooling system is segregated along ethnic lines so that even in the Bosnian Federation, Muslim and Croat students often study different syllabi, with inevitable consequences. And since the opposing parties can find no agreement on the narrative of the 1992–95 war, school curricula commonly exclude the subject.

"We can all agree that 'the war was bad,'" surmised Enes Muslimović, a 24-year-old Bosniak photographer who was born 12 days after Croatian HVO troops murdered his uncle, a captured Bosnian soldier, in November 1993. "But beyond that, the divisions still run strong." (I visited his family in 2015 when I was writing a follow-up to their story, which I had first reported during the war.)

Good-humoured, astute, and engaging, Enes spoke without bitterness and talked easily of meeting up with Croatian friends at the local nightclub, Tron, where young Bosniaks and Croats, whose fathers had slugged it out in a bitter and bloody war a quarter century earlier across front lines just a hundred yards away, now drank and danced together, seemingly untroubled by the ghosts of war.

But Enes's voice wearied when he spoke of Bosnia's segregated schools and the inability of members of each of the three main communities to reach beyond their own experiences to find common understanding.

"No one is ready to criticize their own side's actions in the war," he said. "And with so much of schooling segregated, if conflict ever begins again, it will be much easier to form battalions along sectarian lines. Just march them out of class straight into their units."

This younger generation of which he is part, the best hope for Bosnia, is leaving the country in huge numbers, voting with its feet against stagnated politics and a declining economy. Bosnia suffers the world's second highest youth unemployment rate at 47.4%.

That statistic is just one figure in a trend of overall decline. Other figures are equally gloomy. Bosnia's population has dropped by a fifth from its pre-war number; deaths outnumber births; and the country's current rate of outgoing migration is so extreme that it now lies in 16th place in the world for per capita emigration, a rate of exodus that far exceeds that of any other Balkan country.

Given this egregious list of contemporary ills, it is no wonder that undercurrents of the war still run long and deep, and that peace can be defined more as an absence of fighting than as a stable progression to a better future.

Yet despite it all—amidst all the unhappiness and discord—I found innumerable individuals, such as Irena Omazić in Vitez, who were determined to engage with the issues of reconciliation as an act of conscious personal choice, rather than submit to the easy dictates of hate.

Some survivors found that a need to embrace life required them to relinquish bitterness; others found that the values their families instilled gave rebirth to tolerance. Many found that working alongside members of another sectarian group eventually palliated their anger. Others set aside their grievances by deferring punishment to a celestial power.

"I can say I feel a sense of peace not because of anything anyone else has done to bring peace to Bosnia—screw them," said Irena, outlining her own path towards tolerating the men who killed her father. "Peace has come about through various influences at home: through my family's influence; through my own identity; through religion; and maybe through education, though education is last on the list, as it was segregated."

She paused.

"But when I think about my father's last moments and when I wonder

what his last words were, ," she says, her tone shifting, "it comes back to me and I can't breathe. The weight returns."

"THE TRUTH IS SOMETHING IN PEOPLE'S MINDS"

Walking through the aftermath of a massacre one autumn afternoon in 1993, I encountered three dead women, eyes open, staring outwards from the open trapdoor of a grain pit. One had been shot repeatedly in the chest, the other in the throat, the third in the mouth. They were bunched tightly together, seated shoulder to shoulder, and had linked their arms in comfort and solidarity to face their deaths.

All Muslims, they had been killed in an outhouse in the village of Stupni Do when Croatian HVO troops overran it on 23 October 1993. In total the troops slew 37 people in the ensuing massacre. The youngest victim was two years old.

What I did not know until much later was that there had been a survivor in that pit. In 2017, 24 years later, I sat in a café in Vareš, a run-down industrial town that had once been a major center for iron ore mining and steel production, and spoke with Mufida Likić, who as a 14-year-old girl had hidden beneath her 21-year-old sister, Medina, in the pit. Mufida had already been bleeding from a wound to her left leg, incurred when the troops shot her earlier as she ran for shelter. She lay concealed, wounded and in silence, as they slew her sister, along with her aunt and her cousin. Mufida waited an hour buried beneath the dead, until she was sure the killers had gone. Then she scrambled from under the bodies and stumbled outside, moving uphill towards the forest, where she met up with other survivors.

Fourteen years later, she testified at The Hague in the 2007 trial of two Bosnian Croats, Milivoc Petković and Slobodan Praljak, both of whom the International Criminal Tribunal for the Former Yugoslavia (ICTY) subsequently found guilty of multiple war crimes, including executive involvement in the massacre at Stupni Do. They were sentenced to jail for 20 and 25 years, respectively.

The judicial saga continued when, on 29 November 2017, one of the convicted men, Praljak, swallowed a vial of poison and died when the ICTY rejected his appeal of his sentence in one of its final acts.

Following Praljak's suicide, the president of the Croatian Bishops' Conference condemned what he called the "unjust verdicts" of the international court and suggested the charges against the guilty men were false. "We have to live well with each other and cooperate," said Archbishop Želimir Puljić of Zadar, Croatia, "but we can't build a future when lies are told about our history."

Such powerful statements, by powerful figures, reflect a persistent culture of denial. Despite this atmosphere, Mufida said she felt that the court at The Hague had afforded some sense of relief to victims of war crimes. It had allowed them a sense of being heard.

"I was a 14-year-old girl who for many years carried with me the memory of being chased, shot, pursued, then of hiding beneath my sister who was killed above me, before escaping a flaming village," she said. "To be able to stand up

in court and say, 'This and this happened,' to be listened to, helped me. But if I wanted a greater sense of relief, I did not really find it. What I got instead was the sense of partial justice."

Resolution 827 of the UN Security Council established the ICTY in May 1993, specifically to try crimes committed in the territory of the former Yugoslavia. The court was located in The Hague, and during its 24-year existence, it indicted a total of 161 persons. It issued its final judgement in November 2017.

Originally the ICTY promoted the view that its work would contribute to reconciliation in Bosnia by illuminating the guilt of individuals—as opposed to generating a sense of collective responsibility for a particular sectarian group. But this aspiration was largely defeated, at least in the short term, by the manner in which nationalists in Bosnia hijacked ICTY verdicts for their own political goals.

As the overwhelming majority of the accused in Bosnia were Serbs, it became easy for the Bosnian Serb leadership to advertise the ICTY judgements as a conspiracy against Serbs, nullifying the ICTY's hopes of reconciling through the acceptance of a common truth and instead rooting perception of the court in national myth. The leadership of the Bosnian Croats remained equally convinced that the court exaggerated its own lesser role in war crimes for political reasons. Meanwhile, many of the Bosniaks, conveniently overlooking their own side's involvement in atrocities, focused instead on the greater criminal activities of their foes, defining their relationship with Bosnia's Serbs entirely through the prism of the genocide committed against them. This was exactly the opposite of the ICTY's original intent.

I was especially struck by this when I met, in 2017, Momčilo Krajišnik, a leading wartime Bosnian Serb nationalist. The ICTY had sentenced Krajišnik to 20 years in jail, and he was released from prison in 2013 after serving two-thirds of his sentence.

"There is no 'truth' here!" he insisted. "The truth is something in people's minds—it is an illusion in Bosnia."

Along with Radovan Karadžić, Krajišnik co-founded the Srpska Demokratska Stranka (SDS, Serb Democratic Party) in 1990 and was a key figure in the presidency of Republika Srpska throughout the war. He was arrested in 2000, and in 2006 the ICTY found him guilty of crimes against humanity.

"History is written by the winners," he continued, smiling and unrepentant, at his office in Pale, the Bosnian Serb stronghold above Sarajevo. "You from the international community made the truth here. The ICTY did not succeed, as there are three perspectives on truth, and Serbs, Muslims, and Croats each regarded their own fighters as heroes."

Krajišnik's opinion notwithstanding, supporters of The Hague tribunal suggest that future Bosnian generations may one day recognize the information acquired during ICTY investigations as fact, and therefore understand a truth essential for the affirmative remolding of their country. The tribunal's proponents hope that Bosnia's experience may eventually parallel that of Germany in the 1960s, when young Germans reshaped their nation by acknowledging their parents' Nazi past.

As yet, there is little evidence to support this hypothesis in Bosnia. By the time the court wound up in 2017, Judge Carmel Agius, the ICTY's president, underscored

the importance of truth in the healing process but acknowledged that the UN court had limited power to effect reconciliation. "We are closing the door, but we are giving you a large collection of determined facts," he said. "We are giving you the truth about what happened. However, we are not offering reconciliation, because it has not been the mandate of this court to do it. We have not dealt with it at all."

Yet many Bosnians have themselves discovered various degrees of reconciliation in the years since the war.

In Mufida Likić's case, the outsider status of the perpetrators of the Stupni Do massacre was more important in allowing her to live amongst local Croats after the war than the limited satisfaction she felt on learning that a few of the guilty men had been imprisoned at The Hague.

Croats and Muslims had enjoyed exemplary relations in the Vareš municipality, which includes Stupni Do, even after the start of war in Bosnia. It was not until the arrival of extremist Croatian paramilitary groups in the autumn of 1993—they were sent in from elsewhere in Bosnia—that the communities began to divide. These strangers committed the massacre and left the area once their task was complete.

"It took me a long time to start speaking to Croats here again normally," said Mufida. "Years. But I understood that the killings were done by people from outside of our community, not from within. And that really helped in allowing me to start the process of reconciliation.

"But forgiveness?" she posed. "Nema. [There is not.] Maybe one day. Everything is possible. But not yet. Not forgiveness."

RELINQUISHMENT OF LOATHING

Bosnia does not have any national initiatives to foster reconciliation. As I spoke to various survivors of the war, I came to see that the ability to reconcile instead originated from a variety of different and sometimes overlapping personal reasons. Some, like Mufida Likić, discovered that, despite their extreme trauma, local conditions and the historical harmony of a mixed community led inexorably to a process of reconciliation. Others expressed their drive to reconcile as a necessity without which they were unable to re-engage with life.

Kemal Pervanić is one of the best known and most eloquent survivors from the Omarska concentration camp, where Serbs detained 6,000 Bosniaks and Croats during their purge of the Prijedor area over a five-month period starting in spring 1992. He described his own path to redemption as a journey of several stages, lasting years, in which he moved from a sense of victimhood—characterized by feelings of

hatred towards his torturers in which he fantasized about killing them—through a stage of reconciliation, and eventually to forgiveness.

"Reconciliation comes before forgiveness," he told me when we met in London in January 2018. "In our language, if you literally translate 'reconciliation,' the word is *pomirenje*, which really means 'to make peace.' This precedes actual forgiveness."

Kemal was held for 10 weeks in Omarska, a period in which hundreds of inmates from the camp were killed, either dying of torture at the hands of Serbian guards or removed during the night and executed, their bodies buried in one of the scores of mass grave sites located in the Prijedor region. (In total, thousands of Bosniaks and Croats were murdered in Prijedor in 1992.) Today he devotes his work to reconciliation and peace-building in the region.

Unlike Mufida Likić, who suffered at the hands of strangers in Stupni Do, Kemal Pervanić counts amongst those who terrorized him former classmates and even a teacher from his secondary school. The horror was more intimate and the inheritance of hatred harder to resist.

His own choice to embark on the road to forgiveness was, he told me, partly initiated by the desire to live his life to the fullest, and partly by a rejection of the bleak alternatives offered by continued bitterness.

"I don't think that after that type of experience you can live a normal life unless you are able to forgive," Kemal explained. "Unforgiveness is an internal corrosion. If you are not able to forgive, then you become the center of the entire universe. Everything revolves around you. You are still really a victim, and victimhood is the most dangerous state of mind. It makes you justify all different acts, which are really unjustifiable."

Kemal pronounced the terms *reconciliation* and *forgiveness* with careful deliberation and nuance, noting that the first was a form of acceptance of the desire to live together again, utilising memories of what had happened in the war in an affirmative way. The term *forgiveness*, he added, involved a relinquishment of loathing in a process that began internally and progressed, eventually extending to those who had abused him in the Omarska concentration camp.

"You can't reconcile with others unless you reconcile with your own past first," he said. "You have to make peace with yourself and your own past. You choose. And it is a choice: do I want to stay a victim for whatever reason, maybe because I feel more comfortable in that place, or because I am too afraid of a better life?"

He described a sense of internal burden in the aftermath of war, which other survivors I talked to echoed. That weight only truly shifted when Kemal had a eureka moment of forgiveness alone in the shower, many years after he had started working towards reconciling with local Serbs, including his abusers.

"It was like being cleansed," he said. "I just said, 'I forgive you.' The feeling that came with it was a moment of elation. You feel so light without knowing that you felt so heavy to carry this burden. At once that moment enabled me to get rid of that burden. I chose to forgive and I have to live by it. I did say consciously, 'Yes—I forgive all of you.' But there was a long process before that."

The process had included a face-to-face meeting with the former secondary

school teacher who had interrogated him in Omarska. The two met face to face in 2002, an encounter Kemal recalled as "really unpleasant." At first, the man tried to evade his own responsibility for the abuse of Kemal and others. Eventually, though, in a circumspect manner, he discussed the concept of forgiveness.

"In the context of that conversation he was asking me for forgiveness," said Kemal, "even though he was saying all the time 'Not my fault, not my fault.'"

ELECTIVE AMNESIA

The Prijedor region poses specific challenges to reconciliation. Unlike Vareš, where the war crime was a one-off event perpetrated by outsiders, in Prijedor the overwhelming majority of Serbs involved in the protracted incarceration, torture, killing, and burial of prisoners were local men, and the area has the highest number of convicted war criminals of anywhere in Bosnia. Yet despite the flagrance and mass scale of the 1992 killings, today many Serbs living in Prijedor prefer ignoring the truths of the past rather than confronting them. Some even deliberately conceal them.

"It is better not to talk about these things," said Rada, a local Bosnian Serb woman in her 40s, standing near the scene of the infamous Keraterm massacre site in Prijedor, a former ceramics factory where at least 150 Muslim men were murdered, machine-gunned by Bosnian Serb police during the night of 24 July 1992.

"We are all good people, but somewhere we got broken," Rada added. "We need psychologists. We became insane. But really it doesn't help to discuss the past. We should put that ball down and just get on with the rest of life."

As she spoke, a Bosniak man, whose own father had died in the massacre there, offered her ICTY documents he held in his hand, detailing the crimes of the wartime president of Prijedor municipality for his role in the killing and incarceration of Bosniaks at Keraterm. Rada remained intransigent. "A lot of bad things happened to both sides, and I don't want to talk about it now or read your documents," she insisted. "We are not realistic neighbours and we cannot reconnect again."

Just as Bosnians share no common narrative in recalling the war, in Prijedor they are divided as to how to remember its victims. The city has held an annual commemoration of victims of massacres there, White Ribbon Day, on 31 May each year since 2012, but attendance is low. And local Bosnian Serb authorities have not agreed to the establishment of a memorial to the 102 children killed during the war, let alone to the thousands of adult victims of the purges.

However, some young Serbs have begun to question their recent history and the behaviour of their parents' generation in Prijedor during the conflict. After all, some facts are hard to ignore, such as the 2013 census, which showed that the conflict reduced the municipality's pre-war Bosniak majority to a 32 percent minority.

"We believe in 'responsible recall,'" said Branko Ćulibrk, 31, a founding member of Prijedor-based NGO Kvart, which works to spread a message of reconciliation through local youth groups.

Ćulibrk, a Serb, lost his father during the war. A paramilitary fighter, his father was killed in action. He said, "Largely the young here don't think they have an obligation to remember the past, based on the rhetoric of Serb authorities who tell them to look to the future. But you cannot create a proper future without acknowledging the truth of the past."

Kvart has had some success in engaging the emerging generation with the topic of the war through workshops and summer camps, but the NGO remains an isolated outpost in a sea of elective amnesia. People have twice assaulted Ćulibrk for his work and broken the windows of Kvart's offices with bricks.

"Friends say, 'Branko—you are crazy! How can you try to revise what we fought for when the Muslims killed your father?'" he said, smiling. "I tell them that I don't know whose bullet killed my dad, but anyway it's not a reason to hate anyone."

RESPONSIBLE RECALL

The pattern of individual reconciliation in Bosnia is unlikely to move the nation to a more positive future without political momentum and widespread recognition of a single, fact-based wartime narrative. Yet in a land crippled by the worst efforts of the divisive political elite, it still seems remarkable that so many people have attempted to take their own road to reconcile themselves with the past. Defying political paralysis, this human factor has produced survivors capable of holding their gaze and saying "Good morning" as they recall the personal horrors of the war, while yesteryear's war criminals drop their gaze to the ground in shame. The pattern is far from universal, though. While some Bosnians have chosen to grapple with reconciliation, others have been unable to break free from prejudice and loathing. Though the Dayton Accords halted the war, acts of hatred remained common long after the cessation of military hostilities.

Sometimes messages of hate have come as single, searing acts. When the Fako family returned to their family home in Ilidža, a suburb of Sarajevo, in the spring of 1996, months after the Dayton Accords, one Serb went to extraordinary lengths to make them feel hated.

The family is Muslim intelligentsia. Džemal Fako was an economist, 50 years old, when the war began descending by stages into the city. His wife, Atija, one year his junior, was a professor. They have a son and daughter: Amel and Amela, who were 22 and 25 years old, respectively, at the conflict's start.

When the fighting started in April 1992, they had a lucky escape, as Ilidža became the focus of activity for Serb paramilitary groups, and during the purge of the suburb many Muslims were arrested and later killed. Fleeing into the government-held area of central Sarajevo with little more than a bag between them, they survived the war, though paramilitaries burned Džemal's elderly parents to death in their home in eastern Bosnia during the first summer of the conflict.

On 10 March 1996, four months after the signing of the Dayton Accords, Amela and Atija returned to their home for the first time since the war to see how it had fared. A Serb family had been living in it for the duration of the conflict and had left just ahead of the owners' return, taking everything with them, including

all the furniture, the washing machine, the Volkswagen car, skis, and Amela's accordion and Amel's guitar.

However, in the interim of three days between the Serb family's departure and the Fako family's visit, someone else had entered the building. When Amela and Atija went into their gutted home, they found that an intruder had hung a family portrait at the top of the stairs. It was the only family artifact remaining in the bare house. The photograph, taken years earlier, showed Amela and Amel standing on either side of their parents.

The picture had been defaced. Ron Haviv's photograph of this defiled image—so inanimate compared with the action and movement in many of his photographs from Bosnia—is a still-life study of indelible and searing hatred, made all the more chilling by the controlled erasure of each Fako family member's face and the drawing of a single line—a stake—through each body. The image visited the intimacy of loathing upon the innocence and affection of a family unit.

"It was so full of hate," recalled Amela, who saw it first as she climbed the stairs. "The hate and anger was very, very precise."

The family still keeps the photograph hidden in the bottom of a closet as testimony to the era's darkness. Now married and a mother, Amela has consciously raised her own children to avoid the hatred of the war. She and speaks forcefully of her hopes for her children's generation, wishing that they might to break the cycle of sectarian division affecting Bosnia.

But the family also acknowledged the complexity of the word "forgiveness."

"What does it actually mean to forgive?" asked Atija. "Whom am I to forgive? Someone personally, or people in general? I would really like my former Serb neighbors to come back here, have coffee with me in my home, and talk honestly about what happened. It would be easiest for both of us. But that won't happen. We are no longer in contact. The efforts made to divide us from each other succeeded in preventing us from speaking again."

"WE ARE ALL LOSERS HERE"

Not every perpetrator looks at the floor when confronted by an innocent. Across much of Bosnia, a form of gratuitous post-war loathing has continued even years after the war's end. This hatred has been especially prevalent in Republika Srpska, whose citizens never abandoned its desire to secede from Bosnia altogether.

Here it has remained commonplace for Serb communities living near the sites of mass graves to preserve the secrecy of their locations rather than divulge them to the authorities, even though by keeping silent the community extends the pain of the relatives of those murdered and buried in perpetuum. This retention of knowledge has become one of the most potent and shameful defacements of the nominal peace. Far worse than denial, it suggests taking glee in gratuitous cruelty.

In October 2013, Bosnian authorities discovered one of the largest mass graves in Bosnia, located outside the Serb village of Tomašica, just 20 kilometres south of Prijedor. At peak capacity, the grave contained the bodies of 596 Muslims and Croats. The site had remained secret for years because of the local villagers' continuing conspiracy of silence.

These secret gravesites included many of the infamous secondary burial locations in which Bosnian Serb units had relocated the bodies of murdered Muslims, sometimes several times over, in the effort to contaminate the trail of evidence against themselves—and to extend the distress of relatives.

Nedžiba Salihović, 66 years old when I met her on 22 November 2017, lost her husband and son in the infamous Srebrenica massacre of 1995.

Parts of her husband's body were found in two different gravesites, after Serbs had moved it from one to the other. She had last seen him at the Dutch UN base at Potočari in July 1995, where Bosniaks from the falling enclave gathered, hoping for protection.

"There wasn't time to say goodbye properly," said Nedžiba, remembering the moment she was put aboard a bus bound for Tuzla while Bosnian Serb soldiers took her husband away. "He just said to me, 'Take care of our sons.'" Two of those sons managed to escape through the forest, but the Serbs captured and executed 23-year-old Kiram. His body was recovered in pieces from multiple gravesites exhumed by forensic teams over the years. They found a head here, a finger there, a leg bone elsewhere. Eventually, in 2007, 12 years after the massacre, Nedžiba decided to bury the incomplete skeleton. "We'd found enough of him," she said, "to bury what had been found."

The first time she attempted to visit her home village in 1997, under protection of the United Nations, local Serbs pelted the convoy with stones. She returned to Biljača, where the family had lived until they fled to Srebrenica early in the war, in 2000. Yet even then, some of the Bosnian Serb villagers living there, despite having known her family in peacetime, sang songs celebrating the murder of Muslims.

"I didn't care," she said defiantly. "I was born here, I was married here, I spent a lot of my life here, and I returned without my husband or son. They were free to kill me if they wished."

She told me that her Serbian neighbors eventually agreed simply "not to talk about the war" with her, insisting that they had not personally participated in the slaughter. After that, relations had entered a nascent stage of reconciliation.

In Nedžiba's case, her faith, and the devolution of justice from the international criminal court to God, eased reconciliation.

"I did forgive," she told me, "and I hope that God will forgive, too. He is the final judge. I pray every day for the strength to keep forgiveness. I make myself hug

my neighbors. We are all losers here." Yet the hunger for spiritual retribution lingered close by.

"God will punish the guilty," she added. "When they are old and have grandchildren and think everyone has forgotten what they have done, when they are in the prettiest time of their lives, then God won't have forgotten what they did."

Bosnia and Herzegovina Now

by Ron Haviv

What happens when 3.5 million people suffer from post-traumatic stress disorder? What happens when a whole nation—forged from an imposed peace agreement, with opposing sides forced to live together—can't move beyond the past? Bosnia and Herzegovina is a country that continues to battle itself as it moves in a constant circle.

Memorials litter parks and hilltops. Conversations turn to politics and, at a moment's notice, back to the war. The political parties remain the same as those that brought the conflict to fruition. There is no agreed-upon history of the war taught in schools. Children learn old grievances from their parents, ensuring that for many the war will always be a dividing line. Stories from the 1990s now take their place alongside older tales of war, those from the 14th century to World Wars I and II. Repressed anger and hatred simmer just beneath the surface.

The pressing question: How can we use memory to move past the loss and create one nation for all Bosnians?

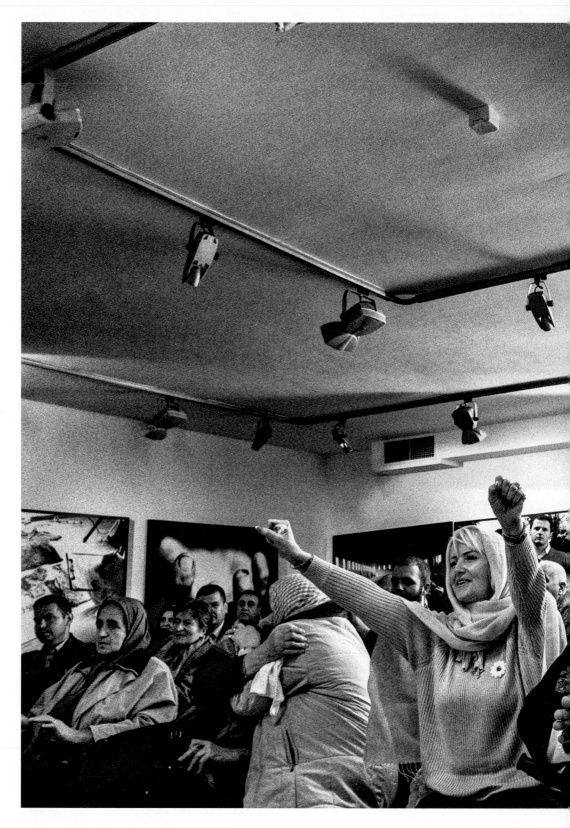

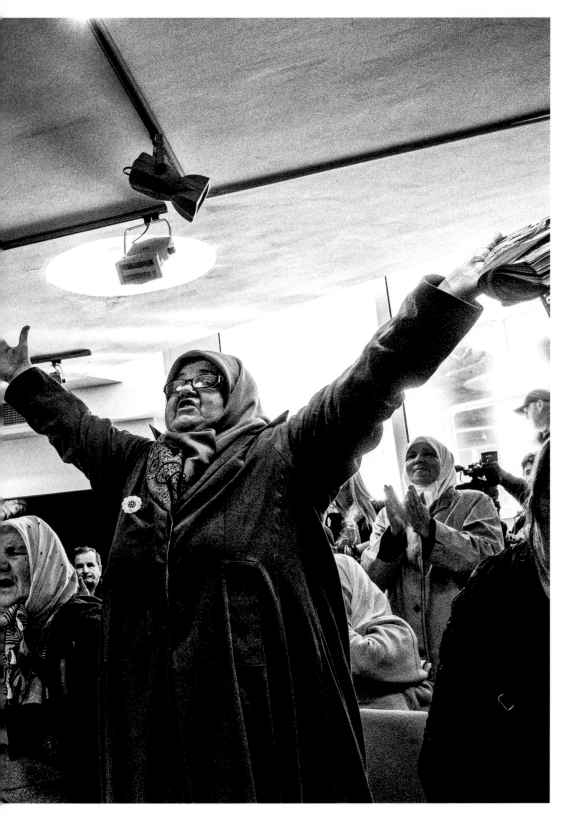

Bosnia and Herzegovina

Reportage

Pages 212-213: In 2017 Nedžiba Salihović and other Srebrenica widows celebrate the conviction of Bosnian Serb General Ratko Mladić for his role in the 1995 genocide at Srebrenica. Salihović lost her husband and son in the massacre. (See image of Salihović in a refugee camp in 1995 on page 195.)

Top: The cable car on Trebević mountain, Sarajevo, reopened in 2018, 26 years after the siege began.

The border between the Federation of Bosnia and Herzegovina and Republika Srpska.

According to the Dayton Accords of 1995, Bosnia and Herzegovina was constructed as a single sovereign state composed of two autonomous territories. Hoping to eliminate further ethnic conflicts, the accords determined that Muslims and Croats control the BiH Federation while Bosnian Serbs would control Republika Srpska.

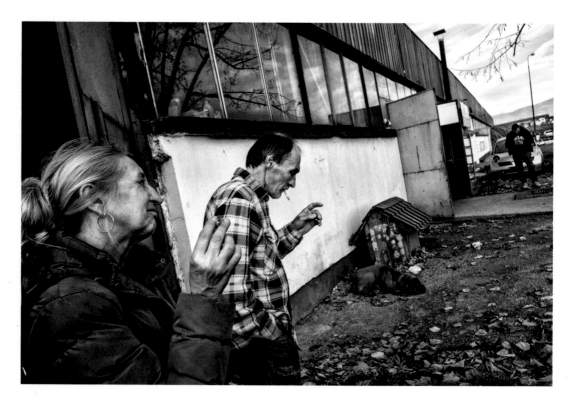

A Serbian couple runs an automotive shop on the site of the infamous Keraterm prison camp near Prijedor, Republika Srpska.

Keraterm was one of several camps in Bosnia's Prijedor region that operated in the spring and summer of 1992 holding about 7,000 inmates.

Bullet holes remain where prisoners were executed in the Keraterm prison camp in 1992.

Around 200 civilians at the camp were killed in one night in this space. See Elvis Garibovic's story, page 228.

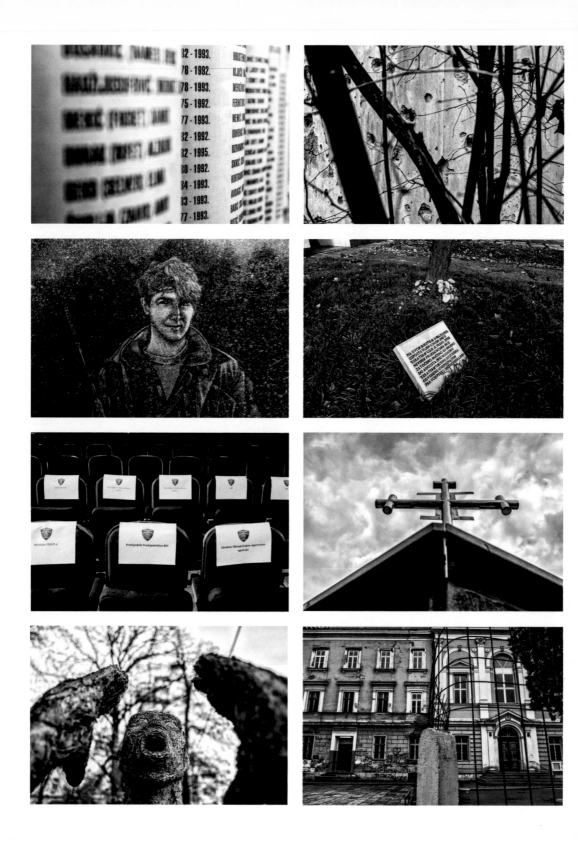

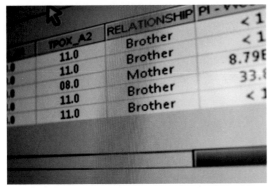

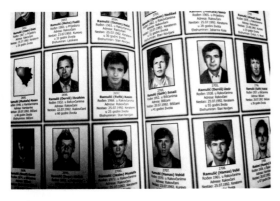

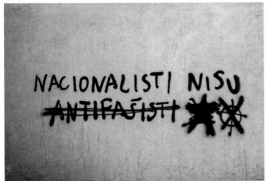

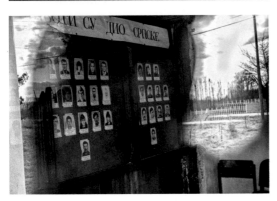

1. Names of children killed in Sarajevo during the war.

2. Grave for a young Serbian soldier killed during the war in the city of Pale, which overlooks Sarajevo.

3. An official ceremony for the Bosnian special forces. Each ethnic group in the tripartite government has its own cabinet ministers and presidents in duplicate positions, all looking to represent the interests of their own side.

4. A statue in honor of the genocide in Srebrenica.

5. Bullet holes from the war remain in buildings across Bosnia.

6. A memorial at the site of the Keraterm prison. Part of the writing says, "Over 3,000 innocent citizens of Prijedor were captured and tortured."

7. A cross honors Serbian soldiers lost during the war in Republika Srpska.

8. Two schools exist side by side in the town of Travnik—the Muslim school on the left and the Croatian on the right. They stand as a symbol of ethnic division for both supporters and opponents of the practice.

9. A screen shows DNA matches of relatives and victims at the office of the International Commission of Missing Persons.

10. Images of Bosnians found in mass graves, in the offices of the NGO Izvor in Republika Srpska. The NGO tries to "establish a culture of remembrance in the local community that carries a heavy load of war crimes."

11. Graffiti in Republika Srpska saying nationalists are not freedom fighters.

12. A memorial for Serb soldiers at the site of the Trnopolje prison camp.

13. A war memorial in honor of Serbian soldiers who died during the war, at the site of the Trnopolje prison camp in Republika Srpska.

14. A statue of a partisan fighter from World War II. Partisans fought the Axis Powers, with the end result that Josip Tito ruled over Yugoslavia.

15. The remains of a demolished Serbian graveyard. As different areas of the country came under the control of one of the two entities making up Bosnia and Herzegovina, each side destroyed what the other left behind.

16. A memorial for Muslims killed by Croats in Ahmici.

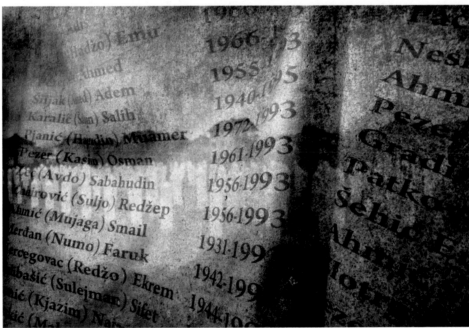

Top: An area inside Republika Srpska near the town of Prijedor, alleged to contain an unexcavated mass grave of Bosnian victims.

Bottom: Names of Muslim victims killed by Croats in Ahmici.

Top: A model of villages being built for Gulf Arab residents as vacation homes around Sarajevo.

Bottom: In the Bosnian city of Mostar, hundreds of people gather to pray after the suicide of Bosnian-Croat military leader General Slobodan Praljak, who was on trial at The Hague for war crimes.

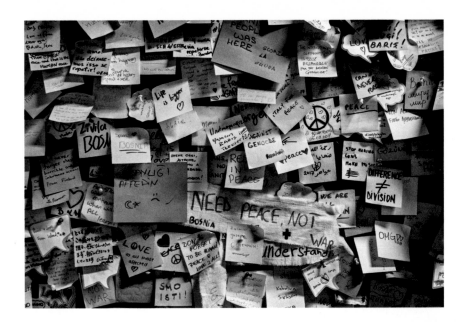

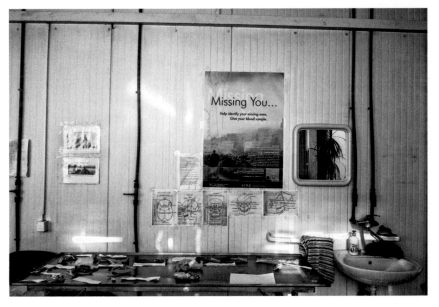

Top: A display of peace messages at the genocide museum in Sarajevo. War tourism forms a large part of the city's economy.

Bottom: Bones lie on a table at the International Commission on Missing Persons, in charge of identifying bodies found after the war.

Top: The youth of Sarajevo spend time in clubs and cafés, yet with the employment rate at nearly 50 percent for young Bosnians, those who can leave the country often choose to do so.

Bottom: Fashion models prep before a show by Bosnian designer Ena Dujmović for her 'Plusminus' brand. People around the world recognize the talent of Bosnian filmmakers, authors, and other creatives.

Top: Irena Omazić at the local bus station in Vitez. She often had to ride the bus to Sarajevo alongside the man who killed her father. In 2018, he was sentenced to 27 years in prison. See Anthony Loyd's story 'God Won't Have Forgotten.'

Bottom: Bosnians picnic at a war memorial site overlooking the city of Sarajevo.

Memorials abound for the war dead on all three sides and offer a reminder of the past. These sites, along with oral histories, carry on the legacy of separation.

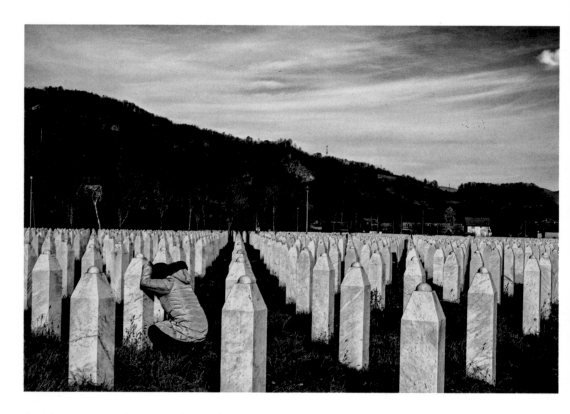

A woman mourns at the grave of a family member lost during the Srebrenica massacre.

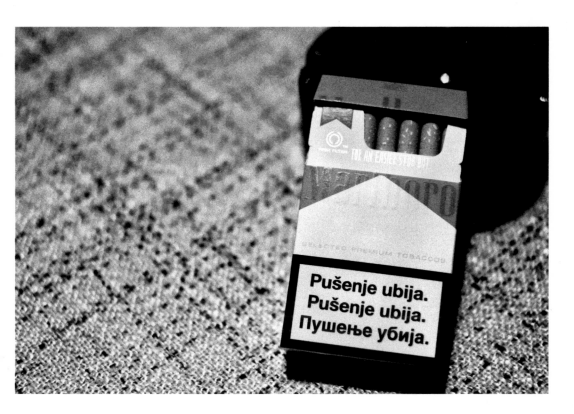

"No Smoking" warnings are printed in three languages: Bosnian, Croatian, and Serbian. All three phrases are pronounced the same way and mean exactly the same thing.

The Wolf You Feed 228

by Elvis Garibovic

I come from Kozarac, a Muslim village in the municipality of Prijedor in the northwest of Bosnia and Herzegovina. On May 24, 1992, the Serbian Army, which had seized military control of Prijedor on April 30, told all Bosnians and Croatians in the region to surrender. The war was raging across Bosnia, but as the Serbs had control of all media and utilities, we had been in the dark about the escalation of the conflict. We were given only one hour's notice before the Serbs started shelling. My village was one of the targets.

I was 19 and fled with my family; we were eventually evacuated to Sivci, another predominantly Muslim village within Prijedor. We stayed in Sivci till June 14, a Sunday. Early in the day, we were picking strawberries when Serbian forces arrived with T-84 tanks, infantry troops, buses, and trucks. One tank near us suddenly blew away a house 50 meters from us. The Serbs started taking all able-bodied men, leaving women and children behind. The day proceeded with Serbian forces shouting at us, people screaming, shots being fired, hand grenades going off, and tanks rumbling.

A small man from the Serbian Army started beating me while I was in line with the other men. I was a Muslim with an American name and therefore marked to be killed. I remember his steel-toed cowboy boots hitting the left side of my body—my stomach, my ribs, my shoulder area, my left arm. He was hitting me so hard that after a while his double-edged bayonet fell onto the ground next to my neck. The beating stopped only because he had to bend over slowly to retrieve his knife. Through my left eye, I could see his hand grabbing the knife. The blade passed next to my throat. There were screams, and then the blade disappeared.

My cousin was 18 years old at the time and behind me in line. Years later, he said, "I thought he was going to cut your throat." My reply: "Imagine how I felt."

We were bused to Keraterm, a former ceramic tile factory, where we were searched. All our belongings, money, documents, and keys were taken and thrown into a large brown cardboard box. Just over 500 people were taken that day, and dozens were killed immediately.

Keraterm soon developed a reputation as a concentration camp.

I ended up in Room 3, with my two brothers, cousins, friends, and other relatives. That room became notorious—regarded as the worst room in the camp. Well over 200 of us were crowded into a space the size of two garages.

Elvis Garibovic has survived the stuff of nightmares. Picked up by Serb militia in April 1992 as the former Yugoslavia unraveled and before the world had heard of ethnic cleansing, he was subjected to torture and extreme deprivation in makeshift concentration camps in Serb-held northwest Bosnia. Months later, a small group of journalists, granted fleeting access to the camps, broadcast his plight—along with that of thousands of other Bosnian Muslim men. Photographer Ron Haviv captured Garibovic's emaciated physique at the Trnopolje camp. (In Haviv's image, page 189, Garibovic has his back to the camera on the right side of the frame.) Garibovic, then 19, survived his ordeal, but it took years and moving to another continent for him to come to terms with the experience.

The crowd was so dense that if you fell asleep standing up, you wouldn't fall to the ground. Four of us managed to get a pallet that measured one meter by one meter. I had 0.25 square meters to stand or sleep on. All the windows and doors were shut; there was no fresh air, no food. We could hear the running of a tap somewhere and people begging for water.

The first morning, at 5 o'clock, one of the guards, Zoran Žigić (who was later convicted of war crimes), started asking who would like to go to the toilet. Five people lined up. He pulled out his handgun and started beating the first one in line on the head. The gun went off, and I got covered with blood. There was silence in the room. A man had been shot; he was still standing, missing the left side of his head, his hair and skin gone. Something white—what I think was the skull—was exposed. Then Žigić reloaded his gun. In the process, hair from the man's head ended up on the gun. Pointing the muzzle between the injured man's eyes, the soldier asked the man to remove the hair from the gun. "Slowly, slowly," Žigić said to his victim. The man survived the morning but was in a lot of pain. Days later, he was still lying on the concrete floor, maggots feasting on his head.

For three days, the Serbian guards relentlessly beat, killed, and tortured the detainees. The easy access to Room 3, with its two large metal doors, made it the logical choice for guards and soldiers who wanted to wreak havoc. Nights were the worst. It is so hard to close your eyes when all night you hear the screams of poor souls who are called outside of the room and then, meters from you, beaten, tortured, and shot. They always called for their mums while they were dying, not their wives, not their kids. Just for their mums, to hold them in their last moments.

Their final gasps for air echoed through the night.

Most of the time, friends of the dead would take them to the entrance so that we wouldn't trip on their bodies while moving around. We would make the guards aware of a body to be taken away, but on nights when the guards felt like beating us, there would be multiple casualties, so the dead ended up stacked next to the door, ready for collection. Eventually the guards would require us to stack them ourselves on the pallets in front of the camp. Later they removed those pallets, and black hearses took the bodies away. The Serbian soldiers were becoming more efficient.

A meal was served once a day around 3 p.m. This was usually a watery soup—if you were lucky enough to get that. I came to know that hunger is a constant pain in your stomach, a pain that takes years to go away.

Both of my brothers managed to escape the unbearable conditions in Room 3, moving to Room 2, the largest room in the camp, which eventually held more than 600 people. Moving required waiting for someone to die—dead body out, live body in. We wouldn't tell even the others in the room of our plans. (Your life could be sold for couple of cigarettes.) I am the youngest, and my middle brother was the first to move. He slept next to the entrance in Room 3, a high-risk spot, as guards would sometimes pass the steel door, fire a few shots into it with a handgun, and walk away. After sleeping there a few days, a young man in Room 2 died, just a couple of meters away from my brother, who swapped places with him. A couple of weeks later, my older brother left Room 3 by the same method. I was left alone. I knew I had a choice: sleep by the door or end up inside the black hearse.

In July, I went to Room 2 by moving into the space of someone who had been taken out and never returned. Days later, there was a massacre in Room 3. Around 200 people were killed in one night.

The morning after the massacre, my cousin was picked with four other men, given a square shovel, and taken back to Room 3 to clean it. The men found 5 centimeters of blood filling the entire room, clotted with fabric, skin, hair, teeth. My cousin said he would never forget the smell of death.

A large truck with a 12-meter insulated container was filled with dead bodies. Guards asked the wounded to come forward. They never came back.

The next morning, I passed the entrance to Room 3. A metal fire hydrant stood next to the door leading to the toilets, like a useless sentry. The walls were filled with thousands of bullet holes, and the metal doors were shredded by bullets as if they were made of paper. I touched the metal; both the fire hydrant and the exit holes in the doors were as sharp as razors.

—

In Keraterm, a couple of days after the massacre, July 26, I had my 20th birthday, the moment I learned the meaning and the power of *hope* and *will*. I wasn't prepared to gamble my life, so I started observing, learning, and evolving simply to survive.

I gave myself two weeks to live, as the starvation was causing my body to shut down.

On August 5, Serbian forces organized buses to transport us out of Keraterm. The first two buses they filled contained mainly Croatian men, then Bosnian men (I counted well over 100).

The next 12 buses (with 1,200 to 1,400 people) were destined for Trnopolje, which in English means "field of thorns." When I saw Trnopolje, I hoped it might be better there. We were thousands of Bosnian and Croatian men. Years later, the men from the first buses were all found in a mass grave.

In the first food line in Trnopolje, after my transfer from Keraterm, the person dishing out the food refused to fill the 10-by-15-centimeter plastic bag that I kept in my pocket for food. He said I wouldn't last the night, and he gave my portion to the next person in line.

Later on August 5, there was a commotion. People were rushing to the barbed wire fence. We saw a reporter lady trying to talk to people. Cameras were rolling.

In the following days, more photographers arrived, including Ron Haviv. Seeing them there, with two or three cameras slung around their necks, I

decided to take my shirt off, in the hope that I would get their attention and have my picture taken. Then my family would know the last place I had been, if I were to disappear as countless others already had.

I didn't realize how skinny I was until I took my shirt off.

I was ashamed of the way I looked, with all my bones sticking through the skin—my ribs, my spine, my skinny arms. The pain I had to endure to just stand up in the summer heat and have the photo taken is indescribable.

On August 21, another convoy arrived; we were told it was to take some of us to a free territory inside Bosnia. My two brothers and I managed to get inside the bus. But then a Serbian guard entered, took the safety off his AK-47, and said if we didn't get out he would kill us all.

Once off the bus, in a mass of pushing and shoving, I saw a Ukrainian man I knew from primary school. (His dad was the local barber.) I asked him if he could get us on the bus, but he said, "Elvis, please don't ask me." Then he turned away. After a while, the three of us brothers managed to get to the front of the surging crowd. We would be next to get back on the bus to freedom.

One of our Serbian neighbours appeared out of nowhere with an AK-47 pointed at us. He screamed at us to move back. We asked him to let us get on, but he was adamant. We could see there was more room in the bus. To our left, they had just let a group of nine get on. Then our Ukrainian neighbour turned the gun sideways and used it to push us back into the crowd. We watched the other lucky ones enter and wave goodbye. More than 220 men who rode on that bus were killed later that day on the Korićani

Cliffs, on Mount Vlašić—pushed into a 300-meter-deep ravine. Hand grenades followed them, just in case anyone had survived. Ten of them did.

Years later, after the war, my dad went to Bosnia and paid our neighbour, the father of the man who had pushed us away from the bus, a visit. The two fathers sat down and had a chat. My dad asked about that day. "My son knew what they were going to do to them," the neighbour said. "I hope they realised he knew."

The International Red Cross (IRC) arrived in Trnopolje at the end of August 1992 and registered all camp survivors. They told us there would be no more convoys. I was given the number 00 206 145. Before leaving Trnopolje, we signed documents stating that we would leave all our property to the Serbian side; otherwise they wouldn't let us go. The IRC took us to Karlovac in Croatia; I believe there were 1,512 survivors. We spent the next six weeks there. In an interview, an elderly British lady asked me where I would like to go. "As far from that hell as possible," I answered.

It was decided that a small group of us, about 30 people, would be sent to New Zealand.

———

On October 2, 1992, I became free. I think of it as my second birthday, when the new life started.

During the XIV Winter Olympics in Sarajevo in 1984, the mascot for the games was Vučko, a wolf common to the forests of that region. In fables, the wolf embodies courage and strength and symbolizes winter. When I left Bosnia, I felt that there were two wolves inside me, one nice and kind and caring, and the other

full of rage, hatred, and sadness. I wasn't going to let the bad wolf win; I did not feed him.

New Zealand was a perfect country to start fresh and to heal the wounds that eyes cannot see. It was so peaceful. It was beautiful. But the transition wasn't easy. I found it hard to talk to other young people—they were so immature. I had more decent conversations with their parents or grandparents. Getting a job was high on my list, and when I bought my first home at 24, I felt I was really settling down in New Zealand.

Years later, I met a most amazing woman, Linda. We have been together the last 18 years and have a daughter and three sons.

Five years ago, we decided to move to Australia, to start a new adventure and enjoy the outdoors. We bought a café, my wife's lifelong dream.

My children are all in school, and we are trying to be the best parents we can be, always encouraging them and raising them to be great people one day.

I am 196 centimeters tall, or 6 feet 5. The day Ron Haviv took my picture in Trnopolje, I weighed just over 60 kilograms (132 pounds). Today I weigh 110 kilograms (242 pounds), and I pump iron at the gym.

A day in a concentration camp is like a year of living normally. You witness major events each day, if you survive the day. You realize that you might be around for a few hours or a few days, so you make every moment count. You must answer the question, What kind of person are you?

I saw myself as Bosnian in a newly formed country with multiple nationalities, just as Croatians, Slovenians, Serbians, and Macedonians saw themselves in their own newly formed countries after the breakup of Yugoslavia. In today's Bosnia we call ourselves Bosnian, Bosnjak [also known as Bosniak], Bosanac, Serbian, or Croatian. We do not label each other by religion. The other side assigned us the term "Muslim," and I cannot define myself or any other people by their religion, whether Muslim, Catholic, Orthodox, or Jewish.

I met a Bosnian man in New Zealand who was an Auschwitz survivor. I could share my story with him, and he could share his with me. Since then, I have found a new level of understanding for Jewish people and survivors of the Holocaust. We have seen the cruelty of one human being toward another.

To forgive someone who has sent you to hell takes a lot of inner strength. Why does the victim have to be the one to forgive? Does that make him the better person? In whose eyes? Or does that make him weak so they can do it again? I can't see all Serbs as the same. As one is trying to kill me, another is saving my life.

I visited the Mauthausen concentration camp in Austria in 2002. I looked in the eyes of the detainees in a photographic display at the camp and recognized the look. I had it once. It was as if I were looking through their eyes, seeing pain, suffering, despair, sadness, hunger, but also *love, will,* and *hope.*

I have learned that talking about my experience is the best way to deal with it. It's important to make people aware that these things did happen. But I only tell the story to the ones who are *worthy*—the ones who are willing to listen, who are genuine, kind, understanding, the ones who can *love.* Only the ones who truly want to understand will open their hearts.

I returned to Bosnia to visit in 2002, and saw that I am among the lucky ones. I remember all the good people that are no longer walking on this earth. Many who survived are seeking justice. Many feel that they cannot find justice. Many find that they cannot move forward. Some choose not to. Some ask me if I plan to go back. My answer is simple: I paid an enormous price. I gave enough.

The Perils of a Peace Imposed

by Pedrag Peđa Kojović in
conversation with
Fiona Turner on the lessons
of the Dayton Accords

Fiona Turner: Say a little, if you would, about your personal story—about your transition from being a reporter to being a politician.

Predrag Peđa Kojović: When I decided to quit my job at Reuters and return to Sarajevo, I had no plans of getting involved in politics. I imagined my life as quieter, with more time with my partner, Kimberley Music, and with childhood friends, and with less stress. But I found it ethically unacceptable to live in my own social bubble and ignore the dominance of the right-wing politics and the negative economic, social, and psychological consequences that politics had on people. Some of my friends, including the film directors Danis Tanović and Dino Mustafić, felt the same way.

We felt that there might be some truth in the verses of Dante, who wrote that the worst places in hell are reserved for those who in a time of moral crisis keep their neutrality. We also felt that acting through civil society organizations or as public intellectuals is not a potent way to effect real change. Those who dislike revolutions and yet want to make real, substantive changes in a society could do so most effectively through the parliaments (there are multiple parliaments in BiH). So on April 5, 2008, we started a political party named Naša Stranka (Our Party).

Naša Stranka is multiethnic and is the most progressive BiH party. It has matured from a grassroots organization of pure dissent against the political establishment into the fastest-growing social-liberal party in the region and is now a full member of the Alliance of Liberals and Democrats for Europe (ALDE). We will, I expect, be part of the government after October's election.

On a personal level, I've found it interesting and somewhat disillusioning to see that very often what I as a journalist thought would happen, once the photo ops and staked-out statements are over, is not as noble or as serious as I expected. But I also now know how much could be done if you manage to win the trust of the majority of voters.

FT: What was the vision of the Dayton Accords and what were the agreement's basic flaws?

PK: Any agreement that stops the killings, the ethnic cleansing —in other words, the war—is an achievement worthy of praise. The Dayton Peace Accords, in that sense, deserve both our respect and our gratitude.

If not for Article IV, which became and is still the BiH Constitution,

Predrag Peđa Kojović lives in Sarajevo, where he was born to a Serb father and a Croat mother in 1965. When the country tore itself apart in the early 1990s, Kojović started reporting for Reuters, believing that if the outside world knew what was happening, it would instigate change. Disillusioned, after the war he left Bosnia, working as a journalist in the United States. Several years later he returned home to co-found Naša Stranka (Our Party), a progressive liberal party. In 2018, he won a seat in the national parliament. He argues that the Dayton Accords' rigid encoding of ethnic identity in the national constitution has effectively blocked progress toward peace.

British journalist **Fiona Turner**, who was a producer for ABC News during the war in Bosnia, asked Kojović to reflect on the conflict, the Dayton Accords, democracy, and the future of his country. This interview took place before the 2018 elections.

the Dayton Accords might be flawless. The first basic flaw of the Dayton constitution, as it is called on the street, is that in order to save vital ethnic interests, Article IV created a legal, procedural, and political nightmare. BiH occupies less than half the territory of New York State, yet the constitution divided a simple prewar state into two state-like entities. One entity is called the Republika Srpska, the other the Federation of Bosnia and Herzegovina. The Federation is further divided into 10 counties. Counties are then divided into local municipalities. There is also a town in the north, Brčko, that does not belong to either entity. It is its own district.

The Presidency of BiH comprises three people: a Serb from the Republika Srpska, and a Bosniak (Bosnian Muslim) and a Croat from the Federation. The position of president rotates every eight months among the three members. They have meetings where they vote on issues, and each of them has veto power. They each travel in a separate plane, drive in a separate motorcade, and have a separate little military welcoming unit.

This tripartite presidency is just the tip of a complicated, bureaucratized political model that suffers from all the ills of Eastern European inefficiency and corruption. Multiple governing bodies and hundreds of ministers—and more than 50 percent of the national GDP—are required to govern barely 3.5 million people. This model dictates the structure of every government body by rigid ethnic formulas. It gives members of parliament the right to veto even ethnically neutral legislation. It practically eliminates the most basic of all democracy principles: legislative decision-making by majority rule.

A second basic flaw is that the Dayton constitution defines BiH as a state of ethnic Bosniaks, Serbs, and Croats. This excludes more than 20 legally recognized national minorities, as well as a number of our citizens who express their identity simply as Bosnians or Herzegovinians. The constitution itself discriminates against citizens based on their ethnicity.

Unless you publicly declare yourself as Bosniak, Serb, or Croat, you cannot run for the presidency of BiH, you cannot run for certain legislative bodies, you cannot be an elected professor at a public university, you cannot get a job of importance in public companies, and you cannot serve in some governmental agencies. Furthermore, if you are a Bosniak or a Croat but you live in the Republika Srpska, you cannot run for the presidency. If you identify as a Serb and happen to live in a part of the Federation, as I do, you cannot run for president either.

I doubt that more than half of Americans would accept living under a constitution that barred its Hispanic, African American, and Chinese citizens from holding positions in government or that disallowed everybody but those of British, Irish, or German extraction to run for office.

The European Court of Human Rights, based in Strasbourg, ruled in 2008 that a constitution imposing such blunt discrimination on its citizens based on ethnicity is unacceptable and must be changed. But the leaders of the Bosniak, Serb, and Croat nationalistic parties ignored the court's judgement. For them, the existing system is perfect. It encourages political homogenization within every ethnic group and allows their parties to stay in power by manipulating the postwar traumas of their own people and spreading fear of a new conflict.

The fundamental error of the Dayton constitution, however, is the absence of ethics. The constitution legalized what the warring sides had achieved by military and criminal means—by the spurious policies of ethnic cleansing and war crimes, including the genocide in Srebrenica. After the war the Dayton Accords did not outlaw them but rather gave them an advantage, and ever since they have practiced politics as a continuation of war by other means.

FT: Can you give us an example you have personally experienced that illustrates why the larger system doesn't work?

PK: I was born in Sarajevo. My mother's ethnic background is Croatian; my father is an ethnic Serb. But my immediate family included Bosniaks and Montenegrins. My family paid no attention at all to somebody's ethnic or religious background. None.

To participate in the election in 2014, I had to officially choose my ethnicity, so on the form I circled "Serb." But as a result, as a Serb living in the Federation, I am prohibited from running for the presidency of BiH.

I am one of many who believe that having a single president elected by popular vote, even if most of his constitutional powers are transferred to government and parliament, would encourage a different and inclusive political rhetoric. That candidate would have to appeal to all citizens and all ethnic groups. This would be the first major step toward the healing of a society ripped apart by the war. The system we have now is pushing BiH in the opposite direction. It's dividing us more and more along ethnic and religious lines. And that is not how we lived here for many centuries.

FT: A key ingredient of a successful peace process is magnanimity in victory and no sense of humiliation in defeat. To what extent is peace in Bosnia flawed because no one can claim victory or defeat?

PK: The presidents of Croatia and Serbia met just before the war in BiH—a couple of times—in a restaurant in Karađorđevo, a historic city in Serbia. They drew a new map of the Balkans on a napkin and agreed to split the territory of BiH between themselves. The executors of this deal were to be the nationalistic political parties of Serbs and Croats in BiH, and the neighboring states would provide military, financial, and political support.

The proceedings at The Hague International Criminal Tribunal for the Former Yugoslavia established this aggression as factual truth. But the introduction to the Dayton Accords defined the war as a "tragic conflict in the region," avoiding qualifying it as an aggression on a sovereign state by Serbia and Croatia.

The nationalist parties found that definition satisfying because it allowed them to form narratives, new national myths, that suited them. Each of the warring sides created a distinct answer to the question "What happened in the '90s?" They presented themselves as heroic defenders of their ethnic group against the evil and barbarism of others. By controlling the media and educational curricula in postwar BiH, they created at least three opposing views of the war. We have yet to see if their propaganda effort, after more than 20 years, has made a deep, long-lasting impact in the minds and hearts of youngsters.

FT: What role has the international community played?

PK: A strong, unanimous political statement by the international community and a military "finger-four" flyover in the spring of 1992 would have stopped the war, and the recent history of the region would be completely different. After all, that is exactly what it took to stop the war, but only after 1,425 days of fear, hunger, and misery were endured, 1.2 million people were displaced, and 120,000 were dead.

The international community's governance of BiH is mandated to last until the country is deemed politically and democratically stable and self-sustainable. The country is still heavily dependent on both financial and political aid. The international armed forces are by far the strongest armed forces in the country. The High Representative of BiH, which acts on behalf of the Peace Implementation Council, has absolute power to interpret the Dayton constitution. The council comprises 55 countries and agencies that support the peace process in multiple ways. This international muscle makes it harder to understand why we are not moving in the right direction.

In the meantime, the very problems of nationalism, racism, and religious intolerance that members of the European Union and the international community are trying to solve in BiH have shown up in their own yard. This, I assume, weakens their hand and their resolve significantly.

FT: What role can public narratives play?

PK: It is unfortunate that public narratives in BiH are not aimed toward reconciliation among the people and reintegration of the country but rather toward the opposite.

The public narrative, the one that is dominant because the nationalists promote it, treats the horrors of the war as campaign material. The nationalists add salt to the wound by denying what courts have found to be true. They point to the crimes of the other warring parties while staying completely blind to the crimes of their own ethnic group. They thrive on making BiH dysfunctional as a state. This proves their point that we cannot live together the way we lived for centuries. They manipulate people's war traumas, playing with their post-traumatic stress disorder and fear of a new war, and use them for politics.

I have to say, regretfully, that these are successful political campaigns. The nationalists have been winning every election since Dayton. The EU seems to be OK with this approach. They shake the hands of these politicians, pat their shoulders, and smile during official photo ops.

The larger world, and the EU in particular, must bring a much more sophisticated approach and must withhold support—and stop the photo ops—with those who are willing to ignore internationally sanctioned truth for the sake of political power.

My own political party is working hard to express a different public narrative, to give voice to the alternative stories of real people.

In all the Balkans, only in the language of Montenegrins are there not one but two distinct words for "courage." One word, *hrabrost*, the more common one, defines bravery as an act of defending oneself from others. Self, of course, includes yourself, your family, and your city or your country. The other one, *čojstvo*, refers to the bravery of defending others from oneself. And that is the one that's been absent not only from the BiH dictionary but from its politics in all the years that followed the unfinished war.

FT: How do we stop passing grievances and prejudice down the generations?

PK: Some five or six years ago I was at a town hall meeting where I spoke with new members of our party in Srebrenica. After the official program was finished, I sat down for a casual talk with some of the new members. There was a middle-aged woman, an older man, and a youngish guy. The woman was so thin she seemed weightless. Her face was wrinkled by the horrors and hardships she had been through. Her husband, her sons, and her daughter, as well as many of her other relatives, had been killed or even executed during the war in Srebrenica. What kept her alive was her nephew. She held my hand in her lap as she spoke softly to me.

"I like you; I think you are a good man. If I was not scared that my murdered children would never forgive me for supporting a Serb, I would vote for you."

The young man said, "My father, a Serb, stayed in Srebrenica in our house, while most of the other Serbs left just before Srebrenica was surrounded by Ratko Mladić's troops. He even took a gun and joined the BiH army, which was almost 100 percent Muslims. Still, one night they came and took him to the police station and he never came back. We found his body only after the war, in one of those mass graves. He had been shot—that much we know, because there was a bullet hole in his skull. I hope they just shot him. I hope it was quick."

The woman started to cry. We sat in silence for a while.

"What do you do?" I asked the older man, who was bold, with a big belly and the nicest smile. "I make wine," he said, "berry wine. It's really good—you have to try it. It's becoming famous."

He got up from the table to get a bottle. "He runs a big company," said the youth while we waited for the older man to come back. "They have, I think, hundreds of employees. It's one of the very few places that you find work here."

"Who are 'they'?" I asked.

The young man said, "He has a partner, a Serb. They run this company together, and it's the only company here where Serbs and Bosniaks work together. Everything else in this town is split along ethnic lines."

The man came back and put a bottle of his wine on the table. It was named Malina (Raspberry).

"Open it when you get home, and let me know what you think," he said as he started wrapping the bottle in daily newspapers he'd found on the next table.

"I heard," I said, "that you have a partner, a Serb."

"Yup, my old prewar buddy. We do everything together. We have 400 employees."

"Were you here, during the war?" I asked him.

"Yes," he said. "I was in the Bosnian Army, until the end of the war."

"And where was he?" I asked. He was, of course, in the Serbian Army.

"Listen," he said, "I know what you are asking me, and I'll tell you this. You had to be in the army; everyone had to be in the army. I was in the army with my people; he was in the army with his people. But that's the war, that's what it does to people. He committed no war crimes, I committed no war crimes, and when we met after the war, we sat and talked, and we said, 'All those who have blood on their hands should be prosecuted and sentenced, and we who survived and did not hate anybody because of their ethnicity or religion should go on with life, rebuild this town, and try to live the way we lived before those nationalists poisoned the people and started the war.' Both of us, my partner and I, have children, and we want them never to experience what we have experienced. Never. All people need the same things: peace, security, a good job—and they need to study, so they will live better than we do now."

A brief silence engulfed our table. The young man commented on the absence of his generation in the town. "If you want to study, you have to go to either Belgrade or Sarajevo. There are no good universities here, only the private ones that practically sell diplomas. Serbs go to Belgrade to study and they never come back. Bosniaks go to Sarajevo and stay there, too. Why would they come back here? This is a black hole."

"It is," nodded the woman.

FT: As a politician, you must hold hope for the future. How do we prepare a better future for the next generation?

PK: They are our best and last hope. Elders are consumed by their war experiences. Everyone who was here during the war is wounded in some way. When you listen to the stories of rape and mass killings and meet people who lost all their family, lost everything they had, it's hard to see them imagining a brighter future, especially considering that on the streets, in their daily lives, they meet the perpetrators of those crimes.

It brings to mind Theodor Adorno's formulation that "to write poetry after Auschwitz is barbaric." But, really, it is a rhetorical position. We have no choice. We must write poetry. And it must be a poetry of hope and of "never, never again."

We were unfortunate to live in what Hegel called "congested history"—a time of major political tectonic shifts, of dramatic, large-scale, political, violent events. Ethnic cleansing, religious intolerance, state corruption, and nationalism filled the power vacuum after the fall of communism. History left all these things for the next generations of BiH as heavy, almost impenetrable obstacles to a better future.

No Mere Postscript: The International Criminal Courts

by Justice Richard Goldstone

Justice Richard Goldstone served as the first chief prosecutor of the UN criminal tribunals for the former Yugoslavia and for Rwanda, 1994–96. A judge in his native South Africa, he headed the Goldstone Commission, which investigated political violence in the country in the early 1990s. Goldstone has dedicated much of his life to investigating war crimes and international human rights violations, including those in Iraq, Kosovo, and Gaza. He argues that international criminal justice offers more than just a legal postscript to nations emerging from war. It can influence the path to peace, and it provides important solace to victims.

M odern international criminal justice began with the trials of the major German and Japanese war criminals, after World War II had come to an end in 1945. It was an era that saw aggressive war used to conquer European nations, racist policies that methodically wiped out millions of innocents, and the inhumane treatment of both civilians and war prisoners. The primary purpose of the trials was to punish those leaders who were responsible for committing heinous crimes that compromised human dignity. It was the hope that holding individuals accountable would allow societies to move beyond collective guilt and start to repair themselves. This hope was complemented by a belief that such trials would deter aggression in the future and therefore advance the cause of world peace.

That hope was destined to be largely frustrated in the decades that followed. Devastating wars continued to be fought—often within nation-states. Criminal attacks on innocent civilians continued to be perpetrated. Bitterness and grievances often prevented the healing of national wounds.

It is both difficult and unwise to generalise about the contribution of international criminal justice to the maintenance or restoration of peace. Context is all-important. Yet reviewing various experiences over the past generation does inform our understanding of the role of international tribunals.

The war crimes committed in the former Yugoslavia in the early 1990s led the Security Council of the United Nations to establish the International Criminal Tribunal for the former Yugoslavia (ICTY) in May 1993. Under international law, the Security Council could take that action only by using the peremptory powers conferred upon it by Chapter VII of the UN Charter, and only as a means to remove the threat to international peace and security that the ongoing war posed. In order to establish the ICTY, the Security Council had to link peace and justice.

The ICTY did not prevent the continued perpetration of serious war crimes. Indeed, the infamous genocide in Srebrenica in July 1995 was carried out on the orders of Radovan Karadžić (self-proclaimed president of the Republika Srpska) and Ratko Mladić (commander of the Bosnian Serb army), a few months after it was publicly announced by the ICTY that war crimes charges were being prepared against them for crimes including genocide and crimes against humanity. The indictment was issued on 25 July 1995.

However, the ICTY's indictment of Karadžić in 1995 set the stage for a gathering near Dayton, Ohio, in the United States, in November of that year. This was the conference that produced the agreement known as the Dayton Accords. Had Karadžić attempted to attend the conference, the US would have arrested him and transferred him to The Hague for trial. In effect, the indictment prevented an alleged war criminal from participating in the negotiations; this made it politically possible for the leaders of Bosnia and Herzegovina to attend. The Dayton Accords ended the war. The peace that has held for the past 24 years may have failed to bring stability to the region, but it has undoubtedly saved many thousands of lives. It is difficult, if not impossible, to determine the extent to which the ICTY's presence and investigations, whilst the war was raging, deterred the commission of war crimes, but certainly the

political and military leaders of Serbia, Croatia, and Bosnia and Herzegovina took explicit notice of the ICTY. On some occasions, they warned their armed forces not to commit war crimes.

Although the ICTY might have aided the Dayton peace negotiations, it has hardly reconciled the citizens of the former Yugoslavia. Lasting peace still eludes the people of the Balkans. But the evidence of hundreds of witnesses, and the many thousands of pages of analysis found in the tribunal's judgments, built a foundation of facts about the conflict of the 1990s. The Bosniak community of Bosnia and Herzegovina, from which came the large majority of victims, has generally embraced the tribunal's findings. On the other side, nationalism and populism have played a major role in encouraging many in the Serb and Croatian communities to question the legitimacy and findings of the ICTY.

More than a year after establishing the tribunal for the Balkans, in November 1994 the UN established the International Criminal Tribunal for Rwanda (ICTR). The ICTR brought to justice all the leaders of Rwanda who were responsible for the genocide and crimes against humanity committed in that country in the middle of 1994. The tribunal's work made it impossible to deny the horrendous killing of about 800,000 innocent civilians and played a role in publicly establishing the guilt of the leaders. Some of the relevant evidence and findings of the ICTR are presented at the Kigali Genocide Memorial Museum.

The work of the ICTR also allowed the Government of the Republic of Rwanda to turn to a form of traditional justice (*gacaca*) to investigate the guilt or innocence of tens of thousands of suspects who had been held in grossly inadequate prisons. Judged by modern international standards, gacaca was hardly a fair system of justice. However, it provided a solution to the intractable problem of bringing closure to the allegations made against the suspects. Today, there is no longer violence between the Hutu and Tutsi people of Rwanda. Whilst Rwanda is by no means a model democracy, peace and prosperity are manifest in the African nation.

Following on the heels of the examples in Yugoslavia and Rwanda, the Extraordinary Chambers in the Courts of Cambodia (ECCC) were established in 1997, two decades after the genocidal killings had taken place in that country. Domestic politics precluded the ECCC from playing a substantive role in bringing justice to those victims who were still alive, yet many thousands of Cambodians attended the hearings or listened to the radio and television broadcasts of the proceedings.

Other forms of transitional justice are able to give victims their due and bring peace to nations. The most obvious is a truth-and-reconciliation commission. It was such a commission that made public many of the horrendous crimes committed by the apartheid government forces in South Africa. The truth-and-reconciliation process helped South Africa ameliorate the political animosity and divisions of the apartheid era. Those divisions have not, by any measure, disappeared—the inequities in post-apartheid society are still all too present in the unequal society that remains, more than two decades after South Africa became a democracy.

———

The expectations held out by international criminal justice systems necessarily depend on the context in which they operate. In the case of the Nuremberg and Tokyo trials, the war had ended with the total surrender of Germany and Japan, respectively. The ECCC was established some decades after the Pol Pot regime committed the crimes. So, too, the ICTR was established after the killings had ended. On the other hand, the ICTY was conceived during the fighting of the war in the Balkans. For the first two years of its life, the ICTY operated during a bloody war, and from the end of 1995 it continued its work after the war had ended. It was again, albeit briefly, thrust into investigating a then-current war in 1999 when NATO used military force in protection of the Albanian population of Kosovo.

Whether such tribunals are established during war or in the aftermath of war, the benefits that might be expected from international criminal justice have been highly exaggerated. The cost of international courts is high and, often, the conviction rate is low. While the Nuremberg and Tokyo trials hardly covered more than the tip of the iceberg of the huge crimes committed during World War II, they did succeed in recording in detail the criminality respectively of the German and Japanese leaders and their armed forces. That has made it far more difficult for those who still seek to deny that criminal conduct or to rewrite the history of that period.

By the end of the 20th century, the successes of ad hoc and hybrid criminal tribunals were sufficient to encourage a significant number of states to support the establishment of a permanent international criminal court. The result was that 120 nations meeting in Rome agreed upon a statute for the International Criminal Court (ICC) in the middle of 1998. The Rome Statute required a very high threshold in order to come into operation—ratification by no less than 60 nation-states. Most supporters of the ICC feared that the requisite number of states would take a decade or more to ratify the statute. It took less than four years. Yet it is regrettable that the four most populous nations in the world—China, India, Russia, and the US—have not ratified the Rome Statute, primarily because of the importance they assign to their own sovereignty. Despite the fact that the ratification of the Rome Statute is incomplete, if there were no ICC in operation today, there would be a strong call from many nations to establish one.

The ICC has gotten off to a slow start. In 17 years, it has held very few trials, and it has not accomplished enough to enable a judgement on its effect on the maintenance of peace. However, Colombia provides an interesting case study. In 2002, the Latin

American nation ratified the Rome Statute. It would appear that the threat of prosecution by the ICC brought the government and some of the rebel groups, especially the Fuerzas Armadas Revolucionarias de Colombia (FARC, Revolutionary Armed Forces of Colombia), to the negotiating table. That, in turn, led to the ceasefire and eventually the peace agreement and the turning in of weapons under UN supervision. The FARC has become a regular political party and participated in the 2018 elections in Colombia. The peace is by no means secure—a sizeable proportion of the electorate rejects the peace agreement and calls for harsher punishment for those members of the rebel groups who committed crimes against the people of Colombia. Time will tell whether the hard work of the peace negotiators will produce lasting solutions. Regardless, the interventions and threatened investigations by the ICC positively influenced the leaders on all sides.

A most important lesson to be learned from the history of the international criminal courts and tribunals is that victims of massive crimes cry out for, and indeed demand, some form of accountability and justice. If that call is thwarted, there will be a cancer in that society which, sooner or later, will manifest itself in further cycles of violence. The history of the Balkans and Rwanda provides evidence in support of this assertion. To that extent, at least, justice mechanisms have helped maintain peace in a number of postwar societies.

A second lesson is that providing justice in the domestic courts of countries transitioning from war and oppression to democracy is too burdensome to practically accomplish within the countries themselves. No domestic system has the resources required to investigate, prosecute, and try tens of thousands of war crimes and human rights violations—especially given the number of crimes committed and the magnitude of those crimes. Furthermore, in many situations the most guilty are likely either to be protected by their supporters or to be the target of reprisals from their victims. Thus, we find no illustrations of effective domestic criminal justice mechanisms in the aftermath of massive war crimes and human rights violations.

Modern international criminal courts, in some circumstances, bring perpetrators to justice, and some also help maintain peace. But international criminal justice provides more than just a legal postscript to nations emerging from war. Its principal beneficiaries are the victims, to whom tribunals can provide some solace. In the end, the success or failure of tribunals should be judged by the real benefits that the suffering parties receive.

Martin Fletcher
Peace without Harmony

Gilles Peress
**The Battle for History
(1994–2019)**
Text by Chris Klatell
with Gilles Peress

Monica McWilliams
and Avila Kilmurray
The "Hen Party"

Peace without Harmony 252

by Martin Fletcher

O
n a cold, dank December afternoon in West Belfast, I join two young American tourists and an older couple from Cork at the foot of the Falls Road, the republican stronghold in this part of the city. There we meet Peadar Whelan, a former member of the Irish Republican Army (IRA) who served 16 years in Northern Ireland's notorious Maze prison for his role in the attempted murder of a police officer in the early days of the Troubles. He participated in the "blanket protests" of the late 1970s, when republican prisoners refused to wear prison uniforms and desecrated their cell walls after their political status was withdrawn. He was there in 1981 when Bobby Sands and nine other IRA prisoners starved themselves to death.

In 1997, **Martin Fletcher** arrived in Belfast on assignment for *The Times* of London to find, as he puts it, "the province claustrophobic, insular, and caught in a time warp." Three decades of the Troubles meant that McDonald's opened in Moscow before it came to Northern Ireland, foreigners were rare, and kneecappings were still common. Fletcher bore witness as republicans and nationalists on one side, and unionists and loyalists on the other, edged towards the historic Good Friday or Belfast Agreement in 1998. Two decades on, Fletcher returns to Northern Ireland to find that the political, social, and economic discrimination that fuelled the Troubles has gone. But peace building, as opposed to peacemaking, has a long way to go. Though the two communities have agreed to disagree without resorting to violence, there is little harmony, little in the way of reconciliation, and no common vision of the future. And over everything hangs the dark cloud of Brexit, threatening to unravel the 1998 accord and undermine the fragile peace.

Today, nearly four decades on and 60 years old, Whelan serves as a genial and amusing guide on one of the Troubles tours that introduce tourists to Northern Ireland's recent history. His language suggests his political views have scarcely mellowed. He shows us where, in 1969, "loyalist mobs" launched "pogroms" against Roman Catholic families at the start of the Troubles, "systematically burning their ways through the streets." He shows us the bullet holes they left in the red brick walls of St Comgall's Primary School. He shows us murals honouring the hunger strikers, and elaborate memorials for "IRA volunteers and civilians murdered by loyalist and British forces."

On Bombay Street, a front line in those early battles, a plaque commemorates Gerard McAuley, a 15-year-old boy shot by a sniper while helping Catholic families escape the loyalist incursion. He was the first IRA "volunteer" to die in the Troubles.

Bombay Street's neat terraced homes back on to a huge peace wall—a hideous concrete, steel, and wire mesh barrier more than 20 feet high that was erected in late 1969 to divide the republican Falls from the loyalist stronghold of the Shankill Road to the north. Their rear gardens are caged in with steel mesh. Whelan insists such protection remains necessary today. Loyalists still hurl missiles over the top of the wall, he says. On cue, a female resident walks past. I ask if she would like the wall taken down. "I'd like it higher still," she retorts.

Whelan then takes us to one of the few gates in that two-mile wall. There he delivers us to our second guide, who is his loyalist mirror image and asks us to just call him "Jim." Whelan ventures no farther into the Shankill. "I wouldn't take the chance," he says as he departs.

Jim is about the same age as Whelan and equally affable, though a little more reticent about his past. A former member of the

Northern Ireland

Reportage

loyalist paramilitary Ulster Volunteer Force, he also spent time in the Maze—15 years. "Murder was involved," he says coyly, adding: "Whatever I was asked to do during the conflict, I did."

Compared with the densely populated and relatively prosperous Falls, the Shankill is dilapidated, depressed, and scarred by wasteland. Over the next hour, Jim shows us why he "decided at the age of 16 to join an armed group." He leads us through dreary streets, past shuttered shops, to the sites of three pubs, a fishmonger, and a furniture showroom that were destroyed by "no-warning sectarian IRA bomb attacks," killing many innocent men, women, and children. "I'm sure your guide [Whelan] didn't tell you about any of this," he says.

A cross made of red metal poppies (flowers that have come to symbolise Northern Ireland's allegiance to Britain) marks each site. A plaque next to one proclaims: "In memory of five innocent Protestants slaughtered here by a republican murder gang." At another, a mural declares, "We remember the victims of Provisional Sinn Féin genocide," and denounces "30 years of indiscriminate slaughter by so-called non-sectarian Irish freedom fighters."

When I suggest that such angry words must make reconciliation hard, Jim replies, "They challenge the republican narrative of this conflict. We don't want people to forget what happened. Sinn Féin would say they didn't do these things, but they are rewriting history. They're masters of that."

The tour over, I hurry back to the city centre in search of warmth and sustenance, uncertain whether to be encouraged or discouraged by what I have seen. On the one hand, it is remarkable that tourists now flock to the Falls and Shankill Roads: within a three-mile radius of a small memorial park in the Shankill, no fewer than 600 people died during the Troubles. It is even more remarkable that former republican and loyalist paramilitaries, once mortal enemies, now collaborate to run these popular tours.

But a quarter of a century into Northern Ireland's peace process, I am also struck by the lingering hostility, by the persistence of two utterly conflicting narratives of what took place, by the seeming inability of both communities to move on. Nothing symbolizes this more than the continued presence of that grotesque peace wall, whose gates are still locked nightly.

Whelan's last words before handing us over to Jim linger in my mind. When I asked if he liked his loyalist counterpart, he replied, "He's a unionist. He has unionist beliefs. He wants to remain part of Britain. As a republican I want links with Britain broken. Whatever human, personal connection we might have, the defining factor is political."

I also recall Jim's astute observation as he ended his tour back at the peace wall: "Before this comes down, the walls in people's heads need to come down."

———

I first arrived in Northern Ireland, a province roughly the size of Connecticut or Yorkshire, as Belfast correspondent of *The Times* of London in 1997.

It was a grim place. Some 3,600 civilians, paramilitaries, and members of the security forces had been killed, and roughly 50,000 injured, during three decades of conflict between a Protestant majority determined that Northern Ireland should remain part of the United Kingdom, and a Catholic

minority that wanted Ireland reunited. The violence had left scarcely a town or village unscarred.

The IRA and the loyalist paramilitaries had declared ceasefires three years earlier, and a slow, tortuous peace process had begun, but the killings and beatings, the exiles and kneecappings, had not stopped.

On my very first day, Bernadette Martin, an 18-year-old Catholic girl, was shot dead as she lay in her Protestant boyfriend's bed in the loyalist village of Aghalee. Shortly afterwards another Catholic teenager, James Morgan, was abducted while hitchhiking in County Down, mutilated beyond recognition, and dumped in a water hole used for disposing of animal carcasses. Then a 79-year-old man, John Browne, became the oldest person ever kneecapped after republican thugs hunting a child molester in North Belfast broke into the wrong flat.

Heavily armed troops still patrolled the streets of what was probably the most militarised society in Europe. Slate-grey armoured police Land Rovers sped through cheerless housing estates dissected by hideous peace walls. The army bases, police stations, courts, and public buildings were veritable fortresses, symbols of the British state entirely cocooned within steel mesh cages.

Loyalists and republicans staked out their territories with flags, painted kerbstones, and murals that glorified their gunmen. As the loyalist marching season neared its climax on July 12—the anniversary of Protestant King William's victory over Catholic King James at the Battle of the Boyne in 1690—most law-abiding citizens either fled or stocked up and battened down until the inevitable mayhem subsided.

The province was claustrophobic, insular, and caught in a time warp. The Troubles meant that McDonald's had opened in Moscow before the franchise came to Northern Ireland, and the giant British supermarket chains had only just begun to move in. Foreigners were rare. Even the people of Britain and Ireland avoided the benighted place.

Northern Ireland was deeply patriarchal, with not one woman amongst its 21 members of the British and European parliaments. It was deeply conservative, with the fundamentalist Ian Paisley fulminating against "sodomites at Stormont" when Elton John performed at Northern Ireland's seat of government; a production of *Jesus Christ Superstar* was picketed for blasphemy. The sectarian conflict dominated the political agenda to the exclusion of social issues and isolated the province from progressive outside influences.

Then something astonishing happened. Sensing that the conflict had exhausted both communities, British Prime Minister Tony Blair and Irish Taoiseach (Prime Minister) Bertie Ahern threw themselves into the search for peace. Aided by US President Bill Clinton and retired US Senator George Mitchell, they refused to let the process be derailed by walkouts, violence, or heated standoffs over seemingly intractable issues. They persuaded leaders of Northern Ireland's rival communities—including David Trimble, the Ulster Unionist Party (UUP) leader, and Sinn Féin's Gerry Adams and Martin McGuinness—to

make previously unthinkable concessions. On Good Friday in 1998, after a marathon final negotiating session that lasted 33 hours, Northern Ireland's main parties reached an historic agreement to end Europe's longest conflict.

Nationalists and republicans on one side conceded that Ireland could be reunited only with the consent of the majority of Northern Ireland's people. Loyalists and unionists on the other side agreed to share power in the Northern Ireland Assembly at Stormont. Both sides undertook to resolve their disagreements peacefully. And while those who forged the Good Friday or Belfast Agreement fanned out to share its lessons in other trouble spots around the world, I moved on to Brussels—leaving behind a province suffused with a hope that its citizens had seldom felt before.

––––

Returning two decades later, I am pleased and relieved to discover that much of that optimism was warranted. Despite pockets of discontent, notably on working-class loyalist estates afflicted by high unemployment, low educational standards, and a sense of having "lost the war," Northern Ireland is unquestionably a far better place than the one I remembered.

The paramilitaries have certainly not gone away. Dissident republicans still target soldiers, police, and prison officers. Loyalist groups have mutated into criminal gangs more interested in drug dealing and extortion than fighting republicans. Both sides still administer brutal beatings and shootings to exert control over their working-class estates. In April 2019 dissident republicans provoked international outrage by shooting a young journalist, Lyra McKee, during a riot in Derry triggered by a police search for weapons.

But the level of violence has fallen dramatically and is very localised. The British troops, sangars, checkpoints, and helicopters have largely disappeared. The ubiquitous murals, which once portrayed menacing gunmen, tend now to be commemorative or cultural.

The new Police Service of Northern Ireland (PSNI) has replaced the tainted, over-whelmingly Protestant Royal Ulster Constabulary and is half the size. A residual legacy of mistrust means that the PSNI still struggles to recruit enough Catholics, but it enjoys a 74 percent approval rating and is overseen by a policing board that includes Sinn Féin. The PSNI patrols in un-armoured cars and no longer tolerates no-go areas.

The Maze prison, that potent symbol of the Troubles where hundreds of republican and loyalist paramilitaries were locked up in eight segregated, semi-autonomous H-blocks, has been closed and largely demolished. Belfast's Crumlin Road gaol, which also held hundreds of loyalist and republican prisoners, is now a museum and conference centre. The heavily fortified Andersonstown barracks, which overlooked a key junction in republican West Belfast, have been replaced by a community garden.

Belfast's loyalist housing estates are still run down, but the city centre has been transformed by gleaming new office and apartment blocks overlooking the

cleaned-up River Lagan and by shopping centres, chic hotels, smart restaurants, a concert hall, and a sports arena. All are built with large expanses of glass—a commodity whose use was necessarily minimised during the days of terrorist bombings.

In Derry, Northern Ireland's second-largest city, a highly symbolic pedestrian peace bridge now curves elegantly across the River Foyle, connecting the city's overwhelmingly Catholic west bank with the Protestant Waterside. It ends at Ebrington Barracks, the notorious former army base from which British paratroopers launched the Bloody Sunday crackdown on a civil rights march in 1972. Catholics once feared to cross the river, but today both communities mingle freely at the parade ground, which hosts concerts and festivals.

An economy fuelled by substantial US and European investment has bolstered Northern Ireland's sense of reinvigoration, though the province still has a bloated public sector and relies on a hefty British subsidy. Workplace discrimination against Catholics, a root cause of the Troubles, has been virtually eliminated. Foreign faces are common. So are cars with Irish number plates that loyalists would have targeted during the Troubles. Belfast now suffers from traffic jams, which it never did before.

Tourism—virtually non-existent 20 years ago—has taken off with Northern Ireland attracting a record 2.6 million visitors in 2016. The decision by cable TV's HBO to film Game of Thrones in Northern Ireland has given the province a huge boost, spawning a vibrant new film industry and luring tens of thousands of "Thronies" from across the world to the many spectacular locations where the series was filmed. (Parts of rural and coastal Northern Ireland are stunningly beautiful.)

Tourists also flock to the new Titanic Belfast museum, a monument to the city's industrial heritage, erected where the world's biggest ship was launched in 1911. The site was previously a wasteland, the RMS Titanic having been airbrushed out of the city's history because her sinking was a source of shame to the Protestant workforce that built her.

And what of those loyalist parades that used to spark such ugly confrontations every summer—particularly those of the Orange Order, which celebrate Protestant history and culture and which nationalists consider triumphalist? Today, all but a tiny handful pass off peacefully—thanks to a general weariness with confrontation, more local dialogue, and the rulings of an independent Parades Commission established at the time of the Good Friday Agreement.

Out of curiosity I return, one bright but bitterly cold Sunday morning, to Drumcree Parish Church, which stands amid fields on the edge of Portadown, an hour's drive south of Belfast. Back in July 1998, this was a war zone. The new commission had banned the local Orangemen from marching back to town along the nationalist Garvaghy Road, following their annual church service commemorating the Battle of the Boyne. Thousands of supporters poured in to help them complete a parade they had held every year since 1807, but one of the biggest military operations Northern Ireland had ever seen blocked them. Riots erupted across the province, and eight days of violence ended only when three young brothers died in an arson attack on the house of a Catholic woman living on a loyalist estate in Ballymoney, County Antrim.

Astonishingly, Portadown's Orangemen have made a token attempt to complete

their aborted march every Sunday since that occasion 20 years ago. On this Sunday, 19 of them, most now elderly and all wearing their traditional black suits and orange sashes, set off from the church at 1 p.m. precisely.

A hundred yards down the icy lane, where a bridge crosses a stream, a single police sergeant blocks their way. David Jones, the veteran district secretary of Portadown's Loyal Orange Lodge, delivers a pro forma complaint, telling the officer, "We shall continue to protest here because we believe we should have the same rights as every other citizen within the UK." The sergeant acknowledges the protest. The Orangemen then form a circle for a Bible reading and prayer; march back to the church, where they sing the British national anthem; and— in stark contrast to 1998—drive peacefully home to Sunday lunch.

That is it: no passion, no angry words, no confrontation. I feel I am watching an historical re-enactment, not a live political protest.

———

The physical and economic transformation of Northern Ireland is obvious, but after a few days back in the province I begin to realise that this new veneer of normality is misleading. Beneath the surface, several essential elements of peace—closure, justice, reconciliation, healing, and strong leadership—are still sorely lacking.

One afternoon I visit Anne Morgan, a retired teacher, in her detached home on the edge of Newry. She tells me her story in a living room festooned with Christmas decorations. She is the eighth child of a Catholic butcher named John Ruddy. The ninth was Seamus, who

joined the political wing of the republican Irish National Liberation Army (INLA) as a student and then moved to Paris in 1983 to teach English.

In 1985, a feud erupted within the INLA and Seamus disappeared. Months later, her brother's clothes were found in the Seine. There were bullet holes on either side of his jacket's hood and bloodstains on the collar.

For the next 14 years, Seamus's family lived in dreadful limbo, not knowing what had become of him. They could not talk openly of his disappearance for fear of INLA retribution. People avoided them. For the last decade of her life, Seamus's heartbroken mother sat at her window, looking down the street. "We feel she was waiting for him to come round the corner," Morgan tells me.

Then, following the Good Friday Agreement, the republican paramilitaries published a list of those they had "disappeared" for various alleged transgressions. Seamus was on it. A new Independent Commission for the Location of Victims' Remains was empowered to receive confidential information on the whereabouts of the 16 Disappeared, which could not be used in criminal prosecutions. One by one, the remains of fathers, husbands, sons, and a lone mother were exhumed from the bogs and beaches where they had been shot and buried two or three decades earlier.

An INLA leader summoned Morgan to Dublin and gave her a crude map of a Normandy forest with a cross where her brother was allegedly buried. The commission and French authorities twice searched the site and found nothing. In 2017 they launched a third search using advanced forensic techniques and fresh information from INLA sources. After four fruitless days, Morgan set off back to

Paris with her husband, only to receive a call on the train. Seamus's remains had been found. "We hugged each other and cried. It was unbelievable," Morgan says.

Back in Newry, Seamus was given the funeral he had been denied for 32 years, and buried beside his parents. For the first time, Morgan felt true happiness. She could enjoy herself without feeling guilty. "It means everything to me, knowing that he's not alone in a forest in France," she says. "Now I sing in the car at the top of my voice with the radio on."

Nobody would call the families of the 16 Disappeared lucky, and they certainly have not received justice, but they are fortunate in the sense that all but three of them now have some sort of closure. That cannot be said for most other victims of the Troubles, even though the Good Friday Agreement stresses the importance of healing after a long, bloody sectarian conflict such as Northern Ireland's. It states, "It is essential to acknowledge and address the suffering of the victims of violence as a necessary element of reconciliation."

There have been a handful of inquiries into high-profile killings, most notably the 12-year, £190 million Bloody Sunday inquiry, which exonerated the 28 unarmed civilians shot that day—14 fatally—and blamed the soldiers. Those conclusions had a huge cathartic impact on Derry and undoubtedly helped the city start to mend.

But for most ordinary people who were bereaved, injured, or traumatised during the Troubles, there has been no such process, and they have received scant compensation.

Successive reports on ways of dealing with the past have fallen foul of Northern Ireland's enduring political divisions. A team that was supposed to review each of the Troubles' killings was shut down in 2014 amid allegations of bias. Creation of a proposed new Historical Investigations Unit has been repeatedly delayed by arguments over issues such as calls for an amnesty for British soldiers and the withholding of evidence on national security grounds. Other efforts were also stymied, including a new information-retrieval process that would have allowed perpetrators to provide information without fear of prosecution, and an oral history archive that would have given recognition to the dead.

The justice department has been denied the £10 million it requires to finance more than 50 Troubles-related inquests postponed for decades because they were too complex or involved national security issues. Unionists blocked the funding because many of those deaths were the result of police or army actions, not IRA attacks.

Around 500 of the Troubles' most seriously injured victims were for decades denied desperately needed supplements to their meagre state pensions because 10 of them were injured by their own hand—making or planting bombs, for example: Unionist politicians will not sanction payments to those it calls terrorists, and Sinn Féin insists there can be no hierarchy of victims.

Judith Thompson, a forthright English woman who now champions the injured and bereaved as commissioner of the Commission for Victims and Survivors (Northern Ireland), reckons that roughly 500,000 people—nearly a

third of the province's population—still suffer in some way as a result of the Troubles, with 200,000 experiencing mental health problems and 17,000 having post-traumatic stress disorder. Sixty-odd organisations dealing with trauma victims still receive thousands of referrals each year, and it is no accident that Northern Ireland has the UK's highest suicide rate. Many more people —4,500— have killed themselves since the Good Friday Agreement than were killed during the entire course of the Troubles.

"The peace process has delivered to the victims and survivors what it's delivered to everyone, which is a much, much better place to live in," Thompson tells me during an interview in her Belfast office. "However, for those people most severely affected by the Troubles, it has spectacularly failed to deliver proper reparation, proper access to truth, justice, and acknowledgement—and that's a big thing for people."

The victims and survivors are meanwhile growing old. "There's a very keenly felt sense by some that 'they're just waiting for us to die,'" Thompson says with feeling.

This failure to address the legacies of the Troubles matters. It nourishes hatred. It hampers reconciliation. "It's a massive impediment," Thompson concludes. "Without this, we're not going to get the rest done. This is the bit that's holding us back."

———

At the grass-roots level, many groups and individuals are working to improve crosscommunity relations. They include former combatants such as John "Jackie" McDonald, a burly, crew-cut, tattooed leader of the Ulster Defence Association from South Belfast who spent five years in the Maze for extortion, blackmail, and intimidation.

McDonald now collaborates with his former IRA adversaries to defuse tensions and de-glamourise paramilitarism in the eyes of the young. "We've been to prison. Some of our closest friends have been murdered," he explains when we meet in the staunchly loyalist Sandy Row district of South Belfast. "We've been through it all, and we know we can't go back there."

These grass-roots activists are making some progress, especially in Derry, where both the Troubles and the peace process began. That city has a large Catholic majority, and its sectarianism was never as virulent as Belfast's. I am pleasantly surprised, for example, to find residents of a tiny, hard-core loyalist enclave called the Fountain, where murals still proclaim "Under Siege" and "No Surrender," staging a joint Christmas craft fair with nationalists, on the far side of the great steel mesh fence encircling their homes.

But what strikes me most forcefully is how divided Northern Ireland remains. It still has Protestant sports, newspapers, and musical instruments—and Catholic ones. Strangers still perform verbal minuets to determine whether they are talking to a Protestant or a Catholic. A union between a man and a woman of the same colour, nationality, and Christian faith—albeit different denominations—is still called a mixed marriage and stigmatised in some quarters.

Of the province's 800-odd social housing estates, 90 per cent remain "single identity"— exclusively Catholic or Protestant. Some 90 peace walls still divide those estates, almost as many as at

the time of the Good Friday Agreement, and polls show that those who live near the walls are overwhelmingly opposed to their removal.

"There's no healing," Jennifer Hawthorne, the Belfast regional manager of Northern Ireland Housing Executive, explains to me. "These were the communities most affected [by the Troubles] and therefore [they] are carrying the legacy of the continued hurt and pain and sectarianism." The executive is supposed to demolish all the walls by 2023, but given the near impossibility of doing that, it is instead trying to improve their appearances.

Northern Ireland's educational system also perpetuates what some refer to as "benign apartheid." Powerful vested interests, notably the Catholic Church, have ensured that just 65 of Northern Ireland's 1,150 primary and secondary schools are integrated. Scarcely 22,000, or eight per cent, of Northern Ireland's children attend these schools. That means the remaining 92 per cent are separated from their Catholic or Protestant counterparts starting at the age of four.

"If we're ever going to make a difference in Northern Ireland, we have to mix our communities up much, much earlier," says May Blood, a former trade union activist from the Shankill who now sits in the House of Lords and campaigns tirelessly for integrated education.

Speaking more generally, Baroness Blood voices a complaint I hear repeatedly during my return to Northern Ireland: "We have not made the progress we should have made. It's our politicians who are holding us back."

She is absolutely right. The province's politicians must indeed bear much of the blame for the lack of healing. They have largely ignored the Good Friday Agreement's injunction to "strive in every practical way towards reconciliation and rapprochement." They have largely failed to make a success of power-sharing. Over much of the past two decades, the Northern Ireland Assembly and its executive have lurched from one crisis to another, and those institutions have been suspended for years at a time amid bitter disputes over issues such as IRA decommissioning and unionists' alleged lack of respect for nationalism.

Dr Jonny Byrne, a senior lecturer on peace process issues at the University of Ulster, puts it this way: "If our government and parties can't share power together, how can we begin to provide an example for our communities?"

For one brief period, two of Northern Ireland's most unlikely bedfellows—Martin McGuinness and Ian Paisley—did provide the sort of visionary leadership that the province so badly needs.

McGuinness, one of seven siblings raised in a tiny house in Derry's nationalist Bogside, left school at 15 to work as a butcher's assistant, was imprisoned for possessing explosives, and became leader of the IRA in Northern Ireland. Disciplined and ruthless, he was undoubtedly responsible for many atrocities, including the assassination of Lord Mountbatten, the second cousin of Queen Elizabeth II, before embarking on a long, tortuous transformation from paramilitary to peacemaker that led to some astonishing scenes: the former terrorist meeting Tony Blair at Downing Street, being received by successive US presidents at the White House, and even shaking hands with the queen— the head of the state against which McGuinness had waged such a bloody war. ("I'm still alive," she replied enigmatically when he asked how she was.)

Paisley was a fiery fundamentalist preacher and lifelong enemy of nationalism, republicanism, and Catholicism who flirted with loyalist paramilitaries, harnessed the power of the mob, and rallied supporters against successive peace initiatives with cries of "Not an inch," "No surrender," and "Never, never, never." He refused to let the Democratic Unionist Party (DUP), which he had founded, participate in the Good Friday peace talks. But finally—at age 81—he, too, relented and agreed to enter a power-sharing government with Sinn Féin in 2007.

For 13 months, against all expectations, Paisley and McGuinness worked so constructively and harmoniously together as First and Deputy First Ministers that they were dubbed the "Chuckle Brothers." Sadly, that partnership proved an aberration, a brief hiatus. McGuinness and Paisley are now both dead, and Northern Ireland's new generation of political leaders have shown no such willingness to collaborate.

The DUP's present leader, Arlene Foster, saw her father—a part-time policeman— shot during the Troubles, and she herself survived an IRA bomb blast on her school bus. But neither she nor her Sinn Féin counterpart, Michelle O'Neill, was an active participant in the Troubles. They did not negotiate the Good Friday Agreement, so they have less invested in its success. They lack their predecessors' authority, stature, and clout.

Their two parties, Northern Ireland's biggest, pursue zero-sum politics. They engage in point-scoring and finger-pointing. They fight for their own communities, not the common good. They offer no vision of a shared future and have little interest in compromise, because they know that voters fearful of losing their cultures and identities will elect those hard-line parties who promise to defend them most robustly. The relatively centrist, formerly dominant Ulster Unionist Party (UUP) and Social Democratic and Labour Party (SDLP) were electorally savaged for the concessions they made earlier in the peace process. The UUP no longer sends a single MP to Westminster, while the SDLP holds just two of Northern Ireland's 18 parliamentary seats.

And, of course, the stakes are no longer as high. "When my father's generation failed, the price was more gravestones. For this generation, the result is just stagnation," Paisley's son, Ian Paisley Jr, tells me over coffee in Ballymena's town hall.

"It reminds me of being at a dance," he says. "If you want to dance with someone, and they want to dance with you, that's great, but at the moment we're not even in the same room." Paisley Jr, who now represents the North Antrim parliamentary constituency that his father held for 40 years, still carries a gun and checks under his car for bombs each morning.

———

Over all of this looms the Brexit process, whose denouement under Boris Johnson remains impossible to predict but which potentially poses a grave threat to the Good Friday Agreement.

The genius of that accord was that it dissolved the 310-mile border between Northern Ireland and the Republic of Ireland—that century-old scar and symbol of the island's partition. It banished the border physically: the end of the conflict, and the fact that Britain and Ireland were both members of the customs union and single market of the European Union, removed the need for checkpoints and border posts. It also banished the border psychologically by allowing the people of Northern Ireland to be British citizens, Irish citizens, or both.

Brexit could wreck all that. Depending on the terms of Britain's departure from the EU, Brexit could entail the restoration of border controls either in the North Sea between Northern Ireland and Britain, which would anger unionists, or between Northern Ireland and the Republic, which would anger nationalists. Any such infrastructure along the land border would become a target for republican paramilitaries. British security forces would then have to protect it, fuelling republican anger and expanding the scope for confrontation.

Brexit has already harmed the peace process in other ways. It has undermined trust in the British government: Theresa May allowed the DUP to dictate policy because

she lacked a parliamentary majority; Johnson abandoned the DUP after regaining a majority; and senior members of the ruling Conservative Party have in general shown a lamentable disdain for the province's fragile status quo.

The nationalist community has seen two decades of steady rapprochement between north and south going into reverse. Brexit has strained relations between Dublin and London, and it now threatens to impede cross-border business, undermine north-south cooperation in fields ranging from healthcare to intelligence sharing, and weaken human rights protections.

With so much in flux, Brexit has also revived talk of a border poll—a refrendum on Irish reunification that would have been almost unthinkable a few years ago. Northern Ireland voted by 56 to 44 per cent to remain in the EU in the 2016 referendum on Britain's EU membership. By 2019, support for remaining had risen to nearly 70 per cent. Centrist voters, including some moderate unionists, are now willing to at least consider reunification as a means of keeping the province inside the EU.

Northern Ireland's peace process has certainly not failed. Crucially, its rival communities have learned how to disagree without killing each other, and that is an enormous gain.

"We used to be bloody and divided. We are now just divided," Ian Paisley Jr tells me during our conversation in Ballymena.

"We are in a very different place," says Barney Rowan, who reported on countless atrocities as the BBC's highly respected security correspondent in Northern Ireland during much of the Troubles. "The comment that annoys me most is when people say nothing has changed. I think about what we covered in the '80s and

'90s—every thing has changed, but there's still so much more that needs to be done."

And while there is no immutable rule that says a peace process cannot go into reverse, I meet nobody who believes the province will return to the bad old days of the 1970s and 1980s. Republicans have gained far more from politics than they ever did from violence, and the core grievances that triggered the Troubles no longer exist.

"The nationalist community doesn't have that sense of being oppressed and second-class citizens, which were the conditions in which the IRA waged its war," Danny Morrison, a republican elder statesman, tells me as we chat in his Falls Road home one morning. "The state I'm in now is not the state I grew up in. There's no position a nationalist can't hold. A nationalist can become a judge, director of prosecutions, first minister."

Nor has the peace process entirely succeeded. It has brought peace, but not harmony. It has enabled the province to manage the problems caused by two rival tribes sharing the same small patch of earth, but it has not yet resolved them. And although the two communities have largely forsaken violence, they remain deeply divided, and their leaders still fiercely pursue their starkly different visions of Northern Ireland's future.

The euphoria engendered by the Good Friday Agreement vanished long ago. Most people are deeply disillusioned with their politicians. There is a widespread sense of lost opportunity. "The Good Friday Agreement was a ship that was launched and never fitted out," Jackie McDonald, former loyalist paramilitary leader, laments.

After two weeks in Northern Ireland, I end up in the same quandary I faced after

my Troubles tour at the beginning: unsure whether to feel hope or despondency at what I've seen.

Looking for a broader perspective, I seek out Jonathan Powell, Tony Blair's hugely experienced former chief of staff, who worked as hard as anyone to secure the Good Friday Agreement and now heads an NGO that helps resolve armed conflicts around the world.

From his tranquil Westminster office, Powell expresses no sense of failure or disappointment—indeed, quite the opposite. The Good Friday Agreement is "the thing I'm most happy about having done in my life," he says. "People underestimate the importance of it at their peril. It's certainly not a fairy story, but life is a hell of a lot better for most people living in Northern Ireland."

To suggest the peace process has failed would be a complete misunderstanding, he adds. Peace agreements are simply agreements to start addressing fundamental differences through politics, not violence. They mark the start, not the end, of the hard work. Peace building, as opposed to peacemaking, can take generations, and in Northern Ireland, with its centuries-old history of hatred and distrust, it probably will.

"To actually get to what you might call a functioning political system that's not about identity, you're probably looking at 50 years," he concludes.

Powell is right, of course. The bitter legacy of the Troubles was never going to vanish overnight, but there are grounds for hoping that it has at least begun to erode.

—

On my last night in Belfast—a Friday—I visit the Cathedral Quarter, the recently regenerated old part of the city. It is a revelation. Here, at least, there are no flags or painted kerbstones, no overt signs of sectarianism. Its cobbled streets and "entries" or alleyways are lined with restaurants, clubs, and bars, many offering live music. They teem with young professionals, students, and millennials—progressively minded people such as Fionnghuala Nic Roibeaird, 24, and Emmett Costello, 26, for whom the Troubles are dimly remembered history. Like many of their generation, they flatly reject tribalism and are in their own small ways working to surmount it.

Roibeaird, a Gaelic-speaking student of history and sociology at Queens University, is an activist who helps organise cross-community rallies against Northern Ireland's archaic bans on gay marriage and abortion. The daughter of a former IRA member who spent 14 years in the Maze, she even met and befriended the daughter of a

prominent DUP MP at a pro-choice group. "We talk about abortion and gay rights, not tribal politics. You could bring it up, but most people would think you're an idiot," she tells me. "They'd think you were living in the past."

On gay rights, at least, Roibeaird and her colleagues have made considerable progress. The ban on gay marriage was finally lifted in January 2020, after years of resistance by the DUP. Twenty years ago, a gay club or bar in Belfast would have been unthinkable, but the city now has several. The annual Belfast Pride festival now stages Northern Ireland's biggest parade, easily eclipsing any Orange Order march.

Costello runs a company called Inside Moves that organises monthly pop-up parties in different Belfast venues. Towards midnight, he takes me to a rave in the cavernous former printing halls of the *Belfast Telegraph* on the edge of the Cathedral Quarter. There I am greeted by the astonishing sight of 1,700 young people from across the city, Protestant and Catholic, dancing as one beneath the strobe lights.

There is no tension, no hint of animosity. "We're trying to have a party and show there's a community spirit in Belfast," says Costello, who is doing rather more to promote unity than the province's politicians. "Religion is such a non-issue for our generation. It's massively irrelevant. We're a generation where we've not been directly hurt by the Troubles and the pain is not so raw, so it's easier for us to see past that barrier."

Too old for raves, I do not linger, but I leave impressed by the energy and dynamism of the club, by its creativity, inclusivity, and tolerance in a province not known for those commodities. It is just one small, rare shared space in a divided province, but it nonetheless serves as a model for what Northern Ireland could—and might yet—be.

The Battle for History (1994–2019)

Photos by Gilles Peress
Text by Chris Klatell with
Gilles Peress

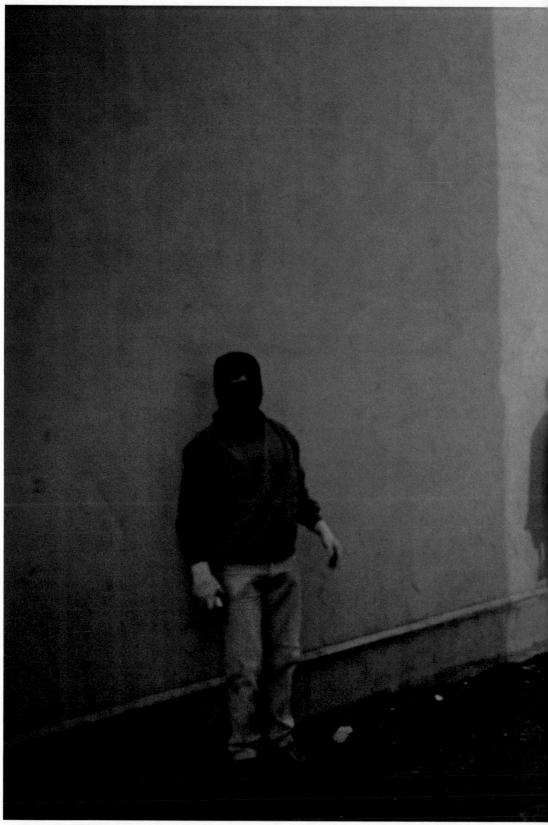

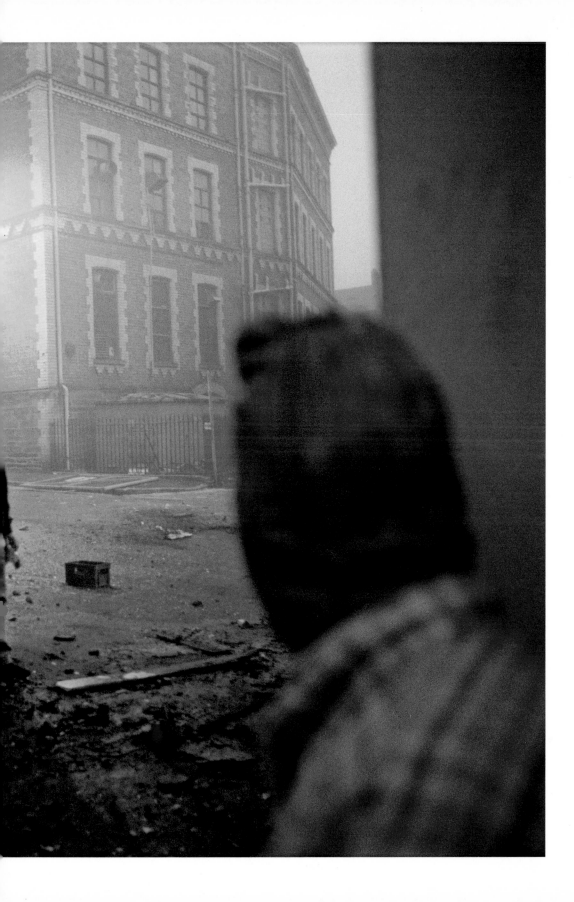

1.

In 1994, the Irish Republican Army and the Combined Loyalist Military Command declared ceasefires on behalf of the predominant paramilitary organizations in the north of Ireland. Political conversations had dragged on for decades, but the ceasefires kick-started a process that eventually led to the 1998 Good Friday or Belfast Agreement and the cessation of active hostilities. Another 26 years on, no one knows if this cessation will be permanent. There have been similar pauses throughout the 800-year British occupation of Ireland, and even the 1994 ceasefires have proved to be neither lasting nor universal. But something today has unquestionably changed.

The previous 30 years had been dominated by the Troubles, a conflict defined not by violence but by the tension between the necessities of everyday life and periodic, inescapable eruptions of violence precipitated by the British Army, by loyalists, and by republicans. Gilles Peress defines the structure of history during this dark and murderous era as helicoidal. Nothing seemed to progress or regress. Rather, each day became a repetition of every previous day like that day: the day when someone was killed or went to prison; the Sunday after a riot; the anniversary of a bombing or a battle; the rare day you escaped, briefly, to the country.

The peace process shifted the pattern: life briefly became, or at least seemed, directional. The texture of existence changed, too: British troops gradually disappeared from the streets; checkpoints and border posts melted away; new names, parade routes, and government structures came into being; and the frequency of bombings, arrests, and killings—and the protests, riots, and anniversaries that followed them— withered away.

But history didn't disappear. It lingered, in the background, with that same quality of being under a curse as it was when bombs exploded daily and you had to open your handbag at the entrance to every store: you're damned if you remember; you're damned if you don't. You're damned if you remember because you'll be traumatized by the past and will therefore repeat your mistakes, and you're damned if you don't because you'll fail to recognize and avoid them.

2.

For millennia, history was written by the victors. You won the war, massacred your enemies, and then controlled the story of their destruction. But technologies of representation and communication have changed radically, pushing us into a narrative epoch in which history is no longer written by a conflict's victors. Today, the victors are often determined, ex post, by whoever authors the conflict's history.

As of 1998, nobody had won the Troubles. No resolution precipitated the end of active conflict. No dictator was overthrown. Independence was not declared, and there was neither a conquest nor a united Ireland—quite the opposite. The end of the war came after a recognition by the IRA and the British Army that neither side

could defeat the other militarily. Each community's position persisted but had to be channeled into different fields of contestation: nominally democratic politics but, more broadly, the battle for history.

The decision to put the IRA's weapons "beyond use" was difficult for Republicans to accept, given their longstanding rejection of any British presence in Ireland, but Irish Nationalists retained a concrete goal—a united Ireland—and developed a plausible narrative (changing demographics combined with political representation and civil rights) for how it could eventually be achieved. To advance this strategy, some hard men threw themselves into building Sinn Féin as a political party, while others, who couldn't make the pivot, found themselves left behind.

Unionists and loyalists, meanwhile, clung to their perpetual hope of outlasting the nationalist siege, now also reframed in demographic and electoral terms.

And the British had their own endgame: to recast their role in the affair. This effort began in earnest with their assertion, incorporated into the 1993 Downing Street Declaration, that they had "no selfish strategic or economic interest in Northern Ireland" and that they instead sought only "to see peace, stability, and reconciliation established by agreement among all the people who inhabit the island." Peace, the declaration proclaimed, "is a very simple idea."

The complication, for many in Ireland, derived from the conviction that centuries of violence, from Oliver Cromwell through the plantation, the famine, partition, and internment, were attributable to Britain's assertion of its strategic and economic interests. The withdrawal of the army now appeared conditioned upon a restatement of this history, which reframed the conflict as merely having been between two sets of unruly natives. Imperialism, Bloody Sunday, shoot-to-kill policies, and official collusion need not be taken into account. These were complications; peace was "simple." As families and communities in the north pushed back, demanding public accountability as a precondition for lasting peace, they encountered a British establishment equally intent on moving on.

These are the lines in the battle for history, the battle being fought on the edges of life since 1994. It's a battle that the republican side has to engage in lest they abandon the concept of a united Ireland, and a battle that loyalists have to wage to maintain a union that only a small minority of people in Ireland or Britain care about. And for the British, it's a referendum not just on Ireland but on the idea of empire, and thus a battle over the idea of Britain itself.

3.

The armed conflict has today been sublimated into proxy wars, through the institutionalization of dueling languages most people don't speak (Irish, Ulster Scots) and phenomena like museumification. In the last 20 years, a plethora of museums dealing with history has emerged: the Orange Order, republicans, Free Derry, and the Apprentice Boys of Derry each have one. The British Army has several. The Crumlin Road Gaol now is one. Even the Ulster Defence Association and the Ulster Volunteer Force—terrorist organizations—have museums. And next to the museums operates a Troubles industrial complex: terror tours, transitional justice institutes, peace forums, and semiofficial reports that claim the conversation for a class of "neutral" professionals and academics who can, from a distance, wag their fingers at "sectarianism" and other working-class concerns.

The murals and graffiti on the walls of Belfast, which once warned outsiders to stay away, now invite tourists to photograph themselves or serve as scenery for period television shows, their violence transformed into something consumable, almost nostalgic. But for people in the north, the flags and bonfires hint at things unresolved. They dance on the edge of people's consciousness, a signal that the battle for history has yet to be decided.

4.

The advent of the European Union stabilized the peace process in Ireland: European guarantees of the free movement of goods and people, and recourse to European law, took the place of bilateral and trilateral agreements that would have triggered flashpoints. In this sense, Maastricht and Lisbon Treaties played as important a role as the Good Friday Agreement. Enveloped in Europe, the north drifted into a choose-your-own-adventure paradigm: Nationalists had Irish EU passports, could buy gas in Buncrana, and had an open road to Dublin. Unionists had British passports, pounds sterling, and EasyJet flights to Edinburgh and London. Freed from the oppressiveness of an inerasable conflict, people began to reimagine their lives, think about jobs and education, and even envision individual progress.

But on a civic level, the deferral to Europe allowed atrophy to set in, leaving dangerously unresolved the question of how peace would survive a withdrawal from the EU. The power-sharing institutions created by the Good Friday Agreement rarely sat, much less functioned; by default, Northern Ireland has recently been governed, or ungoverned, as a colony.

Now, faced with Brexit, people in the north have come to realize that they, like other colonized peoples, have little say over their own future. The loyalist DUP, which dreamed it could influence British policy, found itself abandoned by the conservatives as surplus to requirements. And every constituency bordering the south was represented by a Sinn Féin MP who did not recognize the legitimacy of the British Parliament and therefore had no voice in its debates and no vote.

5.

It's inevitable that the Irish border would become a sticking point for Brexit. Both sides needed to establish a border somewhere for Britain to leave the EU and its customs union, but the border couldn't be in Ireland without undermining the Good Friday Agreement, or outside of Ireland without undermining the union with Britain.

The original partition created Northern Ireland; it's the north's progenitor and its original sin, a 100-year-old imperial gesture that prompted civil war and a century of irresolvable conflict. Were it to reemerge, the ramifications would be equally unpredictable. Nationalists used to say that Ireland would reunite, but "not in my lifetime." Suddenly, it's "possibly in my lifetime."

If you travel through the border today, you see nothing. You see gorgeous landscapes and boring ones. You see a lot of rain and some sun. The only differentiations are the texture of the road paving and the speed limit signs, which show kilometers in the south and miles in the north.

Since before the British conquest, pilgrims have followed these roads to Lough Derg in County Donegal, now just across the border. They circle barefoot across its sharp stones, fasting and praying for release, faithful that, through their suffering, one day they'll find eternal peace.

Chris Klatell
with Gilles Peress

2

3

4
6

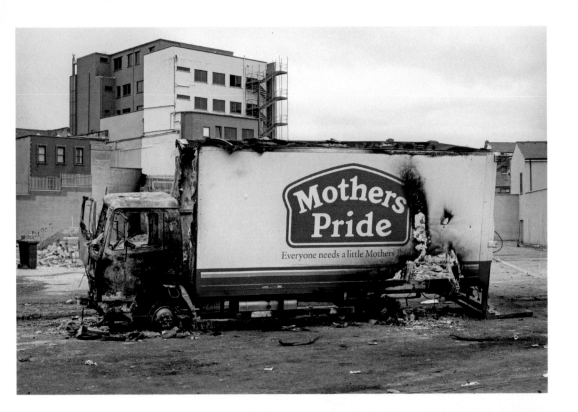

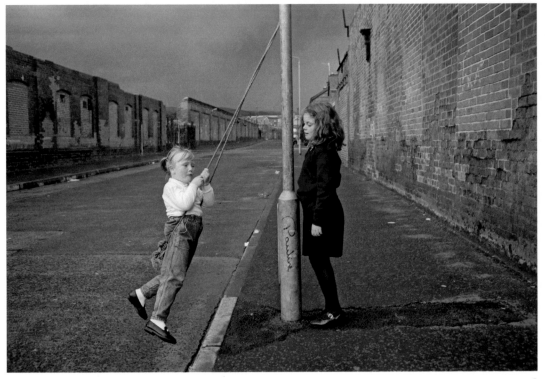

Northern Ireland Reportage

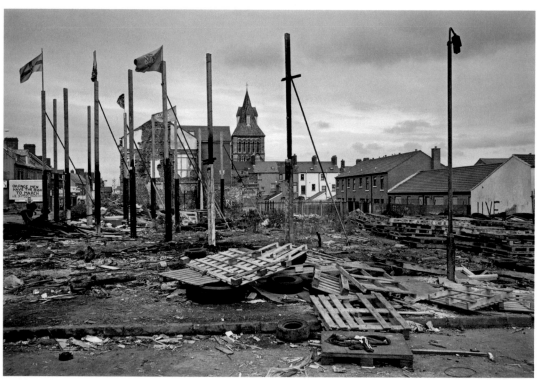

8

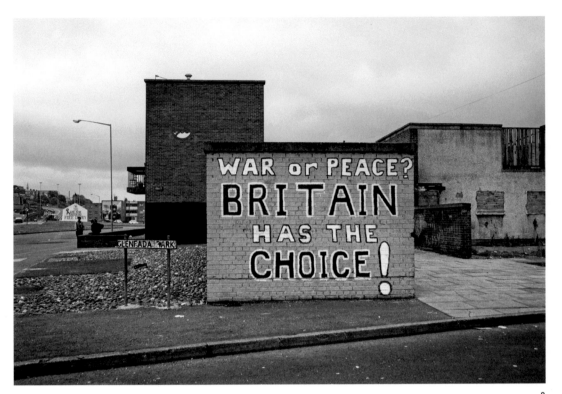

9

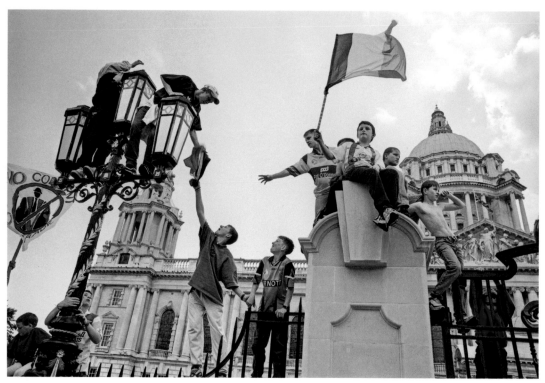

10

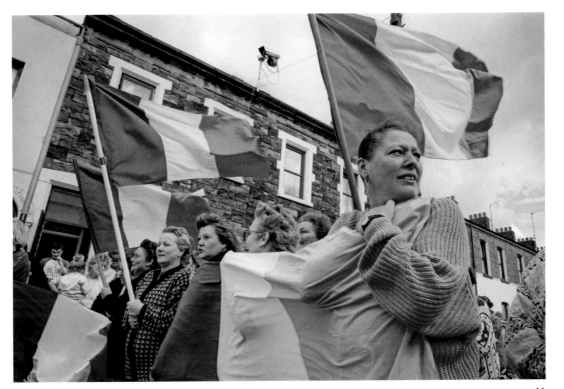

11

Northern Ireland Reportage

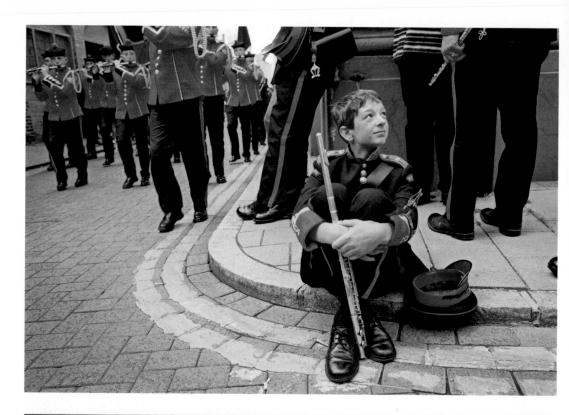

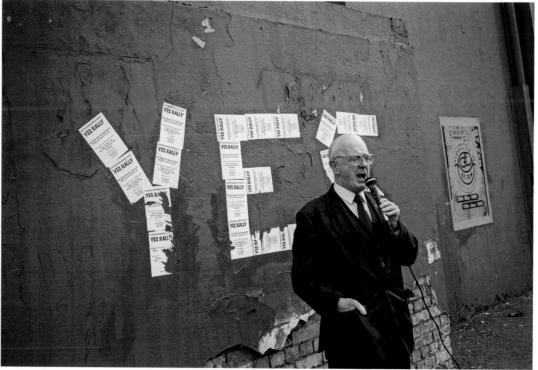

12
14

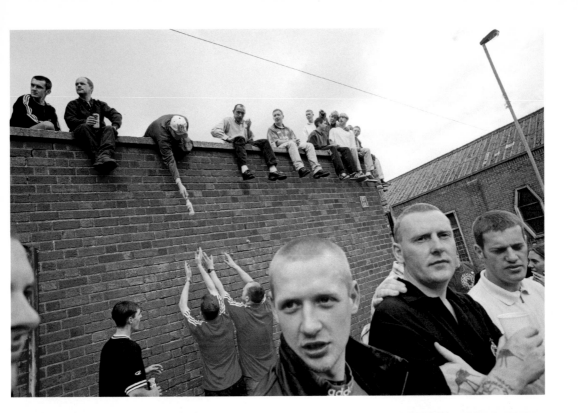

Northern Ireland Reportage

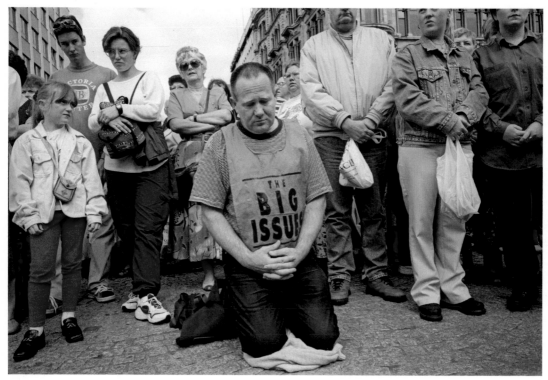

16

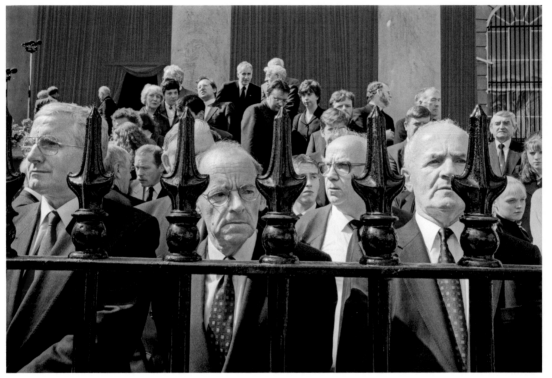

17

Northern Ireland Reportage

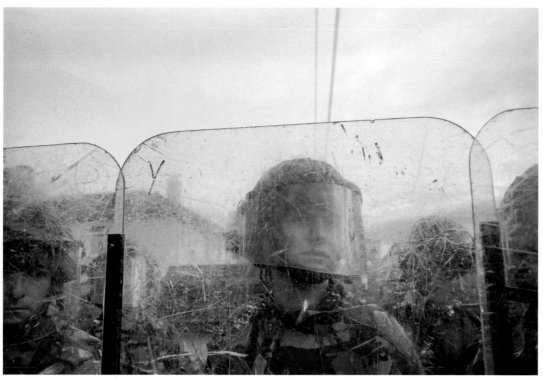

18

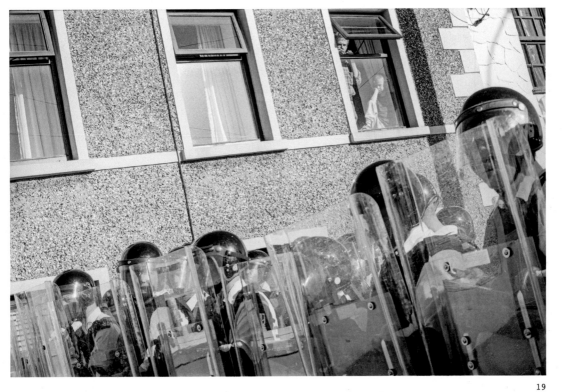

19

20

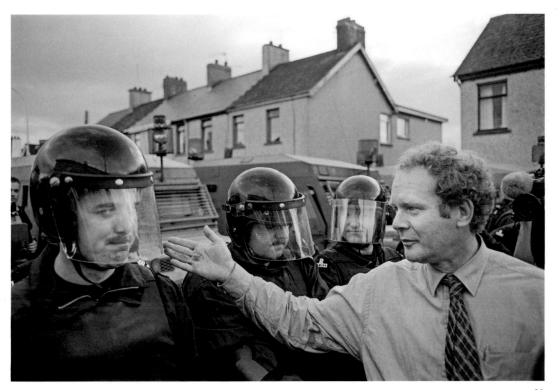

21

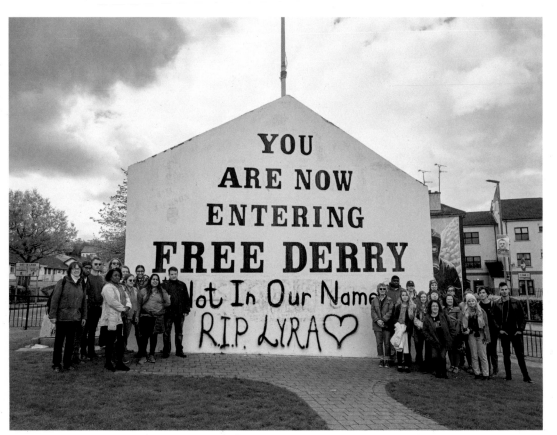

22

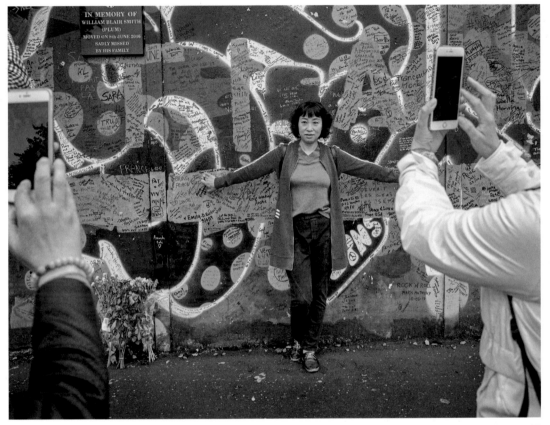

23

Northern Ireland

Reportage

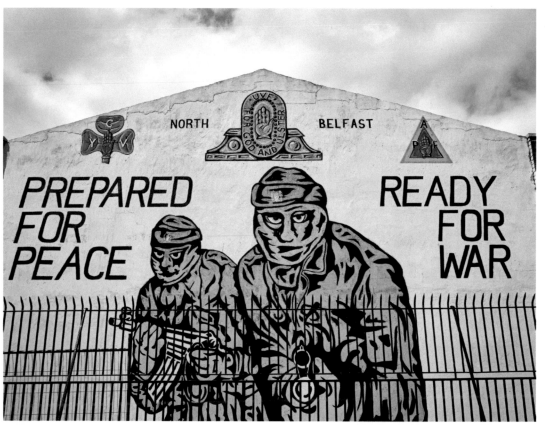

24

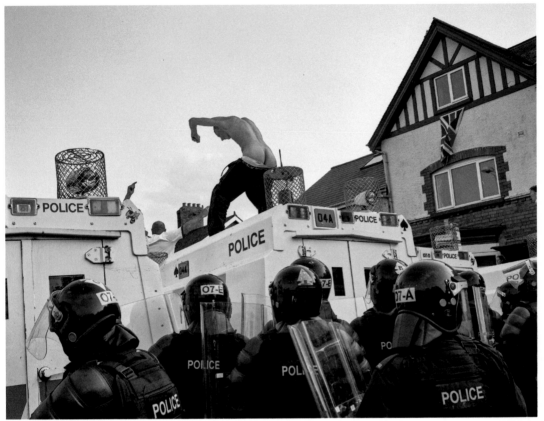

25

Northern Ireland

Reportage

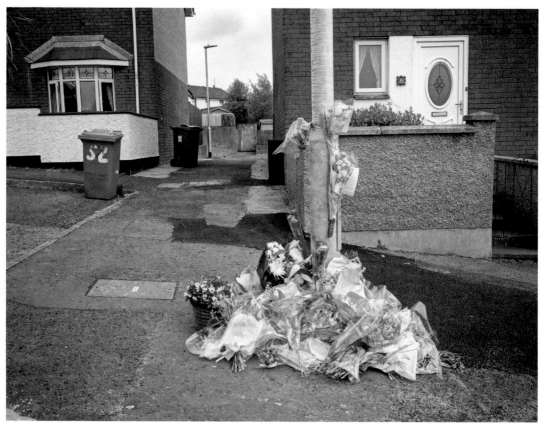

26

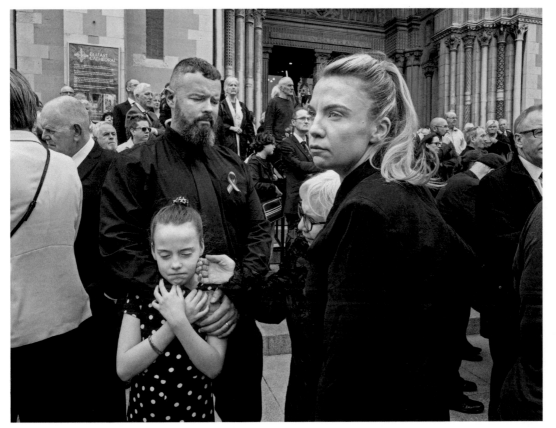

27

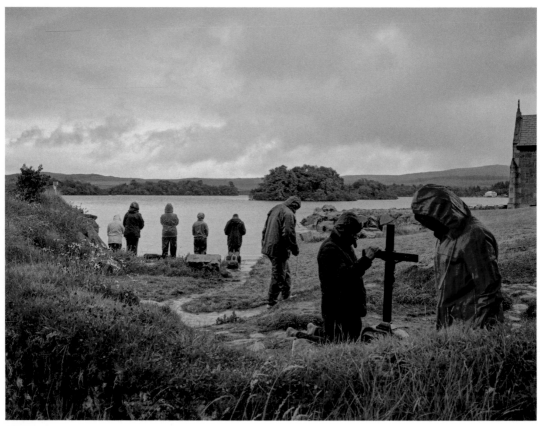

28

29

Northern Ireland Reportage

1. Derry, North of Ireland, 1996
2. Short Strand, East Belfast, North
 of Ireland, 1996
3. Derry, North of Ireland, 1996
4. Near Enniskillen, North of Ireland,
 1998
5. Derry, North of Ireland, 1996
6. Near Clonards, West Belfast, North
 of Ireland, 1994
7. Near Ardoyne, West Belfast, North
 of Ireland, 1994
8. Shankill Road, West Belfast, North
 of Ireland, 1998
9. Bogside, Derry, North of Ireland,
 1996
10. City Hall, City Centre, Belfast,
 North of Ireland, 1996
11. Short Strand, East Belfast, North
 of Ireland, 1994
12. 12th of July Parade, City Centre,
 Derry, North of Ireland, 1996
13. 12th of July Parade, City Centre,
 Derry, North of Ireland, 1996
14. Shankill Road, West Belfast, North
 of Ireland, 1998
15. Near Clonards, West Belfast, North
 of Ireland, 1994
16. After a bombing in Enniskillen,
 City Centre, Belfast, North of
 Ireland, 1998
17. Service after a bombing,
 Enniskillen, North of Ireland, 1998
18. Bellaghy, North of Ireland, 1997
19. Bellaghy, North of Ireland, 1996
20. Ian Paisley, County Antrim, North
 of Ireland, 1998
21. Martin McGuinness, Bellaghy, North
 of Ireland, 1997
22. Bogside, Derry, North of Ireland,
 2019
23. Peace Wall, Loyalist Side, North of
 Ireland, 2017
24. North Belfast, North of Ireland,
 2017
25. 12th of July Parade, near Ardoyne,
 West Belfast, North of Ireland,
 2013
26. Creggan Estate, Derry, North of
 Ireland, 2019
27. Burial of Lyra McKee, St. Anne's
 Cathedral, City Centre, Belfast,
 North of Ireland, 2019
28. Pilgrimage on the Border, Lough
 Derg, Ireland, 2017
29. The Glen, County Antrim, North of
 Ireland, 2017
30. Border Road, North of Ireland, 2019

The "Hen Party" 304

by Monica McWilliams and
Avila Kilmurray

History says, Don't hope
On this side of the grave,
But then, once in a lifetime,
The longed for tidal wave
Of justice can rise up,
And hope and history rhyme.

—

Seamus Heaney, "Doubletake"

Monica McWilliams and **Avila Kilmurray** are civic activists and academics who fought for and won the right of bipartisan civilians to be included in Northern Ireland's peace-making process. They recognized and championed the power of the people to address shared concerns outside the entrapment of party politics. The Northern Ireland Women's Coalition secured two out of 20 seats at the formal negotiations and helped frame the Good Friday or Belfast Agreement to include victims' rights, integrated education, shared housing, and a civic forum, issues that proved to be funda-mental to a sustained peace.

The Irish poet Seamus Heaney, celebrating a tentative peace process in Northern Ireland, once imagined that hope and history could rhyme. For those of us, especially women, who had endured 30 years of violent conflict, the possibility of peace talks in the mid-1990s meant the colliding of opportunity and occasion, with a smidgen of obduracy. We knew that the Troubles, the local name given to Northern Ireland's prolonged period of death and destruction, had to be addressed by inclusive peace building; we owed an attempt at peace to our children as well as to ourselves. For all too long, politics in Northern Ireland had been a playground of political narratives. The violence of the tongue was followed by the violence of the gun, feeding a self-serving sectarianism. Women had keened over the dead, visited prisons, shared antidepressants in their anxiety, and, in a number of cases, become combatants themselves. Yet we were rarely visible. We had never figured in the higher reaches of political decision-making.

The declaration of peace talks and the introduction of an innovative electoral system changed all this. The negotiations choreographed by the British and Irish governments, and chaired by US Senator George Mitchell, were designed to ensure the political representation of loyalist paramilitaries and other smaller parties. The new system provided an opportunity for us, a group of community-based women, to get a seat at the table. We saw ourselves as accidental activists, since we had mostly been focusing on the small "p" politics—of poverty, childcare, and community development—rather than the big "P" politics of constitutional issues. Small "p" politics took the form of participation in community-based organising, setting up women's centres, tackling domestic violence and sexual abuse, and meeting the needs of women on both sides of the "peace walls." Big "P" politics took sides, formulating arguments rather than seeking out niches of commonality, dominating media headlines rather than working quietly. The peace talks provided us women with the chance to step out and be heard.

WHEN EVERYTHING SEEMED POSSIBLE

Notwithstanding the fact that the peace process ended up being a roller coaster of possibility, as often down as it was up, the 1994 paramilitary ceasefires opened up a new kind of conversation and created a climate of potential. Change was not only feasible—we could grasp it with both hands. We could all attempt to take a formal role in the peace negotiations.

The British government announced the list of parties that might stand for election to the peace talks in 1996. We had lobbied successfully for inclusion of a women's party, under the name of the Northern Ireland Women's Coalition (NIWC), to keep the space open. We saw the NIWC as a way to offer women activists from both sides of the community divide— as well as from academia, the trade unions, and broader civil society—a platform. We plundered address books, interrogated community directories, and collated lists of women activists from campaigns and conferences, and we invited all to a number of meetings to discuss whether the notional NIWC could become a reality.

Starting with around 100 women, the NIWC grew. Local groups came together across Northern Ireland. Over 90 women agreed to stand for election in order to gather enough votes for the NIWC to be one of the 10 parties represented at the peace talks. We agreed to have two leaders: Monica McWilliams, from a Catholic and nationalist background, and Pearl Sagar, from a Protestant and loyalist one. We knew we had to structure the party to represent women from both sides of our divided community. We adopted a party platform of three principles—inclusion, equality, and human rights—rather than wasting time on drafting detailed policies. We did things differently: our election poster was a cartoon dinosaur in suffragette colours (green, white, and violet), declaring "Say Goodbye to Dinosaurs." Some male politicians took offence at that.

Our successful election to the peace talks (after a mere six weeks of organising) provided for women's presence and made the talks truly more inclusive. We were the outsiders who had suddenly been elected insiders. Our ineffable confidence came from knowing that none of the long-established names sitting at the table, who had dominated big "P" politics, would have all the answers to making peace possible. We did not present ourselves as politically omnipotent, endlessly repeat a one-sided mantra, bolster egos by denigrating others, or engage in a monologue. We had no need for the hallmarks of the politics of previous years. Instead, we came prepared to listen as well as to seek out new ideas and share helpful suggestions.

Our immediate hope was to contribute to a sustainable peace agreement based on inclusivity. Our longer-term aspiration was to help fashion a new type of politics that was more open to a diversity of views and interests. We wanted to move to a win-win situation rather than the zero-sum game of a still bitterly divided society. Over the decade 1996 to 2006, we realized some of these hopes. We tested out ideas and proposals at internal party meetings, where NIWC members from different community backgrounds listened to the hopes and fears of others. We also organised broader meetings to both explain our positions and garner ideas. We decided to focus on the type of society that we wanted to live in rather than on the issues of national sovereignty that the other parties obsessed over. Our three principles remained our touchstone, enabling us to discuss potentially divisive issues in a

considered manner. Whenever we were in negotiations, we made sure that our team included members from both sides of our communal divide.

Many of our positions were controversial. For example, we argued with sceptics and often-cynical government officials on behalf of victims of the conflict and political prisoners. We promoted integrated education for schoolchildren and shared housing for both communities. We looked at institutional reforms in the context of human rights and equality. Our ideas became an integral part of the Good Friday or Belfast Agreement of 1998, despite having been previously dismissed.

Deliberately forging friendships amongst representatives from widely diverse political parties, including those affiliated with armed groups, proved to be an important tactic. Listening to men and women whose experiences differed from our own gave us insight and seeded new ways of addressing age-old dilemmas. We began to relate. Inviting individuals from a range of backgrounds to our dinner tables, or having a cup of tea together, turned out to be as important as crafting a new position paper (although we were assiduous in drafting proposals as well). The teas and dinners often led to proposals. Politics became humanised through human engagement. Hope and history were starting to rhyme.

A "GREEK CHORUS OF WOMEN"

There were those who found a women's political party threatening to the assumed order. Elected politicians fulminated about the "hen party," and the leader of the UK Unionist Party thought it amusing to refer to "that Greek chorus of women" who had entered the peace talks. Some political advisers viewed engaging with NIWC representatives as wasted time, because we did not form part of the "big political beasts." When we were invited to go into the prisons to talk with those sentenced for political convictions, we were dismissed as being "too fond of the boys" or "in love with murderers." When we drafted the proposal for including a civic forum in the peace agreement in order to promote the idea of a more participative democracy, we were decried as naive. Our argument that measures should be put in place to enhance the representation of women in politics was met with the statement that the peace agreement was about Protestantism-unionism-loyalism and Catholicism-nationalism-republicanism, not about gender; we were told that women should learn to wait until these more serious matters got sorted out.

We dealt with the insults by adopting a combination of humour and publicity. We had to call out attempts to stereotype, misrepresent, and humiliate us as a form of coercive control and abuse of political power. It was not nice for our children to hear their mothers being labelled and insulted on television. But the Women's Coalition had watched and waited for too long, so we worked hard to ensure that our proposals made it through to the final accord, which they did. However, both the civic forum and measures to increase women's political participation still await implementation.

We had to have patience in abundance, as it took hours of discussion, argument, and persuasion to reach a consensus. Our own reaction was at times invigorated, at times despairing, when opportunities that opened up were crushed by those too

shortsighted to see their merit. We often found that political commentators and the media were as hidebound as the established politicians they covered.

The new politics that we hoped for was not achieved, but a relative peace was. Our daughters and sons, then in their early school years, grew up to be young adults in a less anxious and far less dangerous Northern Ireland. Even a fledgling peace process deserves to be celebrated.

The NIWC decided to disband in 2006. We had fought and won four elections and a referendum, but those implementing the Good Friday Agreement became increasingly obsessed with the decommissioning of weapons and the share-out of power rather than progressive social policies. The Northern Ireland Assembly was more often adjourned than operational due to political stalemate, and elections were returning to power the two blocs of Sinn Féin (garnering Catholic-nationalist-republican support) and the Democratic Unionist Party (elected by Protestant-unionist-loyalist voters). We decided that activism in civic society was more effective.

Over time, women were becoming more visible in all of Northern Ireland's political parties as a result of the NIWC's work. For us, however, there is the continuing challenge to support women's voices calling for progressive social change in what is still a conservative and sexist society. Small "p" women's activism persists, but all too often activists have to court the power brokers of the main elected political parties for resources and influence.

We Women's Coalition members returned to civic society believing we had opened the space for young women to rethink how a newly envisaged politics might more effectively deliver on both the greater representation of women and progressive social change. We had helped demystify politics by projecting it as one of a number of strategies to achieve that change. History and hope might still have a chance to rhyme.

The Narcissism of Small Differences: What the IRA Learned about Negotiation from the ANC

310

by Padraig O'Malley

Padraig O'Malley, a professor of peace, describes how he developed a hypothesis: The protagonists in one conflict who have successfully resolved their differences are best positioned to assist those in another conflict. To test this theory, he and others brought leaders of South Africa and Northern Ireland to a meeting at a secured conference center adjacent to the De Hoop Nature Reserve in the Western Cape. The relationships that developed helped pave the way to peace talks on the Northern Ireland conflict.

I began documenting the bumpy transition from apartheid to democracy in South Africa in late 1989, in a process which involved interviewing teams of negotiators on all sides of the conflict. I had also spent 20 years preoccupied with another thorny conflict—the one that had bedeviled Northern Ireland for a generation. Born in Ireland and educated there and in the United States, I was then a fellow at the University of Massachusetts Boston with a focus on divided societies. I had convened two conferences on Northern Ireland, one in Massachusetts in 1975 and another in Virginia in 1985, and had interviewed the leadership on all sides of the conflict for my book *The Uncivil Wars: Ireland Today.*

In the early 1990s, as a member of the Opsahl Commission on Northern Ireland, I and other commission members met with Mitchel McLaughlin, chair of Sinn Féin, the political party that spoke on behalf of the Irish Republican Army (IRA). McLaughlin intimated that the IRA had begun to debate the efficacy of the armed struggle, then in its 25th year. In order to announce a real ceasefire, the Sinn Féin leadership would have to convince the entire membership, across Northern Ireland and the Republic of Ireland, that it was in its best interests to do so. The "wooing" would be an arduous, often emotional process, especially since there was no unanimity at that point from the IRA leadership itself.

In August 1994, when the IRA called a ceasefire, I saw an opportunity to test a hypothesis I was developing about the dispositions and perceptions of protagonists in intercommunal conflict: one divided society is in the best position to help another. Northern Ireland's political elites had bogged down in moving from the bullet to the ballot box, and they might benefit from meeting with a cross section of South African negotiators. (The April 1994 elections in South Africa had extended the franchise to its black citizens. Nelson Mandela, the head of the African National Congress, was elected president, and F. W. de Klerk, who had been president, became deputy president in a power-sharing arrangement.)

In March 1995, after gauging support for my idea in Northern Ireland, I asked Valli Moosa, deputy minister of constitutional affairs in South Africa's new government, whether his ministry might invite Northern Irish negotiators to meet with their South African counterparts. We both understood the obstacles that lay ahead.

I realized that such a meeting would have to fulfill a number of conditions: (a) all parties involved in the conflict would have to attend; (b) key negotiators would have to be on an equal footing—pari passu; (c) both the British and Irish governments would have to approve; (d) President Mandela would have to give his blessing; (e) the Northern Ireland parties would have to ask the South African Ministry of Provincial Constitutional Affairs to host the event; and (f) under no circumstances could the conference be construed as involving either negotiations amongst Northern Ireland's interlocutors or interference of the South African government in the conflict itself.

Moosa's job was to convince his boss, Roelf Meyer. Meyer's was to convince Cyril Ramaphosa, the chair of the Constitutional Convention. Ramaphosa's job was to open the gateway to Mandela. My job was to convince the leadership in all parties in Northern Ireland that they had much to learn from the South Africans. I had warm

relations with Meyer and Ramaphosa, respectively de Klerk's and Mandela's chief negotiators during South Africa's Multi-Party Negotiation Process. After my overtures, both came to Boston in June 1993 to receive honorary degrees at the University of Massachusetts Boston's commencement ceremonies. Ramaphosa and Meyer, arch-protagonists across a negotiating table, spent three days together, far from the madding tumult of the ongoing and intense multiparty negotiations.

Having cemented those relationships, I laid a marker for myself: someday I would call in the chit.

THE PERSONALITIES

And so began my monthly trips to Northern Ireland. Nine parties, including some associated with paramilitaries, were either centrally or peripherally involved in the conflict. All would need to be brought in; for the major ones, it would be a case of either all in or all out. I had to persuade the leadership of the major parties to participate. This included Gerry Adams of Sinn Féin, David Trimble of the Ulster Unionist Party (UUP), the Reverend Ian Paisley of the Democratic Unionist Party (DUP), John Alderdice of the Alliance Party of Northern Ireland, and John Hume of the Social Democratic and Labour Party (SDLP).

I had had a longtime, sometimes difficult, but always warm relationship with Hume. In 1985, he was our commencement speaker at University of Massachusetts Boston and received an honorary doctorate. (Giving away honorary degrees is my forte!) Hume always played his negotiating cards close to the chest, sometimes to the exclusion— and chagrin—of members of his own party. He had clear ideas about peace talks and frowned on initiatives that were not his own. It galled him to see that I was talking to Sinn Féin and the DUP before he had talked to either party. I leaned on the persuasive powers of Mark Durkan, Hume's right-hand person and top negotiator.

To ensure that the SDLP was locked into the process, it was imperative to first draw in Sinn Féin. My relationship with its enigmatic leader, Gerry Adams, was another complicated one. I had met Adams in 1980 and interviewed him repeatedly in the mid-1980s, posing questions that ranged from the personal to the political. It is almost impossible to penetrate his veneer of unflappable equanimity. (He rejects any suggestion that he was ever a member of the IRA. No one believes him.) He always left wiggle room in his interviews—he wasn't exactly ambiguous, but he was also never closed-ended. Adams used to hold his press conferences at Connolly House in West Belfast in an auditorium outfitted for the purpose. He would arrive, make a statement, and refuse to take questions. Instead, he would call on a number of journalists and walk off; and then, one by one, they would enter an enclosed cubicle where he would entertain their questions while others waited outside to be called. It was as formal as a confessional box. In this way, he always managed his message. You messed with Gerry in an article and you would never see the inside of that box again.

I had relationships with other principals as well. I knew Peter Robinson, Paisley's deputy in the DUP, from the late 1970s and had been interviewing him since 1981, mostly at his highly secured residence in East Belfast. I sometimes dined with him in the House of Commons. He was as unflappable as Adams but lacked the latter's

equanimity. He was sardonic—detached, amused at his own observations, and not averse to taking a shot at "Big Ian." Robinson wanted to convince you that he did not kowtow to the Big Man.

The Big Man was, of course, Ian Paisley, the Protestant fundamentalist, firebrand, loyalist, and head of the DUP. He underscored his own sense of self-importance when I relayed to him in the early 1980s that the IRA had never contemplated killing him. ("He is far more valuable to us alive than dead," my Sinn Féin source had said.) Paisley got upset—of course he was on the hit list, he insisted. The Big Man was against meeting with anybody, but absolutely opposed to meeting with Sinn Féin. To him, the political arm of the IRA was the devil incarnate, and the UUP, which competed for Protestant "hearts and minds," was as much his enemy as the SDLP or, for that matter, the British government. They all had his enmity.

I first met David Trimble at the British-Irish Association's annual conference in 1983. Trimble, a practicing lawyer and one of the UUP's brains, was a little stiff, to say the least, and people sometimes mistook his innate shyness for aloofness. He was as soft-spoken as he was hard-headed. We had mutual friends, including a very close one. The UUP represented the rump of the unionist party that had governed Northern Ireland since the statelet's foundation in May 1920. Paisley's DUP was squeezing it from the right, accusing it of "selling out," a refrain hurled at any unionist who agreed to negotiate with nationalists under the belief that such negotiations would lead ineluctably, as a result of some mysterious osmosis, to a united Ireland. On one occasion in late 1996, Trimble and I spent hours talking in Renshaw's Hotel, Belfast— nothing about South Africa or Northern Ireland, just talking.

My approach to each of these men directly and through friends was to pose a question: "If President Mandela invited you to come to South Africa to meet with the leaders who negotiated the end of apartheid, would you come?" That more or less became my mantra for two years. Sinn Féin was the least skeptical, but was quick to tell me it didn't need me as an intermediary, as it had its own direct line to the ANC. Any suggestion of a Sinn Féin presence met with a thumbs-down from the unionists. I became a fixture in Northern Ireland, setting up appointments, waiting, pondering Vladimir's predicament in *Waiting for Godot*. Much of this time involved sitting around drinking Guinness, sometimes five or six pints with a double Black Bush. It was not healthy, but such is the business of pushing peace.

BRINGING IN THE HEAVYWEIGHTS

After a few too many moments of "numbing it out," it was time to call in my chit. I decided that if I couldn't bring the leaders of all Northern Ireland's factions to South Africa, perhaps I could try bringing the South Africans to Northern Ireland. Perhaps they could nudge the talks further. Meyer and Ramaphosa agreed. I returned yet again to Belfast with a different message: the two men who had spearheaded negotiations in South Africa were coming to Belfast and would like to meet with them. This time, there were no naysayers.

On 28 July 1996, Meyer and Ramaphosa took up residence at the Europa Hotel, in the

1970s the most bombed hotel in Europe. Over 36 hours, they met with the leadership of each party for two hours. Meyer had dinner with US Senator George Mitchell, President Bill Clinton's special envoy—the pivotal figure outside of Northern Ireland, and the man who would ultimately guide the peace process across the finishing line. Mitchell gave his blessings, and perhaps also his misgivings, as he had already spent the better part of a year trying to simply bring the parties to the same table. Ramaphosa, on his way to Belfast International Airport, stopped to meet with Adams and McGuiness in West Belfast. On their return, Meyer and Ramaphosa reported to Mandela that in their opinion, South Africa could help. Fine, said Mandela, but my country does not intervene with the conflict in another country without being invited to do so. He required letters from all the parties involved.

I was back in Belfast. It was one thing for Ramaphosa and Meyer to believe that South Africa could assist, another for all the parties in Northern Ireland to believe so. And Mandela had set the stakes higher: all parties had to agree to go to South Africa; if one or another dropped out, a meeting there would make no sense.

Making this happen involved quite a pas de deux—or rather a pas de *neuf* (nine!): first, secure letters from all of them; next, meet the conditions that different parties attached; next, find a venue to accommodate the often contradictory conditions; then, perhaps most difficult of all, hold the parties to their promises to go. In the month between saying yes and departing for the journey, some of those parties began to get cold feet. Some unionists began to tell Paisley that the whole thing was a republican setup—the ANC and Sinn Féin were in cahoots, and how could the DUP justify going to South Africa when it refused to meet with Sinn Féin for negotiations in Northern Ireland? Different media aligned themselves with different protagonists. Helpfully, the South Africans chose a secure conference facility adjacent to the De Hoop Nature Reserve, about a two-hour drive from Cape Town, where the media could not intrude.

In the final days, the DUP began to crack. They did not want to catch sight of Sinn Féin. They would not sit in the same room. Prolific and well-practiced at shouting "sellout" at the UUP, the DUP was hypersensitive to being called the same itself. If the DUP pulled out, Trimble would pull out, too. Each spurned the other; each needed the other's protective presence.

A team of Afrikaners came to our help with great zeal. They divided the conference facility into three parts: one area was set aside for unionists, one was for nationalists, and the center was a neutral space. They assigned Sinn Féin to one area, put the DUP in the area farthest from Sinn Féin, and positioned the more moderate parties from both camps—the UUP, SDLP, and Alliance—as a buffer in the centre. Each area had its own wings with rooms and dining facilities. Each even had its own bar. Each session would be repeated twice so that all parties were receiving the same information. Ramaphosa would host and chair the whole thing.

Cracks widened in May 1997, when the *Sunday People* ran a feature essentially saying the unionists were going to South Africa to negotiate with Sinn Féin. A furious Robinson faxed me: "If the present public understanding of the event remains as

outlined in the *Sunday People* there would be no question of the DUP being present."
He continued, "We will not meet directly or indirectly with [the] IRA–Sinn Féin
murder gang; we will not take part in any event that would give the impression that
we were doing so outside Northern Ireland."

That was a clanger, if ever. Nothing less would suffice than a guarantee of being
"hermetically sealed" from Sinn Féin, from the moment the DUP departed Belfast
on 29 May to the moment they arrived back on 3 June. If I could satisfy them on
these scores, we might squeeze through the political hoops.

On 23 May, I met with Paisley at Peter Robinson's home. What remains most vividly
in my mind is that Paisley, a huge man, had rather small ankles and wore short pink
socks. I thought to myself, how could such a bulk of a man rest on such small feet?
The pink socks stick with me.

I had come with a map of the conference facility's layout, with each area marked off.
The distance between Sinn Féin's area and the unionists' was noted; everyone
would be colour coded according to party. Yet Paisley persisted—what if this or that
happened? What if the media got wind of the gathering? If they couldn't gain
access, wouldn't that enrage them, and what kind of damaging stories might they
write? After a couple of hours Paisley called it a night, saying he would let me know
the DUP's decision the following day. That evening, fearing the worst, with the
conference five days away and with the departure tickets in my hands, I called
Robinson. He told me that if he could get one other senior person in the DUP to go
with him, he would go, even over Paisley's objections. I called Gregory Campbell, a
senior DUP MP I had become close to. Campbell agreed to go. I called Robinson
back. He was all set. I called Trimble. If Robinson was going, so was he. Without
Robinson he was out.

The DUP executive committee met the following day. After some discussion of a local
election, Paisley flipped through his diary and asked, "What about next Monday?"
"I don't know about you, Doc," Peter Robinson says he replied, "but on next
Tuesday I'll be in South Africa." Robinson says that Edwin Poots, a member of the
Northern Ireland negotiating forum, piped up. After hearing an explanation, Poots
said he wanted to go, too. And then Sammy Wilson, also a forum member and a
former lord mayor of Belfast, chimed in. Campbell, of course, was already on board.
In the end, all four—the cream of the DUP negotiating team—attended.

The last piece of the puzzle was to get the British and Irish governments on board. I
enjoyed a special relationship with the British government's Northern Ireland Office
based on my authorship of *The Uncivil Wars*, which had earned me credibility with
secretaries of state for Northern Ireland. Over the years, I had met and interviewed
many of them, and incoming secretaries prepped for office by reading it. The book
greased tracks on the Irish side as well. The multiparty Airlie House Conference, held
in 1985 in Virginia, allowed me to get on familiar terms with various senior British
and Irish officials. In the spring, my access to all these contacts paid off: Dick Spring,
the Irish tánaiste (deputy prime minister) and minister of foreign affairs, and Michael
Ancram, the British minister of state for Northern Ireland, signed off on the project.
Dame Maeve Fort, the British high commissioner to South Africa, also gave her nod.

OVERCOMING THE NARCISSISM OF SMALL DIFFERENCES

Travel arrangements were practically a paean to segregation: Sinn Féin was routed through Paris to Johannesburg, while the other parties went through London. In South Africa there were two sets of VIP lounges in Johannesburg; two sets of military aircraft (one to ferry the unionist parties, SDLP, Alliance, and the smaller parties, and another to ferry Sinn Féin) to fly everyone to Denel Overberg Test Range, a military base close to De Hoop; and two sets of buses to the De Hoop Nature Reserve. There were three sets of accommodations within the conference site. The conference itself held two separate sessions for each proceeding. Finally, a set of byzantine arrangements allowed the delegations to either commingle or remain separate.

On the morning of 30 May, the negotiators from Northern Ireland arrived in two groups. The luggage had been carefully tagged in Belfast. When the first plane landed at Johannesburg, suitcases were unloaded on the runway and the group straggled to a waiting Hercules 130, the huge carrier's backside open to a cruel winter wind as we waited because of a delayed takeoff. Trimble read *William and Mary*; the others slept, chatted, or huddled against the cold.

After Robinson had settled into his accommodations, I was anxious to show him what a good job we had done in complying with the DUP's demands. We reviewed the arrangements, and he had only one comment: "The Sinn Féin bar is bigger than our bar!" I pointed out that his group didn't even drink. He was adamant—we had to fix it. This small incident exemplified a key characteristic of a divided society: the narcissism of small differences. To Robinson, the fact that the makeshift Sinn Féin bar was slightly larger than the makeshift DUP bar triggered a less-than, more-than complex; it signified that the organizers empathized with Sinn Féin's position. It had to be fixed, so we fixed it.

Later that afternoon, the Sinn Féin contingent arrived. Overall, 27 members of nine political parties settled in.

The dinners proceeded on schedule, and the South Africans begin to arrive—16 negotiators from all parties to the South African talks, as well as members of the security and intelligence services. (Ramaphosa, never a man to be where he absolutely does not have to be, arrived the next morning.) South Africans retire early, so their negotiators quit us, leaving only the Afrikaners whose job it was to keep people separate. (They had even hauled in potted trees to make sure that no member of the DUP might ever catch sight of a member of the Sinn Féin delegation.) The centre bar was the place to be. Everyone piled in, in ones and twos. As neither

the Sinn Féin nor the DUP delegates drank, the centrists surreptitiously sized each other up like boxers before the opening bell. They didn't interact.

Then, suddenly, from a unionist came the full-throated strains of "The Fields of Athenry"—a song dear to the heart of nationalists, a song belted out in bars across the Republic and the Catholic north on various and sundry occasions, the litmus test of culture. Heresy! The Irish applauded generously and kept their powder, but then rose to the challenge when the unionists, with a faint taunt, called, "Up to you, lads!" They proceeded to offer an equally full-throated rendition of "The Sash My Father Wore," a Northern Ireland and Ulster Scots folk song commemorating the victory of the Protestant King William over the Catholics supporting King James in 1690, as well as other glories of the Orangemen.

And so the night went: "The Foggy Dew," from the unionists; "Lisnagade," from the nationalists; "Four Green Fields," unionists; "The Patriot Game," unionists. It was a madcap competition to see who could sing more of the other's songs. The beer went down, and the Afrikaners added a few songs of their own honoring various exploits during the Boer Wars. Some got a little maudlin, carried away by the moment and the exhilaration of being part of something that might break the mold of history. The craic was great, God was good, and the night was long.

At about midnight, I noticed a figure skulking amongst the potted trees the Afrikaners had positioned. Out of the shadows came one who shall remain unnamed (for the sake of his political future), breaking DUP curfew for the sake of a pint. He cut a lonesome figure, huddled furtively in the shadows of the now-capacious DUP bar.

RISING TO THE OCCASION

Over the next three days, the engagements were intense—lectures, workshops, and private consultations, all occurring in duplicate. Robinson had demanded, on behalf of the unionists, that "no disadvantage would be felt by our delegation because of these self-imposed conditions and that no event would be arranged for collective delegations that would not apply separately to ourselves." None was and none were. The risk that the other side (or your own side) would see you as soft ensured that there was no overt commingling, but in private arrangements with South Africans as facilitators, a little shuttling back and forth may have discreetly occurred. (Our own commitment to not publicly disclose what took place means I've decided to allow the South Africans to keep such arrangements to themselves—it was their show, not ours.)

The meeting allowed both Sinn Féin and the unionists to speak with members of the South Africa delegation. Sinn Féin formed a bond with Ramaphosa, and the unionists connected with Meyer and the Afrikaners. Later the Irish contingents would each talk with their respective South African mentor—who, unknown to them, would talk to his counterpart and then get back to them.

By mid-morning on Saturday, 1 June, the breakthroughs that Ramaphosa had expected had not occurred, to his disappointment. It was time to bring in Madiba, as

Mandela was affectionately called. The president arrived at noon on 1 June. But we had a problem. The DUP refused to meet with him if Sinn Féin was also in the room. The UUP fell in behind the DUP.

"You are going to have to endure a little apartheid here," I said, greeting him on the tarmac as he walked from the helicopter. He laughed.

He met with all parties together, minus the two unionist ones, then separately with the unionists. This was for the better. To Sinn Féin, he stated in no uncertain terms that it would not be included at a negotiation table unless the IRA reinstated the August 1994 ceasefire it had ended in February 1996 with a bombing at Canary Wharf. To the unionists, he insisted that they decouple two demands (that the IRA declare a permanent ceasefire and that it decommission its weapons). Mandela told them to insist on the ceasefire but to make decommissioning part of the negotiation process, which is what happened.

Trimble was chagrined because the hoped-for private meeting with Mandela did not materialize—for obvious reasons: if one delegation was afforded such access, all would have to be. I corralled the copy of Mandela's autobiography, *Long Walk to Freedom*, that my assistant Margery O'Donnell had brought with her and handed it to Ramaphosa, who was introducing members of the unionist delegations to Mandela. On a piece of paper I had written, "Cyril, please ask Madiba to sign this book as follows: 'Dear David, you are one of the few people who can bring peace to your troubled country. I know you will rise to the occasion. Your friend, Madiba.'" Cyril glanced at it and handed the book with the instruction to Mandela. The ever-astute Mandela didn't miss a beat, inscribing it as asked. When the meeting broke up, I sought out Trimble and told him Mandela had a gift for him—a copy of his autobiography, which he had inscribed. "Read it!" I said. And after Trimble read the inscription, his face broke out in a big smile.

Each party lined up in turn to have a photo op with Mandela. The ice cracked, and the program went into high gear. All the demands of the participants were met. On 20 July 1997, the IRA announced a new ceasefire, and subsequently Sinn Féin was admitted to the peace talks.

On 10 April 1998, all parties signed the Good Friday or Belfast Agreement. The meeting at De Hoop played a limited role in that outcome.

I took to referring to the meeting as the Great Indaba, using the Zulu word that has found widespread use throughout southern Africa to mean, simply, *gathering*. Jeffrey Donaldson, an Ulster unionist negotiator, called the indaba "a game changer," explaining, "We were able to take the lessons we learned from the South African experience and apply them to our own." Monica McWilliams, head of the Women's Coalition, said, "It couldn't have been planned to happen at a more critical point." Irish Taoiseach (Prime Minister) Bertie Ahern acknowledged that the Great Indaba was "highly complex" but led politicians to believe "this problem could be cracked." In a year, he added, the participants were able to make "the enormous moves they had not dared to dream [of] for the previous 60 to 70 years."

The late Martin McGuiness said of the experience, "Groundbreaking! I found that I could learn to love my enemy." And an observer later wrote of David Trimble, in a description that also applied to the other participants, "On a distant field of a South African game park, he began the journey in earnest from leader of one tribe to the architect of a new inclusiveness in Ulster."

Jon Lee Anderson
The Eternal War

Stephen Ferry
**Colombia Between War and Peace
(2016–19)**

Margarita Martinez
Finding Humanity in Havana

The Eternal War

by Jon Lee Anderson

T he chronic violence of his birthplace was an enduring touchstone for the late Colombian novelist Gabriel García Márquez. In his masterpiece, *One Hundred Years of Solitude*, Colombia's two traditional political forces, the Liberals and Conservatives, are engaged in eternal warfare that flares up and dies in a never-ending cycle, like seasonal hurricanes, violently shaping and ultimately overwhelming the lives of his characters.

Describing the epic life of one of his most memorable fictional personalities, García Márquez wrote: "Colonel Aureliano Buendia organized thirty-two armed uprisings and he lost them all. He had seventeen male children by seventeen different women and they were exterminated one after the other on a single night before the oldest one had reached the age of thirty-five. He survived fourteen attempts on his life, seventy-three ambushes, and a firing squad. He lived through a dose of strychnine in his coffee that was enough to kill a horse.... Although he always fought at the head of his men, the only wound that he received was the one he gave himself after signing the Treaty of Neerlandia, which put an end to almost twenty years of civil war. He shot himself in the chest with a pistol and the bullet came out through his back without damaging any vital organ. The only thing left of all that was a street that bore his name in Macondo."

García Márquez's fiction was a florid reimagining of Colombia's history. The novelist was born in 1927 and died in 2014, at age 87, and for most of that time, Colombia was at war with itself in one way or another. Behind the scenes, García Márquez made several personal attempts to broker peace between the warring factions. Although those efforts ultimately failed, he never stopped trying, and he acknowledged ruefully that he had a reputation as "Colombia's last optimist."

Since it declared independence from Spain in 1810, Colombia has suffered from internal conflict for 77 out of the 209 years that have elapsed, during six distinct periods of violent upheaval. It has had numerous coups d'état and military dictators. Ten of its presidents have died violently.

Colombians often trace the start of their country's strife to 1948, when the charismatic Liberal politician Jorge Eliécer Gaitan was assassinated, leading to a decade-long civil war between

In 2016, a peace accord between the government and a guerrilla group ended more than half a century of civil war in Colombia. But violence in this South American state preceded that conflict, and inequality and injustice remain prevalent today. **Jon Lee Anderson** has known the Latin American country since he was four years old, when his diplomat father was assigned to Bogotá and his family moved there. He has reported frequently on Colombia for *The New Yorker*, paying close attention to the ebbs and flows in its quest for peace. In this examination, he asks whether a negotiated settlement can hold when the political winds shift and a new government opposed to the accord takes power. After all, this is a country more accustomed to violence than to peace.

Liberals and their Conservative rivals. The bloodletting, which resulted in at least 200,000 deaths, became known simply as La Violencia. It ended when the two parties agreed to a non-aggression pact, leading to Colombia's longest period of uninterrupted democratic rule, from 1958 until the present. Paradoxically, this period has also been one of Colombia's bloodiest, with a half-dozen guerrilla insurgencies, as well as narco violence, fracturing its peace. The violence has been both deep and broad: huge swathes of the countryside have been de facto battlegrounds where insurgents and government soldiers have fought it out, and where civilians were cannon fodder for both sides. Since 1958, well over a quarter of a million Colombians have been killed for political reasons, with countless more wounded, tortured, imprisoned, or driven into exile. Over seven million Colombians—about one-seventh of the population—have been displaced from their homes, more than anywhere else in the modern world, except for war-torn Syria.

In this period, Colombia became an international byword for murderous violence, producing a dismal new lexicon. It includes terms like *la corbata colombiana*— the Colombian necktie, introduced during La Violencia, describing a form of political murder that involved slitting people's throats and pulling their tongues out through the hole in the neck. *La motosierra* (literally, the chainsaw) was given new meaning in the 1990s by the country's merciless right-wing paramilitary death squads, commonly referred to as *paracos,* when they used it to describe the dismembering of live victims. *Dale taladrín* plays on the word *taladro*, or electric drill—as in "give him the drill." The latest addition to this sick litany are the *casas de pique*—chop houses— where the present-day narco paramilitaries take victims to chop them to pieces.

After so many years of conflict, Colombia has become a security state. With over 400,000 soldiers, it possesses the Western Hemisphere's second-largest standing army after that of the United States. It has also fostered a militarized society in which armed men abound. Many middle-class and affluent Colombians spend their lives cocooned in a web of security: apartment buildings have armed guards at their entrances, while private police patrol shopping malls. At public parking garages, guards with bomb detectors routinely check underneath cars. Thousands of Colombians—businessmen, politicians, and even some journalists—move around inside armored cars, with bodyguards. In the countryside, army posts are ubiquitous, and it is common to see uniformed soldiers out on foot patrol, armed and at the ready. Colombians have become conditioned to this existence and regard it as normal.

In 1961, as a boy of four, I lived with my family in Bogotá. My father was on a US government contract as an agricultural adviser. Most of my earliest memories stem from this period, and many of them have to do with violence or the threat of it. We lived in a suburban neighborhood on the outskirts of Bogotá; every day, I traveled to and from a nursery school in the city with a driver who was also a bodyguard; he had a gun in a shoulder holster. I was never allowed out of the house otherwise, because of the supposedly high risk of being kidnapped. My father owned several rifles that he kept locked inside a gun cabinet. When I asked him why he had them, he explained that Colombia was dangerous, and that whenever he left the capital he had to travel through the countryside, parts of which the "bandits" controlled. They often stopped cars to rob and kill or kidnap people, and as an American official, he was a prime target, as were we, his children.

We spent only a year in Colombia before leaving for Taiwan, and I spent most of the rest of my growing-up years in Asia and Africa. But I retained strong impressions of my circumscribed year in Colombia, and I recalled it often. Later on, my father told me that he had been in a state of anxiety about our safety throughout our time there, and after a friend of his was murdered, he had asked the State Department for a transfer, which is why we had left Bogotá so quickly.

Countless return trips over the years have added more layers to my formative memories of Colombia. The insecure society I became aware of as a child has endured an additional half-century of civil war, moments of which I have glimpsed at various stages. In all that time, the one thing that has remained constant is its violence. It is violence, not peace, that has driven Colombia from one political threshold to the next, in a kind of perpetual cycle.

THE MALOGRADOS

In July 2016, I visited a large base camp of the guerrilla army known as the Fuerzas Armadas Revolucionarias de Colombia (FARC, Revolutionary Armed Forces of Colombia) in the southern province of Yarí, a region of jungle and floodplains in the headwaters of the Amazon. The camp was under the supervision of Comandante Mauricio Jaramillo, a member of its seven-man ruling secretariat. At 69, Mauricio, a trained doctor who was also known as "El Medico," was one of the guerrilla group's most veteran commanders.

I spent several days becoming acquainted with Mauricio and the younger fighters under his command. Most were in still in their 20s and 30s but were already hardened combat veterans. All were anxiously awaiting a final breakthrough in the peace negotiations that were being held in Havana between the FARC and the government, which had dragged on for four years. The fighters remained armed and vigilant, but they were no longer on a war footing, and they spent their days carrying out menial tasks around camp.

Most of the guerrillas had been with the FARC since their early teens, and had left extremely poor families behind, years before, in isolated hamlets and villages across Colombia, when they joined up. For some it had been a Pied Piper phenomenon: the FARC's fighters had come marching through, armed and proud, and the rural youngsters had felt thrilled and wanted in. For some, being a *camarada* (comrade)— as the guerrillas referred to each other—had offered a way out of poverty and broken homes; for others, it had been an escape from terror and humiliation at the hands of marauding paracos, who have historically operated in tandem with Colombia's landowners, politicians, and army.

Many had not seen their parents since they had joined up a decade before or longer, and some became emotional when they spoke of their mothers or the siblings they had left behind.

When it came to their futures, most declared loyally that they would do whatever "the party" wished them to do, and also said that they wanted, somehow, to remain together with their comrades in peacetime. By the party, they meant the Clandestine

Colombian Communist Party, for which the FARC operated as an armed wing. But most had no clear idea what the world beyond the battlefield was like, much less what the future held for them. Some said they wished to be farmers, and a few were interested in "IT," which they spoke of with the enthralled abstraction of youngsters talking about becoming astronauts. Metropolitan Colombia was a galaxy far from theirs, a reality they had only heard about. Others simply expressed a desire to finish elementary or high school. Few had ever lived in a city or even visited one, and most had scant skills other than knowing how to make and break camp, march in the jungle, operate a gun, and fight.

One day, the news went around the camp that one of Mauricio's most far-flung guerrilla columns, known as Columna Uno (Column One), operating in a remote jungle area near the Brazilian frontier, had announced its defection. The commander of the unit had issued a communiqué declaring that he and his group of about 100 fighters were not going to take part in the peace process.

Mauricio said he suspected that *"el narcotráfico"* (drug trafficking) was the real reason for the mutiny. The renegade unit's principal duty on behalf of the FARC, he explained, had been to extract taxes from cocaine traffickers exiting Colombia for Brazil with their product. Having been assigned this task, he surmised, the fighters had become corrupted and turned into *narcotraficantes* (drug traffickers) themselves. It was regrettable, but not entirely surprising; the unit's remoteness had hampered his ability to ensure its fealty to revolutionary values. Mauricio confided that the FARC expected to lose 10 to 15 percent of its fighters in such ways during the coming drawdown. Later that day, Mauricio and the other members of the FARC high

command issued a statement repudiating Columna Uno, declaring it to be a hostile force, and expressing their willingness to cooperate with Colombia's military to bring it to heel. The episode was an early indication that even after a peace agreement, Colombia's long civil war could have a messy aftermath.

A few months later, in September 2016, I returned to the Yarí base. The atmosphere was euphoric; the FARC's leaders and the negotiators for Colombian President Juan Manuel Santos had finally reached a deal. They had set a date for a final peace treaty signing later in the month, and among the guerrillas there was widespread excitement about the imminent end of the war. I also learned more about Mauricio's breakaway group from a fighter who had belonged to it: Martín, a 36-year-old junior officer and paramedic.

Martín had had a narrow escape. He had been with Columna Uno for the previous two years and had been present when the commander had summoned his fighters, informed them of his decision to stay in the field, and asked them, on the spot, for a show of hands. It was an exceedingly tense moment. Most of the fighters had voted to stay with their commander. Martín and nine others had said they wanted to remain with the FARC—to demobilize and go through the peace process that the rebel leadership was in the midst of negotiating. The commander had made a show of respecting their decision, said Martín, but had then isolated them from the main group by dispatching them to an area a couple of days' march away. After a few weeks, he had ordered them via field radio to return to his base, telling them that they would be allowed to leave and would be escorted to Commander Mauricio's Yarí territory. The route he outlined was a strange, circuitous one through the jungle, and Martín and his

comrades were immediately suspicious that the plan was to get rid of them. "Anything could happen" on such a long march, said Martín.

Worried, Martín made contact with Mauricio by field radio and explained what was going on. Mauricio warned him not to return to his commander's camp under any circumstances and advised him to set out immediately for Yarí via an alternate, quicker route. As Martin told it, that was what they had done, deceiving their breakaway commander by calling in periodically via radio and telling him that they were en route to his camp. When they felt they were safely out of his reach, they told him the truth, informing him that they had reached FARC lines and were terminating all further contact with him.

Martín told his story in a deadpan way, downplaying the danger he had been in. But Isabela, a fellow officer, said unequivocally: "They were going to murder them. A lot of the fighters there were malogrados." What she meant was that the Columna Uno soldiers had literally been "ruined," that their political morality had been corroded as a result of their close proximity to the drug trade. They were no longer political outlaws, but criminals. It was the kind of on-the-record admission I couldn't imagine an active member of the FARC ever having made to a journalist before; it had taken several years during the peace negotiations for its leaders to even acknowledge their involvement in the cocaine industry. As part of the final peace accord, they had agreed to cease all their narcotics-related activities but had remained elliptical about what exactly these consisted of. Martín's case brought it all into much sharper relief and made me wonder how many more of the FARC fighters would turn out to be malogrados as time went forward.

THE PRECARIOUS PROMISE OF PEACE

A couple of weeks after I met Martín in Yarí, in late September 2016, the war between the FARC and the state came to a dramatic symbolic end on an open-air stage in the colonial city of Cartagena, on Colombia's Caribbean coast. It was a historic moment. There, in front of a large crowd and on live television, President Juan Manuel Santos appeared together with FARC leader Rodrigo Londoño Echeverri, alias Timochenko. The peace agreement they signed, with a pen fashioned out of a bullet, formally ended the Western Hemisphere's longest-lasting civil war.

It was not the first peace deal entered into in Colombia. The long history of the country's internal conflicts includes an equally long history of treaties signed and broken, of inadequate justice for crimes committed, and of malogrados staying on in the field as armed gangsters of one sort or another. But in a world riven by unceasing conflicts, the 2016 Colombian peace deal stood out as a rare example of political pragmatism, international cooperation, and hope. The process had involved several years of intense negotiations and the involvement of the governments of Venezuela, Cuba, the US, Norway, and the Vatican. For the momentous occasion, United Nations Secretary-General Ban Ki-moon, former King of Spain Juan Carlos, Cuban President Raúl Castro, and US Secretary of State John Kerry were all in attendance.

As a consequence of the agreement, some 8,000 guerrilla fighters laid down their

weapons and moved to demobilization camps, while their leaders set about reorganizing the FARC into a legal political party. Colombia's achievement was consecrated internationally when President Santos, who had tirelessly pushed for the peace agreement throughout his two terms in office, received the Nobel Peace Prize.

With the new peace, hopes soared among Colombians that their country would soon reap its benefits in the form of a more participatory democracy and greater prosperity for all. In a speech lauding the armistice as a "historic achievement," US President Barack Obama declared his intention to seek US government funds to pay for an ambitious postwar program called Peace Colombia, so as to "provide a framework to reinforce security gains, reintegrate former combatants into society, and extend opportunity and the rule of law."

Coming on the heels of Plan Colombia, a $10 billion US military assistance program that had begun in 2000 and had helped Colombia's military vanquish the guerrillas in the battlefield, Peace Colombia was based upon the premise that after the FARC drawdown, Colombians would put aside their differences in order to make their newfound peace a lasting one. What the program may have overlooked was that for many Colombians, violence was the more familiar reality, with peace perceived as a mere tactical interlude in an eternal battle with one's enemies.

REBELS ON THE LEFT, DEATH SQUADS ON THE RIGHT

For the 52 years of its existence as a guerrilla army, the FARC was based in Colombia's undeveloped countryside. In the absence of civic infrastructure and economic ties binding them to Colombia's cities, rural Colombians had little choice

but to support whichever armed force was more dominant in their area. As the decades went by, the FARC became a de facto parallel government in the areas where it was strong, competing with the distant, ineffectual Colombian state based in Bogotá and outlying cities.

Until his death in 2008, at the age of 77, the FARC's *jefe máximo* (top boss) had always been the legendary Manuel Marulanda, aka Tirofíjo or "Sure Shot." A man of peasant origin, Marulanda had been a rebel ever since his youth, when the loyalists of Colombia's two main political parties—the Liberals and the Conservatives—had gone to war with one another during La Violencia. The two parties had worked out a truce in 1957 that formally ended the butchery, but the countryside remained tense and unsettled.

In the course of La Violencia, other armed groups had formed and were prepared for further warfare. (This was the period when my family lived in Bogotá.) Among them were Colombia's communists, who had organized a series of armed peasant enclaves for self-defense. Marulanda helped found one of these, the so-called independent Republic of Marquetalia, which functioned for several years as a kind of autonomous rebel oasis in the back country, in a tense standoff with Bogotá. This status quo lasted until the early 1960s, when the US government, worried about a new Marxist insurgency taking root in the hemisphere—following Fidel Castro's recent successful revolution in Cuba—urged the government of Colombia to attack Marquetalia. Bogotá's government soon obliged, sending in troops and warplanes. The military action over-whelmed the rebels in Marquetalia but sparked off a new war at the same time.

Marulanda and his several hundred followers went on the run. In 1964 they formalized their insurgency by founding

the FARC, and in the years that followed they steadily expanded their numbers as well as their military capability. By the late 1990s, the FARC boasted an army of 20,000 that was active across the length and breadth of Colombia, controlling about a third of the national territory. The guerrillas sustained themselves by taxing local merchants and ranchers and by extracting money from oil and mining companies in exchange for not attacking their installations. Employing the end-justifies-the-means logic of wartime, the FARC also began kidnapping people for ransom, and eventually moved into Colombia's booming drug business.

The FARC was not alone in the field. The same year it took up arms, another Marxist guerrilla group, calling itself the Ejército de Liberación Nacional (ELN, National Liberation Army)—led by Camilo Torres, a Catholic priest inspired by Che Guevara and liberation theology—also initiated hostilities. Today, with an estimated 2,500 fighters spread across several provinces, the ELN remains active, holding fitful peace talks with the government, alternating between military attacks and on-again, off-again ceasefires.

Other insurgent groups have also come and gone, including the Maoist Ejército Popular de Liberación (EPL, Popular Liberation Army), the indigenous-based Movimiento Armado Quintín Lame (MAPL, Quintín Lame Armed Movement), and the M-19, a group founded by urban intellectuals and university students.

The FARC may have begun as a Marxist insurgency, but the conflict in Colombia was not simply a case of leftist guerrillas fighting a right-wing national government. A network of drug traffickers, landowners, right-wing politicians, and private security forces formed paramilitary death squads—the paracos—to defend their interests. These groups, who often acted in coordination with the Colombian army, fought the guerrillas and murdered their sympathizers. They also began terrorizing peasant farmers and seizing their lands. In 1997, a coalition of paramilitary groups operating around the country came together under the umbrella of the Autodefensas Unidas de Colombia (AUC, United Self-Defense Forces of Colombia), led by Carlos Castaño, a cattle rancher's son and onetime associate of drug lord Pablo Escobar. Under Castaño, the AUC grew into a powerful army that competed with the FARC on its own turf, mainly by attacking its civilian base of support, carrying out hundreds of massacres, and displacing hundreds of thousands of Colombians from the countryside. The AUC also moved into the drug business.

Over time, the cocaine trade drew in all the actors in the country's hydra-headed civil war. The FARC began to finance its operations from the trade, first by levying taxes on coca growers, and then by working directly with traffickers. Despite the AUC's own drawdown, which began in 2003, some paracos reorganized themselves into groups that functioned increasingly as *narcoparamilitares*, heavily involved in drug production and trafficking in territory they had come to dominate. Becoming malogrado is a persistent theme among Colombian fighters, no matter which side they are on.

A TALE OF TWO PRESIDENTS: URIBE AND SANTOS

For a study in the complexity, and the toxicity, of Colombia's web of inter-relationships across the unmarked frontiers of its internal wars, one need look no further than Álvaro Uribe Vélez.

A 1991 US Defense Intelligence Agency (DIA) report listed Uribe, who was a senator at the time, as someone who "worked for the Medellín Cartel" and was a "close personal friend of Pablo Escobar." He came out of the cattle-ranching milieu of conservative Antioquia province, of which Medellín is the capital. After the FARC killed his father in a botched 1983 kidnapping attempt, he became involved in the paramilitary underworld and is believed to have helped create one of its most murderous militias, the Bloque Metro. (In this aspect, Uribe's story echoes that of Carlos Castaño, the AUC founder, whose father the FARC also killed.) Uribe's family was also closely associated with another ranching family, the Ochoas—Pablo Escobar's partners in the Medellín Cartel. Unlike the Ochoas, Alvaro Uribe didn't go directly into the cocaine business, but went into politics. After a stint as the chief of civil aviation for the Antioquia province, where the Medellín Cartel was based—and from which its airplanes loaded with cocaine took off—Uribe briefly became Medellín's mayor and went on to serve two terms as a senator. In 1995, he became governor of Antioquia and established a network of armed anti-guerrilla "self-defense associations" linked to the paramilitaries.

Somehow, Uribe has always managed to slough off the myriad accusations against him. He has denied having ties to drug traffickers and to the paracos, but there is overwhelming evidence to the contrary, not least the allegations of several key former paramilitary commanders. Numerous officials and politicians close to Uribe have been arrested for paramilitary-related crimes over the years, as have one of his cousins and a brother. Criminal investigations against Uribe himself have also been underway for years, but Colombia's judiciary has shown itself loath to indict him. Fear

seems to be one of the biggest reasons. In a number of recent cases, witnesses who dared to testify against Uribe have been murdered.

The governorship of Antioquia turned out to be another stepping-stone for Uribe. He finally became Colombia's president in 2002, promising a law-and-order government. He negotiated an accord with the AUC in 2003, in a sweeping amnesty deal that brought an end to its wholesale massacres but also left most of the perpetrators unpunished. He also stepped up the war against the FARC. Intriguingly, his assessment by the DIA seems to have done him no harm. On the contrary—while he was in office, Uribe established a close working relationship with the US government. It was during the Uribe years that the US stepped up its military assistance, under Plan Colombia, and the FARC began to suffer serious blows that weakened its leadership, decimated the ranks of its fighting force, and reduced its hold on territory. In 2008, Marulanda died of a heart attack, and several airborne raids on the FARC redoubts killed senior rebels, rescued hostages, and seized intelligence caches.

As Uribe's defense minister, Juan Manuel Santos presided over these military operations without demurral. But when he succeeded Uribe—who had served his legal limit of two terms in office—and assumed the presidency himself in 2010, Santos resolved to be the man who would bring peace to Colombia. When he sent a trusted emissary to meet secretly with the FARC and sound it out about more substantive negotiations, the FARC expressed its willingness. Even so, in November 2011, when Santos's military high command informed him that it had discovered the location of Alfonso Cano, Marulanda's successor as the head of the FARC, Santos took a

calculated risk and authorized an attack. He reasoned that if the FARC was already ready to talk, it would carry on with or without Cano. ("I told them: '*Quemanlo*—burn him,'" Santos said to me some time afterward.) Cano was shot and killed as he tried to escape. And sure enough, before long, Cano's successor, Timochenko, continued the dialogue with Santos.

Santos's peacemaking efforts did not earn him sympathy from his onetime boss. As the peace talks began in Havana, Uribe began attacking his successor in public statements and via Twitter. Uribe regularly referred to Santos as a traitor, a sellout to the FARC, and an ally of Hugo Chávez and Fidel Castro. These were outlandish claims, but Uribe did not back down. Instead, he created a new political party, the Centro Democrático (Democratic Center), and won a seat for himself in the senate in 2014. This position became his new bully pulpit.

The conflict between the two men seemed almost Shakespearean. They were studies in opposites. Uribe was from a provincial cattle-ranching family and espoused the ultraconservative social and political views of Colombia's hinterland, while Santos, the scion of one of Colombia's most patrician families, which owned a media empire, was a Bogotá blueblood. When, early in his presidency, I asked Santos what he thought was motivating Uribe's attacks against him, he suggested that Uribe was worried about one day having to face justice for crimes he might have committed. Santos's implication was that he knew something about Uribe's crimes. There were military officers who backed Uribe, he acknowledged, men who were similarly concerned about their future because of human rights abuses they had committed. They looked to Uribe as their protector.

Under the transitional justice system Santos called for in his peace deal with the FARC, all former combatants—not just guerrillas but also army officers and civilian irregulars—are required to own up to their wartime activities in special tribunals intended to clear the air about the past, in the manner of South Africa's truth and justice commissions. While most rank-and-file combatants are expected to be set free, those found guilty of war crimes might face restorative sentences of up to eight years, perhaps in prison or, alternatively, in doing some sort of social service work. Harsher punishments—up to 20 years in prison—could await those who try to lie about their crimes in the tribunal.

Santos pushed on in his talks with the FARC. When the peace accord was finally signed in Cartagena, I went to a raucous party attended by senior Colombian government negotiators, British advisers, and Norwegian and Cuban diplomats, with many a fulsome toast to peace. At their base in Yarí, the FARC guerrillas celebrated as well, with their own massive party, complete with live bands and cold beer. They dubbed it "FARCstock." At one point, Timochenko appeared onstage wearing a Che Guevara T-shirt and hailed the gathering as "the war for love."

A few days later, Santos convened a national referendum on the peace treaty. His thinking was that a public vote of approval would help him seal the deal he had just signed with Timochenko. But Uribe had been rallying public opposition to the peace deal, even leading a protest march in Cartagena on the same day as the final ceremony. He had called on Colombians to reject the peace deal, decrying the FARC as "the biggest drug cartel in the world" and declaring: "Why should Colombians be obliged to grant total impunity to the terrorists who have hurt Colombia as badly as Bin Laden hurt the US?"

The pollsters suggested that the yes votes would win—but they were wrong. On October 2, 2016, the no votes won. Uribe's scaremongering had paid off, with a 50.2 percent majority against the peace deal versus 49.8 percent in favor. I knew Colombians on both sides of the divide. Some of those who voted no had been subjected to the FARC's revolutionary taxation in rural areas or had lost friends and relatives in kidnappings or armed attacks. Many more seemed to have been swayed by Uribe's arguments that Santos was turning the country over to the FARC's *narcoterroristas* (drug terrorists), as he called them, and was rewarding rather than punishing them for their years of violence.

Most of the Colombians I knew, however—none of whom felt any particular love for the FARC—were nonetheless horrified by the no vote because it seemed a rejection of peace itself, and because they were suspicious of Uribe's intentions. There was a sense that the vote was a victory of right-wing populism over liberalism. Uribe's allies, which included conservative Catholic clergymen, had also claimed that the peace deal would lead to unacceptable new laws liberalizing gender rights and abortion. Coming as it did just a few weeks after the stunning Brexit vote in the United Kingdom, in which the public chose to withdraw from the European Union, the no vote acquired the nickname of *el Brexit colombiano* (the Colombian Brexit).

In the wake of the referendum, Álvaro Uribe reemerged as the ultimate Colombian power broker and immediately dispatched negotiators to extract concessions from Santos. A week after the vote, however, Santos was awarded the Nobel Peace Prize for his peacemaking efforts. Using this high-profile international recognition to his advantage, Santos pressed on assertively and soon announced an amended peace deal, one that, he insisted, had taken into account the concerns of the no voters. It included stiffer sentencing terms for the FARC leaders, for example, but it was otherwise largely unchanged. In a snub to Uribe, who had demanded that the agreement legally prevent the FARC from becoming involved in politics, the guerrillas retained the right to run for public office. With a controlling majority in Colombia's parliament, Santos managed to secure approval for the new deal's terms. But the battle with Uribe was not over.

PEACE DIVIDENDS—AND DISILLUSIONMENT

In early 2017, the FARC's fighters began their exodus from the jungle, making their way to a couple of dozen demobilization camps that had been set up across the country. There, according to the peace plan, the government would provide them with temporary housing and a survival stipend, as well as food and health care, and they would hand in their weapons, which would be destroyed in a carefully staged process overseen by the UN. The former fighters would receive training in practical skills such as agriculture, plumbing, and animal husbandry, trades that would help them find jobs, and those who wanted to would be able to finish their educations. They ranged in age from their early teens to their 70s; among them were hundreds of pregnant female fighters, as well as others with babes in arms. Some fighters also brought their pets—an exotic array of jungle creatures that included monkeys, coatimundis, and ocelots.

That spring, with the demobilization underway, I asked a senior FARC commander, Carlos Antonio Lozada, how he felt his life had changed. He had spent nearly 30 years in the guerrilla underground. "Are you still a guerrilla?" I asked. We were sitting in an office in the UN compound in Bogotá. Lozada smiled and replied: "We will carry on with the guerrilla way of life and way of interpreting things, but one begins to be aware that there is a new way of doing things." He still had to travel around with armed security guards, but now he did so with a special protection unit that was—in a surreal twist— provided for him by the Colombian government. "I've begun to realize that I can now go and visit my family, for instance, without fearing that something might happen to me at the hands of the state—and this is creating a new expectation of how life can be."

In 2017, the first year in which there was no war between the state and the FARC, the country's immediate "peace dividend," as President Santos referred to it, was dramatic. Tourism to Colombia surged by a remarkable 27 percent, representing some 1.5 million more foreign visitors than in 2016. It was a noticeable spike in a trend that had begun with Santos's presidency, in which talk of peace and a successful overseas tourism promotion campaign had brought increasing numbers of American, European, and Latin American travelers to Colombia. Venturing far beyond the handful of habitual tourist redoubts, visitors were horseback riding through coffee country, boating down the Magdalena River, and hiking among indigenous communities in the Sierra Nevada mountain range. Although the ELN guerrillas and some *narcoparamilitares* remained in the field, conflict-related casualties also declined precipitously.

Yet parts of Colombia remained in limbo. Beyond the emerging tourist circuits, in areas where the effects of the war had been the deepest, the power of the state remained virtually nonexistent, and violence continued to haunt the countryside. Paramilitary drug-trafficking gangs were moving in and taking over coca-growing areas that the FARC had formerly controlled. Cocaine production in Colombia was skyrocketing, and, in addition to Mauricio's Columna Uno, more former guerrillas were now getting involved in the business. A merciless former FARC fighter called Guacho led one breakaway group, operating in the jungle on the border with

Ecuador. In a sickening episode in April 2018, Guacho kidnapped, and then executed, a pair of Ecuadorean journalists and their driver who had strayed into his territory.

In other areas from which the FARC had withdrawn, right-wing paracos also began to rear their heads again. Around the same time that Uribe's campaign against the peace deal got underway, in fact, early warning signs had appeared in the form of stenciled graffiti on walls around San Vicente del Caguán, a town adjacent to the FARC's Yarí stronghold. The signs featured a submachine gun and the initials AUC, and said: "We are back and have come to stay." The group's purpose, added the message, was "to purge FARC militiamen and front men"—an allusion to the guerrillas' civilian sympathizers and noncombatant allies.

The warning was not an idle threat. About 170 "social leaders"—left-wing activists associated with the FARC—were assassinated in 2017, a 30 percent jump over the year before. This meant that every two days, somewhere in Colombia, someone linked to the FARC was murdered as part of a growing pattern of intimidation. In 2018 the death toll soared even higher. As of May 2019, the death toll stood at 837, including 702 activists and 135 former fighters, all murdered since the peace signing. The former FARC guerrillas, who had turned their rebel group into a political party in the intervening year, regularly denounced this alarming trend.

There were other signs that a large segment of Colombian society was unready for the guerrillas to come out of the jungle and live among them. In Colombia's parliament, the conservative bloc led by Álvaro Uribe filibustered for nearly a year to delay authorizing the transitional justice system called for

under the peace deal. Uribe's group wanted stricter punishments for the leaders of the FARC, and they sought to exempt members of the security forces and civilians—the paracos—from the deal. The law passed in late 2017, with new amendments, but there was a growing sense that a hard-line conservative government would not implement key provisions of Santos's peace deal.

Despite the early optimism of some of the FARC's leaders, such as Lozada, disillusionment grew among many former rebels over the perception that the government was failing to implement key aspects of the peace accord, such as providing basic housing and other infrastructure in the demobilization camps: schoolhouses, access roads, latrines, and health-care clinics, as well as educational and vocational training courses. Around the country, the picture was mixed, but overall the camp facilities were inadequate and shoddy, and some had insufficient food and medicine. In a few cases they didn't even exist—after leaving their own remote jungle camps, guerrillas had marched to their designated demobilization sites only to find themselves standing in muddy fields. Some had spent months living in primitive bivouacs they had been forced to build themselves. By early 2018, as many as half of the former fighters had abandoned the demobilization camps. Some had gone home to reconnect with their original families; others had simply gone.

Lozada blamed the problems in the field to ineptitude and, in some cases, sabotage by government bureaucrats who were privately opposed to the accords. He believed that Santos's intentions were genuine, but the country's hard-line conservatives—who had rallied around Uribe—remained a strong influence in Colombian society. Lozada was clear-eyed about the

situation: "The only thing we've really achieved is our political reincorporation. They've thrown a thousand obstacles in our way, but today we are a political party."

In legislative elections held in March 2018, the FARC candidates received less than half of 1 percent of the vote for both the congress and the senate, and won no seats. The peace accords had already guaranteed the FARC five seats in each house for two terms, but their dismal showing as vote-seeking candidates underscored the Colombian electorate's rejection of the former guerrillas and revealed the country's continuing polarization. The party that received the most votes was Álvaro Uribe's right-wing Centro Democrático, and it remained the front-runner for the presidential elections held two months later. While Uribe was prevented by law from running for the top job again himself, his handpicked successor, a 41-year-old senator named Ivan Duque, won the presidency with a handy majority in a June runoff against a left-wing former mayor of Bogotá. The FARC's Timochenko had also put himself forward as a candidate, but, suffering from health problems, he dropped out early on after a short, lackluster campaign.

After the victory, a jubilant-looking Uribe was photographed holding up Duque's hands like a coach celebrating a boxer's successful fight. Such images made it evident who the real power would be in the coming Duque presidency. Within days of his election victory, Duque made it clear, as he had during the campaign, that he was unhappy with Santos's proposed transitional justice package for the FARC and that he intended to amend it. In a bitter public statement, the former senior FARC commander, Iván Márquez, said, "What does it matter? The peace deal is in tatters anyway."

And in a sense it was. Outgoing President Santos defended his peacemaking efforts by pointing out the benefits that the country had already gleaned from the FARC's disarmament. "We had the most peaceful elections in our history," Santos noted in a tweet he sent on June 27, 2018, a few days after the presidential elections. "War wounded have stopped arriving at the Military Hospital, tourists are now going to places where the conflict did not permit before, and we had the lowest homicide rates in 40 years." That may well have been true, but nonetheless, a majority of Santos's countrymen had chosen a man hand-picked by his nemesis Uribe—whose message was revenge, not reconciliation—to take the reins of power in Colombia again.

Some former FARC leaders heeded Uribe's message and went underground. After denouncing death threats against himself, Iván Márquez refused to take up his allotted senate seat. He vanished from public view altogether around the same time that Duque assumed the presidency in August 2018, and is widely believed to have fled to safety in neighboring Venezuela. In July 2019, another senior former rebel leader, Jesús Santrich, also abandoned his seat in congress after allegedly receiving death threats.

THE TURF BATTLES CONTINUE

In Colombia, where a little over 1 percent of the population owns half of the land, the main sources of conflict are, as ever, injustice, inequality, and the chronic poverty they produce. Out in the countryside, Colombia's problems are plain to see.

For a closer view of some of these issues, I flew to Apartadó, a town in banana-growing country near the Gulf of Urabá on Colombia's Caribbean coast. Not far away, the roads peter out in the Darién jungle, where the Isthmus of Panama extends northwest in a land barrier between the Caribbean Sea and Pacific Ocean. It is also where Antioquia—Uribe's home turf—meets the Chocó, one of Colombia's poorest and least developed regions. The Chocó extends from the Pacific to the Caribbean and is a key transshipment route for cocaine and smuggled people leaving for parts north; it is also the traditional home of black Colombians—*afrodescendientes*, many of them descendants of runaway African slaves who have lived in the backwoods as small farmers for centuries.

The Chocó has also long been a paramilitary haven. It was the birthplace of Carlos Castaño's AUC, and despite the group's formal disbandment in the mid-2000s, paramilitarism has remained strong in the region. The politicians, ranchers, and agribusinesses that once backed the AUC continue to exercise behind-the-scenes control over most things, including lands stolen from thousands of displaced farmers, via a seemingly limitless supply of contract killers, known in Colombia as *sicarios*. This has created an ongoing nightmare for vulnerable peasant communities, including groups of dispossessed farmers who have returned to their lands since the demobilization of the AUC.

When they trickled back, beginning in the mid-2000s, most found that their farms had been razed entirely, replaced by industrial-scale African palm oil and banana plantations, or else cleared as pastureland for cattle grazing. The new landowners were primarily agribusinesses or ranchers who had bought up the land cheaply during the years of terror; in some cases, they were directly linked to the Castaños or other paramilitaries who had driven the small farmers out.

It was a frightening atmosphere, but with the AUC unable to mount large-scale massacres as it had before, the farmers banded together and braved the wrath of their formidable neighbors by resettling their land, burning down the usurpers' palm oil trees, rebuilding their homes, and replanting their crops. The presence of the FARC, which had built up its own fighting forces in the region in the intervening years, also acted as a deterrent to the paracos. To protect themselves, several of the returnee farmers' groups proclaimed their neutrality in the conflict by declaring their communities to be "zones of peace" in which no armed groups were welcome.

In 2011, President Santos had bolstered the farmers' fortunes when he passed a land restitution law on behalf of Colombians who had been displaced by the war. Under the new policy, the state gave Urabá's peace communities some physical backup, with new army posts established in their vicinity and government bodyguards provided to certain peace community leaders. But, as ever, it was not enough. A steady string of assassinations has continued. So has intimidation of community leaders and land-restitution activists. This is one area in which Human Rights Watch and other NGOs have criticized Colombia's government for not following through on its own laws to defend the war's victims.

Ironically, the peace deal with the FARC made life suddenly more dangerous for Chocó's peace communities. Since the guerrillas withdrew their armed presence

from the area in 2017, the paracos have begun to move around more openly and have also stepped up their attacks against social activists and peace community leaders. In separate attacks just a few weeks apart, in November and December 2017, sicarios assassinated two leaders of the Curvuradó association of peace communities, a grouping of several rural hamlets made up of returnee farmers.

In February 2018, a few weeks after the latest killings, I visited the area. I wanted to test firsthand the emerging theory that Colombia's bad old days were not over, at least not for some Colombians, and that land conflicts persisted even if military ones were on the wane. I traveled south from Apartadó with a local driver through a landscape of banana plantations and jungle mountains. I kept the purpose of my visit vague, and along the way, the young driver confidingly extolled the virtues of Urabá's paramilitaries. He said that they still controlled life in the region, and that everyone who owned a business paid a percentage of their income to them, including his own father, a cattle rancher. The paracos were a good thing, he explained, because the state was weak, unable to maintain law and order. They kept the guerrillas and other villains at bay. With the paracos around, no one messed with you, he said with a laugh.

After asking him to drop me off in the truck-stop town of Mutatá, I met up with a group of farmers from the Curvuradó peace community. For protection, they had traveled to meet me in a small convoy of several SUVs, with a pair of armed bodyguards provided for them by the government's special protection unit. We drove off the main highway and onto a dirt road that led through patchy forest and agricultural lands. In the ragtag village of Llano Rico, we dropped off one man at his little farm there. He

nodded to the serried ranks of well-tended banana trees that began where his dirt street ended, a few houses away. It was a banana plantation that belonged to a powerful landowning family, which he named. He said quietly, "They're the ones killing us."

A few hundred yards on from Llano Rico, we passed the local army post. I asked my companions about the soldiers' presence: surely they were a deterrent of some sort? The men gave a collective shrug. One of them, Fernando, explained that the soldiers did not regularly patrol and seemed oblivious to what occurred outside their post. The farmers were essentially on their own.

The main hub of the Curvuradó farmers, the Zona Humanitaria Las Camelias, lay a half hour away near a barge-crossing point on the Atrato River, a muddy trough that bisects the region on its way north to the Caribbean. A large hand-painted sign proclaimed Las Camelias to be a place of civilian inhabitants, "a neutral place under international humanitarian law, where armed actors are prohibited."

Las Camelias consisted of a grassy soccer pitch surrounded by 20-odd rudimentary wooden buildings. One was painted purple with a mural depicting an Afro-Colombian woman's face and the words *"Construyendo futuro desde la resistencia"* ("Building a future through resistance").

A tiny general store with a roofed-over dirt floor and a row of wooden benches doubled as the community center. It belonged to María, a thin and taciturn black woman in her 60s. She didn't say much, but she was the acknowledged boss of Las Camelias, and little went on in the community without her say-so. Introducing us, Fernando explained the reason for María's authority. "María

stayed behind when the paracos came," he said. "She never left. She hid herself and lived in the bush when the rest of us fled. She's our leader."

María gave a slight nod and smiled thinly. She presented herself formally, with her full name of Ligia María Chaverri. She confirmed Fernando's rendition of history, telling me that there had been 13 separate civilian exoduses from the area during the period of massacres but that she had remained behind. When I asked how she had survived, María said simply: "I delivered my daughters with my own hands," holding her hands out, palms upward. She added that she had given birth to eight children with her husband, who had died six months earlier, and that she had 40 grandchildren.

The returned farmers of Las Camelias had gathered under María's leadership. They had defiantly carved out little homesteads and croplands, destroying the African palm oil trees that the newcomers had planted. All around Las Camelias I could see blackened palm stumps that jutted up here and there amid yucca fields and banana patches.

One of the farmers' biggest ongoing problems was ensuring that the land restitution the Santos government had promised didn't stall. Years had gone by since their return, but the government still hadn't granted them titles to their lands. This had left things in the area in a dangerous limbo; the paraco-linked landowners knew that if they could chase the farmers off again, they might yet be able to control all the land in the area. As Fernando explained: "The paracos always take over the land wherever they go, but they've found out that on our little piece of land there's a group of people who are willing to resist, and so they're killing us."

Fernando introduced me to a strapping teenage boy, Ramón Bedoya, whose father, Hernán Bedoya, had been one of the two Curvuradó leaders recently killed. After shaking my hand, Ramón looked intently down at the ground as Fernando spoke about his father and what had happened to him. I saw that he was fighting back tears. Fernando went on. "The war hasn't stopped, not for us. They said there would be peace, but none of the promises made have been complied with, not where we live. The war is still going on here, and it's over our land."

The next morning, I crossed the Atrato River to attend a mourning ceremony that had been arranged for Hernán Bedoya. The ceremony had been arranged by Father Alberto Franco, an outspoken Catholic priest who runs the Comisión Intereclesial de Justicia y Paz (CIJP, Inter-Church Justice and Peace Commission), an NGO that operates a civic solidarity network on behalf of persecuted civilians in Colombia. Franco and a group of about 20 foreign volunteer activists had arrived overnight by road from Bogotá. Together with Hernán Bedoya's relatives and a handful of his friends from the local peace communities, as well as several government bodyguards, Father Franco led the group in a convoy of vehicles to the spot where Bedoya had been gunned down in December.

It was an area of cleared land and cattle ranches where the late AUC founder Carlos Castaño had forcibly established a vast estate for himself. According to Father Franco, former associates and relatives of the late paramilitary leader still controlled the land, and he said he suspected they were also behind Bedoya's death.

A large dark stain lay on the road where Bedoya had been gunned down. Under Father Franco's direction, the mourners formed a circle, and for about 20

minutes, Bedoya's friends and relatives gave testimony. His son Ramón said that his father had "died in defense of all of our rights" and that he intended to carry on the land restitution fight his father had led. They then set about painting Bedoya's name and the words *sín olvido*—never forget—on the road where he had died.

Down the road was a beer hall, from which the sound of loud *vallenato* music came throughout the mourning ceremony. Vallenato is Colombia's cowboy music, played with accordions. Now and then, men came past on motorbikes or in pickup trucks. A few trotted by on horses. Several paused briefly to observe the roadside vigil. Others sped up as they passed by, including a man on a motorcycle, who shouted "*Échale, hijo de puta!*" ("Fuck off, son of a whore!") before roaring off. Everyone heard the insult, and several people blanched. Father Franco looked up but carried on with the commemoration. There was fear in the air.

Colombia Between War and Peace (2016–19)

by Stephen Ferry

As a child I grew up in the context of the Vietnam War, with violent protests and angry debates all around. My way of trying to understand was to look at photographs published in *LIFE* magazine and the newspapers. Like many Americans, I was moved by these images to oppose that war, and thus, from an early age, a concern for human rights and a passion for photojournalism came together.

Colombia is a country where the Cold War combined with internal factors to create a human rights disaster, one that implicates all players in the Colombian armed conflict as well as US foreign policy. I documented the Colombian conflict from 1997 to the signing of the Havana peace accords and then, of course, followed the peace process with great interest and hope. It's too early to know whether Colombia has found its way out of a cycle of brutal internal wars, but certainly the signing of the peace accords is a big step forward.

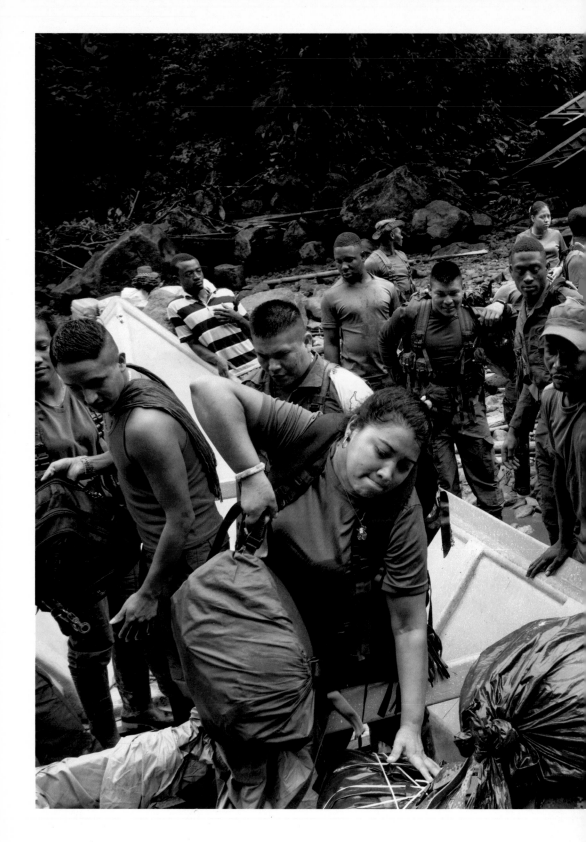

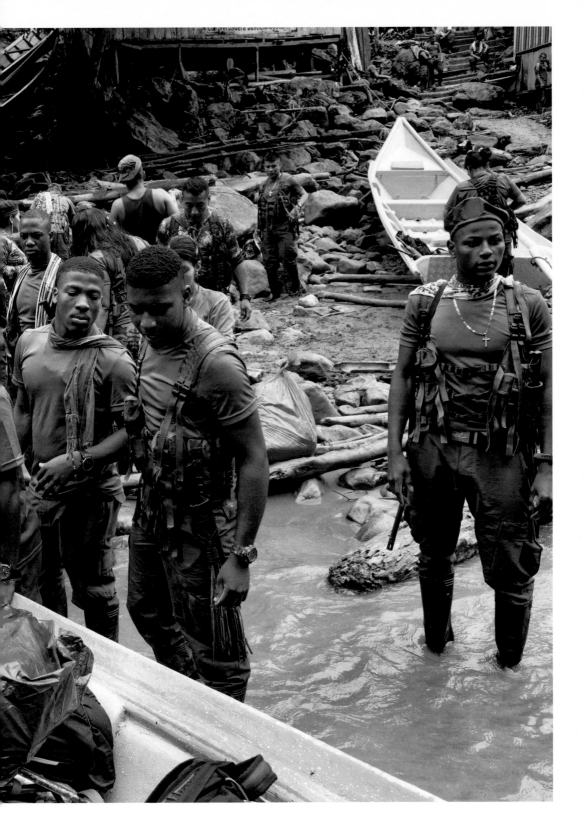

The Last March of the FARC

In the spring of 2016, the 30th Front of
the Revolutionary Armed Forces of
Colombia guerrilla army (FARC) began a
five-day march out of the jungle, crossing
the Western Cordillera mountain range,
one of the three massive fingers of the
Andes that define Colombian geography,
toward a new life. The retreat from the
jungle was a first step towards
demobilization. By concentrating their
forces, they were enabling UN monitors
to observe the process, ensuring that
their troops would not disperse. The
FARC traveled through a landscape of
mountains, coca fields, mule trains, and
small peasant holdings along the old
Camino Real (Royal Road), which the
Spanish used during colonial times.

Images from pages 342 – 349 were taken as
the FARC journeyed out of the jungle.

Top: Jungle camp along the Naya river. FARC troops listen to commanders
explaining the peace process and the transformation of the unit from soldiers
to citizens under the peace agreement.

Bottom: A FARC fighter washes her clothes on an overnight stop in the town of
Rio Mina, in the Upper Naya region. Rio Mina was the epicenter of a massacre
by paramilitaries in 2001, in which up to 110 civilians were killed.

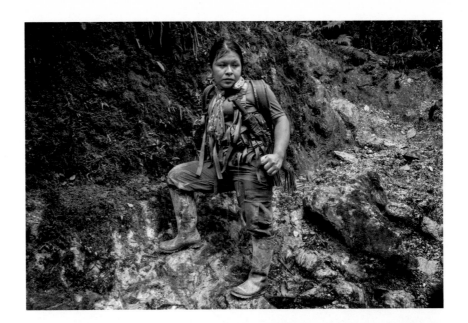

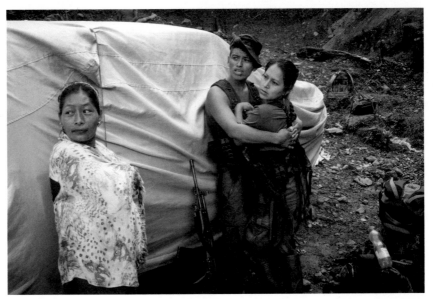

Top: Yesica, a guerrilla fighter, stops to rest during the five-day journey.

Bottom: Guerrilla fighters Diana and Anderson take a moment toward the end of the long march.

Pages 348-349: The guerrillas' mascot, Pelusa, a South American coati who made the journey by mule.

Colombia Reportage

Top: Rodrigo Londoño Echeverri, alias "Timochenko," top commander of the FARC insurgent army, arrives at a celebration for the completion of the FARC's disarmament.

Bottom: Former combatants of the FARC insurgent army celebrate the first anniversary of the peace agreement at the reintegration centre, Aguas Bonitas, Caquetá, while a National Police officer looks on.

Top and bottom: The Territorial Space for Training and Reintegration at Agua Bonita, Caquetá, is one of the 26 demobilization or "concentration" zones where the FARC guerrillas set up homes after coming out of the jungle.

Colombia Reportage

Colombia Reportage

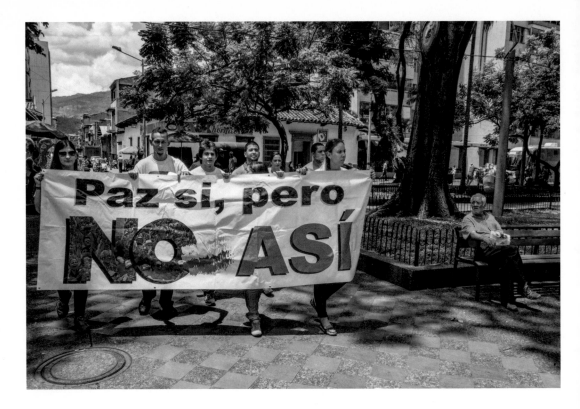

Pages 352–353: Former FARC guerrillas tending crops at the reintegration camp of Agua Bonita, Caquetá. Agriculture is one of several projects at the camp. Others include fish farming, a shoe factory, and a store. *El Tiempo*, Colombia's largest newspaper, described this as "the first socialist town in Colombia."

Pages 354–355: Colombian president Juan Manuel Santos shakes hands with Rodrigo Londoño Echeverri, alias "Timochenko," top commander of the FARC insurgent army, at a celebration for the completion of the FARC's disarmament.

Top: Opponents of the peace treaty travel around Medellín drumming up resistance to the referendum.

Top right: FARC insurgent army members greet one another in the Plaza de Bolivar after their disarmament. For many, despite not having won the war, this was a triumphant moment as they made it to the capital.

Bottom right: FARC ex-commander Carlos Antonio Lozada hands out leaflets on the streets of Bogotá announcing the formation of the FARC's political party.

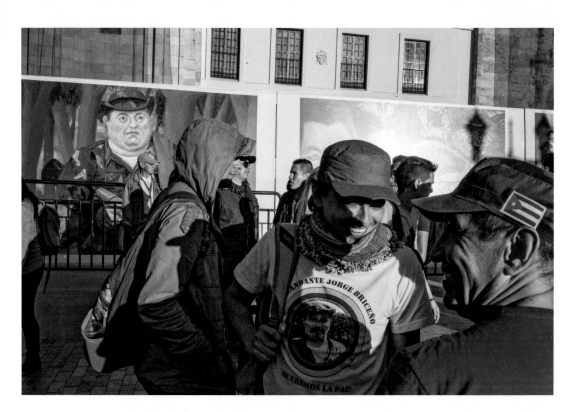

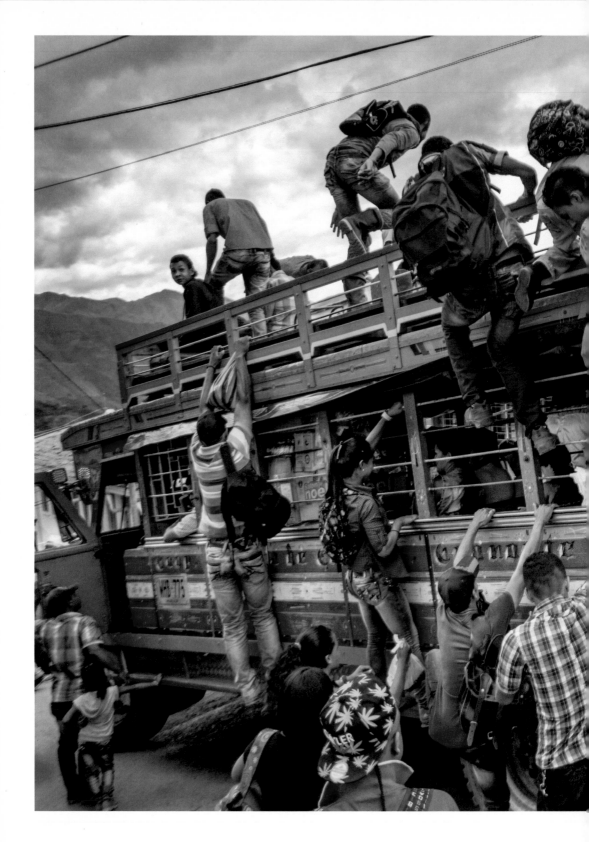

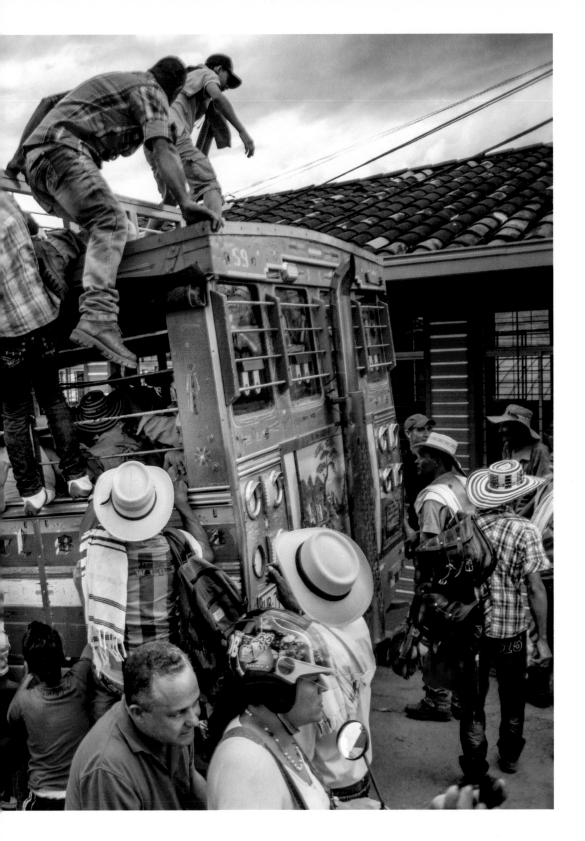

Colombia Reportage

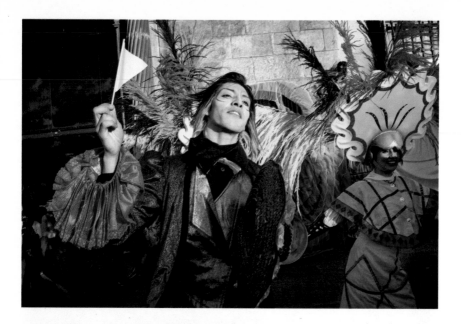

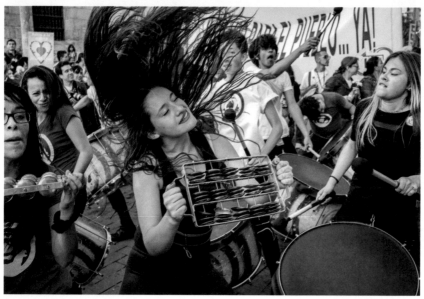

Pages 358-359: Residents of the area of Ituango, a hard-hit war-torn region, make their way home after voting in the plebiscite on the peace treaty.

Top & bottom: Peace demonstration at La Plaza de Bolívar, Bogotá. The peace treaty seeks to protect gay rights along with the rights of other minority groups. Opposition groups include Uribe's conservatives, Catholics, and evangelists.

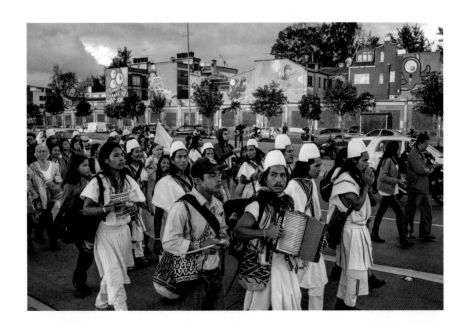

Top: Arhuaco indigenous people from the Sierra Nevada de Santa Marta march in Bogotá in favor of the peace treaty. The Arhuaco, like many of Colombia's indigenous peoples, were the victims of attacks and violations by all parties to the conflict. The state armed forces would kill young indigenous men and dress them as guerrillas to claim as battlefield casualties. For their part, both guerrillas and paramilitaries regularly assassinated indigenous leaders to undermine traditional authority.

Bottom: The peace treaty national plebiscite is rejected by less than half a percentage point. Silent marchers in Bogotá protest their disappointment.

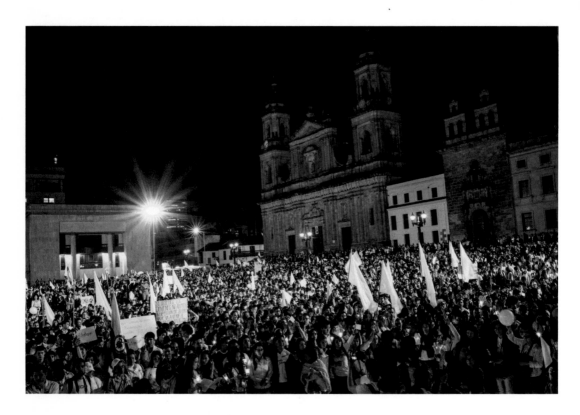

The "silent march," a demonstration in Bogotá in support of the peace process, days after the national referendum in which the peace treaty was narrowly defeated. Earlier the same month, Juan Manuel Santos, the president of Colombia, was awarded the Nobel Peace Prize for negotiating a peace treaty with FARC rebels.

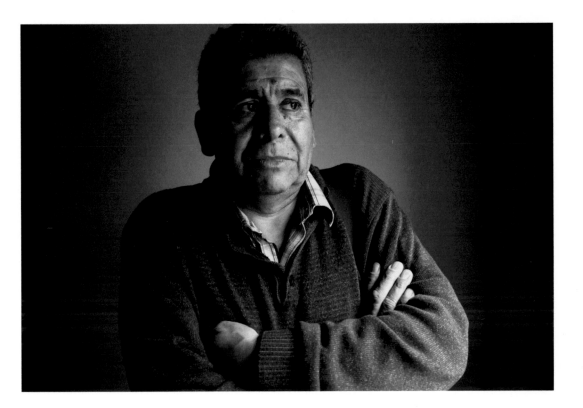

Hector Angulo tells how his parents were kidnapped and subsequently assassinated by the FARC in 2000. He has dedicated his life to trying to find their physical remains in order to give them a proper burial.

A group of indigenous and Afro-Colombian people angrily confront the Colombian Navy, which has appeared in the Atrato River. They see the naval presence as a threat to discussions between local people and members of the Ejército de Liberación Nacional (ELN) insurgent army, a left-wing guerrilla group, regarding the ongoing peace process between ELN and the state.

Decoration of military officers in a promotion ceremony. The NGO Human Rights Watch criticized President Juan Manuel Santos and the Colombian Congress for promoting several officers accused of extra-judicial killings of civilians in the so-called False Positives scandal, including Mauricio José Zabala (center). The term False Positives refers to a macabre practice by the military of abducting and murdering civilian youths, dressing them up as guerrilla combatants, and claiming them as battlefield casualties in order to receive monetary awards and promotions. According to official figures, there are more than 3,000 victims of these extrajudicial executions.

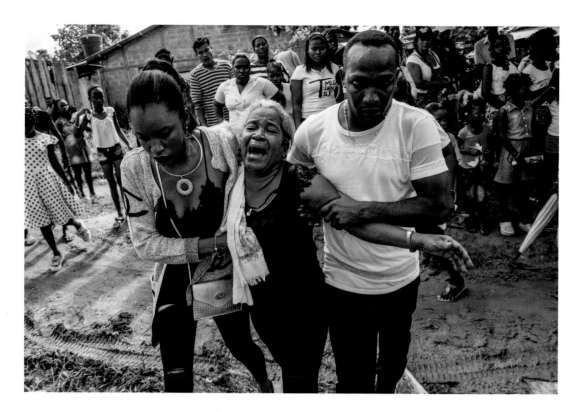

Family members mourn during the funeral service for Wílmar Asprilla Allim, a FARC member assassinated while organizing a political meeting after laying down arms. The right-wing paramilitary group AGC (Gaitanist Self-Defense Forces of Colombia) is believed to have been responsible.

Ex-combatants and commanders of the FARC attend the funeral services for Ángel Montoya Ibarra, a FARC member who, after laying down arms, was participating in the FARC's new political movement. Montoya Ibarra is believed to have been assassinated by members of the neo-paramilitary group AGC while organizing a political meeting.

I magine being in Havana, Cuba, in perhaps the only room in the entire Caribbean city devoid of charm, with its long beige curtains and particleboard tables set in a fixed rectangle. Seated at these tables, facing each other, are two delegations, each exhibiting a froideur that matches the setting. (The berets, scarves, and necklaces that one side wears, though, do offer a whiff of rakishness.) Fingers twitch back and forth like the antennae of anxious insects. Eighteen people—nine in each delegation—wear poker faces, changing their expressions only slightly to issue an icy "Good morning." Occasionally, someone rises and starts pacing, the steps measuring the tension like the beat of a metronome. It is the first moment of the first day of tortuous negotiations between bitter enemies, the Colombian government of President Juan Manuel Santos and the FARC.

Joining them are diplomats from Cuba and Norway, the guarantor countries. Cuba has hosted previous encounters as well. Norway, known for its sometimes epic role in international conflict mediation, has invested time and treasure (and taken a considerable risk) in getting these parties to the table. Each side has also chosen *acompañantes*, companions to the process: Chile for the Colombian government and Venezuela for the FARC.

It is November 19, 2012, and the start of the fourth attempt to reach peace between the democratic government and the Marxist guerrillas. The conflict, rooted in La Violencia (a 10-year civil war triggered by the 1948 assassination of a populist political leader) and in anti-communist repression in rural Colombia (starting in the 1960s), eventually grew to involve paramilitary groups, crime syndicates, drug cartels, and even multinational corporations. The half-century war, funded mainly by the drug trade on one side and by foreign governments, especially the United States, on the other, brought unspeakable violence to Colombia—more than 50,000 kidnappings, hundreds of thousands of deaths, and the displacement of a staggering eight million people.

The Cuban and Norwegian diplomats at this meeting of course know each other. Surprisingly, the leaders of the two antagonists are also old acquaintances. On the FARC side, the man calling himself Iván Márquez (an alias for Luciano Marín) had been a communist militant in his youth and then a high school teacher before he joined the guerrillas, becoming a feared military commander. The chief negotiator for the Colombian government, Humberto de la Calle, was a former vice president, ambassador, and minister. Above all, he was one of the architects of the 1991 constitution that modernized Colombia. The two had met more than two decades earlier, in the second attempt to reach peace, which took place in Venezuela and Mexico in 1991–92.

Margarita Martinez is a Colombian journalist and filmmaker who gained unprecedented access to the peace talks in Havana between the dour representatives of the government of Juan Manuel Santos and the Fuerzas Armadas Revolucionarias de Colombia (FARC , Revolutionary Armed Forces of Colombia). She spent four years watching, filming, and talking with the participants. They broke through their terse standoff only after settling on restorative justice and witnessing the searing testimony of victims. Her documentary *The Negotiation* was finally released in 2018 after a censorship attempt by Santos's nemesis, the former president and political strongman Álvaro Uribe.

The first effort happened in the mid-1980s. As a product of these negotiations, the FARC created a political wing, the Unión Patriótica, but right-wing forces killed at least 3,000 of its members. Talks failed at the third attempt in 2000, when the FARC was at the peak of its power (I covered those negotiations as an Associated Press reporter). Afterward the Colombian government, with the military backing of the US, put all its energy, political will, and resources into defeating the Marxist guerrilla group.

I was a privileged observer of the fourth attempt. A Colombian journalist making a documentary film about the peace negotiations, I was allowed to enter the inhospitable room in early 2014. (My account of the opening comes from footage the Cubans shot to document the historic moment in 2012 when negotiations commenced.) All bets, including my own, were against success. Like most Colombians, I didn't believe there was a will or a way. Alongside my skepticism, I carried with me what had happened in the past, as well as what I was witnessing in the moment: an environment with no confidence, no small talk, no empathy, and a tension so thick you could, as we Colombians say, put a knife in the air and cut it. Months later, the top Cuban diplomat told me informally that both parties were in Havana to sign an agreement, period. That comment gave me the strength to persist despite the daily setbacks in filming, which mirrored the daily setbacks in the talks themselves.

———

The experts say that all high-stakes negotiations have both a formal and an informal aspect. What happens at the negotiating table is important, but so is what happens over coffee in the morning in the halls, over lunch at midday, or in the bar at the end of the night. Hardened

enemies find small ways to find the humanity in each other and to build trust. Personal chemistry, the experts argue, is what cuts through the tension. Charismatic leadership can enable two opposing sides to break through, as Padraig O'Malley shows in his account of the 1997 gathering in South Africa that led to the start of talks ending the conflict in Northern Ireland (see "The Narcissism of Small Differences").

For the first two years (2012-14), the Colombian government delegation— headed by de la Calle and High Commissioner for Peace Sergio Jaramillo—almost totally controlled negotiations at the table and, in fact, prevented any chemistry from developing. Jaramillo had assembled an extraordinary group of technocrats he had nurtured starting in 2004 as the head of the Fundación Ideas para la Paz (FIP, Ideas for Peace Foundation), then at the Defense Ministry and in other positions. Later, he became vice minister of defense and national security adviser. Like many Colombians, he viewed the previous attempt at peace, in 2000, as a show of whiskey-drinking braggadocio that yielded only disaster: the escalation of violence. His efforts to avoid duplicating such unsuccessful tactics may have suppressed the ability of the opposing sides to forge human connections. But Jaramillo went further than discouraging shows of bonhomie, insisting on excruciatingly secretive practices. He perhaps had good reason—the popular former president and senator Álvaro Uribe Vélez opposed negotiating with the FARC, and his objective was rendition, not negotiation.

Even after the secrecy diminished, deep suspicion, mutual disdain, and unrelenting tension marked the entire four years of negotiation. The members of this group never let their rhetorical hair down and

never socialized. The Norwegians occasionally invited the delegations to dinner in their gorgeous Havana embassy, the residence of the ambassador. Though these social encounters were rigid and terribly boring, the Norwegians persisted, arguing that at least the members of the teams would see their bosses interact at the head table. That's how bad it was. The Colombian peace process offers a case study of two sides that were unable to be anything *other* than formal.

———

So the negotiators had to rely on something else—what some experts call a "negative evenness," which was one of the essential ingredients of the muddled peace that eventually emerged.

When the delegations arrived in Havana, both had been defeated, in different ways but to similar degrees. In the case of the FARC, it had an inner conviction of its own failure. Though the organization could still survive for years deep in the jungles and mountains of Colombia, five decades of a peasant battle against an oligarchic state had never been enough to win the war. Its main goal in 2012—in fact, its utter necessity—was to obtain an agreement. But it wouldn't surrender weapons at all costs: the FARC insisted on honor, dignity, and respect for its history and its struggle.

On the other side, the government had also failed. It had spent billions of dollars in US aid, as well as its own precious resources, only to find that the guerrilla force remained in place.

Another aspect of negative evenness was the scarring on both sides that war crimes had caused. The FARC, though it was founded on Marxist ideals, had chosen the cocaine trade, extortion, and kidnapping to finance its war against the state. It had sacrificed the ideological high ground. After 50 years of lawlessness and brutality, the populace bore a deep hatred toward the group.

For its part, the Colombian Army had wantonly killed thousands of citizens who lived in the margins of the country and society. In the "false positives" scandal, members of the military lured peasants and even boys with mental disabilities to remote parts of the country with offers of work. They then murdered these people and presented them to the government as *guerrilleros* (guerrillas) killed in battle, in an effort to inflate body counts and receive promotions or other benefits. (Studies estimated that there had been between 3,000 and 10,000 false positive victims between 2002 and 2010.)

———

The Havana dynamics—the secrecy, the formality, the stasis—did not really begin to shift until after 32 months of a terse standoff. The negotiators had dispensed with the first three items of the six-point agenda set out at the beginning; each point took about six months. Following that year and a half of talks came the most important and difficult point—justice. After 14 months of negotiation, by mid-2014 the parties in Havana were at an impasse, unable to find a way to balance the sentences of guerrillas, agents of the state who had committed crimes against humanity, and individuals

responsible for political crimes. President Santos became restless, fearing that his presidency would end without having had adequate time to implement any solution the negotiators managed to arrive at.

In August 2015, Santos and FARC leader Rodrigo Londoño Echeverri (alias Timochenko) agreed to open the panel and invite a commission of legal experts to help break the logjam over transitional justice. The final team included six respected jurists: Spanish lawyer Enrique Santiago Romero, Conservative Party politician Álvaro Leyva, human rights advocate Diego Martínez, University of Notre Dame professor of law Douglass Cassel, former judge and Constitutional Court of Colombia president Manuel José Cepeda, and Universidad Externado de Colombia rector Juan Carlos Henao (also a former Constitutional Court president). The FARC selected the first three and the government chose the latter three. By September, the panel had a document ready to present in Havana. Its members had resolved the thorniest of issues through a formula satisfactory to both the guerrillas and the government, advising restorative justice for those who had committed crimes against humanity and amnesty for those responsible for political crimes. The agreement privileged getting to the truth of what had happened and acknowledging it over mere punishment.

With this agreement, the peace process was considered concluded. However, the process of tackling restorative justice opened up the table to outside influence, and the rhythm of negotiations changed. The negotiators introduced a moment of immense humanity when they invited victims of some of the most horrendous crimes committed in Colombia to speak. No other peace process had included victims in this innovative way. The United Nations, the Catholic Church, and the National University of Colombia put together a list of victims of the most brutal crimes committed by the guerrillas, the government, and the paramilitaries.

Five groups of 12 victims each (a total of 60) went to Havana starting on August 16, 2014. No one knew how this gambit was going to play out, and all the participants felt high anxiety about what the victims were going to say. Each of them spoke in a large, quiet room with windows that opened on a view of lush Caribbean vegetation. A few sobs and liberal shedding of tears punctuated their stories.

Constanza Turbay was a 57-year-old from the Caquetá Department in the Amazonas region in the country's south. Her brother died while a hostage of the FARC. The FARC killed her mother and her other brother, along with their bodyguards, on a rural road in the south and left their bodies there. Turbay witnessed the demise of her entire nuclear family.

"I've already lost everything," Turbay said calmly to the negotiators. (She had almost lost heart about testifying; when she was leaving the hotel, she balked, and she decided to go ahead only with the help of priests and a psychologist.) "But we

can do a lot to honor those loved ones we lost, to rebuild peace and reconciliation in Colombia."

To everybody's surprise, despite the fact that the peace process had deeply divided Colombia, other victims, like Turbay, were supportive of it. Their testimony gave a feeling of humanity to a dispassionate political process and sent a message to society that they, the ones who had suffered the most, were willing to turn the page and imagine a different country for future generations.

Iván Márquez, the FARC's chief negotiator and a fellow resident of Caquetá, approached Turbay afterward and asked for her forgiveness. "This should never have happened," he said. Turbay told me, off camera, that Márquez's words seemed so sincere that she had a sensation of deep relief—a healing, a respite from the million questions she had asked herself over the years. This was without a doubt, she added, one of the most important days in her life.

Turbay and the others gave the process legitimacy, but they also applied pressure, petitioning to have both sides continue the talks. "No one should live what we went through," said Soraya Bayuelo, a survivor of a massacre in the northern Caribbean plains. "They cannot stand up from the table until they reach an agreement."

———

Democracy is not necessarily a friend of negotiation. President Santos, whose term began in 2010 and was set to end in 2018, in 2016 sent three ministers, headed by Minister of Foreign Affairs María Ángela Holguín, to speed up the seemingly eternal talks. They used the leverage of presidential backing to hold informal meetings, including dinners, with the guerrillas so they could better understand the points of conflict and come up with solutions. They consulted the president daily to keep him involved. In two months, both sides had come to an agreement.

All the parties signed it in September 2016 in a pompous ceremony in the Caribbean port of Cartagena, in the presence of the international community, and set October 2, 2016, as the date for a referendum. No one expected to lose the referendum for peace, but powerful forces aligned against it, and the no camp won by a razor-thin margin. In the days immediately after the vote, a feeling of having descended into the abyss overcame the country. For the first time throughout the process of negotiating the agreement, people took to the street by the thousands, marching all over Colombia, clamoring for peace. A young guerrilla fighter, pregnant, told me she had believed the referendum was just a pro forma step. Now, she said, her eyes a pool of agony, she feared she would have to go back to war. "*Y el bebé?*" she implored. What would become of her baby?

The government, the FARC, and the leaders opposed to peace held new negotiations, and Congress saved the agreement in a highly controversial decision: The government and the FARC signed a revised peace deal and sent it to Congress for ratification instead of conducting a second referendum. Both houses of Congress ratified the revised peace agreement on November 29 and 30, 2016. Everyone wondered, was this step backward just the prelude to another round of war and peace?

In June 2018, 21 months after the signing of the first peace agreement and 19-plus months after Congress ratified the second agreement, 41-year-old Iván Duque, the anointed heir of Álvaro Uribe, was elected president of Colombia. He had lived in the US for 13 years, primarily working in a midlevel position for the Inter-American Development Bank, and he had served four years in Bogotá as a senator. The mandate of his presidency was to change the agreement, in particular weakening certain provisions of the transitional justice system.

At press time, the future of peace is uncertain. The homicide rates, which were at the lowest point in 40 years in Colombia in 2017, have started to inch up again. The annual number of victims of land mines, at its lowest in 2017 with 57 killed, closed the year in 2018 at 171. And coca leaf production, the fuel of the war, is at an all-time high. The statistics look grim.

Meanwhile, Colombia has never celebrated the peace, and everything about it remains unresolved. The future is as much of a muddle as the negotiations were. Progress in Colombia seems to happen in a two-steps-forward, two-steps-back rhythm. Negative evenness, or at least profound ambiguity, prevails. But things are far better than they were before the agreement, which ended the existence of the second-oldest guerrilla force in the world and brought down the overall level of violence greatly.

———

My documentary about the peace process, *The Negotiation*, was screened at the end of 2018. That, too, involved a two-steps-forward, two-steps-back process. Álvaro Uribe saw the trailer two days before the premiere and took to Twitter, calling on the country's largest movie theater chain, Cine Colombia, to take the film out of circu-lation. Cine Colombia suspended online sales of tickets. However, public pressure persuaded it to put the film back into circulation, and—even more fulfilling to me—an outcry arose demanding freedom of expression. At one point, my little documentary was the world's fifth-most-tweeted-about subject, and tickets to see it sold out for the four days that Cine Colombia made them available. Then the movie company decided not to extend the contract for the film—even though it was a box office hit. Maybe the documentary, like the peace process it depicted, was always going to hover on the brink of failing, at least officially.

In May 2016, I interviewed William Ury, the co-founder of Harvard's program on negotiation and one of the world's leading experts on the subject. "Making peace is harder than making war," he told me in an interview in Bogotá. At that moment, when the historic signing of the peace accord was on the horizon, his pronouncement struck me as counterintuitive: How could sitting around a table in an impossibly boring process be harder than 50 years of violence? Now, after more than a year of starts and stops, yeses and nos, the completion of my film and the temporary blocking of my film, Ury's words make perfect sense.

Nicole Tung
**Iraq and Syria:
The Space Between (2011–2018)**

Samantha Power
— Afterword

Iraq and Syria: 379
The Space Between (2011–2018)

by Nicole Tung

To step into the wake of the war against ISIS was to enter a dystopian world. As the circle closed in on the terrorist military group, first in Mosul, then in Raqqa, and then in their last redoubt in Baghouz, I traveled between newly liberated villages and cities. I went to document that vital moment between the end of a conflict and peace—the space where life begins to emerge. At first, everything seemed a blur of rubble, like a dark, smudgy water color of a never-ending nightmare about war and how it forever mutilates lives.

But, very quickly, the streets buzzed back to life. I witnessed civilians, so utterly traumatized, do the only thing they knew how to do: go on and survive. It was remarkable to see the cautious hope among people who had lost everything. They know: peace is so incredibly fragile. Unless the marginalization of peoples in each country is addressed, unless resolution is brought to disputed territories, unless the systematic corruption that hinders everything from rebuilding to job creation is ended, peace can once again unravel with astonishing speed.

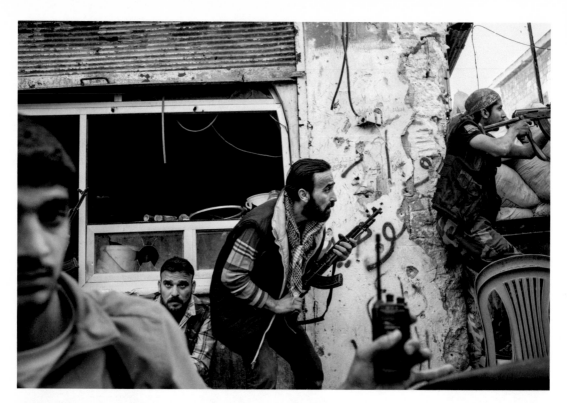

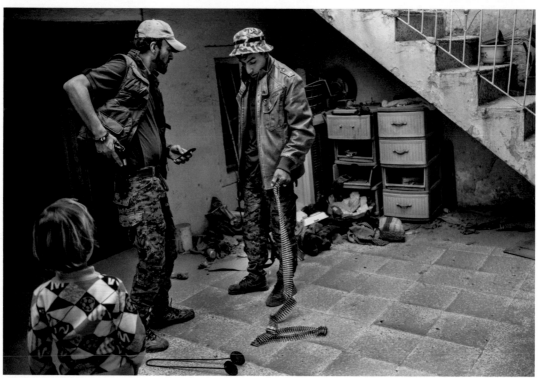

Top left: Fighters with the Free Syrian Army on the front line. With limited access to arms, FSA rebels resorted to making their own weapons. Aleppo, Syria, November 2012

Bottom left: A boy watches as fighters with the Hashd al-Sha'bi, an Iranian-backed Shia group, discuss what to do with ammunition they found in a family home. ISIS fighters used the home while Mosul was under their control. Dozens of residents of the Old City have attempted to return to their houses to clean up and collect whatever they can salvage of their belongings, despite continued security concerns over a handful of remaining ISIS militants and unexploded ordinance in the area. West Mosul, Iraq, November 2017

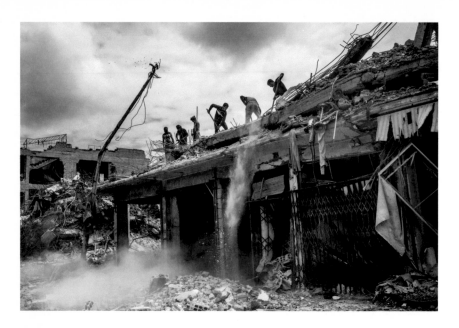

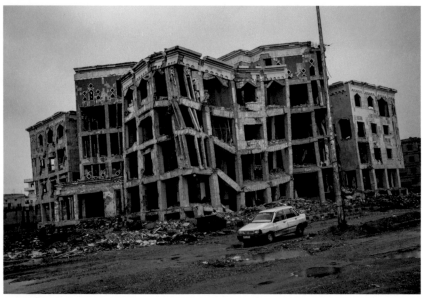

Top: Construction workers clean up rubble from a destroyed building. The offensive to retake the city from ISIS destroyed or damaged an estimated 80 percent of Raqqa's infrastructure. Thousands lost their lives in coalition airstrikes. ISIS militants controlled the city from 2014 until their ouster in 2017. Raqqa, Syria, May 2018

Bottom: Seven months after the ousting of ISIS from their capital, civilians are returning to rebuild their lives and homes. Without a visible presence of NGOs or strong support from the coalition due to ongoing security concerns, the city's residents and civil council and municipality have taken it upon themselves to clean up the rubble and reopen stores in time for Ramadan. An estimated half of the 400,000 civilians have returned to a city devastated by airstrikes, street battles, unexploded ordinance, and destroyed infrastructure, such as bridges and roads. Bodies remain under the rubble, worsening fears that disease could easily break out as the weather becomes warmer. Raqqa, Syria, May 2018

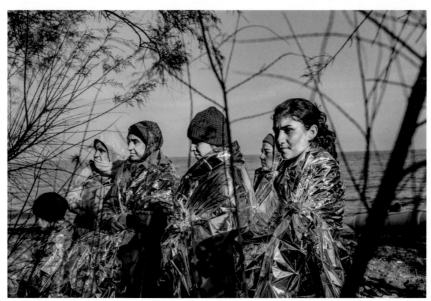

Over one million refugees and migrants reached Europe's shores in 2015, overwhelming the continent and presenting the worst refugee crisis since World War II. Many thousands were fleeing from conflict in Syria, Iraq, and Afghanistan, while thousands of others from Bangladesh, Iran, and Pakistan were seeking better livelihoods. A €3 billion deal struck between Turkey and the European Union, intended to stanch the flow of people, resulted in Turkish authorities cracking down on the smugglers and rounding up refugees, preventing many from making the sea crossing, though some persisted. Lesbos, Greece, December 2015

Pages 384-385: Hundreds of refugees and migrants wait to board a ferry to Athens after receiving their registration papers. Lesbos, Greece, December 2015

End notes Reportage

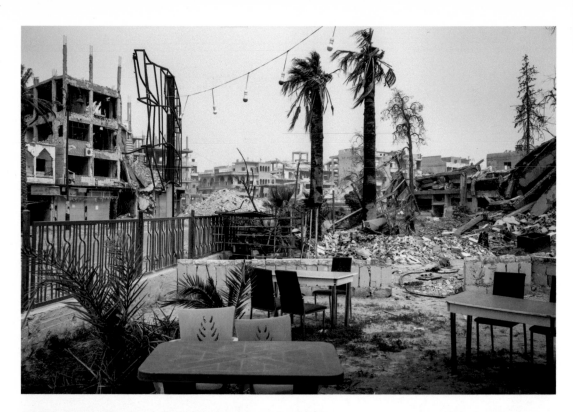

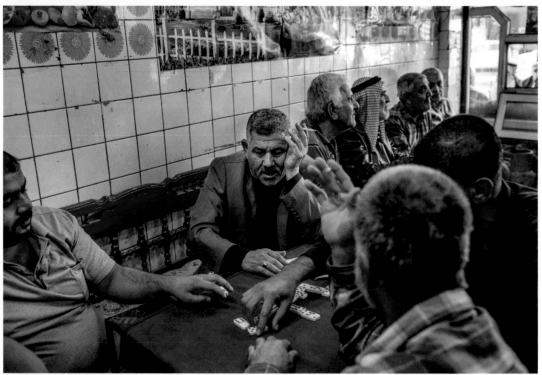

Top: A café opens in Naim Square. While the city was under ISIS control, the extremist group carried out public executions in this square. Raqqa, Syria, June 2018

Bottom: This teahouse remained open during ISIS's rule over the city between 2014 and 2017, but the regime did not allow any board games, dominoes, or other entertainment.

The morality police would frequently search the teahouse for leftover cigarette butts and the smell of cigarette smoke. "One guy threatened to imprison me if he found anything," the owner, Tamer Suleiman, recounted. "After liberation, I was reborn into this new situation we have now. There is nothing more we want than just living like any human being and being able to practice our daily lives," he said. East Mosul, Iraq, November 2017

Top: This theme park reopened in early October, just three months after the end of the fighting in the city. Mosul, Iraq, November 2017

"When ISIS took over Mosul, it became a ghost town. When we came back, there were about 50 to 60 improvised explosive devices, oxygen tanks, and booby traps strewn across the theme park, which had been burned down," park director Yasser Wadullah Al Barawi recounted. "We wanted to reopen this as quickly as possible, but we faced delays because we had to wait for the military operations to finish in the city. But we have finally been able to bring back joy to the people of Mosul."

Bottom: Khaled Mohamed and his bride-to-be step out of the bride's house before their wedding ceremony. The groom's father discouraged the guests from reveling too loudly or making too big a scene as a sign of respect to the residents of Mosul, still mourning their losses and the dead. Mosul, Iraq, November 2017

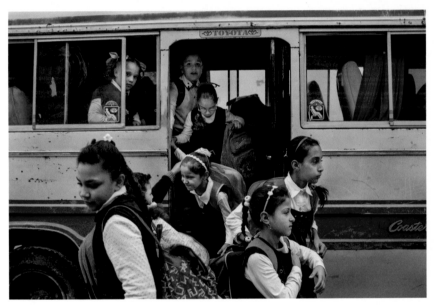

Top: Students attend class five months after the reopening of Hawari Bu Medyan School. Raqqa, Syria, May 2018

Bottom: Schoolgirls arrive at a recently reopened school. For many students, this is the first time they have been able to attend school in years. Western Mosul, Iraq, November 2018

— Afterword 391

by Samantha Power

Samantha Power, US Ambassador to the United Nations from 2013-2017, has spent her professional life searching for ways to prevent egregious human rights abuses. She began her career as a journalist reporting from countries riven by conflict: Bosnia, East Timor, Rwanda, and Sudan. Her 2002 book *"A Problem from Hell": America and the Age of Genocide* explores US responses to the major genocides of the 20th century, while her 2019 memoir *The Education of an Idealist* recounts her experiences trying to secure action to prevent and punish atrocities from inside the US government. She argues for scholars and policy makers to rigorously scrutinize both successful and faltering efforts to establish peace and to make far more substantial investments in diplomacy and conflict resolution at an early stage.

T his is a book situated in the wake of war. My most sustained experience with war and its aftermath came in Bosnia, where I worked as a journalist during the conflict and where I have paid periodic visits in the quarter century that has passed since the Dayton Accords went into effect. Having witnessed even just an infinitesimal fraction of the savagery of Europe's most brutal conflict since World War II, I have reflexively defended the flawed Dayton peace, pressing its critics to remember the human costs of what came before it and invoking Ben Franklin, who famously said there was no such thing as "a bad peace."

Imagine: Reflections on Peace takes issue with Franklin's claim by insisting that, while peace is obviously preferable to shelling and sniping and mass graves, we have a responsibility to critique peace negotiations and accords with the same rigor with which we look at the causes and consequences of conflict. This is especially warranted in light of Peace Research Institute Oslo's finding that, since 1946, roughly 60 percent of armed conflicts have recurred.[1] Even if no peace is perfect, some peace agreements are more imperfect than others.

This book is timely and necessary for a number of reasons.

For starters, conflict is proving a devastatingly resilient feature of the modern landscape. Plato, who knew a few things about violence and human nature, seems to have been right when he said, "Only the dead have seen the end of war." Today, more countries are experiencing some form of violent conflict than at any other time during the last 30 years. And once wars start, they are unfortunately lasting far longer than they once did. In 1970, the average conflict lasted 9.6 years. Those that ended in 2015, the last year for which researchers with the Uppsala Conflict Data Program have analyzed the data, lasted 14.5 years.[2] One reason for this is the multitude of parties involved in many contemporary conflicts. The Cold War was renowned for its proxy wars, where the United States and the Soviet Union chose sides, pumping money and weapons into distant lands in a zero-sum competition. Today, the number of actors choosing sides in other countries' wars has vastly increased, as states like Egypt, Iran, Rwanda, Saudi Arabia, Sudan, Turkey, Uganda, the United Arab Emirates, and others throw their weight behind a wide range of factions. In places where external actors have proliferated—like Libya, South Sudan, and Yemen—negotiations aimed at ending a conflict have become even more multifaceted, and the warring parties' incentive to compromise seems to have diminished, as outside suppliers sustain their financial and military support.

Conflicts produce devastating effects that go beyond the large-scale loss of human life and livelihoods. They often give rise to massive population movements, which are inherently destabilizing *and* which have incited a rise in xenophobia and

1. According to this research, the median duration of post-conflict peace before the conflict recurred was seven years. Scott Gates, Håvard Mokleiv Nygård, Esther Trappeniers, "Conflict Recurrence," Peace Research Institute Oslo Conflict Trends (2016): 2–3, https://www.prio.org/Publications/Publication/?x=9056.

2. *Pathways for Peace: Inclusive Approaches to Preventing Violent Conflict* (Washington, DC: World Bank, 2018), 18, n12, https://openknowledge.worldbank.org/handle/10986/28337. The most recent edition of the Uppsala Conflict Data Program's annual analyses of conflict does not include new information about average conflict duration. See Thérése Pettersson, Stina Högbladh, and Magnus Öberg, "Organized Violence, 1989–2018, and Peace Agreements," *Journal of Peace Research*, 56.4 (2019): 589–603, https://doi.org/10.1177%2F0022343319856046.

nationalism across the globe. The movement of more than one million people, half of them Syrian, across Europe in 2014 and 2015 helped bring about a surge in support for right-wing populism, a repudiation of previous international norms providing for compassionate care and fair processing of those in flight; and a loss of faith in the European Union, which helped fuel support for the narrow Brexit vote in June of 2016.[3]

———

If we can agree with the axiom that less conflict and shorter conflict is better, this book has shown at least some of the ways in which local and international actors can try to improve the odds that peace will last. Peace accords are generally more likely to endure when the suffering and losses of war are recognized and reckoned with in some fashion. But as the authors in this volume show, once mass violence has been perpetrated, it is extremely difficult to muster anything resembling a satisfying form of accountability. As Philip Gourevitch writes about the people of Rwanda who reflected on the importance and inadequacies of Rwanda's unique *gacaca* justice and reconciliation process: "They had no hope of getting over it. The question was only how to get on with it—how to live with it—and that meant how to live with one another." No two Rwandans seemed to share the same perspective on exactly what this required.

Equally, once a society has been militarized, it is immensely challenging to help fighters transition to peacetime. As Jon Lee Anderson writes of the 8,000 Fuerzas Armadas Revolucionarias de Colombia (FARC, Revolutionary Armed Forces of Colombia) rebels in Colombia who laid down their weapons and moved to demobilization camps, "Few had ever lived in a city or even visited one, and most had scant skills other than knowing how to make and break camp, march in the jungle, operate a gun, and fight." At just the time when a monumental investment of resources is needed to help war veterans acquire the skills for peacetime employment, war-ravaged societies are exhausted, their resources strained or altogether depleted.

Greater inclusivity in the negotiating process and implementation mechanisms is essential for creating the conditions for more lasting peace. Many are aware of the findings that women's participation in peace negotiations makes it more likely that the resulting agreements will last. Less well understood is the more basic fact that one of the best predictors of a state's peacefulness—that is, the absence of internal and external conflict—is not wealth, religion, or level of democracy, but rather the way women are treated *within* that state.[4] Indeed, increasing opportunities for

3. The "Leave" campaign increasingly emphasized concerns about the impact of immigration during the lead-up to the referedum, and the pollster who carried out the long-standing "British Social Attitudes" survey concluded that older, socially conservative voters "who were particularly worried about immigration" helped secure a narrow victory for the "Leavers." National Centre for Social Research, "British Social Attitudes 34," 2017, https://www.bsa.natcen.ac.uk/latest-report/british-social-attitudes-34/key-findings/brexit-and-immigration-a-country-divided.aspx.

4. See Valerie Hudson, Bonnie Ballif-Spanvill, Mary Capriolo, and Chad Emmett, *Sex and World Peace* (New York: Columbia University Press, 2012), 205. See also "Just the Facts: A Selected Annotated Bibliography to Support Evidence-Based Policymaking on Women, Peace, and Security," Our Secure Future, January 2019, https://oursecurefuture.org/publications/policymaking-women-peace-security.

women appears to be associated with a reduced risk of armed conflict—what one scholar has referred to as "the pacifying impact of gender equality.[5]" Marie O'Reilly cites Mary Caprioli and Mark Boyer's study of four decades of international crises, which showed that as the percentage of women in parliament increased by 5 percent, a country was five times less likely to use violence against another country.[6] Building a society in which women are safe and equal is an issue of great importance to the cause of peace.

———

This book's contributors have highlighted a range of factors that will help dictate the durability and justness of peace in former conflict zones. One issue, though, looms ominously as a further impediment to sustained peace going forward: climate change. Indeed, according to a wide-ranging study published in the journal *Nature*, if the world does not alter the current trajectory, and global temperatures indeed rise close to 4 degrees Celsius by the end of the century, the risk of climate-influenced violent conflict will be five times greater than it is today.[7]

Two devastating recent conflicts offer an illustration of how climate can help fuel conflict. In the decades prior to 2003, the year of the outbreak of the Darfur genocide, which killed more than 200,000 people, rainfall in the region had dropped precipitously and the Sahara Desert had begun growing by a mile each year. As access to water became increasingly difficult and contentious, the remaining crops that farmers were able to grow could not sustain the needs of the population.

The combination of drought, lack of food, and dwindling access to natural resources brought mainly Arab nomadic peoples into direct conflict with African ethnic groups who tilled the farmland.

Climate change also played a role in the war in Syria. From 2007 to 2010, Syria experienced a devastating and unprecedented drought—the worst in its recorded history. Largely as a result of the massive crop failures and a lack of access to water, more than one million Syrians migrated during that period from rural to more urban areas, stretching the country's infrastructure to a breaking point and generating discontent toward a government that did not provide adequate services to those forced to leave their homes. Many Syria analysts believe that this undercurrent of anger at the Assad government's response to the drought played an important role in setting the stage for the 2011 protests against the Syrian government, which soon began its violent crackdown, resulting so far in the killing of 500,000 people and the displacement of more than half the population.

5. Erik Melander, "Gender Equality and Intrastate Armed Conflict," *International Studies Quarterly* 49 (2005), 695–714.

6. Mary Caprioli and Mark Boyer, "Gender, Violence, and International Crisis," *Journal of Conflict Resolution* 45 (August 2001): 503–18.

7. Katherine Mach, Caroline Kraan, W. Neil Adger, et al., "Climate as a Risk Factor for Armed Conflict," *Nature* 571 (2019): 193–97, https://www.nature.com/articles/s41586-019-1300-6.

In both cases, extreme weather and rapidly changing ecosystems fed into the dynamics of displacement, competition, lack of access to basic resources, and alienation, which in turn helped create the conditions for violent conflict.

Whatever the underlying causes of conflict, the sooner violence can be brought to an end, the better, as conflict only gets harder to address when compounded by the embittering human toll of warfare. We need to act to prevent wars from breaking out and to resolve them at far earlier stages. And for this we need to right a long-standing underinvestment in diplomacy and conflict resolution, developing a cadre of experienced negotiators who will learn from history and bring the full range of stakeholders to the table.

Unfortunately, the trends are not good. In the US, the State Department budget has stagnated in recent years, and seasoned career diplomats have fled the Trump administration, resulting in the smallest diplomatic bench in decades. As of mid-2019, the Pentagon and armed services had more than 225,000 American personnel deployed outside the US; the State Department had only around 9,000. Indeed, the State Department famously has only slightly more diplomats than the Pentagon has people serving in marching bands.

In the United Kingdom, the money spent on diplomacy as a percentage of public sector spending is lower than at any point since 1973. As then-foreign secretary William Hague caustically observed in 2010, "The entire spending of the Foreign Office ... is less than the spending of Kent county council." Almost a decade later, the Foreign and Commonwealth Office's budget has fallen further—to below 0.1 percent of GDP, for the first time ever. And at the United Nations, the Department of Peacekeeping Operations, the UN's military and police arm, which is often used as a stopgap to freeze a conflict in place, has a budget of $6.5 billion, while the Department of Political Affairs—home to mediators, diplomats, and civil affairs specialists—has a budget of $36 million.

———

Each conflict discussed in the main chapters of this book—Lebanon, Cambodia, Rwanda, Bosnia, Northern Ireland, Colombia—has its own dynamics, and what mitigated violence or bred greater inclusion in one part of the world may have no bearing in another. It is glaringly evident that, irrespective of the resources invested by outsiders, it is the will of the war's protagonists and their backers that dictates the overall arc of a conflict—and its amenability to outside mediation or resolution. Nonetheless, by offering a glimpse of the gravity of the challenges that exist in the aftermath of war—challenges that have too often gone unexamined—*Imagine: Reflections on Peace* should above all motivate far more substantial investments in preventing conflict in the first place.

Conflict by the Numbers

Bosnia and Herzegovina

Years of Conflict: 1992–1995

Death Count: 101,000
Research and Documentation Center, Sarajevo.
This figure is still rising as more bodies are being identified.

Displaced: 1,868,368
UNHCR database

War crimes: 161 indicted, 90 convicted
International Criminal Tribunal for the Former Yugoslavia

Population Census in 1991 : 4,377,033
Federal Office for Statistics (BIH)

Cambodia

Years of Conflict: 1970–1992

Death Count: 1.2 million to 2.8 million
Patrick Heuveline, "The Boundaries of Genocide: Quantifying the Uncertainty of the Death Toll During the Pol Pot Regime (1975–79)," in Population Studies 69:2, (2015) 201-218

Displaced: 360,000
UNHCR, US Committee for Refugees and Immigrants

War Crimes: 5 indicted, 4 convicted
Education Centre for Community, Cambodia

Population estimate in 1970 : 7.363 million
Ben Kiernan, "The Demography of Genocide in Southeast Asia: The Death Tolls in Cambodia, 1975-79, and East Timor, 1975-80," Critical Asian Studies, 35:4, 585-597

Colombia

Years of Conflict: 1958–2016

Death Count: 260,000
Basta Ya, Centro Nacional de Memoria Histórica

Displaced: 5.7 million or more
Basta Ya, Centro Nacional de Memoria Histórica

War Crimes: Protests in favor of tribunal, none convened

Population prior to 1960 : 16.4 million
Countryeconomy.com

Lebanon

Years of Conflict: 1975–1989

Death Count: 120,000
UNHCR Commission of Inquiry on Lebanon

Displaced: 965,000
UNHCR Commission of Inquiry on Lebanon

War Crimes: 9 indicted, 2 convicted
Special Tribunal for Lebanon

Population Census 1932: 875,252
The last official census was conducted in 1932. 40 percent of the community was Muslim and 58.7 percent Christian. Today's population is believed to be 5.5 million, the majority of whom are Muslim.

Northern Ireland

Years of Conflict: 1968–1998

Death Count: 3,532
Ulster University Conflict Archive for Northern Ireland

Displaced: 45,000
Liverpool University Press

War Crimes: No criminal court

Convicted Terrorist Offenses:
The Good Friday Agreement allowed for loyalist and republican prisoners convicted on terrorist charges to be freed after serving two years.

Population Census 1971: 1,536,065
31 percent Catholic, 69 percent Protestant or nonaffiliated. The population in 2019 is 1.8 million, about 45 percent of whom have a Catholic family background.

Rwanda

Years of Conflict: 100 days in 1994

Death Count: 800,000 dead
UN official death toll

Displaced: 3,765,000 displaced
UNHCR database

War Crimes: 96 indicted, 61 convicted
International Criminal Tribunal for Rwanda

Gacaca Convictions : 1.9 million indicted, 1,425,000 convicted (75 percent)
UNDP in Rwanda

Population Census 1991: 7,590,235
National Institute of Statistics of Rwanda

Photo by: Gabriela Cristina Anderson

Photo by: Romana Vysatova

Photo by: Jack Hill

Jon Lee Anderson
Jon Lee Anderson is a staff writer for *The New Yorker* and has reported from many countries around the world. His books include *Che Guevara: A Revolutionary Life, The Fall of Baghdad,* and *The Lion's Grave: Dispatches from Afghanistan.* Anderson began his journalism career in 1979 in Peru.

Stephen Ferry
Stephen Ferry is a photographer and author who immerses himself in long-term projects. His work has been published in *The New York Times, National Geographic, GEO,* and *Time*. His book *Violentology: A Manual of the Colombian Conflict* is the product of 10 years of documentation of the armed conflict in Colombia.

Martin Fletcher
Martin Fletcher has had a long career at *The Times* of London. He was Belfast correspondent, Europe correspondent based in Brussels, and, for eight years, Washington correspondent and bureau chief. He was appointed foreign editor for the paper in 2002. The British Press Awards named him Feature Writer of the Year in 2015.

Photo by: Elisa Pelayo

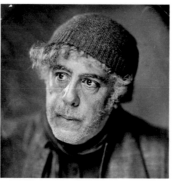

Photo by: Adrian Whipple

Photo by: Nikola Tamindzic

Constance Hale
Constance Hale is a California-based journalist and the author of seven books, including *Sin and Syntax*, a primer on literary style. From 2007 to 2010, she taught narrative journalism at the Nieman Foundation for Journalism at Harvard University. She has edited more than three dozen books, working closely with writers to tell meaningful stories in distinctive voices.

Ron Haviv
Ron Haviv produced some of his most notable work during the Bosnian conflict, where he documented ethnic cleansing. His pictures were later used as evidence in the war crimes trials at The Hague. He has won multiple awards and his work has appeared in many major publications. Haviv is a co-founder of the VII Photo Agency and the VII Foundation.

Elizabeth D. Herman
Elizabeth D. Herman is a photojournalist, researcher, and writer pursuing a PhD in political science at the University of California, Berkeley. Her dissertation research examines the ways in which trauma impacts post-conflict reconciliation.

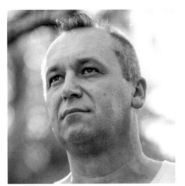

Photo by: Christopher Morris

Photo by: Roy Friedman

Photo by: Victor G. Jeffreys II

Elvis Garibovic
A Bosnian Muslim from a village near Prijedor, Elvis Garibovic was picked up by Serb militia in April 1992 as the former Yugoslavia unraveled, before the world had heard of ethnic cleansing. He was subjected to extreme torture and deprivation in the makeshift concentration camps in Serb-held northwest Bosnia. He now lives in Australia.

Justice Richard Goldstone
Justice Richard Goldstone served as the first chief prosecutor of the UN Criminal Tribunals for the Former Yugoslavia and for Rwanda from 1994 to 1996. He was a judge in his native South Africa and headed the Goldstone Commission, which investigated political violence in South Africa in the early 1990s.

Philip Gourevitch
Philip Gourevitch is a longtime staff writer for *The New Yorker*. His book *We Wish to Inform You That Tomorrow We Will Be Killed with Our Families: Stories from Rwanda* is widely regarded as the definitive piece of reporting on the genocide that took place inside Rwanda over 100 days in the spring of 1994.

Photo by: Maeve Klatell

Photo by: Alizé de Maoult

Chris Klatell
Chris Klatell is a writer and lawyer based in New York. He writes frequently about photography and is working with Gilles Peress on a book about the north of Ireland, to be published in 2020.

Gary Knight
Gary Knight is a photographer and the principal architect of the VII Photo Agency. He is the co-founder and director of the VII Foundation and the president and founder of the VII Academy in Arles, France, and Sarajevo, Bosnia. He began his career photographing in Southeast Asia in the 1980s.

Photo by: Nina Mašić

Pedrag Peđa Kojović
Pedrag Peđa Kojović became a journalist for Reuters during the civil war in Bosnia in 1992. He later co-founded and is currently president of the progressive liberal party in Bosnia, Naša Stranka. He was elected to the national parliament as a representative of Sarajevo in the 2018 Bosnia and Herzegovina elections.

Photo by: Chris Harris

Anthony Loyd
Anthony Loyd is a British foreign correspondent for *The Times* of London and has been reporting from war zones since 1993, when he first traveled to Bosnia. He recently won four awards for his reporting from Syria. He has written a memoir from his time in Bosnia, *My War Gone By, I Miss It So.*

Photo by: Daniel Reina

Margarita Martinez
Margarita Martinez is a Colombian documentary filmmaker and journalist. She started her career at NBC in New York and then returned to Colombia in 1999 to work for the Associated Press, covering internal conflict at one of the peaks of violence. Her film *The Negotiation* was released in 2018.

Photo by: Maëva Neveu

Roland Neveu
Roland Neveu is a French photographer who in 1975 photographed the fall of Phnom Penh to the Khmer Rouge. In much of his work in the following two decades he covered conflict. In the 1980s he photographed the stills for Oliver Stone's feature film *Platoon*. Since then he has done still photography with major Hollywood directors. He now lives in Bangkok.

Photo by: Greenpeace

Padraig O'Malley
Padraig O'Malley is an Irish peace negotiator and is the John Joseph Moakley Distinguished Professor of Peace and Reconciliation at the University of Massachusetts Boston. He concentrates on bringing understanding to divided societies and is the author of several prize-winning books on Northern Ireland.

Photo by: Shereen Hall

Marie O'Reilly
Marie O'Reilly is a researcher who studies how gender affects political and social thinking. She has conducted research and analysis for the Institute for Inclusive Security, the Economist Intelligence Unit, the UN Department of Peace Operations, and the UN Development Programme.

Photo by: Roger LeMoyne

Photo by: Paulo Nunes dos Santos

Don McCullin

Sir Don McCullin is well established in the canon of photography; his work covers all the major late 20th-century conflicts. His lens shows life from the perspective of the disenfranchised and the dispossessed, the civilian casualties of war and the victims of social injustice. McCullin has won multiple awards and was the first photojournalist ever to be awarded a CBE.

Monica McWilliams and Avila Kilmurray

Monica McWilliams and Avila Kilmurray are activists and academics who fought for and won a seat at the peacemaking process in Northern Ireland. McWilliams is a professor of women's studies at the University of Ulster, and Kilmurray is the director of the Community Foundation for Northern Ireland.

Photo by: Jackie Escolar

Photo by: Patrick Brown

Gilles Peress

Gilles Peress is the recipient of the John Simon Guggenheim Fellowship, the Dr. Erich Salomon Prize, and grants from the National Endowment for the Arts. His work has been exhibited by and is in the collections of the Museum of Modern Art, the Metropolitan Museum of Art, the Whitney Museum of American Art, the Art Institute of Chicago, the Getty, and the Centre Pompidou, among others.

Jack Picone

Jack Picone is an Australian documentary photographer, author, and academic. He is a three-time winner of a Picture of the Year International award; his other honors include a UNESCO Humanity Photo award and a World Press Photo award. He was one of only a handful of photographers to document the Rwandan genocide as it was taking place.

Jonathan Powell

Jonathan Powell was the chief of staff to British Prime Minister Tony Blair from 1997 to 2007 and the chief British government negotiator on Northern Ireland for the Good Friday or Belfast Agreement. He is currently director of Inter Mediate, a UK-based NGO committed to conflict resolution around the world.

Contributors

Photo by: Stephen Kelleghan

Samantha Power
Samantha Power served as the US Ambassador to the United Nations from 2013 to 2017, after serving four years as President Barack Obama's special assistant for human rights and multilateral affairs. She is a professor of practice at Harvard Kennedy School and Harvard Law School. Power began her career as a war correspondent covering the breakup of Yugoslavia. Her 2002 book *"A Problem from Hell": America and the Age of Genocide* won the 2003 Pulitzer Prize. Her most recent book is *The Education of an Idealist: A Memoir.*

Mira Sidawi
Mira Sidawi graduated from Lebanese University with a diploma in theater. A Palestinian actress, writer, and director, she has acted in a number of short films and feature films including *Permission, Instead of a Homeland*, and *Mon Souflé*. Most recently she has turned to directing, using wit and a sharp eye to tell the stories of Palestinian life in the camps.

Photo by: Chris McGrath

Nicole Tung
Nicole Tung is a freelance photojournalist who is covering the wars of today. In 2011, she began photographing the Arab Spring. She has spent extensive time in Syria, Libya, and Iraq, focusing on the plight of civilians and those affected by conflict and the consequences of war.

Photo by: Gary Knight

Fiona Turner
Fiona Turner is an Emmy award–winning producer and director with a background in broadcast news and documentary. For ABC News and NBC News, she covered many of the global conflicts of the 1990s, including the breakup of the Balkans. She recently directed and produced a documentary feature film, *Eat Up*.

Photo by: Murenzi Kamatari

Dydine Umunyana
Dydine Umunyana was a child witness to the Rwandan genocide and wrote about the subject in her book *Embracing Survival: Genocide and War through the Eyes of a Child*. Umunyana was appointed a youth peace ambassador in 2013 for the Aegis Trust, an organization dedicated to the prevention of genocide and mass atrocities worldwide.

Photo by: Zelalem Mulat Teklewold

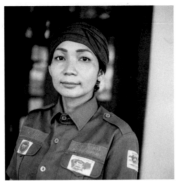

Photo by: Gary Knight

Photo by: Justin McKie

Nichole Sobecki
Nichole Sobecki is a photographer based in Nairobi, Kenya. As a member of the VII Photo Agency, she aims to create photographs and films that demand consideration for the lives of those represented— their joys, their challenges, and, ultimately, their humanity.

Sophary Sophin
Sophary Sophin grew up in the shadow of the Khmer Rouge. Her father was one of the educated "April 17" people whom the Khmer Rouge banished to the countryside, where he married her mother and lived as an agrarian peasant. Sophin works as operations manager for Cambodian Self Help Demining and leads the Rural Schools Village Program.

Jon Swain
Jon Swain was the only British journalist on the ground in Phnom Penh when it fell to the Khmer Rouge in April 1975. The British Press Awards named him Journalist of the Year for his coverage of that event. Roland Joffé's Oscar-winning film *The Killing Fields* depicted him as a character. He was a staff correspondent for many years at *the Sunday Times* of London.

Robin Wright
Robin Wright is an American journalist and author who has won numerous awards for her in-depth analysis and international reporting. Wright has reported from more than 140 countries on six continents and is a columnist for *The New Yorker* and a joint fellow at the US Institute of Peace and the Wilson International Center for Scholars.

ACKNOWLEDGEMENTS

So many people have assisted in the making of this book that the task of thanking them individually is a truly impossible one, and our attempt is necessarily incomplete.

We must start by acknowledging Jennifer Stengaard Gross and Peter Stengaard of Blue Chip Foundation, as well as the William, Jeff, and Jennifer Gross Family Foundation. They believed in this project from the get-go, and their encouragement and generous support turned an idea into a reality.

A few individuals were critical in developing the original idea of *Imagine: Reflections on Peace*. Conversations with James Waite helped the idea germinate and take shape.

Many of the voices who contributed to this project remain anonymous, so we honor those who took significant risks in helping to tell the stories of war and peace. In war reporting, fixers, translators, and local journalists make the work possible, and their efforts often go unsung. We are indebted to them. Equally critical are friends and colleagues who over many years engaged with us in conversation, hashing out ideas. Their contribution permeates every line.

People in Lebanon, Cambodia, Rwanda, Bosnia, Northern Ireland, and Colombia shared their stories with us, for which we are forever grateful. The innumerable sources in the book allowed us to be privy to some of their most personal experiences, memories, and insights. They have also welcomed us into their homes and private spaces to take pictures. We are honored by their generosity and hope we have done them justice.

The writers, photographers and editorial team would like to acknowledge the participation and support of the following people in particular: Mustafa Alali, Alex Anderson, Kiku Adatto, Arshed Baghdadi, Nikola Blagojevic, Philip Blenkinsop, Andrés Caicedo, Alison Cornyn, Dominique Deschavanne, Brid Duffy, María Jimena Duzán, Karina Eckmeier, Roland Eng, Aaron Friedman, Philip Jones Griffiths, Tom Hartley, Michael Hayes, Chris McGrath, Justin McKie, Ossama Muhammed, Martin Parr, Ariane Quentier, Frankie Quinn, Edin Ramulić, Andrew and Atka Reid, Pierre Sagahutu, Leena Saidi, Jean-Daniel Schwartz, Adam Seigel, Sherman Teichman, Lisa Usdan, Marjolein van de Water, Yonola Viguerie, the FARC ex-combatants of Agua Bonita, those in the Humanitarian Zone of Curvaradó, the family of Gilles Peress, the family of Nicole Tung, and the board of the VII Foundation.

Special thanks from the editors go to Giorgio Baravalle for his brilliant design; to the editorial teams at VII Foundation in the United States and Hemeria in France; and to Brigitte Trichet, who coordinated our efforts with grace. Translators Louise Bartlett and Alison Kamm rendered a book written in English into elegant French. Gail Nelson-Bonebrake and Elissa Rabellino copy edited the English version with professional aplomb, and Sophie Loria and Fabienne Texier brought the same to the French.

We thank them all.

— Gary Knight,
Fiona Turner, Constance Hale, and Ron Haviv

Founded in 2001 by Gary Knight and Ron Haviv, the VII Foundation is an independent nonprofit media and education organization. It was established to secure support for documentary practice that addresses complex social, economic, and human rights issues, as well as for vocational media and journalism education.

Imagine: Reflections on Peace is part of a larger project that includes a series of exhibitions, including the opening exhibition at the Museum of the International Red Cross and Red Crescent in Geneva. In addition, it will include seminars, an education program, and other forms of action and advocacy to encourage discourse about how to build and sustain peace.

Concept and Editorial Direction: Gary Knight
Project Director: Fiona Turner
Editors: Constance Hale and Fiona Turner
Consulting Editor: Ron Haviv
Art Direction and Design: Giorgio Baravalle @ de.MO Branding and Design
Coordinator French edition: Brigitte Trichet (Hemeria)
Translation: Louise Bartlett, Alison Kamm
Copy Editors: Gail Nelson-Bonebrake, Elissa Rabellino
Copy Editors French version: Sophie Loria, Fabienne Texier
Image and Printing Process: Printmodel©,Paris

VII Foundation
429 W 45th St
NY NY 10036
www.theviifoundation.org
#Imagine:reflectionsonpeace
www.reflectionsonpeace.org

Hemeria
140, rue de Belleville
75020 Paris
France
@hemeriaphoto
#ExceptionalPhotoBooks
www.hemeria.com

Printed in June 2020 in France
ISBN: 978-1-7344256-0-4
ISBN: 978-2-490952-09-0
Legal deposit: September 2020

Co-published in North America by
SparkPress, a BookSparks imprint
Phoenix, Arizona, USA 85007
www.gosparkpress.com
Print ISBN: 978-1-68463-085-1
E-ISBN: 978-1-68463-086-8
Library of Congress Control Number: 2020909645

Copyright permissions courtesy of: Jon Lee Anderson / Stephen Ferry /
Martin Fletcher / Elvis Garibovic / Justice Richard Goldstone / Philip
Gourevitch / Ron Haviv / Elizabeth D. Herman / Avila Kilmurray / Chris Klatell /
Gary Knight / Anthony Loyd / Margarita Martinez / Don McCullin / Monica
McWilliams / Padraig O'Malley / Marie O'Reilly / Roland Neveu / Gilles Peress /
Jack Picone / Jonathan Powell / Samantha Power / Mira Sidawi / Nichole Sobecki /
Sophary Sophin / Jon Swain / Nicole Tung / Dydine Umunyana / Robin Wright

musée + ⊂ genève
www.redcrossmuseum.ch

Musée International de la Croix-Rouge
et du Croissant-Rouge
Avenue de la Paix 17
1202 Genève - Suisse